Camera Map

Here's a handy map to the buttons, dials, and other external features on your D60. Note that the lens shown is the Nikon AF-S DX Nikkor 18–55 VR (Vibration Reduction) model sold with the D60 kit; other lenses may not have the same controls. Camera controls marked with an asterisk have multiple functions, but for simplicity's sake, I refer to them in this book by the names you see here. See Chapter 1 for details.

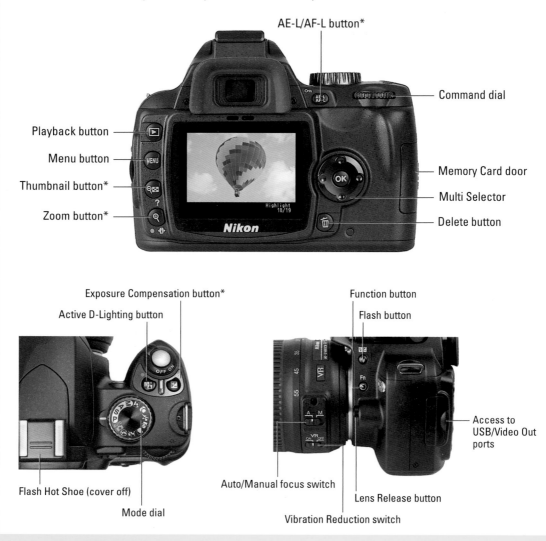

AE-L/AF-L button*

Command dial

Playback button

Menu button

Thumbnail button*

Zoom button*

Memory Card door

Multi Selector

Delete button

Exposure Compensation button*

Active D-Lighting button

Function button

Flash button

Access to USB/Video Out ports

Flash Hot Shoe (cover off)

Mode dial

Auto/Manual focus switch

Lens Release button

Vibration Reduction switch

For Dummies: Bestselling Book Series for Beginners

Nikon® D60
FOR
DUMMIES

Cheat Sheet

Automatic Exposure Mode Quick Reference

Refer to the tables below for a quick explanation of your camera's fully automatic exposure modes, which include Auto and the seven Digital Vari-Program scene modes. In these modes, you can choose between automatic or manual focusing, but you have little or no control over most other picture-taking settings. See Chapter 2 for details.

Symbol	Exposure Mode	Description
AUTO	Auto	Completely automatic photography; the camera analyzes the scene and tries to choose settings that produce the best results.
⊘	No Flash	Same as Full Auto, but with flash disabled.
	Portrait	Designed to produce softly focused backgrounds for flattering portraits.
	Landscape	Designed to keep both near and distant subjects in sharp focus.
	Child	Similar to Portrait mode, but intensifies colors typically found in clothing.
	Sports	Selects faster shutter speed to capture moving subjects without blur.
	Close Up	Produces softly focused backgrounds especially suitable for close-ups of flowers and other nature subjects.
	Night Portrait	Same as Portrait, but with flash mode set to slow-sync, resulting in a slower shutter speed to produce softer lighting and brighter backgrounds.

Advanced Exposure Modes

In these four modes, all covered in Chapter 5, you can adjust aperture (f-stop) to manipulate depth of field (the zone of sharp focus) and adjust shutter speed to determine whether moving objects appear sharply focused or blurry. You also gain access to picture options not available in Auto or Digital Vari-Program scene modes.

Symbol	Exposure Mode	Description
P	Programmed Autoexposure	Camera selects both the f-stop and shutter speed to ensure proper exposure, but the user can choose from multiple combinations of the two settings.
A	Aperture-priority Autoexposure	The user selects f-stop, and the camera selects the shutter speed that will produce a good exposure.
S	Shutter-priority Autoexposure	The user sets shutter speed, and the camera selects the f-stop that will produce a good exposure.
M	Manual Exposure	The user controls both the shutter speed and f-stop.

For Dummies: Bestselling Book Series for Beginners

Nikon® D60

FOR DUMMIES®

by Julie Adair King

WILEY

Wiley Publishing, Inc.

Nikon® D60 For Dummies®

Published by
Wiley Publishing, Inc.
111 River Street
Hoboken, NJ 07030-5774

www.wiley.com

Copyright © 2008 by Wiley Publishing, Inc., Indianapolis, Indiana

Published by Wiley Publishing, Inc., Indianapolis, Indiana

Published simultaneously in Canada

For general information on our other products and services, please contact our Customer Care Department within the U.S. at 800-762-2974, outside the U.S. at 317-572-3993, or fax 317-572-4002.

For technical support, please visit www.wiley.com/techsupport.

Wiley also publishes its books in a variety of electronic formats. Some content that appears in print may not be available in electronic books.

Library of Congress Control Number: 2008930836

ISBN: 978-0-470-38538-8

Manufactured in the United States of America

10 9 8 7 6 5 4 3 2 1

WILEY

About the Author

Julie Adair King is the author of many books about digital photography and imaging, including the best-selling *Digital Photography For Dummies*. Her most recent titles include *Nikon D40/D40x For Dummies, Digital Photography Before & After Makeovers, Digital Photo Projects For Dummies, Julie King's Everyday Photoshop For Photographers, Julie King's Everyday Photoshop Elements,* and *Shoot Like a Pro!: Digital Photography Techniques.* When not writing, King teaches digital photography at such locations as the Palm Beach Photographic Center. A graduate of Purdue University, she resides in Indianapolis, Indiana.

Author's Acknowledgments

I am extremely grateful to the team of talented professionals at John Wiley and Sons for all their efforts in putting together this book. Special thanks go to my awesome project editor, Kim Darosett, who is the type of editor that all authors hope for but rarely experience: supportive, skilled, and amazingly calm in the face of any storm, including my not infrequent freakouts.

I also owe much to the rest of the folks in both the editorial and art departments, especially Heidi Unger, Rashell Smith, Shelley Lea, Steve Hayes, Andy Cummings, and Mary Bednarek. Thanks, too, to my friends at Nikon for their assistance, to Jonathan Conrad for providing the awesome nighttime shot for Chapter 7, and to agent extraordinaire, Margot Maley Hutchison, for her continuing help and encouragement.

Last but oh, so not least, I am deeply indebted to technical editor Chuck Pace, whose keen eye and vast experience set me on the right track whenever I mistakenly thought I should go left. Thank you, thank you, for sharing your time and your expertise — the book would not have been the same without it.

Publisher's Acknowledgments

We're proud of this book; please send us your comments through our online registration form located at www.dummies.com/register/.

Some of the people who helped bring this book to market include the following:

Acquisitions and Editorial

Project Editor: Kim Darosett

Executive Editor: Steve Hayes

Copy Editor: Heidi Unger

Technical Editor: Chuck Pace

Editorial Manager: Leah Cameron

Editorial Assistant: Amanda Foxworth

Sr. Editorial Assistant: Cherie Case

Cartoons: Rich Tennant
(www.the5thwave.com)

Composition Services

Project Coordinator: Kristie Rees

Layout and Graphics: Carrie A. Cesavice, Alissa D. Ellet, Erin Zeltner

Proofreaders: Laura Albert, Joanne Keaton, Amanda Steiner

Indexer: Broccoli Information Management

Publishing and Editorial for Technology Dummies

Richard Swadley, Vice President and Executive Group Publisher

Andy Cummings, Vice President and Publisher

Mary Bednarek, Executive Acquisitions Director

Mary C. Corder, Editorial Director

Publishing for Consumer Dummies

Diane Graves Steele, Vice President and Publisher

Joyce Pepple, Acquisitions Director

Composition Services

Gerry Fahey, Vice President of Production Services

Debbie Stailey, Director of Composition Services

Contents at a Glance

Table of Contents

Introduction

*O*nce upon a time, moving up from a point-and-shoot digital camera to an SLR model meant adding significant weight and bulk to your camera bag — and removing a significant amount from your bank account. But all that changed a few years ago with the introduction of the Nikon D40. Finally, here was a camera that offered the power and flexibility of a digital SLR but in a revolutionary, compact size and at an equally compact price. Combine those benefits with the legendary quality for which Nikon is known, and it's no surprise that the D40, along with its sibling, the D40x, quickly became best-sellers.

Now, Nikon has taken a great thing and made it even better with the follow-up to those two models, the D60. Amazingly, this model is slightly more diminutive than its predecessors, weighing in at just over 16 ounces, yet it offers an even greater array of features.

In fact, the D60 offers so *many* features that sorting them all out can be more than a little confusing, especially if you're new to digital photography, SLR photography, or both. For starters, you may not even be sure what SLR means or how it affects your picture taking, let alone have a clue as to all the other techie terms you encounter in your camera manual — *resolution, aperture, white balance, file format,* and so on. And if you're like many people, you may be so overwhelmed by all the controls on your camera that you haven't yet ventured beyond fully automatic picture-taking mode. Which is a shame because it's sort of like buying a Porsche and never actually taking it on the road.

Therein lies the point of *Nikon D60 For Dummies:* Through this book, you can discover not just what each bell and whistle on your camera does, but also when, where, why, and how to put it to best use. Unlike many photography books, this one doesn't require any previous knowledge of photography or digital imaging to make sense of things, either. In classic *For Dummies* style, everything is explained in easy-to-understand language, with lots of illustrations to help clear up any confusion.

In short, what you have in your hands is the paperback version of an in-depth photography workshop tailored specifically to your Nikon picture-taking powerhouse.

A Quick Look at What's Ahead

This book is organized into four parts, each devoted to a different aspect of using your camera. Although chapters flow in a sequence that's designed to take you from absolute beginner to experienced user, I've also tried to make each chapter as self-standing as possible so that you can explore the topics that interest you in any order you please.

The following sections offer brief previews of each part. If you're eager to find details on a specific topic, the index shows you exactly where to look.

Part I: Fast Track to Super Snaps

Part I contains four chapters that help you get up and running with your D60:

- ✔ Chapter 1, "Getting the Lay of the Land," offers a tour of the external controls on your camera, shows you how to navigate camera menus to access internal options, and walks you through initial camera setup and customization steps.

- ✔ Chapter 2, "Taking Great Pictures, Automatically," shows you how to get the best results when using the camera's fully automatic exposure modes, including the Digital Vari-Program scene modes such as Sports mode, Portrait mode, and Child mode.

- ✔ Chapter 3, "Controlling Picture Quality and Size," introduces you to two camera settings that are critical whether you shoot in automatic or manual modes: the Image Size and Image Quality settings, which control resolution (pixel count), file format, file size, and picture quality.

- ✔ Chapter 4, "Reviewing Your Photos," explains how to view your pictures on the camera monitor and also how to display various types of picture information along with the image. In addition, this chapter discusses how to delete unwanted images and protect your favorites from accidental erasure.

Part II: Taking Creative Control

Chapters in this part help you unleash the full creative power of your D60 by moving into semiautomatic or manual photography modes.

- ✔ Chapter 5, "Getting Creative with Exposure and Lighting," covers the all-important topic of exposure, starting with an explanation of three critical exposure controls: aperture, shutter speed, and ISO. This chapter also discusses your camera's advanced exposure modes (P, S, A, and M), explains exposure options such as Active D-Lighting, metering modes, and exposure compensation, and offers tips for using the built-in flash.

✔ Chapter 6, "Manipulating Focus and Color," provides help with controlling those aspects of your pictures. Look here for information about your D60's manual and auto-focusing features as well as details about color controls such as white balance and the Optimize Image options.

✔ Chapter 7, "Putting It All Together," summarizes all the techniques explained in earlier chapters, providing a quick-reference guide to the camera settings and shooting strategies that produce the best results for specific types of pictures: portraits, action shots, landscape scenes, close-ups, and more.

Part III: Working with Picture Files

This part of the book, as its title implies, discusses the often-confusing aspect of moving your pictures from camera to computer and beyond.

✔ Chapter 8, "Downloading, Organizing, and Archiving Your Photos," guides you through the process of transferring pictures from your camera memory card to your computer's hard drive or other storage device. Look here, too, for details about using the D60's built-in tool for processing files that you shoot in the Nikon Raw format (NEF). Just as important, this chapter explains how to organize and safeguard your photo files.

✔ Chapter 9, "Printing and Sharing Your Photos," helps you turn your digital files into "hard copies," covering both retail and do-it-yourself printing options. This chapter also explains how to prepare your pictures for online sharing, turn a series of photos into a stop-motion movie, and, for times when you have the neighbors over, how to display your pictures on a television screen.

Part IV: The Part of Tens

In famous For Dummies tradition, the book concludes with two "top ten" lists containing additional bits of information and advice.

✔ Chapter 10, "Ten Fast Photo-Retouching Tricks," shows you how to fix less-than-perfect images using features found on your camera's Retouch menu, such as automated red-eye removal. In case you can't solve the problem that way, this chapter also explains how to perform some basic retouching by using tools found in most photo editing programs.

✔ Chapter 11, "Ten Special-Purpose Features to Explore on a Rainy Day," presents information about some camera features that, while not found on most "Top Ten Reasons I Bought My D60" lists, are nonetheless interesting, useful on occasion, or a bit of both.

Appendix: Firmware Notes and Menu Map

Wrapping up the book, the appendix explains how to find out what version of the Nikon *firmware,* or internal software, is installed in your camera and how to find and download updates.

If the information you see on your camera menus and other displays isn't the same as what you see in this book, and you've explored other reasons for the discrepancy, a firmware update may be the issue. This book was written using version 1.00 of the firmware, which was the most current at the time of publication. Firmware updates typically don't carry major feature changes — they're mostly used to solve technical glitches in existing features — but if you do download an update, be sure to read the accompanying description of what it accomplishes so that you can adapt my instructions as necessary. (Again, changes that affect how you actually operate the camera should be minimal, if any.)

On a less technical note, the appendix also includes tables that provide brief descriptions of all commands found on the camera's five menus.

Icons and Other Stuff to Note

If this isn't your first For Dummies book, you may be familiar with the large, round icons that decorate its margins. If not, here's your very own icon-decoder ring:

A Tip icon flags information that will save you time, effort, money, or some other valuable resource, including your sanity.

When you see this icon, look alive. It indicates a potential danger zone that can result in much wailing and teeth-gnashing if ignored.

Lots of information in this book is of a technical nature — digital photography is a technical animal, after all. But if I present a detail that is useful mainly for impressing your technology-geek friends, I mark it with this icon.

I apply this icon either to introduce information that is especially worth storing in your brain's long-term memory or to remind you of a fact that may have been displaced from that memory by some other pressing fact.

Additionally, I need to point out two other details that will help you use this book:

- ✔ **Other margin art:** Replicas of some of your camera's buttons, dials, controls, and menu graphics also appear in the margins of some paragraphs. I include these to provide a quick reminder of the appearance of the button or option being discussed.

- ✔ **Software menu commands:** In sections that cover software, a series of words connected by an arrow indicates commands that you choose from the program menus. For example, if a step tells you to "Choose File➪Print," click the File menu to unfurl it and then click the Print command on the menu.

About the Software Shown in This Book

Providing specific instructions for performing photo organizing and editing tasks requires that I feature specific software. In sections that cover file downloading, archiving, printing, and e-mail sharing, I selected Nikon ViewNX and Nikon Transfer, both of which ship free with your camera and work on both the Windows and Mac operating systems.

However, because those programs don't offer any photo-retouching tools, I also feature Adobe Photoshop Elements for some discussions. The version shown in the book is Elements 6 for Windows, but the tools covered here work mostly the same in versions 4 and 5, and for Mac as well as Windows, unless otherwise specified.

Rest assured, though, that the tools used in both ViewNX and Elements work very similarly in other programs, so you should be able to easily adapt the steps to whatever software you use. (I recommend that you read your software manual for details, of course.)

Practice, Be Patient, and Have Fun!

To wrap up this preamble, I want to stress that if you initially think that digital photography is too confusing or too technical for you, you're in very good company. *Everyone* finds this stuff a little mind-boggling at first. So take it slowly, experimenting with just one or two new camera settings or techniques at first. Then, each time you go on a photo outing, make it a point to add one or two more shooting skills to your repertoire.

I know that it's hard to believe when you're just starting out, but it really won't be long before everything starts to come together. With some time, patience, and practice, you'll soon wield your camera like a pro, dialing in the necessary settings to capture your creative vision almost instinctively.

So without further ado, I invite you to grab your camera, a cup of whatever it is you prefer to sip while you read, and start exploring the rest of this book. Your D60 is the perfect partner for your photographic journey, and I thank you for allowing me, through this book, to serve as your tour guide.

Part I
Fast Track to Super Snaps

The 5th Wave By Rich Tennant

"That's a lovely scanned image of your sister's portrait. Now take it off the body of that pit viper before she comes in the room."

In this part . . .

Making sense of all the controls on your D60 isn't something you can do in an afternoon — heck, in a week, or maybe even a month. But that doesn't mean that you can't take great pictures today. By using your camera's point-and-shoot automatic modes, you can capture terrific images with very little effort. All you do is compose the scene, and the camera takes care of almost everything else.

This part shows you how to take best advantage of your camera's automatic features and also addresses some basic setup steps, such as adjusting the viewfinder to your eyesight and getting familiar with the camera menus, buttons, and dials. In addition, chapters in this part explain how to obtain the very best picture quality, whether you shoot in an automatic or manual mode, and how to use your camera's picture-playback features.

Getting the Lay of the Land

I still remember the day that I bought my first SLR film camera. I was excited to finally move up from my one-button point-and-shoot camera, but I was a little anxious, too. My new pride and joy sported several unfamiliar buttons and dials, and the explanations in the camera manual clearly were written for someone with an engineering degree. And then there was the whole business of attaching the lens to the camera, an entirely new task for me. I saved up my pennies a long time for that camera — what if my inexperience caused me to damage the thing before I even shot my first pictures?

You may be feeling similarly insecure if your Nikon D60 is your first SLR, although some of the buttons on the camera back may look familiar if you've previously used a digital point-and-shoot camera. If your D60 is both your first SLR and first digital camera, you may be doubly intimidated.

Trust me, though, that your camera isn't nearly as complicated as its exterior makes it appear. With a little practice and the help of this chapter, which introduces you to each external control, you'll quickly become as comfortable with your camera's buttons and dials as you are with the ones on your car's dashboard.

This chapter also guides you through the process of mounting and using an SLR lens, working with digital memory cards, and navigating your camera's internal menus. And for times when you don't have this book handy, I show you how to access the Help system that's built into your camera.

Getting Comfortable with Your Lens

One of the biggest differences between a point-and-shoot camera and an SLR *(single-lens reflex)* camera is the lens. With an SLR, you can swap out lenses to suit different photographic needs, going from an extreme close-up lens to a super-long telephoto, for example. In addition, an SLR lens has a movable focusing ring that gives you the option of focusing manually instead of relying on the camera's autofocus mechanism.

Of course, those added capabilities mean that you need a little background information to take full advantage of your lens. To that end, the next four sections explain the process of attaching, removing, and using this critical part of your camera.

Attaching a lens

Whatever lens you choose, follow these steps to attach it to the camera body:

1. **Remove the cap that covers the lens mount on the front of the camera.**

2. **Remove the cap that covers the back of the lens.**

 The cap is the one that doesn't say *Nikon* on it, in case you aren't sure.

3. **Hold the lens in front of the camera so that the little white dot on the lens aligns with the matching dot on the camera body.**

 Official photography lingo uses the term *mounting index* instead of *little white dot.* Either way, you can see the markings in question in Figure 1-1.

 Note that the figure (and others in this chapter) shows you the D60 with its so-called "kit lens" — the 18–55mm Vibration Reduction (VR) zoom lens that Nikon sells as a unit with the body. If you buy a lens from a manufacturer other than Nikon, your dot may be red or some other color, so check the lens instruction manual.

4. **Keeping the dots aligned, position the lens on the camera's lens mount as shown in Figure 1-1.**

 When you do so, grip the lens by its back collar as shown in the figure, not the movable, forward end of the lens barrel.

Mounting index dots

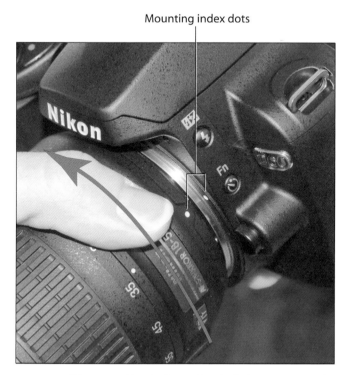

Figure 1-1: When attaching the lens, align the index markers as shown here.

5. **Turn the lens in a counter-clockwise direction until the lens clicks into place.**

 To put it another way, turn the lens toward the side of the camera that sports the shutter button, as indicated by the red arrow in the figure.

6. **On a lens that has an aperture ring, set and lock the ring so the aperture is set at the highest f-stop number.**

 Check your lens manual to find out whether your lens sports an aperture ring and how to adjust it. (The D60 kit lens doesn't.) To find out more about apertures and f-stops, see Chapter 5.

Always attach (or switch) lenses in a clean environment to reduce the risk of getting dust, dirt, and other contaminants inside the camera or lens. Changing lenses on a sandy beach, for example, isn't a good idea. For added safety, point the camera body slightly down when performing this maneuver; doing so helps prevent any flotsam in the air from being drawn into the camera by gravity. See Chapter 3 for tips on cleaning your lens.

Removing a lens

To detach a lens from the camera body, take these steps:

1. **Locate the lens-release button, labeled in Figure 1-2.**

2. **Grip the rear collar of the lens.**

 In other words, hold onto the stationary part of the lens that's closest to the camera body and not the movable focusing ring or zoom ring, if your lens has one.

3. **Press the lens-release button while turning the lens clockwise until the mounting index on the lens is aligned with the index on the camera body.**

 The mounting indexes are the little guide dots labeled in Figure 1-1. When the dots line up, the lens should detach from the mount.

4. **Place the rear protective cap onto the back of the lens.**

 If you aren't putting another lens on the camera, cover the lens mount with the protective cap that came with your camera, too.

VR On/Off Lens-release button

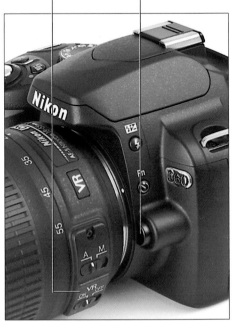

Figure 1-2: Press the lens-release button to disengage the lens from the mount.

Using a VR (vibration reduction) lens

If you purchased the D60 camera kit — that is, the body-and-lens combination put together by Nikon — your lens offers a feature called *vibration reduction*. On Nikon lenses, this feature is indicated by the initials *VR* in the lens name.

Vibration reduction attempts to compensate for small amounts of camera shake that are common when photographers handhold their cameras and use a slow shutter speed, a lens with a long focal length, or both. That camera movement during the exposure can produce blurry images. Although vibration reduction can't work miracles, it does enable most people to capture sharper handheld shots in many situations than they otherwise could.

However, when you use a tripod, vibration reduction can have detrimental effects because the system may try to adjust for movement that isn't actually occurring. That's why your kit lens — and all Nikon VR lenses — have an On/Off switch, which is located on the side of the lens, as shown in Figure 1-2. When you do shoot with a tripod, remember to set that switch to the Off position.

If you use a non-Nikon lens, the vibration reduction feature may go by another name: *image stabilization, optical stabilization, anti-shake, vibration compensation,* and so on. In some cases, the manufacturers may recommend that you leave the system turned on or to a special setting when you use a tripod, so be sure to check the lens manual for information.

Chapter 6 offers more tips on achieving blur-free photos, and it also explains focal length and its impact on your pictures. See Chapter 5 for an explanation of shutter speed.

Focusing and zooming the lens

When paired with a compatible lens, your camera offers autofocusing capabilities, which you can explore in detail in Chapter 6. But with some subjects, autofocusing can be slow or impossible, which is why your camera also offers manual focusing. The process is quick and easy: You just turn the focusing ring on the lens until your subject comes into focus. To try it out, take these steps:

1. **Locate the A-M (Auto/Manual) focusing switch on the side of the lens.**

 Figure 1-3 shows the switch as it appears on the D60's kit lens. The switch should be in a similar location on other Nikon lenses; if you use a lens from another manufacturer, check the lens instruction manual.

2. **Set the switch to the M position, as shown in the figure.**

 Don't try to move the focusing ring on the kit lens with the switch set to the A (autofocus) position; doing so can damage the lens.

3. **While looking through the viewfinder, twist the focusing ring to adjust focus.**

 If you have trouble focusing, you may be too close to your subject; every lens has a minimum focusing distance. (See Chapter 6 for more tips on focus issues.) You may also need to adjust the viewfinder to accommodate your eyesight; see the next section for details.

Focusing ring Zoom barrel Auto/Manual focus switch

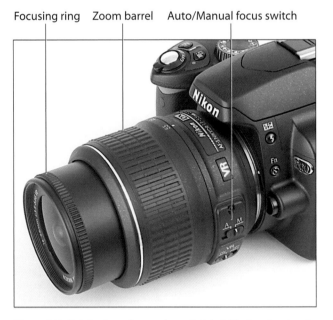

Figure 1-3: Set the focusing mode switch to M before turning the manual focus ring.

Again, the option to switch between autofocusing and manual focusing depends on matching the D60 with a fully compatible lens, as I mentioned in the introduction to this section. The short story is this: The D60 doesn't have an autofocusing system built into the camera body, which means that the lens itself must sport that mechanism in order for you to autofocus. You can still use the lens if it doesn't have an autofocusing system; you simply have to focus manually at all times. When you use such a lens, visit Chapter 6 to find out how to set the camera's Focus mode option, found on the Custom Setting menu, to Manual.

In addition, some lenses (although not the one sold with the D60 kit) enable you to use autofocusing to set the initial focusing point and then fine-tune focus manually. Check your lens manual for information on how to use this option, if available.

If you bought a zoom lens, a movable zoom barrel lies behind the focusing ring, as shown in Figure 1-3. To zoom in or out, just move that zoom ring forward and backward.

The numbers on the zoom ring, by the way, represent *focal lengths*. I explain focal lengths in Chapter 6. In the meantime, just note that when the lens is mounted on the camera, the number that's aligned with the lens mounting index (the white dot) represents the current focal length. In Figure 1-3, for example, the focal length is 55mm.

Adjusting the Viewfinder Focus

Tucked behind the right side of the rubber eyepiece that surrounds the viewfinder is a tiny vertical switch, called a *diopter adjustment control*. With this control, labeled in the left image in Figure 1-4, you can adjust the focus of your viewfinder to accommodate your eyesight.

Diopter adjustment control Focus brackets

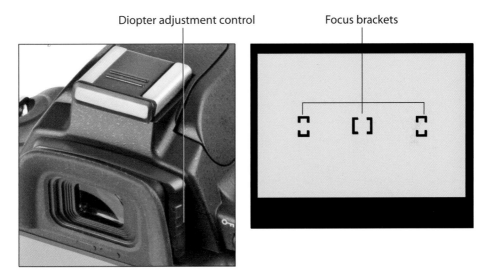

Figure 1-4: Use the diopter adjustment control to set the viewfinder focus for your eyesight.

If you don't take this step, scenes that appear out of focus through the viewfinder may actually be sharply focused through the lens, and vice versa. Here's how to make the necessary adjustment:

1. **Remove the lens cap from the front of the lens.**

2. **Look through the viewfinder and concentrate on the three pairs of brackets shown on the right side of Figure 1-4.**

 The brackets are officially called *focus brackets,* but don't worry about focusing the actual picture now; just pay attention to the brackets.

3. **Slide the diopter adjustment control up or down until the brackets appear to be in focus.**

 The Nikon manual warns you not to poke yourself in the eye as you perform this maneuver. This warning seems so obvious that I laugh every time I read it — which makes me feel doubly stupid the next time I poke myself in the eye as I perform this maneuver.

Working with Memory Cards

Instead of recording images on film, digital cameras store pictures on *memory cards.* Some people, in fact, refer to memory cards as *digital film,* but I hate that term because film and memory cards actually have little in common. Film must be developed before you can view your pictures, a process that involves time and some not-so-nice chemicals. Film can be damaged when exposed to some airport security scanners; memory cards are immune to those devices. The cost per picture is also much higher for film: You have to develop and print each negative, whether the shot is a keeper or a clunker. With digital, you print only the pictures you like — and you can reuse your memory cards over and over and over, saving even more money.

Whatever term you prefer, your D60 uses a specific type of memory card called an *SD card* (for *Secure Digital*), shown in Figures 1-5 and 1-6. Other card types — CompactFlash, Memory Stick, or any others — aren't compatible with your camera. However, if you use SD cards in your cell phone, portable music player, or other device, you can use the same cards in your camera.

Safeguarding your memory cards — and the images you store on them — requires just a few precautions:

Memory card access light

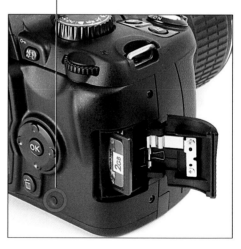

✔ **Inserting a card:** First, be sure that the camera is turned off. Then put the card in the card slot with the label facing the back of the camera, as shown in Figure 1-5. Push the card into the slot until it clicks into place; the memory card access light (circled in Figure 1-5) blinks for a second to let you know the card is inserted properly.

✔ **Formatting a card:** The first time you use a new memory card, take a few seconds to *format* it by choosing the Format Memory Card option on the Setup menu. This step simply ensures that the card is properly prepared to record your pictures. See the upcoming section "Cruising the Setup menu" for details.

Figure 1-5: Insert the card with the label facing the camera back.

✔ **Removing a card:** After making sure that the memory card access light is off, indicating that the camera has finished recording your most

recent photo, turn the camera off. Open the memory card door, as shown in Figure 1-5. Depress the memory card slightly until you hear a little click and then let go. The card should pop halfway out of the slot, enabling you to grab it by the tail and remove it.

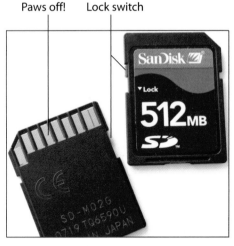

Paws off! Lock switch

✒ **Handling cards:** Don't touch the gold contacts on the back of the card. (See the left card in Figure 1-6.) When cards aren't in use, store them in the protective cases they came in or in a memory card wallet. Keep cards away from extreme heat and cold as well.

Figure 1-6: Avoid touching the gold contacts on the card.

✒ **Locking cards:** The tiny switch on the left side of the card, labeled *lock switch* in Figure 1-6, enables you to lock your card, which prevents any data from being erased or recorded to the card. Press the switch toward the bottom of the card to lock the card contents; press it toward the top of the card to unlock the data.

You can protect individual images from accidental erasure by using the camera's Protect feature, covered in Chapter 4.

Exploring External Camera Controls

Scattered across your camera's exterior are a number of buttons, dials, and switches that you use to change picture-taking settings, review and edit your photos, and perform various other operations. Sometimes a single twist of a dial gets the job done; other times, you press several buttons in sequence.

In later chapters, I discuss all your camera's functions in detail and provide the exact steps to follow to access those functions. This section provides just a basic road map to the external controls plus a quick introduction to each. You may want to put a sticky note or other bookmark on this page so that you can find it for easier reference later. (The cheat sheet at the front of the book offers a similar guide, albeit with less detail.)

With that preamble out of the way, the next three sections break down the external controls found on the top, back, and front-left side of the camera.

Topside controls

Your virtual tour begins at the top of the camera, shown in Figure 1-7. There are four controls of note here, as follows:

✏ **On/Off switch and shutter button:** Okay, I'm pretty sure you already figured this combo button out. But check out Chapter 2 to discover the proper shutter-button-pressing technique — you'd be surprised how many people mess up their pictures because they press that button incorrectly.

✏ **Active D-Lighting button:** Your D60 offers an exposure feature called *Active D-Lighting,* which is designed to help you get better results when you shoot high-contrast scenes — a dark subject against a bright background, for example. To turn the feature on and off, you press this button while rotating the Command dial, covered in the next section. Chapter 5 explains Active D-Lighting in detail.

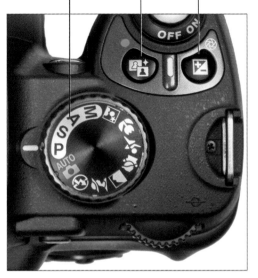

Active D-Lighting

Mode dial Exposure Compensation

Figure 1-7: The tiny pictures on the Mode dial represent special automatic shooting modes.

✏ **Exposure Compensation button:** This button activates a feature that enables you to tweak exposure when working in three of your camera's autoexposure modes: programmed autoexposure, aperture-priority autoexposure, and shutter-priority autoexposure, represented by the letters P, S, and A on the camera Mode dial. Chapter 5 explains.

✏ **Mode dial:** With this dial, you set the camera to fully automatic, semi-automatic, or manual photography mode. The little pictographs, or icons, represent the Nikon Digital Vari-Program modes, which are automatic settings geared to specific types of photos: action shots, portraits, landscapes, and so on. Chapter 2 details the Digital Vari-Program and Auto modes; Chapter 5 explains the four others (P, S, A, and M).

Back-of-the-body controls

Traveling over the top of the camera to its back side, shown in Figure 1-8, you encounter the following controls:

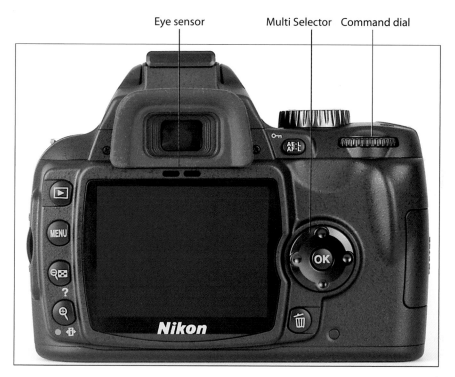

Eye sensor Multi Selector Command dial

Figure 1-8: You use the Multi Selector to navigate menus and access certain other camera options.

- ✔ **Command dial:** After you activate certain camera features, you rotate this dial, labeled in Figure 1-8, to select a specific setting. For example, when you shoot in the A exposure mode (aperture-priority autoexposure, detailed in Chapter 5), rotating the Command dial changes the aperture (f-stop).

- ✔ **AE-L/AF-L and Protect button:** Like several buttons, this one serves multiple purposes. When you're taking pictures in some automatic modes, you can lock in your focus and exposure settings by pressing and holding this button. Chapter 5 explains why you may want to do so. In picture playback mode, pressing the button locks the picture file — hence the little key symbol that appears on the camera body next to the button — which protects the picture so that you can't accidentally delete it. See Chapter 4 for details on that option.

You can adjust the performance of the button as it relates to locking focus and exposure, too. Instructions in this book assume that you stick with the default setting, but if you want to explore your options, see Chapter 11.

✔ **Eye sensor:** See those two tiny black bars under the viewfinder? (Refer to Figure 1-8.) They enable the camera to automatically shift from displaying critical shooting data on the monitor to showing it in the viewfinder. As soon as you put your eye to the viewfinder, the monitor shuts down, and the viewfinder is activated. Take your eye away from the viewfinder, and the reverse happens. This setup saves battery life because both displays aren't active at once. But if you prefer, you can disable the eye sensor via the Setup menu, covered later in the chapter. The viewfinder then remains on while the shooting data is displayed on the monitor.

✔ **Multi Selector:** This dual-natured control plays a role in many camera functions. You press the outer edges of the Multi Selector left, right, up, or down to navigate camera menus and access certain other options. At the center of the control is the OK button, which you press to finalize a menu selection or other camera adjustment. See the next section for help with using the camera menus.

✔ **Delete button:** Sporting a trash can icon, the universal symbol for delete, this button enables you to erase pictures from your memory card. Chapter 4 has specifics.

✔ **Playback button:** Press this button to switch the camera into picture review mode. Chapter 4 details the features available to you in this mode.

✔ **Menu button:** Press this button to access five menus of camera options. See the next section for details on navigating menus; see the appendix for a complete listing of all menus and menu options.

✔ **Thumbnail/Help button:** In playback mode, pressing this button changes the number of picture thumbnails displayed on the monitor. You also can reduce the magnification of a thumbnail — zoom out, in other words. (The minus sign in the magnifying glass is the universal symbol for zoom out.) In other modes, the button accesses the camera's built-in help system. See "Asking Your Camera for Help," later in this chapter, for details.

✔ **Zoom/Setting/Reset button:** Even more multifunctioned, this button has three main roles:

• In playback mode, pressing this button magnifies the currently displayed image and also reduces the number of thumbnails displayed at a time. Note the plus sign in the middle of the magnifying glass — plus for zoom in.

- When you're in picture-taking mode, the button enables you to display the Shooting Info screen or the Quick Settings screen (both covered later in this chapter) or turn the LCD monitor off. (The *I* marking below the button reminds you of the button's connection to the Shooting Info screen.) See the upcoming section "Using the Shooting Info and Quick Settings Displays" for details.

- The little green dot that appears under the button indicates the button's Reset function. Pressing this button and the Active D-Lighting button — which is also neighbored by a green dot — simultaneously for more than two seconds restores the most critical picture-taking options, such as Image Quality and Image Size, to their default settings. See "Browsing the Custom Setting menu," later in this chapter, for more on this topic.

In this book, I refer to these last two buttons as the Thumbnail button and the Zoom button, respectively. This isn't the approach that Nikon takes in its manuals — instructions therein call the button by the name that's relevant for the current function. I think that's a little confusing, so I always refer to each button by one name only.

Front-left buttons

On the front-left side of the camera body, you find two final external controls, labeled in Figure 1-9. These work as follows:

✓ **Fn/Self-Timer button:** The *Fn* is short for *function,* in case you were wondering. By default, pressing this button puts the camera into Self-Timer mode, in which the camera snaps the picture automatically a few seconds after you press and release the shutter button. This feature allows for hands-free picture taking — useful for times when you want to include yourself in the shot, for example.

If you don't use the Self-Timer mode often, you can set the button to control one of four other functions instead. Chapter 11 shows you how.

Flash button

Function button

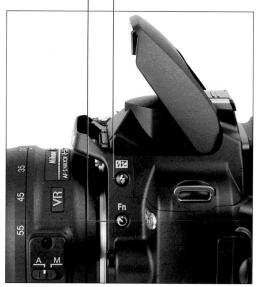

Figure 1-9: You press the Flash button to pop up the built-in flash.

 ✓ **Flash/Flash compensation:** Pressing this button pops up the camera's built-in flash (except in automatic shooting modes, in which the camera decides whether the flash is needed). By holding the button down and rotating the Command dial, you can adjust the flash mode (normal, red-eye reduction, and so on). In advanced exposure modes (P, S, A, and M), you also can press this button, along with the Exposure Compensation button, and then rotate the Command dial to adjust the flash power. See Chapter 5 for all things flash related.

Ordering from Camera Menus

 You access many of your camera's features via internal menus, which, conveniently enough, appear when you press the Menu button. Features are grouped into five main menus, described briefly in Table 1-1.

Table 1-1	D60 Menus	
Symbol	**Open This Menu . . .**	**to Access These Functions**
▶	Playback	Viewing, deleting, and protecting pictures
📷	Shooting	Basic photography settings
✏️	Custom Setting	Advanced photography options and some basic camera operations
🔧	Setup	Additional basic camera operations
🖌️	Retouch	Built-in photo retouching options

After you press the Menu button, you see on the camera monitor a screen similar to the one shown in Figure 1-10. Along the left side of the screen, you see the icons shown in Table 1-1, each representing one of the five available

menus. The icon that is highlighted or appears in color is the active menu; options on that menu automatically appear to the right of the column of icons. In the figure, the Shooting menu is active, for example.

I explain all the important menu options elsewhere in the book; for now, just familiarize yourself with the process of navigating menus and selecting options therein. The Multi Selector, shown in the margin here, is the key to the game. You press the edges of the Multi Selector to navigate up, down, left, and right through the menus.

In this book, the instruction "Press the Multi Selector left" simply means to press the left edge of the control. "Press the Multi Selector right" means to press the right edge, and so on.

Here's a bit more detail about the process of navigating menus:

- ✏ **To select a different menu:** Press the Multi Selector left to jump to the column containing the five menu icons. Then press up or down to highlight the menu you want to display. Finally, press right to jump over to the options on the menu.

- ✏ **To select and adjust a function on the current menu:** Again, use the Multi Selector to scroll up or down the list of options to highlight the feature you want to adjust and then press OK. Settings available for the selected item then appear. For example, if you select the Image Quality item from the Shooting menu, as

Menu icons

SHOOTING MENU

▶		
⬛	Optimize image	N
	Image quality	FINE
	Image size	⬜
🔧	White balance	AUTO
	ISO sensitivity	100
	Noise reduction	OFF
?	Active D-Lighting	OFF

Figure 1-10: Highlight a menu in the left column to display its contents.

shown on the left in Figure 1-11, and press OK, the available Image Quality options appear, as shown on the right in the figure. Repeat the old up-and-down scroll routine until the choice you prefer is highlighted. Then press OK to return to the previous screen.

In some cases, you may see a right-pointing arrowhead instead of the OK symbol next to an option. That's your cue to press the Multi Selector right to display a submenu or other list of options.

SHOOTING MENU		Image quality	
Optimize image	N		
Image quality	FINE	NEF (RAW)	OK
Image size		JPEG fine	
White balance	AUTO	JPEG normal	
ISO sensitivity	100	JPEG basic	
Noise reduction	OFF	NEF (RAW) + JPEG basic	
Active D-Lighting	OFF		

Figure 1-11: Select the option you prefer and press OK again to return to the active menu.

Again, I present this information just as a general introduction, so don't worry about memorizing it. I tell you exactly which Multi Selector actions to take whenever I explain a function that requires its use.

Using the Shooting Info and Quick Settings Displays

As you advance in your photography and begin to move beyond the automatic settings, you need a way to keep track of what camera settings are currently active. That's the purpose of the Shooting Info display, shown in Figure 1-12. The figure shows the display in its normal, horizontal orientation; if you rotate the camera to shoot a picture in the vertical orientation, the display automatically rotates on the monitor, too, so that the information is always easily readable.

If what you see in the figure looks like a big confusing mess, don't worry. Most of it won't mean anything to you until you make your way through later chapters. The figure does label the following two key points of data that are helpful even in fully automatic mode, though:

- **Battery status indicator:** A "full" battery icon like the one in the figure shows that the battery is fully charged; if the icon appears empty, go look for your battery charger.

- **Pictures remaining:** The number you see here indicates how many additional pictures you can store on the current memory card. If the number exceeds 999, the value is presented a little differently. The initial K appears above the value to indicate that the first value represents the picture count in thousands. For example, 1.0 K means that you can store 1,000 more pictures (*K* being a universally accepted symbol indicating 1,000 units). The number is then rounded down to the nearest hundred. So if the card has room for, say, 1,230 more pictures, the value reads as 1.2K.

Battery status icon

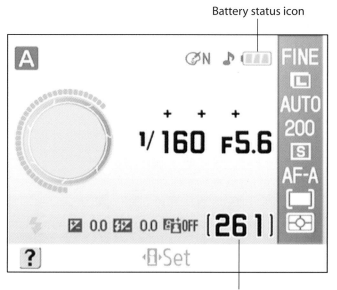

Pictures remaining

Figure 1-12: View picture-taking settings in the Shooting Info display.

 After viewing current camera settings in the Shooting Info display, you can switch to the Quick Settings display, shown on the left in Figure 1-13. From here, you can adjust the most critical picture-taking settings via the screen instead of digging through menus.

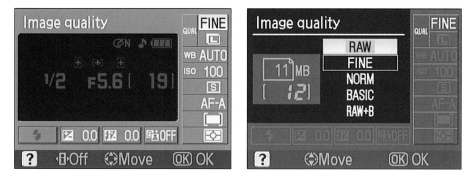

Figure 1-13: You can adjust some camera settings more easily by using the Quick Settings display than by using the regular menus.

Follow these steps to try it out:

1. **Display the Shooting Info screen, if it isn't already visible on the monitor.**

 The display appears automatically when you first turn on the camera and then turns itself off after about eight seconds of camera inactivity. Use either of these techniques to bring the display back to life:

 - Press the Zoom button.

 - Press the shutter button halfway and then release it.

 The screen also appears automatically in a couple of other situations, such as when you press the Flash button, or if you set the camera to the P, S, or A exposure mode and then press the Exposure Compensation button. But I find the first two techniques the easiest to remember, especially because the Zoom button is labeled with the little *I* (for *information*).

2. **Press the Zoom button again to switch to the Quick Settings display.**

 In this display, the center area of the screen is dimmed and bordered on the right and below by a variety of options, as shown on the left in Figure 1-13.

3. **Press the Multi Selector to highlight the camera setting that you want to change.**

 In Figure 1-13, for example, I highlighted the Image Quality setting. The name of the selected setting appears in the upper-left corner of the screen.

4. **Press OK.**

 Now you're taken to a screen that contains all the available options for the setting that you selected in Step 3. For example, the right image in Figure 1-13 shows the screen that appears if you select the Image Quality setting and press OK.

5. **Use the Multi Selector to select the option you want to use.**

 I selected Raw in Figure 1-13.

6. **Press OK to apply the change and return to the Quick Settings display.**

 If you want to change other settings, just repeat Steps 3 through 6.

7. **Press the Zoom button once to turn the monitor off; press it twice to return to the Shooting Info screen.**

 The monitor turns itself off automatically when you put your eye to the viewfinder — or if you don't press any other buttons or perform any camera functions for about eight seconds.

Again, don't worry now about what any of the symbols or options in the Shooting Info and Quick Settings displays mean — I explain all of that in later chapters. For now, just familiarize yourself with this method of adjusting camera settings.

Through the Setup menu, you can adjust the appearance and behavior of the Shooting Info screen. The section "Cruising the Setup menu," later in this chapter, spells out two of the pertinent options (Auto Shooting Info and Shooting Info Auto Off). Chapter 11 discusses how to change the look of the display. But while working with this book, I recommend that you stick with the default settings so that things look and work as described in these steps and elsewhere.

Decoding Viewfinder Data

When the camera is turned on, you can view some camera settings and other critical information in the viewfinder as well as on the Shooting Info display. The viewfinder data changes depending on what action you're currently undertaking. For example, if you simply turn on the camera and look through the viewfinder without pressing the shutter button, you see the data labeled in Figure 1-14. When you depress the shutter button halfway to initiate autofocusing — a topic that I discuss in Chapter 2 — you see a slightly different set of information.

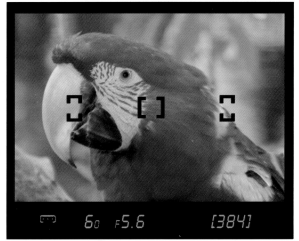

Figure 1-14: You also can view some camera information at the bottom of the viewfinder.

Rather than give you a full guide to all the possible viewfinder readouts here, which would only boggle your mind and cause lots of unnecessary page-flipping, I show you the relevant viewfinder displays as I cover the various photographic topics later in the book.

Asking Your Camera for Help

Programmed into your camera's internal software is a handy information help line — a great tool for times when you forget the purpose of a particular feature or would like a little picture-taking guidance. This digital 411 offers assistance in two ways:

✔ Press and hold the Thumbnail button to display information about the current shooting mode or selected menu option. For example, Figure 1-15 shows the Help screen associated with the Image Quality setting. If you need to scroll the screen to view all the Help text, keep the Thumbnail button depressed and scroll by using the Multi Selector. Release the Thumbnail button to close the information screen.

> **?** Image quality
>
> Choose file format used to record pictures.

Figure 1-15: Press and hold the Thumbnail button to display onscreen help.

✔ If the camera thinks you're headed for a picture problem, it may display a blinking question mark on the monitor or in the viewfinder. Again, press and hold the Thumbnail button to see what's up.

Reviewing Basic Setup Options

You know how sometimes you visit someone's house, and their kitchen cabinets are arranged in a way that doesn't make sense to you? Why are the mugs above the microwave instead of above the coffeepot? And wouldn't it be better if the serving spoons were next to the stove instead of by the dishwasher? Well, that's how I feel about the two menus discussed in this section, the Setup menu and the Custom Setting menu.

Both menus contain options that control basic camera functions, such as how long the monitor displays a recorded image after you press the shutter button and how certain information appears on the monitor. But mixed in with those options are totally unrelated controls, such as those that adjust the exposure metering mode, covered in Chapter 5.

Well, I can't rearrange the menus for you any more than I can put those mugs near the coffeemaker, so instead, the following sections describe in detail only the basic setup options found on each menu. For options related to other aspects of camera operation, I list the chapter where you can find more information.

The figures in this section show only the first handful of options on each menu, again in the interest of saving page space for more critical information. Note, too, that I cover the Setup menu first, even though it's listed after the Custom Setting menu on the camera; the Setup menu contains the bulk of the basic settings and also contains one setting that affects the appearance of the Custom Setting menu. (See the earlier note about kitchen reorganization.)

If you don't yet know how to select options from the menus, see the earlier section, "Ordering from Camera Menus," for help.

Cruising the Setup menu

Start your camera customization by opening the Setup menu. It's the menu marked with the little wrench icon, as shown in Figure 1-16.

Here's a quick rundown of each menu item, with those related to basic operations listed first:

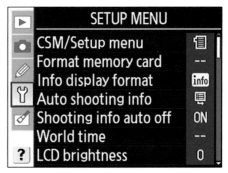

Figure 1-16: Set the CSM/Setup Menu option to Full to access hidden functions.

- ✔ **CSM/Setup Menu:** Guess what? You can even customize the Setup menu and its neighbor, the Custom Setting menu! At the default setting, Simple, some options are hidden on both menus. Choose Full to access the hidden settings. You can also choose My Menu and select exactly which options appear and which are hidden.

 While working with this book, choose Full so that what you see in your menus matches my figures. When you're ready to head off on your own, though, see Chapter 11 for details on how to establish your own, custom menus.

- ✔ **Format Memory Card:** The first time you insert a new memory card, you should use this option to *format* the card, a maintenance function that wipes out any existing data on the card and prepares it for use by the camera. If you previously used your card in another device, such as a digital music player, be sure to copy those files to your computer before you format the card.

- ✔ **Info Display Format:** With this setting, you can alter the visual design of the Shooting Info display, covered earlier in this chapter. You can establish this setting independently for the Digital Vari-Program modes and the other shooting modes (manual, aperture-priority autoexposure, and so on). Use the default setting, Graphic, for both categories so that your display matches what you see in this book. Chapter 11 gives you a look at the other modes.

✔ **Auto Shooting Info:** When you turn this option on, as it is by default, the Shooting Info display automatically appears when you depress the shutter button halfway. The camera is smart enough, however, not to activate the display when your eye is close to the viewfinder. As with the preceding option, you can establish different settings for the two categories of shooting modes; I suggest that you keep both categories set to On while working with this book. See the earlier section "Using the Shooting Info and Quick Settings Displays" for details about the display. If you do turn the option off, you can still use the Zoom button to activate the Shooting Info display.

✔ **Shooting Info Auto Off:** Also related to the Shooting Info display, this option determines whether the camera turns off the Shooting Info display and fires up the viewfinder display when you put your eye to the viewfinder. In other words, it enables or disables the little eye sensor under the viewfinder. I suggest that you leave this option turned on, as it is by default.

✔ **World Time:** When you turn on your camera for the very first time, it automatically displays this option and asks you to set the current date and time.

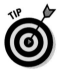

Keeping the date/time accurate is important because that information is recorded as part of the image file. In your photo browser, you can then see when you shot an image and, equally handy, search for images by the date they were taken. Note that the date and time *are not* imprinted on your picture; however, if you want that to happen, you can make it so via the Date Imprint option on the Custom Settings menu, covered in the next section.

Also, if you see the message "Clock Not Set" on the camera monitor, the internal battery that keeps the clock running is depleted. Simply charging the main camera battery and then putting that battery back in the camera sets the clock ticking again, but you need to reset the camera time and date.

✔ **LCD Brightness:** This menu selection offers two options, as shown on the left in Figure 1-17. If you select LCD brightness, you can make the camera monitor brighter or darker, as shown on the right image in the figure.

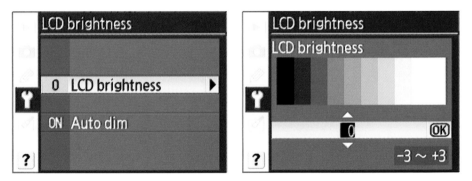

Figure 1-17: You can adjust the brightness of the camera monitor.

If you take this step, keep in mind that what you see on the display may not be an accurate rendition of the actual exposure of your image. Crank up the monitor brightness, for example, and an underexposed photo may look just fine. So I recommend that you keep the brightness at the default setting (0). As an alternative, you can display the *histogram,* an exposure guide that I explain in Chapter 4, when reviewing your images.

When the second monitor control, Auto Dim, is turned on, as it is by default, the monitor gradually dims after a few seconds when the Shooting Info screen is displayed. You can disable that feature by setting the option to Off.

✔ **Video Mode:** This option is related to viewing your images on a television, a topic I cover in Chapter 9. Select NTSC if you live in North America or other countries that adhere to the NTSC video standard; select PAL for playback in areas that follow that code of video conduct.

✔ **Language:** You're asked to specify a language along with the date and time when you fire up your camera for the first time. Your choice determines the language of text on the camera monitor. Screens in this book display the English language, but I find it entertaining on occasion to hand my camera to a friend after changing the language to, say, Swedish. I'm a real yokester, yah?

✔ **File No. Sequence:** This option controls how the camera names your picture files. When the option is set to Off, as it is by default, the camera restarts file numbering at 0001 every time you format your memory card or insert a new memory card. Numbering is also restarted if you create custom folders (an advanced option covered in Chapter 11).

Needless to say, this setup can cause problems over time, creating a scenario where you wind up with multiple images that have the same file name — not on the current memory card, but when you download images to your computer. So I strongly encourage you to set the option to On. Note that when you get to picture number 9999, file numbering is still reset to 0001, however. The camera automatically creates a new folder to hold for your next 9999 images.

As for the Reset option, it enables you to assign the first file number (which ends in 0001) to the next picture you shoot. Then the camera behaves as if you selected the On setting.

✔ **And the rest:** The remaining functions on this menu, listed below, relate to image playback, organization, and camera maintenance:

- *Image Comment:* See Chapter 11 to find out how to use this feature, which enables you to add text comments into a picture file. You then can read that information in Nikon ViewNX, the software that shipped with your camera. (The text doesn't actually appear on the image itself.)

- *Folders:* This feature is an advanced file-organization option; leave the option set at the default until you read about it in Chapter 11.

- *Clean Image Sensor:* Your D60 is set up at the factory to perform an internal cleaning routine each time you turn the camera on or off. This cleaning system is designed to keep the image sensor — that's the part of the camera that actually captures the image — free of dust and dirt.

 By choosing the Clean Image Sensor command, you can perform a cleaning at any time, however. Just choose the command, press OK, select Clean Now, and press OK again. You also can tell the camera to perform automatic cleaning only at startup, only at shutdown, or never; to do so, select Clean At instead of Clean Now. Then press the Multi Selector right, highlight the cleaning option you prefer, and press OK.

- *Mirror Lock-Up:* This feature is necessary when cleaning the camera interior — an operation that I don't recommend that you tackle yourself. See Chapter 3 for more information on camera cleaning. And if you've used mirror lock-up on a film camera to avoid camera shake when shooting long-exposure images, note that in this case, the lock-up feature is provided for cleaning purposes only. You can't take pictures on the D60 while the mirror lock-up is engaged.

- *Firmware Version:* This screen is informational in nature only; it tells you the current version of the camera *firmware* (internal operating software). The appendix explains how to check which version is installed in your camera and how to update it via Nikon's Web site if needed.

- *Dust Off Ref Photo:* This specialty feature enables you to record an image that serves as a point of reference for the automatic dust-removal filter available in Nikon Capture NX. I don't cover this accessory software, which must be purchased separately, in this book.

- *Auto Image Rotation:* Keep this option set at the default setting (On) so that the image is automatically rotated to the correct orientation (horizontal or vertical) in playback mode. The orientation is recorded as part of the image file, too, so the auto-rotating also occurs when you browse your image thumbnails in ViewNX. Note, though, the rotation data may not be accurate for pictures that you take with the camera pointing directly up or down.

Browsing the Custom Setting menu

Figure 1-18 shows the Custom Setting menu, whose icon, for reasons I can't figure out, is a little pencil. At any rate, many options here involve photographic functions, such as using the flash, selecting an exposure metering mode, and so on.

As with the Setup menu, some options are hidden unless you set the CSM/Setup Menu option to Full, as requested in the preceding section. Go ahead and take that step now if you haven't already.

With that task out of the way, the following list describes just the Custom Setting menu items related to basic camera operations:

	CUSTOM SETTING MENU	
▶	Ⓡ Reset	--
📷	01 Beep	ON
🖊	02 Focus mode	AF-A
🔧	03 AF–area mode	[▪]
☑	04 Release mode	Ⓢ
?	05 Metering	◙
	06 No memory card?	LOCK

Figure 1-18: The Custom Setting menu contains additional basic options.

- ✓ **Reset:** Select this option to restore all features on the Custom Setting menu to their default settings. Note that the two-button reset technique I describe earlier in the chapter, in the section "Back-of-the-body controls," affects only a few options on this menu, all of which fall in the category of critical image-capture settings (such as focus mode and shooting mode). If you're interested, you can find a complete list of all the camera's default settings in the back of the camera manual.

- ✓ **Beep:** By default, your camera beeps at you after certain operations, such as after it sets focus when you shoot in autofocus mode. If you're doing top-secret surveillance work and need the camera to hush up, set this option to Off. On the Shooting Info display, a little musical note icon appears to the left of the battery icon when the beep is enabled. (Refer to Figure 1-12.) Turn the beep off, and the icon appears in a circle with a slash through it.

- ✓ **No Memory Card?:** Keep this one set at the default (Release Locked), which disables the shutter button when no memory card is in the camera. If you set it to Enable Release, you can take a temporary picture, which appears in the monitor with the word "Demo" but isn't recorded anywhere. (The feature is provided mainly for use in camera stores, enabling salespeople to demonstrate the camera without having to keep a memory card installed.)

- ✓ **Image Review:** Leave this option set to On if you want the camera to automatically display each picture briefly in the monitor after you press the shutter button.

 If you're shooting fast-paced action and you want to speed up *shot-to-shot time* — how long the camera makes you wait after taking one picture before you can take another — try turning this feature off. You can then review your pictures by pressing the Playback button.

- ✓ **AF-Assist:** On the front of your camera, there's a little light tucked right below the Mode dial. This light is the *autofocus-assist illuminator.* In dim lighting, it shoots out a beam of light to help the camera's autofocus system find its target. In general, leaving the AF-Assist option enabled is

a good idea, but if you're doing a lot of shooting at a party, wedding, or some event where the light from the lamp may be distracting, you may want to disable it.

Regardless of the setting you choose here, however, the illuminator doesn't light in manual focus mode or in the Sports or Land-scape Digital Vari-Program modes. In addition, the feature doesn't operate incontinuous-servo autofocus mode or when the center autofocus area mode is not selected. You can explore those two focus options in Chapter 6.

✓ **Self-Timer/Fn Button:** Here's where you establish the operation you want to assign to this button, introduced in the earlier section "Front-left buttons." See Chapter 11 for more details.

✓ **Auto-Off Timers:** When your camera is turned on but idle for a period of time, it conserves battery power by automatically turning off the moni-tor and exposure meter. Options on this menu determine how much time must pass before this occurs:

 • *Short:* The monitor turns off after eight seconds of inactivity; the exposure meter, after four seconds. After you take a picture, it is displayed on the monitor for four seconds, assuming that the Image Review option, explained earlier, is enabled.

 • *Normal:* The monitor goes dark after 12 seconds; the exposure meter, eight seconds. The image-review period remains at four seconds.

 • *Long:* Monitor shutdown occurs after 20 seconds; the exposure meter turns off after one minute. The image-review period is 20 seconds.

 • *Custom:* Choose this option to specify your own timing for monitor and meter shutdown and for the image-review period.

If you know you're perilously close to complete battery drainage, select the Short auto-off settings and turn off Image Review altogether.

✓ **Date Imprint:** If you want the shooting date and time to appear on your image, this feature provides that option. By default, it's turned off; you can choose instead to print the date or the date and time. You also can imprint a date counter, which indicates the number of days between the shooting date and a date that you select. Whichever data you choose, it appears in the lower-right corner of your photo.

This information is permanently imprinted in your image and *can't be removed* after the fact. So I suggest that you leave the option disabled and instead add date information in your photo editing program. Some programs can even automatically add that data when you print the image. Chapter 8 shows you how to determine the shooting date and time for a photo by looking at its internal file data, or *metadata*.

That wraps up all the basic customization settings. For details about other items on the Custom Setting menu, flip to the appendix, which points you to the chapter where I cover each option.

2

Taking Great Pictures, Automatically

*A*re you old enough to remember the Certs television commercials from the 1960s and '70s? "It's a candy mint!" declared one actor. "It's a breath mint!" argued another. Then a narrator declared the debate a tie and spoke the famous catchphrase: "It's two, two, two mints in one!"

Well, that's sort of how I see the Nikon D60. On one hand, it provides a full range of powerful controls, offering just about every feature a serious photographer could want. On the other, it offers automated photography modes that enable people with absolutely no experience to capture beautiful images. "It's a sophisticated photographic tool!" "It's as easy as 'point and shoot!'" "It's two, two, two cameras in one!"

Now, my guess is that you bought this book for help with your camera's advanced side, so that's what other chapters cover. This chapter, however, is devoted to your camera's simpler side. Because even when you shoot in automatic exposure and focus modes, following a few basic guidelines can help you get better results. For example, your camera offers a variety of automatic exposure modes, some of which may be new to you. The mode affects the look of your pictures, so this chapter explains those options. In addition, this chapter reviews flash options available to you in automatic modes and covers techniques that enable you to get the best performance from your Nikon's autofocus and autoexposure systems.

Getting Good Point-and-Shoot Results

Your D60 offers several automatic photography modes, all of which I explain later in this chapter. But in any of those modes, the key to good photos is to follow a specific picture-taking technique.

 To try it out, set the Mode dial on top of the camera to Auto, as shown in the left image in Figure 2-1. Then set the focusing switch on the lens to the A (auto-focus) position, as shown in the right image in Figure 2-1.

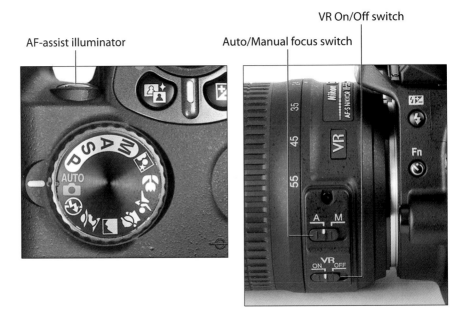

AF-assist illuminator

Auto/Manual focus switch

VR On/Off switch

Figure 2-1: Choose these settings for fully automatic exposure and focus.

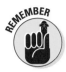 Unless you are using a tripod, also set the VR (vibration reduction) switch to the On setting, as shown in Figure 2-1. This feature is designed to produce sharper images by compensating for camera movement that can occur when you handhold the camera. Note that Figure 2-1 features the Nikon lens that is bundled with the D60; if you own a different lens, check your lens manual for details about switching from auto to manual focusing and for tips on using its vibration reduction feature, if provided.

Your camera is now set up to work in the most automatic of automatic modes. Follow these steps to take the picture:

1. **Looking through the viewfinder, frame the image so that your subject appears under one of the three focus brackets, as shown in Figure 2-2.**

2. **Press and hold the shutter button halfway down.**

 The camera's auto-focus system begins to do its thing. In dim light, a little lamp located on the front of the camera, just beneath the Mode dial, may shoot out a beam of light. That lamp, called the *autofocus-assist illuminator,* helps the camera measure the distance between your subject and the lens so that it can better establish focus. You can see the lamp in the left image in Figure 2-1, which shows a top view of the camera.

 At the same time, the autoexposure meter analyzes the light and selects initial aperture (f-stop) and shutter speed settings, which are two critical exposure controls. These two settings appear in the viewfinder; in Figure 2-2, the shutter speed is 1/250 second, and the f-stop is f/5.6. (Chapter 5 explains these two options in detail.) The built-in flash may pop up if the camera thinks additional light is needed.

Focus brackets

Figure 2-2: The brackets in the viewfinder indicate autofocus points.

Active autofocus bracket

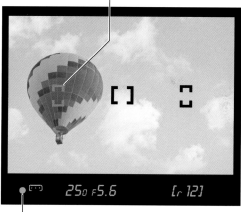

Focus indicator

Figure 2-3: The green light indicates that the camera has successfully locked focus on the object under the red focusing bracket.

When the camera has established focus, the focus indicator in the viewfinder lights, and one of the focus brackets turns red, as shown in Figure 2-3. The red bracket indicates the area of the frame that the camera used to establish focus. The auto-exposure meter continues monitoring the light up to the time you take the picture, so the f-stop and shutter speed values in the viewfinder may change if the light shifts.

3. Press the shutter button the rest of the way down to record the image.

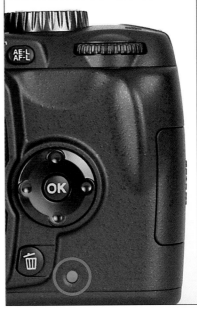

While the camera sends the image data to the camera memory card, the memory card access lamp lights, as shown in Figure 2-4. Don't turn off the camera or remove the memory card while the lamp is lit, or you may damage both camera and card.

When the recording process is finished, the picture appears briefly on the camera monitor (assuming that you enable the Image Review feature, as explained in Chapter 1). See Chapter 4 to find out how to switch to playback mode and take a longer look at your image.

I need to add one important note about Step 2: Which focusing brackets the camera uses to establish focus depends on the current AF-area mode setting (the AF stands for autofocus). There are three possibilities:

Figure 2-4: The memory card access lamp lights while the camera sends the picture data to the card.

✔ **Closest Subject:** The camera locks focus on the pair of brackets that contains the object closest to the camera lens.

✔ **Dynamic Area:** In this mode, you use the Multi Selector to specify which pair of brackets you want the camera to use when focusing. But if the object within those brackets moves after you press the shutter button halfway to lock in focus, the camera looks for focus information from the other brackets. This mode is designed for subjects that may be moving unpredictably; the idea is that the subject is likely to wind up within one of the three focus areas.

✔ **Single Point:** In this mode, you use the Multi Selector to select a single pair of focus brackets, and the camera then bases focus only on that area.

The default AF-area setting varies depending on which automatic exposure mode you use (Auto, Portrait, and so on); I spell out that detail when describing each mode later in this chapter. If you want to change the AF-area mode, Chapter 6 explains how. But even if you do so, your camera may not be able to lock focus where you intend. Some subjects just give autofocusing systems fits: Highly reflective objects, subjects behind fence bars, and scenes in which little contrast exists between the subject and the background are just a few potential problem areas.

My advice? If the autofocus mechanism can't lock onto your subject after a few seconds, just switch to manual focusing and be done with it.

A few final points about working in the point-and-shoot modes covered in this chapter:

✔ The built-in flash unit is disabled in Sports, Landscape, and Auto Flash Off modes. For other modes, you can choose from a couple of flash options; see the upcoming section "Using Flash in Automatic Exposure Modes" for details.

✔ Instructions I give in the steps here assume that you are using the camera's default Release Mode setting, which records a single image with each press of the shutter button. For a look at your other options — continuous (burst mode) shooting, self-timer shooting, and remote-control shooting — see the last section in the chapter.

Using Flash in Automatic Exposure Modes

The built-in flash on your Nikon offers a variety of different modes. Table 2-1 offers a quick-reference guide to the six basic modes. In addition to these basic modes, the camera also offers some combo modes, such as Auto with Red-Eye Reduction, Slow Sync with Red-Eye Reduction, and the like.

Table 2-1	Flash Mode Quick-Reference Guide	
Symbol	*Flash Mode*	*What It Does*
⚡AUTO	Auto	Fires the flash automatically if the camera thinks the ambient light is insufficient.
⚡	Fill	The flash fires regardless of the ambient light.
⚡ (Off)	Off	The flash doesn't fire.
⚡👁	Red-Eye Reduction	The camera emits a brief preflash before the actual flash to help reduce red-eye reflections.
⚡ SLOW	Slow Sync	Results in a longer-than-normal exposure time so that the background is illuminated by ambient light and the foreground is lit by the flash.
⚡ REAR	Rear-Curtain Sync	Causes illuminated, moving objects (such as car head lamps) to appear as long, trailing fingers of light.

More focus factors to consider

When you focus the lens, either in autofocus or manual focus mode, you determine only the point of sharpest focus. The distance to which that sharp-focus zone extends from that point — what photographers call the *depth of field* — depends in part on the *aperture setting*, or *f-stop*, which is an exposure control. Some of the D60's Digital Vari-Program autoexposure modes are designed to choose aperture settings that deliver a certain depth of field.

The Portrait setting, for example, uses an aperture setting that shortens the depth of field so that background objects are softly focused — an artistic choice that most people prefer for portraits. On the flip side of the coin, the Landscape setting selects an aperture that produces a large depth of field so that both foreground and background objects appear sharp.

Another exposure-related control, *shutter speed,* plays a focus role when you photograph moving objects. Moving objects appear blurry at slow shutter speeds; at fast shutter speeds, they

appear sharply focused. On your D60, the Sports shooting mode automatically selects a high shutter speed so that you can "stop" action, producing blur-free shots of your favorite soccer player, flying bird, or other object in motion.

A fast shutter speed can also help safeguard against allover blurring that results when the camera is moved during the exposure. The faster the shutter speed, the shorter the exposure time, which reduces the time that you need to keep the camera absolutely still. If you're using the Nikon D60 kit lens, you can also improve your odds of shake-free shots by enabling the vibration reduction (VR) feature. (Set the switch on the lens to the On position.) For a very slow shutter speed, using a tripod is the best way to avoid camera shake; be sure to turn the VR *off* when you do so.

If you want to manipulate focus and depth of field to a greater extent than the automated exposure modes allow, visit Chapter 6. For an explanation of the role of shutter speed and aperture in exposure, check out Chapter 5.

 To select a flash mode, press and hold the Flash button on the side of the camera as you rotate the Command dial. I highlighted both controls in Figure 2-5. An icon representing the currently selected mode appears in the Shooting Info display, shown in the left image in Figure 2-6. (Press the shutter button halfway or press the Zoom button, if needed, to activate the display.) The viewfinder display doesn't advise you of the specific flash mode but instead just shows the universal lightning bolt icon when the flash is enabled, as in the right image in the figure, and turns off the icon when the flash is disabled.

 Now for the bad news: Your flash flexibility is limited when you use any of the automatic exposure modes covered in this chapter. In Portrait mode, for example, you can't use a flash unless the camera thinks the lighting is suitably dim. That restriction becomes problematic for outdoor, daytime

portraits, which almost always benefit from using flash to better illuminate subjects' faces. (Chapter 7 offers an illustration.) Additionally, you don't have access to flash compensation, which enables you to diminish or strengthen the burst of light the flash produces. Bummer, as the youngsters say.

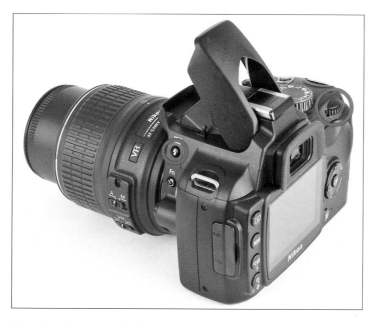

Figure 2-5: To change the flash mode, rotate the Command dial while pressing the Flash button.

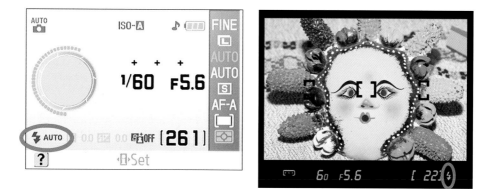

Figure 2-6: A flash status icon appears in the Shooting Info display and viewfinder.

The upcoming sections tell you which flash modes are available in each of the fully automatic exposure modes. For more details about flash photography, including information about flash compensation, see Chapter 5.

Exploring Your Automatic Options

You can choose from eight fully automatic exposure modes, all of which you access via the Mode dial on the top of the camera, shown in Figure 2-7.

Auto

Digital Vari-Program modes

The next sections provide details on each of these options. For information about the four other settings on the Mode dial — P (programmed auto), S (shutter-priority autoexposure), A (aperture-priority autoexposure), and M (manual exposure), see Chapter 5.

Figure 2-7: You can select from eight fully automatic, point-and-shoot photography modes.

Auto mode

In this mode, represented by the green camera icon you see in the margin here, the camera selects all settings based on the scene that it detects in front of the lens. Your only job is to lock in focus, using the two-stage auto-focus technique that I outline at the beginning of the chapter, or by setting the lens to manual mode and using the focus ring on the lens barrel, as explained in Chapter 1.

Auto mode is great for casual, quick snapshooting. But keep these limitations in mind:

- **AF-area (autofocus area) mode:** This mode uses the Closest Subject AF-area mode setting. That is, the camera calculates the distance of objects that fall within the three focus brackets in the viewfinder and then bases focus on the nearest object. The only way to override this decision is to switch to manual focusing.

- **Flash:** You have three flash mode choices: Auto, Auto with Red-Eye Reduction, and Off. You can't enable the flash if the camera's autoexposure meter doesn't sense that additional light is needed. Nor can you adjust the intensity of the flash, a feature I cover in Chapter 5.

- **Color:** You can't adjust color. If the image displays a color cast, you must switch to a mode that enables you to adjust the White Balance setting, covered in Chapter 6.

- **Exposure:** You have access to two exposure-adjustment options:

 - *Active D-Lighting:* This feature adjusts exposure in a way that improves pictures that include both very dark areas and very

bright areas. Chapter 5 covers this option in detail, along with other exposure features, but in short, Active D-Lighting is designed to brighten shadow areas but leave the highlight areas alone so that they don't become too bright.

When you shoot a high-contrast scene, such as a dark object against a bright background, experiment by taking some photos with Active D-Lighting enabled and some with it turned off. To enable the feature, press and hold the Active D-Lighting button, located on top of the camera and shown in the margin here. You then can view the status of the option in the Shooting Info display or in the viewfinder, as shown in Figure 2-8. Rotate the Command dial while keeping the button pressed to turn the feature on or off. (When you release the button, the viewfinder display returns to showing the normal shooting data.)

Again, Chapter 5 provides a full explanation of this feature, along with some examples of its impact on your pictures. For information about a related feature, the D-Lighting filter on the Retouch menu, see Chapter 10.

- *ISO Sensitivity:* This setting determines the light sensitivity of the camera — or, to put it another way, how much light is needed to properly expose the image. By default, this option is set to Auto, and the camera adjusts the ISO Sensitivity as needed. For more information about how ISO affects your pictures — and why you may want to select a specific ISO setting — visit Chapter 5. Be aware, though, that even if you do so, the camera has the final say: If the ISO you select isn't workable given the available light, the camera overrides your decision when you shoot in Auto exposure mode or any of the Digital Vari-Program modes.

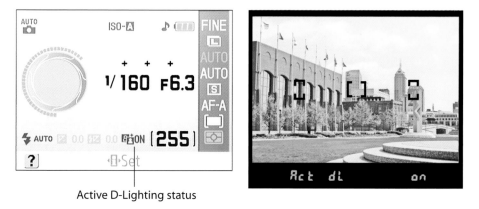

Active D-Lighting status

Figure 2-8: You can take advantage of Active D-Lighting in the fully automatic exposure modes.

I purposely didn't include an example of a photo taken in Auto mode because, frankly, the results that this setting creates vary widely depending on how well the camera detects whether you're trying to shoot a portrait, landscape, action shot, or whatever. But the bottom line is that full auto is a one-size-fits-all approach that may or may not take best advantage of your camera's capabilities. So if you want to more consistently take great pictures instead of merely good ones, I encourage you to explore the exposure, focus, and color information found in Part II so that you can abandon this mode in favor of modes that put more photographic decisions in your hands.

Digital Vari-Program modes

In Auto mode, the camera tries to figure out what type of picture you want to take by assessing what it sees through the lens. If you don't want to rely on the camera to make that judgment, your D60 offers seven *Digital Vari-Program modes* that are designed for popular categories of pictures.

Most people in the photography community refer to these modes as *scene modes* or *creative scene modes*. I prefer the latter term because that's what the Digital Vari-Program modes enable you to do: automatically capture specific scenes in ways that are traditionally considered best from a creative standpoint. For example, most people prefer portraits that have softly focused backgrounds. So in Portrait mode, the camera selects settings that can produce that type of background.

All the Digital Vari-Program modes share a few limitations — or benefits, depending on how you look at things:

- ✔ **Exposure:** As with Auto mode, the camera takes complete control of exposure, with the exception of the Active D-Lighting and ISO Sensitivity settings, both introduced in the preceding section and detailed in Chapter 5.

- ✔ **Color:** You can't tweak color, either. Some modes manipulate colors in ways that you may or may not appreciate, and you're stuck if you have a color cast problem.

- ✔ **Flash and AF-area mode:** Available flash options vary depending on the Digital Vari-Program mode you select, as does the AF-area (autofocus area) setting. But none of the Digital Vari-Program modes offers complete flexibility over these functions.

In the next sections, you can read about the unique features of each of the Digital Vari-Program modes. To see whether you approve of how your camera approaches the different scenes, take some test shots. If you aren't happy with the results, you can switch to one of the advanced exposure modes (P, S, A, or M) and then check out Chapters 5–7 to find out how to manipulate whatever aspect of the picture isn't to your liking.

What does [r 12] in the viewfinder mean?

When you look in your viewfinder to frame a shot, the initial value shown in brackets at the right end of the viewfinder display indicates the number of additional pictures that can fit on your memory card at the currently selected Image Size and Image Quality settings. (Chapter 3 explains those settings.) For example, in the left viewfinder image below, the value shows that the card can hold 22 more images.

As soon as you press the shutter button halfway, which kicks the autofocus mechanism into action, that value changes to instead show you how many pictures can fit in the camera's *memory buffer.* In the right image here, for example, the "r 12" value tells you that 12 pictures can fit in the buffer. This number also varies depending on the size and quality settings you use.

So what's the *buffer?* It's a temporary storage tank where the camera stores picture data until it has time to fully record that data onto the camera memory card. This system exists so that you can take a continuous series of pictures without having to wait between shots until each image is fully written to the memory card.

When the buffer is full, the camera automatically disables the shutter button until it catches up on its recording work. Chances are, though, that you'll very rarely, if ever, encounter this situation; the camera is usually more than capable of keeping up with your shooting rate.

For more information about rapid-fire photography, see the section on action photography in Chapter 7.

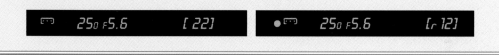

Auto Flash Off mode

The Auto Flash Off mode delivers the same results as Auto mode but ensures that the flash doesn't fire. In other words, think of this mode as a faster alternative to selecting Auto mode and then changing the flash setting to Off. From a practical standpoint, this mode provides an easy way to ensure that you don't break the rules when shooting in locations that don't permit flash: museums, churches, and so on.

Portrait and Child modes

The Portrait and Child modes are so closely related that it makes sense to consider them together.

First, Portrait mode. This mode selects an aperture setting designed to produce a short depth of field, which results in a slightly blurry background and thus puts the visual emphasis on your subject. Figure 2-9 offers an example. However, this effect occurs only if your subject is at least a few feet from the background. The extent to which the background blurs also depends on the other depth-of-field factors that I discuss in Chapter 6. Portrait mode also selects settings designed to produce natural skin tones.

Portrait mode

Figure 2-9: Portrait mode produces a softly focused background.

If you use autofocusing, the camera sets the AF-area mode option to Closest Subject, which makes sense because the closest thing to the lens in most portraits is, in fact, the subject. If your subject is posed behind some object and the camera mistakenly locks focus on that object, you can either adjust the AF-area mode setting, as covered in Chapter 6, or just switch to manual focus.

Child mode, represented by the toddler icon you see in the margin here, also attempts to produce a soft-focus background and bases autofocus on the closest subject. But in Child mode, the camera renders hues that are traditionally found in clothing and backgrounds more boldly than in Portrait mode. In Figure 2-10, for example, notice that the football and the little boy's shorts are noticeably more vivid than in the portrait example in Figure 2-9. Skin tones are left natural, although they, too, can appear a little more saturated, depending on the subject and the lighting. Child mode also softens focus just a tiny bit; the idea is to keep baby-soft skin looking, er, baby soft.

Child mode

Figure 2-10: Child mode renders non-skin colors more vividly than Portrait mode.

From my viewpoint, the decision to use Child mode doesn't have anything to do with the age of the subject — heck, most adults appreciate being rendered with

softer skin, too. A more important consideration is how colors are rendered. I prefer Portrait mode because the strengthened background colors in Child mode can easily distract the eye from the subject's face, which should be the point of emphasis in any portrait.

Keep in mind, too, that you can use these modes any time you want a short depth of field, not just for people pictures. Try both modes when shooting statues, still-life arrangements (such as a vase of flowers on a kitchen table), and the like. Do note, though, that the short depth of field produced by Portrait and Child modes may result in softer focus on objects set in front of your subject, not just those behind it. And one more tip: If the particular child you're photographing seems to be in perpetual motion, both modes may select a too-slow shutter speed, resulting in a subject that appears even blurrier than the background. In that situation, Sports mode may deliver better results.

Landscape mode

Like the Child and Portrait modes, Landscape mode bases autofocus on the closest subject. But whereas Child and Portrait modes aim for a very shallow depth of field (small zone of sharp focus), Landscape mode, which is designed for capturing scenic vistas, city skylines, and other large-scale subjects, goes the other route, selecting an aperture setting (f-stop) that produces a large depth of field. As a result, objects both close to the camera and at a distance appear sharply focused. Figure 2-11 offers an example. For this picture, I set focus on the tree on the far right side of the frame. Notice that the tree on the far left appears nearly as sharp, despite its distance from my established focus point.

In addition, this mode boosts colors slightly to produce the kind of bold, rich hues that most people prefer in landscape pictures. The built-in flash is disabled, which is typically no big deal: Because of its limited range, a built-in flash is of little use when shooting most landscapes anyway.

Landscape mode

Figure 2-11: Landscape mode produces a large zone of sharp focus and also boosts color intensity slightly.

However, if you attach an external flash unit, you can use it in this mode. (Chapter 5 discusses external flash units.)

Again, think beyond the Landscape moniker when you look for good ways to put this mode to use: Try it when shooting long-range pictures of animals at the zoo, for example, so that critters both near and far appear sharp.

Chapter 6 shows you more ways to extend depth of field and get more control over your photo colors.

Sports mode

Sports mode activates a number of settings that can help you photograph any moving object, whether it's an athlete or a romping dog like the one in Figure 2-12, without blur. First, the camera selects a fast shutter speed, which is needed to "stop motion."

In addition, this mode sets the AF-area (autofocus area) mode to Dynamic Area. That is, you use the Multi Selector to indicate which pair of focus brackets you want the camera to use when calculating the focusing distance. But if the object moves beyond those brackets before you capture the image, the camera tries to draw focus information from the other brackets. With luck, your subject will move within one of the focus areas before you record the image. (If not, you can always simply switch to manual focusing.)

Sports mode

Figure 2-12: To capture moving subjects without blur, try Sports mode.

Finally, the built-in flash is disabled. That can be a problem in low-light situations, but it also enables you to shoot successive images more quickly because the flash needs a brief period to recycle between shots. If you own an external flash unit, however, you can use it in Sports mode if you like; just be aware that you may sacrifice in the speed-shooting department

because of the necessary flash-recycle time. Additionally, the fastest shutter speed you can use with flash is 1/200 second, which may be too slow to captures some subjects without blur.

Even without flash, whether the camera can select a shutter speed fast enough to stop motion depends on the available light and the speed of the subject itself. The available light also determines what aperture setting the camera uses, which, as noted earlier in this chapter, affects the depth of field, or zone of sharp focus. In Figure 2-12, the camera selected a shutter speed that did, in fact, catch my furkid in mid-romp, although if you look very closely, you can see some slight blurring of his beard. Because of the very bright light, the camera also selected a small aperture setting, which produces a large depth of field — so the grass in the background is as sharply focused as that in the foreground. To fully understand these issues, explore Chapters 5 and 6.

Sometimes, allowing a moving object to blur can actually create a heightened sense of motion — an artistic choice that you can't make in Sports mode. For more control over shutter speed, try out S mode (shutter-priority auto-exposure), explained in Chapter 5.

Close Up mode

Switching to Close Up mode doesn't enable you to focus at a closer distance to your subject than normal (as it does on some non-SLR cameras). The close-focusing capabilities of your camera depend entirely on the lens you bought.

But the settings of Close Up mode do affect focus in other ways. First, the camera sets the AF-area mode to Single Area and then bases focus on the subject that falls within the center focus brackets. (If you like, you can use the Multi Selector to base focus on the left or right pair of focus brackets instead of the center brackets, however).

Second, Close Up mode selects an aperture setting designed to produce short depth of field, which helps keep background objects from competing for attention with your main subject. As with Portrait and Child modes, though, how much the background blurs varies depending on the distance between your subject and the background, as well as a few other factors, all outlined in Chapter 6.

As for flash, you can set its mode to Auto, Auto with Red-Eye Reduction, and Off. (I urge you, though, to be very careful about using the built-in flash when you're shooting a person or animal at close range — that strong burst of light isn't healthy for the eyes.)

Chapter 7 offers additional tips on close-up photography.

Night Portrait mode

 As its name implies, the Night Portrait mode is designed to deliver a better-looking portrait at night (or in any dimly lit environment). It does so by con-straining you to using Slow Sync, Slow Sync with Red-Eye Reduction, or No Flash modes. In all three flash modes, the camera selects a shutter speed that results in a long exposure time. That slow shutter speed enables the camera to rely more on ambient light and less on the flash to expose the picture, which produces softer, more even lighting.

 I cover the issue of long-exposure and slow-sync flash photography in detail in Chapter 5. For now, the critical thing to know is that the slower shutter speed means that you probably need a tripod. If you try to handhold the camera, you run the risk of moving the camera during the long exposure, resulting in a blurry image. Enabling the vibration reduction (VR) feature of your lens, if available, can help, but for nighttime shooting, even that may not permit successful handheld shooting. Your subjects also must stay perfectly still during the exposure, which can also be a challenge.

Changing the (Shutter Button) Release Mode

In addition to all its other mode settings — exposure modes, focus modes, flash modes, and the like — your D60 offers a generically named but critical setting called Release mode.

This setting simply determines what happens when you completely depress the shutter-release button, known by most people as simply the shutter button. You have five options, as follows:

 ✔ **Single Frame:** This setting, which is the default, records a single image each time you press the shutter button completely. In other words, this is normal-photography mode.

 ✔ **Continuous:** Sometimes known as *burst mode,* this setting records a con-tinuous series of images as long as you hold down the shutter button. On the D60, you can capture a maximum of about three images per second. Obviously, this mode is great for capturing fast-paced subjects; see Chapter 7 for details and more action-photography tips.

 ✔ **Self-Timer:** Want to put yourself in the picture? Select this mode and then press the shutter button and run into the frame. As soon as you press the shutter button, the autofocus-assist illuminator on the front of the camera starts to blink, and the camera emits a series of beeps (assuming that you didn't disable its voice, a setting I cover in Chapter 1). A few seconds later, the camera captures the image.

The default delay time between your shutter-button press and the image capture is 10 seconds, but you can change it to 2, 5, or 20 seconds. Just pull up the Custom Setting menu and highlight the Self-Timer option, as shown in Figure 2-13. Press OK to display the four time options, as shown on the right screen in the figure, highlight your preference, and press OK again.

I also often use the self-timer function when I want to avoid any possibility of camera shake. The mere motion of pressing the shutter button can cause slight camera movement, which can blur an image. So I put the camera on a tripod and then activate the self-timer function. This enables "hands-free" — and therefore motion-free — picture-taking.

✓ **Delayed Remote and Quick Response Remote:** The final two Release mode settings relate to the optional Nikon wireless remote-control unit. If you select Delayed Remote, the camera snaps the picture two seconds after you press the shutter-release button on the remote unit. If you select Quick Response Remote, the image is captured immediately.

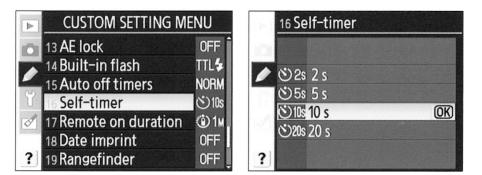

Figure 2-13: You can adjust the self-timer capture delay via the Custom Setting menu.

You can change the Release mode via the Custom Setting menu. But a more convenient method is to use the Quick Settings display. Use the Multi Selector to highlight the Release mode option, as shown in the left image in Figure 2-14. Press OK to display the available modes, as shown on the right, and then highlight your choice and press OK again. (Chapter 1 explains more about using the Quick Settings display, if you need help.)

If you want to use Self-Timer mode, you have an even easier option: Just press the Fn/Self-Timer button on the left-front side of the camera. By default, pressing the button automatically switches the camera to Self-Timer mode.

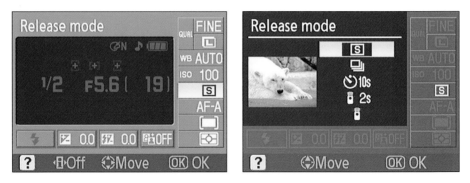

Figure 2-14: You can change the Release mode via the Quick Settings display.

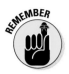

Unfortunately, after you take your picture or turn off the camera, the Release mode automatically reverts to either Single Frame or Continuous mode, depending on which of the two you previously selected. So if you want to take a series of self-timer pictures, you must press the Fn/Self-Timer button between each shot. In addition, the camera also cancels out of the remote-control modes if it doesn't receive a signal from the remote after a period of time. You can specify how long the camera should wait to take this step by using the Remote On Duration option on the Custom Setting menu. (A shorter delay saves battery life.)

Controlling Picture Quality and Size

*A*lmost every review of the D60 contains glowing reports about the cameras' top-notch picture quality. As you've no doubt discovered for yourself, those claims are true, too: This baby can create large, beautiful images.

What you may *not* have discovered is that Nikon's default Image Quality setting isn't the highest that the D60 offers. Why, you ask, would Nikon do such a thing? Why not set up the camera to produce the best images right out of the box? The answer is that using the top setting has some downsides. Nikon's default choice represents a compromise between avoiding those disadvantages while still producing images that will please most photographers.

Whether that compromise is right for you, however, depends on your photographic needs. To help you decide, this chapter explains the Image Quality setting, along with the Image Size setting, which is also critical to the quality of images that you print. Just in case you're having quality problems related to other issues, though, the first section of the chapter provides a handy quality-defect diagnosis guide.

A word of warning before you dive in: This stuff may be a little confusing at first. In fact, I pretty much guarantee it. Some math is even involved, which is usually against my principles. On top of that, discussions of picture quality and size involve lots of technical terms, such as pixels, resolution, JPEG compression, and the like.

So take it slowly, and if your eyes start to glaze over, put the book down and come back later for another go-round. It may require a few reads of this chapter, but before long, you'll feel confident about controlling these important aspects of your pictures.

Diagnosing Quality Problems

When I use the term *picture quality,* I'm not talking about the composition, exposure, or other traditional characteristics of a photograph. Instead, I'm referring to how finely the image is rendered in the digital sense.

Figure 3-1 illustrates the concept: The first example is a high-quality image, with clear details and smooth color transitions. The other examples show five common digital-image defects.

Figure 3-1: Refer to this symptom guide to determine the cause of poor image quality.

Each of these defects is related to a different issue, and only one is affected by the Image Quality setting on your D60. So if you aren't happy with your image quality, first compare your photos to those in the figure to properly diagnose the problem. Then try these remedies:

- **Pixelation:** When an image doesn't have enough *pixels* (the colored tiles used to create digital images), details aren't clear, and curved and diagonal lines appear jagged. The fix is to increase image resolution, which you do via the Image Size control. See the next section, "Adjusting Resolution (Image Size)," for details.

- **JPEG artifacts:** The "parquet tile" texture and random color defects that mar the third image in Figure 3-1 can occur in photos captured in the JPEG *(jay-peg)* file format, which is why these flaws are referred to as *JPEG artifacts.* This is the defect related to the Image Quality setting; see "Changing the File Type (JPEG or Raw)" to find out more.

- **Noise:** This defect gives your image a speckled look, as shown in the lower-left example in Figure 3-1. Noise can occur with very long exposure times or when you choose a high ISO Sensitivity setting on your camera. You can explore both issues in Chapter 5.

- **Color cast:** If your colors are seriously out of whack, as shown in the lower-middle example in the figure, try adjusting the camera's White Balance setting. Chapter 6 covers this control and other color issues. Note, though, that you can control white balance only when you shoot in the advanced exposure modes (P, S, A, and M).

- **Lens/sensor dirt:** A dirty lens is the first possible cause of the kind of defects you see in the last example in the figure. If cleaning your lens doesn't solve the problem, dust or dirt may have made its way onto the camera's image sensor. See the sidebar "Maintaining a pristine view," elsewhere in this chapter, for information on safe lens and sensor cleaning.

When diagnosing image problems, you may want to open the photos in ViewNX or some other photo software and zoom in for a close-up inspection. Some defects, especially pixelation and JPEG artifacts, have a similar appearance until you see them at a magnified view. (See Part III for information about using ViewNX.)

I should also tell you that I used a little digital enhancement to exaggerate the flaws in my example images to make the symptoms easier to see. With the exception of an unwanted color cast or a big blob of lens or sensor dirt, these defects may not even be noticeable unless you print or view your image at a very large size. And the subject matter of your image may camouflage some flaws; most people probably wouldn't detect a little JPEG artifacting in a photograph of a densely wooded forest, for example.

In other words, don't consider Figure 3-1 as an indication that your D60 is suspect in the image quality department. First, *any* digital camera can produce these defects under the right circumstances. Second, by following the guidelines in this chapter and the others mentioned in the preceding list, you can resolve any quality issues that you may encounter.

Adjusting Resolution (Image Size)

Like other digital devices, your D60 creates pictures out of *pixels,* which is short for *picture elements.* You can see some pixels close up in the right example of Figure 3-2, which shows a greatly magnified view of the eye area in the left image.

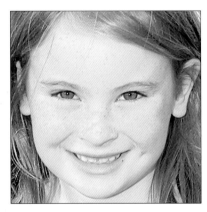

Figure 3-2: Pixels are the building blocks of digital photos.

You specify the pixel count of your images, also known as the *resolution,* via the Image Size control, accessible through both the Shooting menu and the Quick Settings display. The D60 offers three Image Size settings: Large, Medium, and Small; Table 3-1 lists the resulting resolution values for each setting.

Table 3-1	Image Size (Resolution) Options
Setting	*Resolution*
Large	3872 x 2592 (10.2 MP)
Medium	2896 x 1944 pixels (5.6 MP)
Small	1936 x 1296 pixels (2.5 MP)

In the table, the first pair of numbers shown for each setting represents the image *pixel dimensions* — that is, the number of horizontal pixels and the number of vertical pixels. The values in parentheses indicate the total resolution, which you get by multiplying the horizontal and vertical pixel values. This number is usually stated in *megapixels,* abbreviated MP for short. One megapixel equals 1 million pixels. (I rounded off the MP values in the table.)

Note, however, that if you select Raw (NEF) as your file format, all images are captured at the Large setting. You can vary the resolution only if you select JPEG as the file format. The upcoming section "Changing the File Type (JPEG or Raw)" explains file formats, which you specify via the Image Quality setting.

So how many pixels are enough? To make the call, you need to understand how resolution affects print quality, display size, and file size. The next sections explain these issues, as well as a few other resolution factoids. If you're already schooled on the subject, skip to "Accessing the Image Size control," later in this chapter, for specifics on how to adjust this option.

Pixels and print quality

When mulling over resolution options, your first consideration is how large you want to print your photos, because pixel count determines the size at which you can produce a high-quality print. If you don't have enough pixels, your prints may exhibit the defects you see in the pixelation example in Figure 3-1, or worse, you may be able to see the individual pixels, as in the right example in Figure 3-2.

Depending on your photo printer, you typically need anywhere from 200 to 300 pixels per linear inch, or *ppi,* of the print. To produce an 8-by-10-inch print at 200 ppi, for example, you need 1600 horizontal pixels and 2000 vertical pixels (or vice versa, depending on the orientation of your print).

Table 3-2 lists the pixel counts needed to produce traditional print sizes at 200 ppi and 300 ppi. But again, the optimum ppi varies depending on the printer — some printers prefer even more than 300 ppi — so check your manual or ask the photo technician at the lab that makes your prints. (And note that ppi is *not* the same thing as *dpi,* which is a measurement of printer resolution. *Dpi* refers to how many dots of color the printer can lay down per inch; most printers use multiple dots to reproduce one pixel.)

Even though many photo-editing programs enable you to add pixels to an existing image, doing so isn't a good idea. For reasons I won't bore you with, adding pixels — known as *resampling* — doesn't enable you to successfully enlarge your photo. In fact, resampling typically makes matters worse. The printing discussion at the start of Chapter 9 includes some example images that illustrate this issue.

Table 3-2	Pixel Requirements for Traditional Print Sizes	
Print Size	*Pixels for 200 ppi*	*Pixels for 300 ppi*
4 x 6 inches	800 x 1200	1200 x 1800
5 x 7 inches	1000 x 1400	1500 x 2100
8 x 10 inches	1600 x 2000	2400 x 3000
11 x 14 inches	2200 x 2800	3300 x 4200

Pixels and screen display size

Resolution doesn't affect the quality of images viewed on a monitor, television, or other screen device as it does printed photos. What resolution *does* determine is the *size* at which the image appears.

This issue is one of the most misunderstood aspects of digital photography, so I explain it thoroughly in Chapter 9. For now, just know that you need *way* fewer pixels for onscreen photos than you do for printed photos. For example, Figure 3-3 shows a 450-x-300-pixel image that I attached to an e-mail message.

For e-mail images, I recommend a maximum of 640 pixels for the picture's longest dimension. If your image is much larger, the recipient can't view the entire picture without scrolling the display.

In short, even if you use the smallest Image Size setting on your D60, you'll have more than enough pixels for most onscreen uses. The only exception might be an image that you want to display via a digital projector that has a very large screen resolution. Again, Chapter 9 details this issue, and also shows you how to prepare your pictures for online sharing.

Pixels and file size

Every additional pixel increases the amount of data required to create a digital picture file. So a higher-resolution image has a larger file size than a low-resolution image.

Figure 3-3: The low resolution of this image (450 x 300 pixels) ensures that it can be viewed without scrolling when shared via e-mail.

Large files present several problems:

- You can store fewer images on your memory card, on your computer's hard drive, and on removable storage media such as a CD-ROM.

- The camera needs more time to process and store the image data on the memory card after you press the shutter button. This extra time can hamper fast-action shooting.

- When you share photos online, larger files take longer to upload and download.

- When you edit your photos in your photo software, your computer needs more resources and time to process large files.

To sum up, the trade-off for a high-resolution image is a large file size. But note that the Image Quality setting also affects file size. See the section "Changing the File Type (JPEG or Raw)" for more on that topic. The upcoming sidebar "How many pictures fit on my memory card?" provides details on the file-storage issue.

Resolution recommendations

As you can see, resolution is a bit of a sticky wicket. What if you aren't sure how large you want to print your images? What if you want to print your photos *and* share them online?

Personally, I take the "better safe than sorry" route, which leads to the following recommendations about the Image Size setting:

- **Always shoot at a resolution suitable for print.** You then can create a low-resolution copy of the image in your photo editor for use online. Chapter 9 shows you how.

 Again, you *can't* go in the opposite direction, adding pixels to a low-resolution original in your photo editor to create a good, large print. Even with the very best software, adding pixels doesn't improve the print quality of a low-resolution image.

- **For everyday images, Medium (5.6 MP) is a good choice.** I find 10.2 MP, which you get at the Large setting, to be overkill for most casual shooting, which means that you're creating huge files for no good reason. Even at the Medium setting, you get enough pixels (2896 x 1944) to produce a 5-x-7-inch print at 300 ppi or an 8-x-10-inch print at 200 ppi.

- **Choose Large (10.2 MP) for an image that you plan to crop, print very large, or both.** The benefit of maxing out resolution is that you have the flexibility to crop your photo and still generate a decent-sized print of the remaining image. For example, I shot the left photo in Figure 3-4 at the zoo. (What, you think I can afford an arctic safari or something?) Even with a powerful zoom lens, I couldn't get close enough to fill the frame with the bear's head, which was my compositional goal. Shooting at the highest resolution enabled me to crop the photo and still have enough pixels left to produce a great print, as you see in the right image.

- **Reduce resolution if shooting speed is paramount.** If you're shooting action and the shot-to-shot capture time is slower than you'd like — that is, the camera takes too long after you take one shot before it lets you take another — dialing down the resolution may help. Also see Chapter 7 for other tips on action photography.

Figure 3-4: Capture images that you plan to crop and enlarge at the highest possible Image Size setting.

Accessing the Image Size control

When you choose an Image Quality setting that captures your image in the Raw (NEF) format, you don't need to worry about the Image Size setting — the camera captures all Raw images at the Large resolution. (You can explore the issue of format in the next section.)

If you capture images in the JPEG format, you can choose any of the three Image Size options. You can make your selection via the Quick Settings display or from the Shooting menu, as follows:

✔ **Quick Settings display:** First, display the Shooting Info screen, if it isn't already visible, by pressing the shutter button halfway or by pressing the Zoom button. Then press the Zoom button to shift to the Quick Settings display and use the Multi Selector to highlight the Image Size option, as shown on the left in Figure 3-5. Press OK to display the screen shown on the right in the figure, highlight the resolution setting that you want to use, and press OK again.

✔ **Shooting menu:** Display the Shooting menu and highlight the Image Size option, as shown on the left in Figure 3-6. Press OK to access the resolution options, as shown on the right in the figure. Highlight your choice and press OK again.

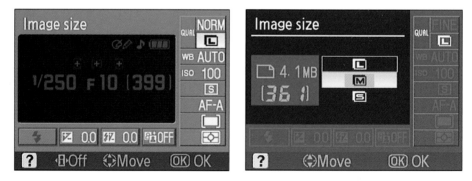

Figure 3-5: The Image Size control is positioned at the top of the Shooting Info display.

Figure 3-6: You can also adjust Image Size through the Shooting menu.

When you change the Image Size setting, the file size changes, which changes the number of new shots you can fit on the current memory card. If you change the resolution via the Quick Settings display, you can view the number of shots remaining and the file size when you select Large, Medium, or Small on the second screen, as shown in the right image in Figure 3-5. In the figure, for example, the current file size is 4.1MB (megabytes), and the number of remaining shots is 361.

Changing the File Type (JPEG or Raw)

When you display the Shooting Menu, you see an option named Image Quality right above the Image Size control. (Refer to Figure 3-6.) If I had my druthers, the Image Quality option would instead be called File Type, because that's what the setting controls.

How many pictures fit on my memory card?

That question is one of the first asked by new camera owners — and it's an important one because you don't want to run out of space on your memory card just as the perfect photographic subject presents itself.

As explained in the Image Size and Image Quality discussions in this chapter, image resolution (pixel count) and file format (JPEG or Raw) together determine the size of the picture file which, in turn, determines how many photos fit in a given amount of camera memory.

The table below shows you approximately how many pictures fit on a 1GB (gigabyte) memory card at each of the possible resolution/format combinations on the D60. If you have a 2GB card, double the picture counts; for a 526MB (megabyte) card, expect to fit half the number of pictures.

Picture Capacity of a 1GB Memory Card

Size	JPEG Fine	JPEG Norm	JPEG Basic	NEF (Raw)	NEF (Raw) + JPEG Basic
Large	129	251	487	79	70
Medium	225	431	839	NA*	NA*
Small	487	888	1500	NA*	NA*

NEF (Raw) images are always captured at the Large size.

The file type, more commonly known as a file *format,* determines how your picture data is recorded and stored. Your choice does impact picture quality, but so do other factors, as outlined at the beginning of this chapter. In addition, your choice of file type has ramifications beyond picture quality.

At any rate, your D60 offers the two file types common on most of today's digital cameras: JPEG and Camera Raw, or just Raw for short, which goes by the specific moniker NEF on Nikon cameras. You can choose from five Quality options, three of which deliver JPEG files, one which produces a Raw file, and one which creates the same image twice, once in each format.

The next sections explain the pros and cons of the five Image Quality settings. If your mind is already made up, skip ahead to "Adjusting the Image Quality setting" for specifics on making your selection.

WARNING!

Don't confuse *file format* with the Format Memory Card option on the Setup menu. That option erases all data on your memory card; see Chapter 1 for details.

JPEG: The imaging (and Web) standard

Pronounced *jay-peg,* this format is the default setting on your D60, as it is for most digital cameras. JPEG is popular for two main reasons:

- ✓ **Immediate usability:** All Web browsers and e-mail programs can display JPEG files, so you can share them online immediately after you shoot them. The same can't be said for NEF (Raw) files, which must be converted to JPEG files before you can share them online. And although you can print Raw files directly from Nikon ViewNX, you must convert them to a standard format to view or print them from most other photo programs. You can read more about the conversion process in the upcoming section "NEF (Raw): The purist's choice."

- ✓ **Small files:** JPEG files are smaller than NEF (Raw) files. And smaller files means that your pictures consume less room on your camera memory card and in your computer's storage tank.

The downside — you knew there had to be one — is that JPEG creates smaller files by applying *lossy compression.* This process actually throws away some image data. Too much compression leads to the defects you see in the JPEG Artifacts example in Figure 3-1.

Fortunately, your camera enables you to specify how much compression you're willing to accept. The Image Quality menu offers three JPEG settings, which produce the following results:

- ✓ **JPEG Fine:** At this setting, the compression ratio is 1:4 — that is, the file is four times smaller than it would otherwise be. In plain English, that means that very little compression is applied, so you shouldn't see many compression artifacts, if any.

- ✓ **JPEG Norm:** Switch to Norm (for Normal), and the compression ratio rises to 1:8. The chance of seeing some artifacting increases as well.

- ✓ **JPEG Basic:** Shift to this setting, and the compression ratio jumps to 1:16. That's a substantial amount of compression and brings with it a lot more risk of artifacting.

Note, though, that even the JPEG Basic setting on your D60 doesn't result in anywhere near the level of artifacting that you see in my example in Figure 3-1. Again, that example is exaggerated to help you be able to recognize artifacting defects and understand how they differ from other image-quality issues.

In fact, if you keep your image print or display size small, you aren't likely to notice a great deal of quality difference between the Fine, Normal, and Basic compression levels, although details in the Fine version may appear slightly crisper than the Normal and Basic options. It's only when you greatly enlarge a photo that the differences become apparent.

Take a look at Figures 3-7 and 3-8, for example. I captured the scene in Figure 3-7 four times, keeping the resolution the same for each shot but varying the Image Quality setting. For the photo you see in Figure 3-7, I used the JPEG Fine setting. I thought about printing the three other shots along with the JPEG Fine example, but frankly, you wouldn't be able to detect a nickel's worth of difference between the examples at the size that I could print them on this page. So Figure 3-8 shows just a portion of each shot at a greatly enlarged size. The first three images show the JPEG Fine, Normal, and Basic shots; for the fourth image, I used the NEF (Raw) setting, which applies no compression. (Note that during the process of converting the Raw image to a print-ready file, I tried to use settings that kept the Raw image as close as possible to its JPEG cousins in all aspects but quality. But any variations in exposure, color, and contrast are a result of the conversion process, not of the format per se.)

Figure 3-7: This vintage camera and light meter offered a good test for comparing the Image Quality settings.

Even at the greatly magnified size, it takes a sharp eye to detect the quality differences between the Raw and Fine images. When you carefully inspect the Normal version, you can see some artifacting start to appear; it's most visible in how well the red dots and number are rendered. The boundaries of the red dot, for example, aren't as well defined, and the color appears to "bleed" a little outside the dot. Jump to the Basic example, however, and compression artifacting becomes more apparent. (Note that the jagginess of the letters is not a function of compression but a result of blowing the picture up way beyond what the original pixel count can support.)

Nikon chose to use the Normal setting as the default on the D60. And for everyday images that you don't plan to print or display very large, that's probably just ducky. And because file size shrinks as you apply more compression, Normal enables you to fit more photos on your memory card than Fine or NEF (Raw). As a point of reference, Table 3-3 shows you the approximate file size, in megabytes (MB), of an image captured at each of the D60's resolution options (Large, Medium, and Small) and using each of the Image

Quality settings. Elsewhere in this chapter, the sidebar "How many pictures fit on my memory card?" shows you how many images you can store on a 1GB (gigabyte) storage card at each of the various combinations of Image Size and Image Quality settings. Keep in mind that in both cases, the numbers you see in the table are rough averages; depending on the image, your picture files may be smaller or larger.

Figure 3-8: Here you see a portion of the vintage light meter from Figure 3-7 at greatly enlarged views.

Table 3-3	Image Quality + Image Size = File Size		
Image Quality	*Large*	*Medium*	*Small*
JPEG Fine	4.8MB	2.7MB	1.2MB
JPEG Normal	2.4MB	1.3MB	0.6MB
JPEG Basic	1.2MB	0.7MB	0.3MB
NEF (Raw)	9.0MB	NA*	NA*
NEF (Raw) + JPEG Basic	10.1MB	NA*	NA*

**NEF (Raw) images are always captured at the Large size.*

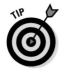

For my money, though, the file size benefit you gain when going from Fine to Normal isn't worth even a little quality loss, especially with the price of camera memory cards getting lower every day. You never know when a casual snapshot is going to turn out to be so great that you want to print or display it large enough that even minor quality loss becomes a concern. And of all the defects that you can correct in a photo editor, artifacting is one of the hardest to remove. So if I shoot in the JPEG format, I stick with Fine.

I suggest that you do your own test shots, however, carefully inspect the results in your photo editor, and make your own judgment about what level of artifacting you can accept. Artifacting is often much easier to spot when you view images onscreen than I can reproduce here in print because the print process itself obscures some of the tiny defects caused by compression.

If you don't want *any* risk of artifacting, bypass JPEG altogether and change the file type to NEF (Raw), explained next.

Whichever format you select, however, be aware of one more important rule for preserving the original image quality: If you retouch pictures in your photo software, don't save the altered images in the JPEG format. Every time you alter and save an image in the JPEG format, you apply another round of lossy compression. And with enough editing, saving, and compressing, you *can* eventually get to the level of image degradation shown in the JPEG example in Figure 3-1, at the start of this chapter. (Simply opening and closing the file does no harm.)

Always save your edited photos in a non-destructive format. TIFF, pronounced *tiff,* is a good choice and is a file-saving option available in most photo-editing programs. Should you want to share the edited image online, create a JPEG copy of it when you're finished making all your changes. That way, you always retain one copy of the photo at the original quality captured by the camera. You can read more about TIFF versus JPEG in Chapter 8, in the section related to processing Raw images. Chapter 9 explains how to create a copy of your photo for online sharing.

NEF (Raw): The purist's choice

The other picture-file type you can create on your Nikon is called *Camera Raw,* or just *Raw* (as in uncooked) for short.

Each manufacturer has its own flavor of Raw. Nikon's is called NEF, so you see the three-letter extension NEF at the end of Raw file names if you use a Windows computer. In addition, the Raw format setting on your camera is officially called NEF (Raw), although it appears without the NEF on the Shooting Info display.

Raw is popular with advanced, very demanding photographers, for two reasons:

✔ **Greater creative control:** With JPEG, internal camera software tweaks your images, making adjustments to color, exposure, and sharpness as needed to produce the results that Nikon believes its customers prefer. With Raw, the camera simply records the original, unprocessed image data. The photographer then copies the image file to the computer and uses special software known as a *raw converter* to produce the actual image, making decisions about color, exposure, and so on at that point. The upshot is that "shooting Raw" enables you, and not the camera, to have the final say on the visual characteristics of your image.

✔ **Best picture quality:** Because Raw doesn't apply the destructive compression associated with JPEG, you don't run the risk of the artifacting that can occur with JPEG.

But of course, as with most things in life, Raw isn't without its disadvantages. To wit:

✔ **You can't do much of anything with your pictures until you process them in a Raw converter.** You can't share them online, for example, or put them into a text document or multimedia presentation. You can print them immediately if you use Nikon ViewNX, but most other photo programs require you to convert the Raw files to a standard format first. So when you shoot Raw, you add to the time you must spend in front of the computer instead of behind the camera lens.

✔ **To get the full benefit of Raw, you need software other than Nikon ViewNX.** The ViewNX software that ships free with your camera does have a command that enables you to convert Raw files to JPEG or to TIFF, introduced in the preceding section. However, this free tool automates the process, making all those color, exposure, and other decisions for you — which pretty much defeats the purpose of shooting Raw.

Nikon Capture NX offers a sophisticated Raw converter, but it costs about $150. If you own Adobe Photoshop or Photoshop Elements, however, you're set; both include the converter that most people consider one of the best in the industry. Watch the sale ads, and you can pick up Elements for well under $100.

Of course, the D60 also offers an in-camera Raw converter, found on the Retouch menu. But although it's convenient, this tool isn't the easiest to use because you must rely on the small camera monitor when making judgments about color, exposure, sharpness, and so on. The in-camera tool also doesn't offer the complete cadre of features available in Capture NX and other converter software utilities.

Chapter 8 offers more information on the in-camera conversion process and also offers a look at the Adobe converter found in Photoshop Elements.

✓ **Raw files are larger than JPEGs.** The type of file compression that Raw applies doesn't degrade image quality, but the tradeoff is larger files. In addition, Nikon Raw files are always captured at the maximum resolution available on the camera, even if you don't really need all those pixels. For both reasons, Raw files are significantly larger than JPEGs, so they take up more room on your memory card and on your computer's hard drive or other picture-storage device. (See the sidebar "How many pictures can I fit on my memory card" for details.)

Are the disadvantages worth the gain? Only you can decide. But before you make up your mind, refer to Figure 3-8 and compare the JPEG Fine example with its NEF (Raw) counterpart. Be sure that you judge the two on the basis of quality rather than color, contrast, and exposure, which are due to adjustments I may have made during the conversion process and not the choice of file format. You may be able to detect some subtle quality differences when you really study the two, but a casual viewer likely would not, especially if shown the entire example images at normal print sizes rather than the greatly magnified views shown in the figure. I took Figure 3-7, for example, using JPEG Fine.

That said, I *do* shoot in the Raw format when I'm dealing with tricky lighting because doing so gives me more control over the final image exposure. For example, if you use a capable Raw converter, you can specify how bright you want the brightest areas of your photo to appear and how dark you prefer your deepest shadows. With JPEG, the camera makes those decisions, which can potentially limit your flexibility if you try to adjust exposure in your photo editor later.

I also go Raw if I know that I'm going to want huge prints of a subject. But keep in mind: I'm a photography geek, I have all the requisite software, and I don't really have much else to do with my time than process scads of Raw images. Oh, and I'm a bit of a perfectionist, too. (Although I'm more bothered by imperfections than I am motivated to remove them. A lazy perfectionist, if you will.)

If you do decide to try Raw shooting, you can select from two options on your camera's Image Quality menu:

 ✏ **NEF (RAW):** This setting produces a single Raw file. Again, you don't have a choice of Image Size settings; the camera always captures the file at the maximum resolution (10.2MP).

 ✏ **NEF (RAW)+JPEG Basic:** This setting produces two files: the standard Raw file plus a file stored in the JPEG Basic format. At first glance, this option sounds great: You can share the JPEG online or get prints made and then process your Raw files when you have time.

The problem is that, like the Raw file, the JPEG copy is captured at that very high pixel count — which is *too* large for onscreen viewing. That means that you have to edit the JPEG file anyway to trim down the pixel count before online sharing, so the time savings is reduced. And although the JPEG copy contains enough pixels for generating a good print, the high level of compression applied at the basic setting may lead to disappointing print quality. So in my mind, this combo format option is a washout. But do your own tests to see whether these print quality or display size issues are a concern to you.

My take: Choose JPEG Fine or NEF (Raw)

At this point, you may be finding all this technical goop a bit much — I recognize that panicked look in your eyes — so allow me to simplify things for you. Until you have time or energy to completely digest all the ramifications of JPEG versus Raw, here's a quick summary of my thoughts on the matter:

 ✏ If you require the absolute best image quality and have the time and interest to do the Raw conversion, shoot Raw. See Chapter 8 for more information on the conversion process.

 ✏ If great photo quality is good enough for you, you don't have wads of spare time, or you aren't that comfortable with the computer, stick with JPEG Fine.

 ✏ Stay away from JPEG Normal and Basic. The tradeoff for smaller files isn't, in my opinion, worth the risk of compression artifacts. As with my recommendations on image size, this fits the "better safe than sorry" formula: You never know when you may capture a spectacular, enlargement-worthy subject, and it would be a shame to have the photo spoiled by compression defects.

Adjusting the Image Quality setting

The easy part of understanding the Image Quality option is actually selecting the setting you want to use. As with the Image Size options, you can access the Image Quality options in two ways:

🔍 ✔ **Quick Settings display:** First, display the Shooting Info screen by pressing the shutter button halfway or by pressing the Zoom button. Then press the Zoom button again to get to the Quick Settings display. Highlight the Image Quality option, as shown on the left in Figure 3-9, and then press OK to display the screen shown on the right in the figure. Highlight the option you want to use and press OK again. Note that as when you change the Image Size via the Quick Settings display, the second screen shows you the file size that will result from your selected quality setting. In the right image in Figure 3-9, for example, the file size is 7.3MB. The other value indicates how many more pictures will fit on your memory card at the current setting.

✔ **Shooting menu:** Press the Menu button, highlight the Shooting menu, and then highlight Image Quality, as shown on the left in Figure 3-10. Press OK to access the quality options, as shown on the right, select your choice, and press OK again.

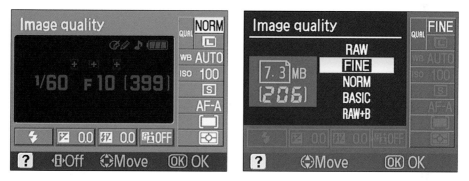

Figure 3-9: You can set the file type (JPEG or Raw) via the Quick Settings display.

Figure 3-10: The Shooting menu also offers access to the Image Quality option.

Maintaining a pristine view

Often lost in discussions of digital photo defects — compression artifacts, pixelation, and the like — is the impact of plain-old dust and dirt on picture quality. But no matter what camera settings you use, you aren't going to achieve great picture quality with a dirty lens. So make it a practice to clean your lens on a regular basis, using one of the specialized cloths and cleaning solutions made expressly for that purpose.

If you continue to notice random blobs or hair-like defects in your images (refer to the last example in Figure 3-1), you probably have a dirty *image sensor*. That's the part of your camera that does the actual image capture — the digital equivalent of a film negative, if you will.

Your D60 offers an automated, internal sensor-cleaning mechanism. By default, this automatic cleaning happens every time you turn the camera on or off. You also can request a cleaning session at any time via the Clean Image Sensor command on the Setup menu. (Chapter 1 has details on this menu option.)

But if you frequently change lenses in a dirty environment, the internal cleaning mechanism may not be adequate, in which case a manual sensor cleaning is necessary. You can do this job yourself, but . . . I don't recommend it. Image sensors are pretty delicate beings, and you can easily damage them or other parts of your camera if you aren't careful. Instead, find a local camera store that offers this service. In my area (central Indiana), sensor cleaning costs from $30–$50.

One more cleaning tip: Never — and I mean *never* — try to clean any part of your camera using a can of compressed air. Doing so can not only damage the interior of your camera, blowing dust or dirt into areas where it can't be removed, but also crack the external monitor.

Don't be confused by the fact that the format names presented via the Quick Settings display differ from the "official" names on the Shooting menu; the Quick Settings display simply uses shortened versions of those names. The top and bottom format options on the Quick Settings screen deliver Raw files; the three middle choices are the JPEG format options.

As you adjust format, remember that this setting and the resolution (Image Size) setting *together* determine file size and picture quality. As a reminder, notice that the two are listed together in the Quick Settings display with the category labeled Qual (for Quality), as shown on the left in Figure 3-9.

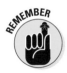

If you combine low resolution with the JPEG Basic setting, expect teeny files but not-so-hot picture quality. On the flip side, selecting JPEG Fine or Raw together with the Large resolution setting produces the best quality but also larger files.

4

Reviewing Your Photos

In This Chapter

▶ Exploring picture playback functions

▶ Viewing images on the camera monitor

▶ Deciphering the picture information displays

▶ Understanding the exposure histogram

▶ Deleting bad pictures and protecting great ones

*W*ithout question, my favorite thing about digital photography is being able to view my pictures on the camera monitor the instant after I shoot them. No more guessing whether I captured the image I wanted or I need to try again; no more wasting money on developing and printing pictures that stink. In fact, this feature alone was reason enough for me to turn my back forever on my closetful of film photography hardware and all the unexposed film remaining from my predigital days.

But simply seeing your pictures is just the start of the things you can do when you switch your D60 to playback mode. You also can review all the camera settings you used to take the picture, display graphics that alert you to serious exposure problems, and add file markers that protect the picture from accidental erasure. This chapter tells you how to use all these playback features and more.

After you explore these playback functions, be sure to also visit Chapter 9, which covers some additional ways to view your images, including how to create slide shows, display your photos on a television screen, and turn a series of photos into a stop-motion movie.

Inspecting Your Pictures

After you take a picture, it automatically appears briefly on the camera monitor. (At least, it does if you enable the Image Review option found on the Custom Setting menu, as I suggest in Chapter 1.)

To get a longer look at your photos, switch the camera to playback mode. The next sections explain how to enter and exit said mode, review your photos, and customize a few aspects of how the camera displays your images.

Setting Playback menu options

Figure 4-1 introduces you to the Playback menu, which offers only six options. Of those six, only the first three specifically relate to viewing your pictures on the camera monitor. The final three relate to creating digital slide shows, viewing stop-motion movies, and printing directly from a memory card, all of which you can explore in Chapter 9.

Figure 4-1: The Playback menu contains just a handful of options.

The next two sections discuss the Playback Folder and Rotate Tall options, both of which work in conjunction with related options on the Setup menu. For details on the Delete option, see "Deleting Photos," near the end of this chapter.

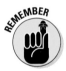

To access menus, press the Menu button. Then use the Multi Selector and the OK button to navigate through the menus and select options therein. Chapter 1 has more information, if you need help.

Selecting a playback folder

When your camera records images onto your memory card, it organizes the pictures into folders that are assigned generic names: 100NCD60, 101NCD60, and so on. By using the Folders option on the Setup menu, you can create your own, customized folder storage system. I cover this advanced feature in Chapter 11.

If you do create custom folders, you then must select the folder you want to view when you switch to playback mode. You do this via the Playback menu, like so:

1. **Display the Playback menu and highlight the Playback Folder, as shown in the first screen in Figure 4-2.**

2. **Press OK to display the Playback Folder options, shown in the second screen in the figure.**

 You get two choices:

- *Current:* With this option enabled, you can view only images stored in the folder that's currently selected for the Folders option on the Setup menu.

- *All:* Choose this option to view all images in all folders.

Figure 4-2: Specify which folder of images you want to view.

3. **Highlight the option you want to use and press OK to return to the Playback menu.**

Again, you don't need to worry about this whole thing unless you create custom folders, as covered in Chapter 11. If you stick with the default folder structure, you can view all your pictures regardless of whether you set the Playback Folder option to Current or All.

Enabling automatic picture rotation

When you take a picture, the camera can record the image *orientation* — that is, whether you held the camera normally, creating a horizontally-oriented image, or turned the camera on its side to shoot a vertically-oriented photo. This bit of data is simply added into the picture file.

During playback, the camera reads the data and automatically rotates the image so that it appears in the upright position in the monitor, as shown on the left in Figure 4-3. The image is also automatically rotated when you view it in Nikon ViewNX, Capture NX, and some other photo programs that can interpret the data. Your other option is to disable this feature, in which case the image appears sideways in the monitor, as shown in the right example, and when you view it in the aforementioned photo software.

Official photo lingo uses the term *portrait orientation* to refer to vertically-oriented pictures and *landscape orientation* to refer to horizontally oriented pictures.

Figure 4-3: You can display vertically-oriented pictures in their upright position (left) or sideways (right).

Enabling auto image rotation requires a trip to both the Setup menu and the Playback menu. Take these steps:

1. **On the Setup menu, enable Auto Image Rotation, as shown in the left image in Figure 4-4.**

 Don't see Auto Image Rotation on the menu? Scroll to the very beginning of the Setup menu and set the CSM/Setup Menu option (not shown in the figure) to Full. As covered in Chapter 1, some menu items are hidden unless you take this step.

SETUP MENU	
Folders	NCD60
File no· sequence	ON
Clean image sensor	--
Mirror lock-up	--
Firmware version	--
Dust off ref photo	--
Auto image rotation	ON

PLAYBACK MENU	
Delete	
Playback folder	NCD60
Rotate tall	ON
Slide show	2s
Print set (DPOF)	
Stop-motion movie	

Figure 4-4: Visit the Setup and Playback menus to enable image rotation.

2. **Display the Playback menu.**

 Again, Chapter 1 explains the process of using menus, if you need help.

3. **Enable the Rotate Tall option, as shown in the right image in Figure 4-4.**

 Now your camera displays vertically oriented pictures as shown in the left image in Figure 4-3.

If you shoot pictures with the lens pointing directly up or down, the camera may incorrectly sense the picture orientation. If that issue is a bother to you, just turn off Auto Image Rotation on the Setup menu before you shoot the pictures. The camera then won't record the orientation information as part of the picture file.

Displaying your pictures: The basics

After you establish the two playback preferences covered in the preceding sections, the following steps walk you through the basics of viewing your pictures:

1. **Press the Playback button, found on the left side of the monitor and shown in the margin here.**

 The monitor displays the last picture you took, along with some picture data, such as the frame number of the photo.

 To find out how to interpret the picture information and specify what type of data you want to see, see the upcoming section "Viewing picture data." If you're curious now, though, or if the picture data is hampering your ability to see the picture itself, press the Multi Selector up or down to cycle through the picture data display formats.

2. **To scroll through your pictures, rotate the Command dial or press the Multi Selector right or left.**

 I highlighted the Command dial and Multi Selector in Figure 4-5. Press the Multi Selector right or rotate the Command dial to the right to advance to the next picture; go the other direction to view previous pictures.

3. **To return to picture-taking mode, press the shutter button halfway and then release it.**

These steps assume that the camera is currently set to display a single photo at a time, as shown in Figure 4-5. You can also display multiple images at a time; the next section tells all.

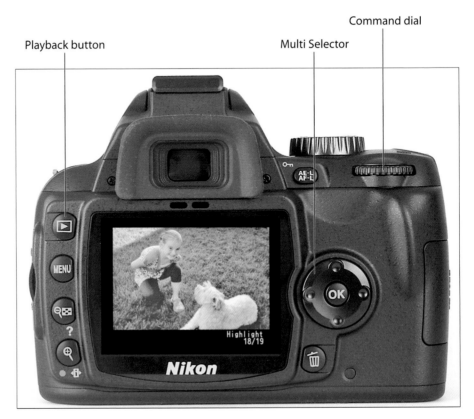

Command dial

Playback button

Multi Selector

Highlight
18/19

Nikon

Figure 4-5: Navigate and inspect your photos using these controls.

Viewing multiple images at a time

 If you want to quickly review and compare several photos, you can set the camera to display thumbnails of four photos, as shown in the top image in Figure 4-6, or nine photos, as shown in the lower image. The key is the Thumbnail button, found just under the Menu button and shown in the margin here. Just press the button to cycle from single-picture view to four-picture view; press again to switch to nine-picture view.

 To reduce the number of thumbnails from nine to four, press the Zoom button, located one step down from the Thumbnail button and shown clinging to the margin here. To go from four thumbnails to the single-picture view, press the button again.

 You can also just press the OK button to shift from four- or nine-image view to single-frame view.

While you're viewing images in the four- or nine-thumbnail mode, use these techniques to navigate your photo collection:

Selected photo

- ✔ **Scroll through your pictures.** Rotate the Command dial or press the Multi Selector right or left.

- ✔ **Select an image.** As you scroll through your pictures, a yellow highlight box indicates the currently selected image. For example, in the top image in Figure 4-6, Image 18 is selected. To select a different image, just keep using the Command dial or Multi Selector to scroll the display until the highlight box surrounds the image.

- ✔ **View the selected image at the full-frame size.** Again, either press the OK button or press the Zoom button to return to full-frame view.

Zooming in for a closer view

Figure 4-6: You can view four or nine thumbnails at once.

By pressing the Zoom button, posing here in the margin, you can more closely inspect a portion of the onscreen image. This feature comes in especially handy for checking small details, such as whether anyone's eyes are closed in a group portrait, for example, and for determining whether the subject of your picture is sharply focused.

Here's the scoop on this feature:

- ✔ **Zoom in.** You can enlarge an image display to a maximum of 13 to 25 times its original size, depending on the resolution (pixel count) of the photo. Just keep pressing the Zoom button until you reach the magnification you want.

- ✔ **View another part of the picture.** Whenever the image is magnified, a little navigation thumbnail showing the entire image appears briefly in the lower-right corner of the monitor, as shown in Figure 4-7. The yellow outline in this picture-in-picture image indicates the area that's currently consuming the rest of the monitor space.

Figure 4-7: Use the Multi Selector to move the yellow outline over the area you want to inspect.

Use the Multi Selector to scroll the display to view a different portion of the image. Press up to scroll up, left to scroll left, and so on. After a few seconds, the navigation thumbnail disappears; just press the Multi Selector in any direction to redisplay it.

✔ **View more images at the same magnification.** Here's an especially neat trick: While the display is zoomed, you can rotate the Command dial to display the same area of the next photo at the same magnification. So, for example, if you shot that group portrait several times, you can easily check each one for shut-eye problems.

✔ **Zoom out.** To zoom out to a reduced magnification, press the Thumbnail button.

✔ **Return to full-frame view.** When you're ready to return to the normal magnification level, you don't need to keep pressing the Thumbnail button until you're all the way zoomed out. Instead, just press the OK button, which quickly returns you to the standard view.

Viewing picture data

In playback mode, the camera monitor displays one of five different styles of picture information along with the image. The next sections explain the details you can glean from each of the picture information display modes.

To cycle between the picture information modes, press the Multi Selector up or down. (In case you missed it, the Multi Selector is the round, four-way toggle switch with the OK button in the middle, shown earlier in Figure 4-5.)

File Information mode

In this display mode, the monitor offers a data readout similar to what you see in Figure 4-8. The following three bits of info may appear at the top of the monitor:

- **Retouch Indicator:** This icon appears in the upper-left corner of the monitor if you used any of the Retouch menu options to alter the image. (I cover the Retouch features in Chapters 8, 9, 10, and 11.)

- **Protect Status:** If you see the little key icon, shown in Figure 4-8 to the right of the Retouch Indicator icon, you previously used the camera's file-protection feature to prevent the image from being accidentally deleted. See "Protecting Photos," later in this chapter, to find out how to accomplish that feat.

- **Frame Number/Total Pictures:** In the upper-right corner of the display, you see two numbers separated by a slash. The first value indicates the frame number of the currently displayed photo; the second tells you the total number of pictures on the memory card.

Jumping to the data underneath the image, you can view these details:

- **Folder Name:** Folders are named automatically by the camera unless you create custom folders, an advanced trick you can explore in Chapter 11.

- **Filename:** The camera also automatically names your files. Filenames end with a three-letter code that usually represents the file format, which is either JPG (for JPEG) or NEF (for Camera Raw) and depends on the Image Quality setting you select. Chapter 3 discusses these two formats. If you create a dust-off reference image, an advanced feature explained in Chapter 1, the camera instead uses the extension NDF. And if you create a stop-motion movie, a project you can tackle in Chapter 9, the file extension is AVI, which represents a digital-movie file format.

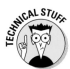

 The first three letters of the assigned filenames also vary. Here's what the possible three-letter codes indicate:

 - *DSC:* This code means "normal, plain-old picture file."

 - *SSC:* This trio appears at the beginning of files that you create with the Small Picture option on the Retouch menu. Chapter 9 discusses this feature, which creates a copy of an image in a size that's suitable for Web use.

 - *ASC:* Stop-motion movie files begin with this three-letter code.

 - *CSC:* This code is used for images that you alter using other Retouch menu features. For example, I applied the Quick Retouch feature to the image in Figure 4-8, so the filename begins with CSC, and the Retouch Indicator appears in the top-left corner of the monitor.

- - (underscore): If you change the Color Mode setting on the Optimize Image menu to the Adobe RGB color profile, a topic you can investigate in Chapter 6, an underscore character precedes the filename. (The exception is for dust-off reference photos, which don't use the underscore.)

✓ **Date and Time:** Just below the folder and filename info, you see the date and time that you took the picture. Of course, the accuracy of this data depends on whether you set the camera's date and time values correctly, which you do via the Setup menu. Chapter 1 has details.

✓ **Image Quality:** Here you can see which Image Quality setting you used when taking the picture. Again, Chapter 3 has details, but the short story is this: Fine, Normal, and Basic are the three JPEG recording options, with Fine representing the highest JPEG quality. The word *Raw* indicates that the picture was recorded in the Nikon Camera Raw format, NEF.

✓ **Image Size:** This value tells you the image resolution, or pixel count. See Chapter 3 to find out about resolution and how it affects print quality, onscreen display size, and the picture file size.

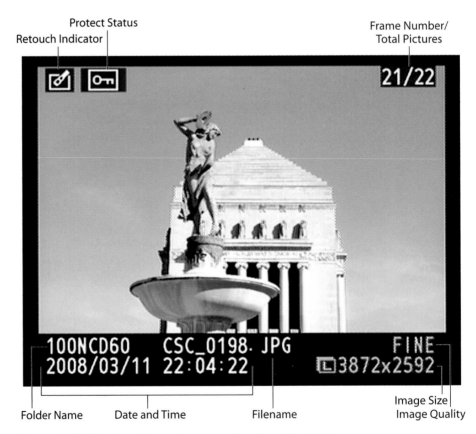

Figure 4-8: In File Information mode, you can view these bits of data.

Shooting Data display mode

This mode actually presents you with two screens of information, which you toggle between by pressing the Multi Selector up and down. Figure 4-9 shows you the two screens, referred to in the Nikon manual as Shooting Data Page 1 and Shooting Data Page 2.

The two screens list all the critical camera settings you used to take the picture: shutter speed, aperture, white balance, and so on. Chapters in Part II give you the background you need to decode all of this data, but I do want to call your attention to a couple of factoids now:

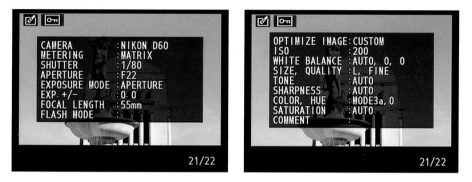

Figure 4-9: You can view the camera settings used to capture the image in Shooting Data display mode.

- The top-left corner of the monitor shows the Protect Status and Retouch Indicator icons, described in the preceding section. If you don't see these icons, don't worry; it simply means that you didn't protect or retouch the photo.

- The current frame number, followed by the total number of images on the memory card, appears in the lower-right corner of the display.

- The Comment item, which is the final item on the second screen, contains a value only if you used the Image Comment feature on the Setup menu. I cover this option in Chapter 11. The data screen displays only the first 15 letters of any comment you create.

- If the ISO value (on screen 2) appears in red, the camera is letting you know that it automatically overrode the ISO setting that you selected in order to produce a good exposure. This flag occurs only when you shoot in an advanced exposure mode (P, S, A, or M) and only if you enabled auto-ISO adjustment through the Custom Setting menu. See Chapter 5 for details on ISO and automatic ISO adjustment.

Active D-Lighting and Retouch History display mode

This mode simply adds a third page of information, shown in Figure 4-10, to the two that you can display in the Shooting Data mode. The first item on the page lets you know whether you took the picture with Active D-Lighting enabled; if so, the word Auto appears. Otherwise, the word Off appears, as shown in the figure. The Retouch item lists any editing features that you may have applied from the Retouch menu. You also see the Protect Status, Retouch Indicator, and Frame Number/Total Pictures values that are standard in all view modes. (See the earlier section "File Information display mode" for details.)

Figure 4-10: Check this screen to see whether Active D-Lighting was enabled when you took the picture.

Highlight display mode

One of the most difficult photo problems to correct in a photo editing program is known as *blown highlights* in some circles and *clipped highlights* in others. In plain English, both terms mean that *highlights* — the brightest areas of the image — are so overexposed that areas that should include a variety of light shades are instead totally white. For example, in a cloud image, pixels that should be light to very light gray become white due to overexposure, resulting in a loss of detail in those clouds.

In Highlight display mode, areas that fall into this category blink in the camera monitor. This warning is a great feature because simply viewing the image isn't always a reliable way to gauge exposure; the relative brightness of the monitor and the ambient light in which you view it affect the appearance of the image onscreen.

Figure 4-11: In Highlight mode, blinking areas indicate blown highlights.

Along with the blinking highlight warning, you see the standard bits of information in this mode: the Protect Status, Retouch Indicator, and File Number/Total Pictures values. The label *Highlight* also appears to let you know the current display mode, as shown in Figure 4-11.

For details on correcting this exposure problem, visit Chapter 5.

Histogram display mode

This display mode offers an even more detailed analysis of the image exposure. A *histogram* — that chart-like thing labeled in Figure 4-12 — indicates the distribution of shadows, highlights, and midtones (areas of medium brightness) in your image. Photographers use the term *tonal range* to describe this aspect of their pictures.

The horizontal axis of the graph represents the possible picture brightness values, from the darkest shadows on the left to the brightest highlights on the right. And the vertical axis shows you how many pixels fall at a particular brightness value. A spike indicates a heavy concentration of pixels. For example, in Figure 4-12, the histogram shows that most of the image pixels are clustered in the range just above medium brightness.

As with the Highlight display, the histogram is provided to give you a way to gauge exposure that's a little more reliable than simply eyeballing the image on the monitor. Remember, if you adjust the brightness of the monitor or the ambient light affects the display brightness, you may not get the real story on exposure.

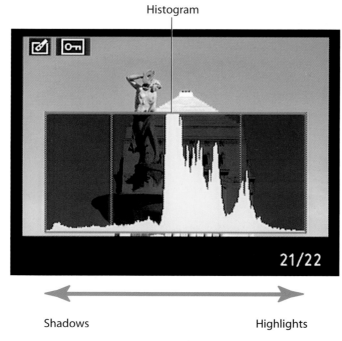

Figure 4-12: The histogram indicates the tonal range of your image, ranging from shadows on the left to highlights on the right.

I suggest that you check both the histogram and the Highlight display, though, when you're concerned about overexposure. If an image contains only a small area of blown highlights, the histogram may indicate only a very small pixel population at the brightest end of the spectrum, leading you to assume that you're okay in the exposure department. But if those blown highlights happen to fall in an important part of your image — someone's face, for example — they can wreck your picture.

Also keep in mind that there is no one "perfect" histogram that you should try to achieve. Instead, you need to interpret the histogram with respect to the amount of shadows, highlights, and midtones that comprise your subject. For example, an initial look at the histogram in Figure 4-12 might lead you to worry that your image is lacking in contrast because most of the pixels are clustered in one area, and there aren't a lot of strong shadows or very bright highlights. But the histogram actually makes sense for this particular image. (Refer to Figure 4-11 for a look at the whole scene.) The subject contains very few dark areas, so you wouldn't expect to see many pixels showing up in the shadows range. And because a large portion of the scene is that medium-bright sky, the number of pixels that fall at the highlight end of the histogram is low by comparison. You should pay attention, however, if you see a very high concentration of pixels at the far right or left end of the histogram, which can indicate a seriously overexposed or underexposed image, respectively.

For more information about exposure, visit Chapter 5.

Deleting Photos

You can erase pictures from the memory card in your camera in three ways, as explained in the following sections.

If you "locked" a picture file by using the Protect feature described later in this chapter, you must remove the protection before you can delete the image, no matter which of these three methods you choose.

Deleting the currently displayed photo

In full-frame view, you can erase the image that's currently on the screen by pressing the Delete button, labeled in Figure 4-13 and shown in the margin just for good measure. You see a message asking whether you really, *really* want to erase that picture, as shown in the figure. If you do, press the Delete button again. Or to cancel out of the process, press the Playback button.

This technique also works in multiple-thumbnail view. In the latter view, use the Multi Selector to highlight the picture you want to erase before you press the Delete button.

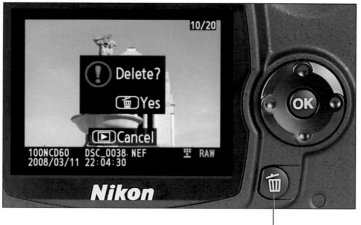

Delete button

Figure 4-13: Press the Delete button to display this confirmation screen; press again to dump the picture for good.

If you accidentally erase a picture, don't panic — you *may* be able to restore it by using data-restoration software such as MediaRecover ($30, www.media recover.com) or Lexar Image Rescue (also $30, www.lexar.com). But in order to have a chance, you must not take any more pictures or perform any other operations on your camera while the current memory card is in it. If you do, you may overwrite the erased picture data for good and eliminate the possibility of recovering the image.

Deleting all photos

For this operation, you need to display the Playback menu and highlight Delete, as shown in the first image in Figure 4-14. Press OK to display the two options shown in the second image. Select the All option and then press the Multi Selector right. You then see a confirmation screen that asks you to verify that you want to delete all of your images. Select Yes and press OK.

This step deletes only the pictures in the folder that is currently selected via the Playback Folder option on the Playback menu. See the section "Selecting a playback folder" earlier in this chapter for information. (Unless you created custom folders, a feature I cover in Chapter 11, you don't need to worry about this issue.)

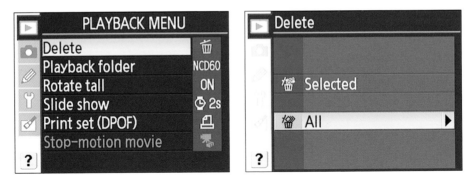

Figure 4-14: To delete all photos, use the Delete option on the Playback menu.

Deleting a batch of selected photos

To delete several selected pictures at once, take these steps:

1. **Display the Playback menu, highlight Delete, and press OK.**

 You see the Delete screen shown in the second image in Figure 4-14, in the preceding section.

2. **Highlight the Selected option and press the Multi Selector right.**

 You see a screen that displays thumbnails of your images, as shown in Figure 4-15.

3. **Select the first image that you want to mark for deletion.**

 The image surrounded by the yellow box is the currently selected image. Press the Multi Selector right or left to scroll through your images until the highlight appears on the first one you want to delete. (You can also rotate the Command dial, but in this case, doing so jumps you to the next screenful of images instead of simply highlighting the next image.)

4. **To mark an image for deletion, press the Multi Selector up.**

 A little trash can icon, the universal symbol for delete, appears on the thumbnail, as shown in Figure 4-15.

5. **To remove the delete marker from an image, highlight the image and press the Multi Selector down.**

 The trash can icon disappears, and your image is no longer scheduled for deletion.

Delete icon

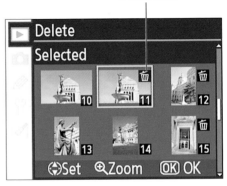

Figure 4-15: Press the Multi Selector up and down to select and deselect images.

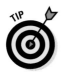

By pressing the Zoom button, you can get a temporary, full-frame view of the highlighted image. When you release the button, the display reverts to thumbnail view.

6. **After marking all the images you want to delete, press OK.**

 You see a confirmation screen telling you the total number of pictures marked for deletion and asking permission to zap those images to digital oblivion.

7. **Select Yes from the confirmation screen and press OK.**

 The camera trashes those photos and returns you to the Playback menu.

Protecting Photos

You can protect pictures from accidental erasure by giving them *protected status.* After you take this step, the camera doesn't allow you to erase a picture by using either the Delete button or the Delete option on the Playback menu.

Formatting your memory card, however, *does* erase even protected pictures. See the nearby sidebar for more about formatting.

The picture protection feature comes in especially handy if you share a camera with other people. You can protect pictures so that those other people know that they shouldn't delete your super-great images to make room on the memory card for their stupid, badly photographed ones. (This step isn't foolproof, though, because anyone can remove the protected status from an image.)

Perhaps more importantly, when you protect a picture, it shows up as a "read only" file when you transfer it to your computer. Files that have that read-only status can't be altered. Again, anyone with some computer savvy can remove the status, but this feature can keep casual users from messing around with your images after you've downloaded them to your system. Of course, *you* have to know how to remove the read-only status yourself if you plan on editing your photo in your photo software. (**Hint:** In Nikon ViewNX, you can do this by clicking the image thumbnail and then choosing File➪Protect Files➪Unprotect.)

Anyway, protecting a picture is easy: Just display the picture you want to protect in full-frame view — or in thumbnail view, use the Multi Selector to scroll the display until the image is surrounded by the yellow box. Then press the AE-L/AF-L button, labeled in Figure 4-16 and superglued to the margin here. See the tiny key symbol that appears above the button on the camera? That's your reminder that you use the button to "lock" a picture. After you do, the same symbol appears on the image display, as shown in Figure 4-16. To remove the protection, display the image and then just press the button again.

Protect icon Toggle Protect On/Off

Figure 4-16: Press the AE-L/AF-L button to prevent accidental deletion of an image.

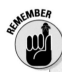

Deleting versus formatting: What's the diff?

In Chapter 1, I introduce you to the Format Memory Card command, which lives on the Setup menu and erases everything on your memory card. What's the difference between erasing photos by formatting and by choosing Delete from the Playback menu and then selecting the All option?

Well, in terms of pictures taken with your Nikon, none. But if you happen to have stored other data on the card, such as, say, a music file or a picture taken on another type of camera, you need to format the card to erase everything on it. You can't view those files on the monitor, so you can't use Delete to get rid of them.

Also keep in mind that the Delete function affects only the currently selected folder of camera images. As long as you use the default folder system that the camera creates for you, however, "currently selected folder" is the same as "all images." The section "Selecting a playback folder," earlier in this chapter, talks more about this issue; Chapter 11 explains how to create your own, custom folders.

One final — and important — note: Although using the Protect feature (explained elsewhere in this chapter) prevents the Delete function from erasing a picture, formatting erases all pictures, protected or not.

Part II
Taking Creative Control

The 5th Wave By Rich Tennant

"My God! I've gained 9 pixels!"

In this part . . .

As nice as it is to be able to set your Nikon to automatic mode and let the camera handle most of the photographic decisions, I encourage you to also explore the advanced exposure modes (P, S, A, and M). In these modes, you can make your own decisions about the exposure, focus, and color characteristics of your photo, which are key to capturing an image as you see it in your mind's eye. And don't think that you have to be a genius or spend years to be successful — adding just a few simple techniques to your photographic repertoire can make a huge difference in how happy you are with the pictures you take.

The first two chapters in this part explain everything you need to know to do just that, providing both some necessary photography fundamentals as well as details about using the advanced exposure modes. Following that, Chapter 7 helps you draw together all the information presented earlier in the book, summarizing the best camera settings and other tactics to use when capturing portraits, action shots, landscapes, and close-up shots.

5

Getting Creative with Exposure and Lighting

*B*y using the Auto and Digital Vari-Program exposure modes, all covered in Chapter 2, you can take great pictures with your D60. But to fully exploit your camera's capabilities — and, more important, to exploit *your* creative capabilities — you need to explore your camera's four advanced exposure modes, represented on the Mode dial by the letters P, S, A, and M.

This chapter explains everything you need to know to start taking advantage of these four modes. First, you get an introduction to the critical exposure controls known as *aperture, shutter speed,* and *ISO.* Adjusting these settings enables you to not only fine-tune image exposure but also affect other aspects of your image, such as *depth of field* (the zone of sharp focus) and motion blur.

Following a review of those basics, you can explore specific D60 exposure features, such as Exposure Compensation, metering modes, and flash options available to you in the advanced exposure modes. In addition, this chapter

details the Active D-Lighting feature, which you can use in any of your camera's exposure modes to get better results when shooting high-contrast scenes.

If you're worried that this stuff is too complicated for you, by the way, don't be. Even in the advanced exposure modes, the camera provides you with enough feedback that you're never truly flying without a net. Between the in-camera support and the information in this chapter, you can easily master aperture, shutter speed, and all the other exposure features — an important step in making the shift from picture-taker to photographer.

Kicking Your Camera into Advanced Gear

The first step to taking the exposure reins is to set your camera's Mode dial to one of the four shooting modes highlighted in Figure 5-1: P, S, A, or M. You also need to shoot in one of these modes to use certain other camera features, such as manual white balancing, a color feature that you can explore in Chapter 6.

Each of the four modes offers a different way to control two critical exposure settings, *aperture* and *shutter speed*. Later in this chapter, I explain these controls fully, but here's a quick introduction:

Advanced exposure modes

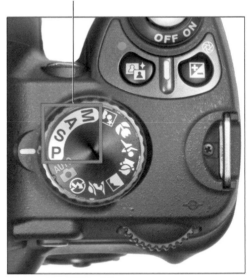

Figure 5-1: You can control exposure and other picture properties fully only in P, S, A, or M mode.

- ✔ **P (programmed autoexposure):** In this mode, the camera selects both the aperture and shutter speed for you. But you can choose from different combinations of the two, which gives you creative flexibility not possible in the fully automatic exposure modes discussed in Chapter 2.

- ✔ **S (shutter-priority autoexposure):** In this mode, you select a shutter speed, and the camera chooses the aperture setting that produces a good exposure.

✏ **A (aperture-priority autoexposure):** The opposite of shutter-priority autoexposure, this mode asks you to select the aperture setting. The camera then selects the appropriate shutter speed to properly expose the picture.

✏ **M (manual exposure):** In this mode, you specify both shutter speed and aperture.

To sum up, the first three modes are semi-automatic exposure modes that are designed to help you get a good exposure while still providing you with some photographic flexibility. Note one important difference between P and the other two semi-auto modes, however: Although you can select from different combinations of aperture and shutter speed in that mode, the choices presented to you are limited to those that will properly expose the picture. In A and S modes, you can dial in settings that will result in an under- or over-exposed image. (The camera will warn you about the potential problem, however.)

Manual mode puts all exposure control in your hands. But even in Manual mode, the camera assists you by displaying a meter that tells you whether your exposure settings are on target.

Again, I realize that the descriptions of these modes won't make much sense to you if you aren't already schooled in the basics of exposure. If you are and you just want to know the specifics of using these modes on your D60, flip ahead to the section "Setting ISO, f-stop, and Shutter Speed," later in this chapter. For details about the aforementioned exposure warnings and meter, see "Monitoring Exposure Settings" instead. Otherwise, the next several sections provide you with the fundamentals you need to make good use of the advanced modes.

Introducing the Exposure Trio: Aperture, Shutter Speed, and ISO

Any photograph, whether taken with a film or digital camera, is created by focusing light through a lens onto a light-sensitive recording medium. In a film camera, the film negative serves as that medium; in a digital camera, it's the image sensor, which is an array of light-responsive computer chips.

Between the lens and the sensor are two barriers, known as the *aperture* and *shutter,* which together control how much light makes its way to the sensor. The actual design and arrangement of the aperture, shutter, and sensor vary depending on the camera, but Figure 5-2 offers an illustration of the basic concept.

The aperture and shutter, along with a third feature known as *ISO,* determine *exposure* — what most of us would describe as the picture's overall brightness and contrast. This three-part exposure formula works as follows:

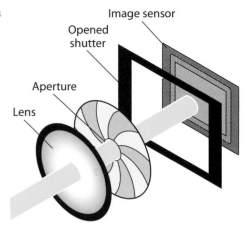

Figure 5-2: The aperture size and shutter speed determine how much light strikes the image sensor.

▸ **Aperture (controls amount of light):** The *aperture* is an adjustable hole in a diaphragm set just behind the lens. By changing the size of the aperture, you control the size of the light beam that can enter the camera. Aperture settings are stated as *f-stop numbers,* or simply *f-stops,* and are expressed with the letter *f* followed by a number: f/2, f5.6, f/16, and so on. The lower the f-stop number, the larger the aperture, and the more light is permitted into the camera, as illustrated by Figure 5-3.

The range of possible f-stops depends on your lens and, if you use a zoom lens, on the zoom position (focal length) of the lens. When you use the kit lens sold with the D60, you can select apertures from

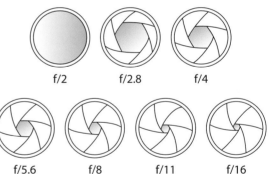

Figure 5-3: A lower f-stop number means a larger aperture, allowing more light into the camera.

f/3.5–f/22 when zoomed all the way out to the shortest focal length (18mm). When you zoom in to the maximum focal length (55mm), the aperture range is f/5.6–f/36. (See Chapter 6 for a discussion of focal lengths.)

▸ **Shutter speed (controls duration of light):** Set behind the aperture, the shutter works something like, er, the shutters on a window. When you aren't taking pictures, the camera's shutter stays closed, preventing light from striking the image sensor, just as closed window shutters prevent sunlight from entering a room. When you press the shutter button, the shutter opens briefly to allow light that passes through the aperture to hit the image sensor.

The length of time that the shutter is open is called the *shutter speed* and is measured in seconds: 1/60 second, 1/250 second, 2 seconds, and so on. Shutter speeds on the D60 range from 30 seconds to 1/4000 second when you shoot without flash. If you do use a flash, the range is more limited; see the sidebar "In sync: Flash timing and shutter speed," near the end of the chapter, for information.

Should you want a shutter speed longer than 30 seconds, manual (M) exposure mode also provides a feature called *bulb* exposure. At this setting, the shutter stays open indefinitely as long as you press the shutter button down.

✏ **ISO (controls light sensitivity):** ISO, which is a digital function rather than a mechanical structure on the camera, enables you to adjust how responsive the image sensor is to light. The term ISO is a holdover from film days, when an international standards organization rated each film stock according to light sensitivity: ISO 200, ISO 400, ISO 800, and so on. Film or digital, a higher ISO rating means greater light sensitivity, which means that less light is needed to produce the image, enabling you to use a smaller aperture, faster shutter speed, or both.

On the D60, you can select ISO settings of 100, 200, 400, 800, 1600, and 3200. Note that the ISO 3200 setting is called Hi 1.

Distilled down to its essence, the image-exposure formula is just this simple:

✏ Aperture and shutter speed together determine the quantity of light that strikes the image sensor.

✏ ISO determines how much the sensor reacts to that light.

The tricky part of the equation is that aperture, shutter speed, and ISO settings affect your pictures in ways that go *beyond* exposure. You need to be aware of these side effects, explained in the next section, to determine which combination of the three exposure settings will work best for your picture.

Understanding exposure-setting side effects

You can create the same exposure with many combinations of aperture, shutter speed, and ISO. You're limited only by the aperture range allowed by the lens and the shutter speeds and ISO range offered by the camera.

But as I hinted in the preceding section, the settings you select impact your image beyond mere exposure, as follows:

✏ **Aperture affects depth of field.** The aperture setting, or f-stop, affects *depth of field,* which is the range of sharp focus in your image. I introduce this concept in Chapter 2, but here's a quick recap: With a shallow depth of field, your subject appears more sharply focused than faraway objects; with a large depth of field, the sharp-focus zone spreads over a greater distance.

As you reduce the aperture size — or *stop down the aperture,* in photo lingo — by choosing a higher f-stop number, you increase depth of field. As an example, take a look at the two images in Figure 5-4. For both shots, I established focus on the foreground grass. Notice that the background in the first image, taken at an aperture setting of f/5.6, appears noticeably softer than in the right example, taken at f/13. Aperture is just one contributor to depth of field, however; see Chapter 6 for the complete story.

✓ **Shutter speed affects motion blur.** At a slow shutter speed, moving objects appear blurry, whereas a fast shutter speed captures motion cleanly. Compare the tall foreground grass in the images in Figure 5-4, for example. A brisk wind was blowing when I took these pictures, and as a result, the foreground grass is captured without blur only at the 1/160 second shutter speed used for the left image. How fast a speed you need to freeze action depends on the speed of your subject, of course.

f/5.6, 1/160, ISO 200 f/13, 1/60, ISO 400

Figure 5-4: Stopping down the aperture (by choosing a higher f-stop number) increases depth of field, or the zone of sharp focus.

If your picture suffers from overall image blur, as in Figure 5-5, where even stationary objects appear out of focus, the camera itself moved during the exposure. As you increase the exposure time (by selecting a slower shutter speed), you increase the risk of this problem because

you have to keep the camera still for a longer period of time. Most people enter the camera-shake zone at speeds slower than about 1/50 second, although some people have steadier hands than others. I'm not one of them, as my 1/20 second handheld example in Figure 5-5 shows.

f/13, 1/20, ISO 200

Some Nikon lenses, including the 18–55mm zoom lens sold in the D60 kit, offer *vibration reduction,* which is designed to help compensate for small amounts of camera shake. If you're using a lens from another manufacturer, the feature may go by the name *image stabilization* or something similar. Whatever you call it, this option can enable you to capture sharp images at slightly slower shutter speeds than normal when handholding the camera. On the D60 kit lens, just set the VR switch on the side of the lens to the On position to enable vibration reduction.

Figure 5-5: Slow shutter speeds increase the risk of all-over blur caused by camera shake.

You also can use a tripod or otherwise steady the camera to lower the chances of camera shake. If you do, however, turn off vibration reduction, if your lens offers it; the mechanism that makes the feature work sometimes tries to adjust for movement that isn't occurring, thereby messing up your shot. (Note that some lenses have a special tripod setting, too, so check your lens manual.)

See Chapter 6 for tips on solving other focus problems and Chapter 7 for more help with action photography.

✔ **ISO affects image noise.** As ISO increases, making the image sensor more reactive to light, you increase the risk of producing a defect called *noise.* This defect looks like sprinkles of sand and is similar in appearance to film *grain,* a defect that often mars pictures taken with high ISO film. Noise can also be caused by very long exposure times.

Ideally, then, you should always use the lowest ISO setting on your camera — 100 — to ensure top image quality. But sometimes, the lighting conditions simply don't permit you to do so and still use the aperture and shutter speeds you need. As an example, when I shot the images in Figure 5-6, the lighting was so dim that I needed a shutter speed of 1/15 second to properly expose the picture at ISO 100, even with the aperture opened to f/5.6, the maximum for the lens I was using.

That shutter speed was much too slow for me to be able to successfully handhold the camera, especially since this particular lens didn't offer a vibration reduction feature. Having no tripod with me, I had no choice but to raise the ISO. Moving up to ISO 400 enabled me to use a shutter speed of 1/80 and capture a sharp image.

f/5.6, 1/15 second, ISO 100

f/5.6, 1/80 second, ISO 400

Figure 5-6: Raising the ISO enabled me to use a fast enough shutter speed to get a sharp handheld shot.

Fortunately, you usually don't encounter serious noise on the D60 until you really crank up the ISO. Take a look at Figure 5-7, for example, which shows you the same scene captured at ISO 100 and ISO 1600. I shot these images in bright light that allowed a fast shutter — meaning, any noise should be due to ISO rather than long exposure time. At this size, it's difficult to detect much difference between the two images. And in fact, you may even be able to get away with one step up the ladder, to the max of ISO 3200, as I did for Figure 5-8, if you keep your print or display size small — although some quality loss is noticeable in Figure 5-8 if you compare it closely with the ISO 100 version in Figure 5-7.

But as with other image defects, noise becomes more apparent as you enlarge the photo. To prove the point, Figure 5-9 shows you magnified views of a bit of my statue scene captured at each of the D60's ISO settings. Noise also is easier to spot in areas of flat color, such as the sky in my example, than in an area of busy detail, where the noise can hide a little more. An object with a rough or textured surface, such as the portion of the statue's hand that you see in the figure, disguises noise somewhat as well.

ISO 100	ISO 1600

Figure 5-7: When you keep the image print size small, the quality difference between ISO 100 and ISO 1600 isn't easy to detect.

ISO 3200 (Hi 1)

Figure 5-8: Even at ISO 3200, noise isn't horribly distracting at this print size.

Putting the f (stop) in focus

One way to remember the relationship between f-stop and depth of field, or the range of distance over which objects remain in sharp focus, is simply to think of the *f* as standing for *focus*. A higher f-stop number produces a longer depth of field, so if you want to extend the zone of sharp focus to cover a larger distance from your subject, you set the aperture to a higher f-stop. Higher f-stop number, greater zone of sharp focus.

Please *don't* share this tip with photography elites, who will roll their eyes and inform you that the *f* in *f-stop* most certainly does *not* stand

for focus but for the ratio between the aperture size and lens focal length — as if *that's* helpful to know if you're not an optical engineer. (Chapter 6 explains focal length, which *is* helpful to know.)

As for the fact that you *increase* the f-stop number when you want a *smaller* aperture, well, I'm still working on the ideal mnemonic tip for that one. But try this in the meantime: *L*ower f-stop, *l*arger aperture. Or maybe the opposite: *R*aise the f-stop to *r*educe the aperture size and *r*estrict the light. (As I said, I'm working on it.)

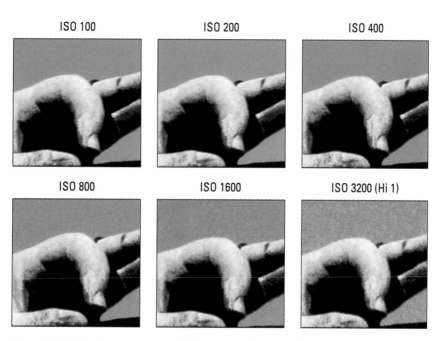

Figure 5-9: Noise becomes more visible as you enlarge your images.

Long story short, understanding how aperture, shutter speed, and ISO affect your image enables you to have much more creative input over the look of your photographs — and, in the case of ISO, to also control the quality of your images. (Chapter 3 discusses other factors that affect image quality.)

Doing the exposure balancing act

As you change any of the three exposure settings — aperture, shutter speed, and ISO — one or both of the others must also shift in order to maintain the same image brightness. If you want a faster shutter speed, for example, you have to compensate with either a larger aperture, to allow in more light during the shorter exposure, or a higher ISO setting, to make the camera more sensitive to the light — or both. And as the preceding section explains, changing these settings impacts your image in ways beyond exposure. So when you boost that shutter speed, you have to decide whether you prefer the shorter depth of field that comes with a larger aperture or the increased risk of noise that accompanies a higher ISO. Figure 5-10 offers an illustration to help you envision this balancing act.

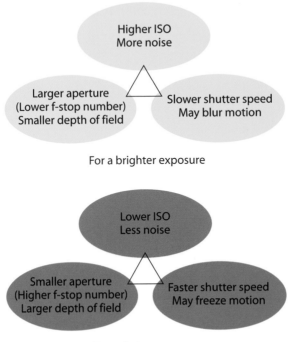

Higher ISO
More noise

Larger aperture
(Lower f-stop number)
Smaller depth of field

Slower shutter speed
May blur motion

For a brighter exposure

Lower ISO
Less noise

Smaller aperture
(Higher f-stop number)
Larger depth of field

Faster shutter speed
May freeze motion

For a darker exposure

Figure 5-10: When adjusting exposure, remember the side effects produced by different aperture, shutter speed, and ISO settings.

Everyone has their own approach to finding the right combination of aperture, shutter speed, and ISO, and you'll no doubt develop your own system as you become more practiced at using the advanced exposure modes. In the meantime, here's how I handle things:

✔ I always use the lowest possible ISO setting unless the lighting conditions are so poor that I can't use the aperture and shutter speed I want without raising the ISO.

✔ If my subject is moving (or might move, as with a squiggly toddler or antsy pet), I give shutter speed the next highest priority in my exposure decision. I might choose a fast shutter speed to ensure a blur-free photo or, on the flip side, select a slow shutter to intentionally blur that moving object, an effect that can create a heightened sense of motion. (The waterfall photo in Chapter 7 offers an example of the latter technique.)

✔ For images of a non-moving subjects, I make aperture a priority over shutter speed, setting the aperture according to the depth of field I have in mind. For portraits, for example, I use a wide-open aperture (low

f-stop number) so that I get a short depth of field, creating a nice, soft background for my subject. For landscapes, I go the opposite direction, stopping down the aperture as much as possible to capture the subject at the greatest depth of field.

I know that keeping all this straight is a little overwhelming at first, but the more you work with your camera, the more the whole exposure equation will make sense to you. You can find tips for choosing exposure settings for specific types of pictures in Chapter 7; keep moving through this chapter for details on how to actually monitor and adjust aperture, shutter speed, and ISO settings. And for specifics on selecting exposure settings in each of the four advanced exposure modes, jump ahead to the section "Setting ISO, f-stop, and Shutter Speed."

Monitoring Exposure Settings

You can view the current f-stop and shutter speed in the viewfinder display, as shown in Figure 5-11, and in the Shooting Info display, as shown in Figure 5-12. (Remember, you can display the Shooting Info screen by simply pressing the shutter button halfway and then releasing it. Pressing the Zoom button also cycles the monitor from Shooting Info mode to Quick Settings mode to off.) For the ISO setting, you must look to the Shooting Info display; the current setting appears in the middle of the right column of the display, as labeled in Figure 5-12.

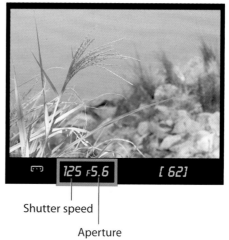

Shutter speed

Aperture

Figure 5-11: The shutter speed and f-stop appear in the viewfinder display.

In the viewfinder, shutter speeds are presented as whole numbers, even if the shutter speed is set to a fraction of a second. For example, for a shutter speed of 1/125 second, you see just the number 125 in the viewfinder, as in Figure 5-11. When the shutter speed slows to 1 second or more, you see quote marks after the number — 1" indicates a shutter speed of 1 second, 4" means 4 seconds, and so on. That inch-mark system is used both in the viewfinder and in the Shooting Info display.

TIP

Note also the gold, circular graphic on the left side of the Shooting Info display, labeled *Aperture icon* in Figure 5-12. That circle is a visual representation of the aperture setting, just like the ones you see in Figure 5-3, earlier in the chapter. As you choose a lower f-stop number, the circle expands, indicating that you're opening up the aperture. Choose a higher f-stop number, and the circle shrinks, indicating that you're stopping down the aperture. (If you don't see this graphic, visit Chapter 11 to find out how to set the Shooting Info display to the Graphic option, which is what I use in figures in this book.)

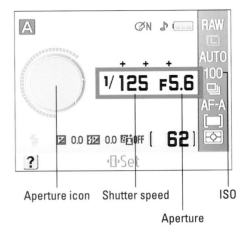

Aperture icon Shutter speed ISO

Aperture

Figure 5-12: The gold circle is a graphical representation of the aperture size.

In addition to showing you the current shutter speed and f-stop, the viewfinder and Shooting Info screen offer a couple of other exposure cues, which vary depending on whether you're using P, S, A, or M exposure mode, as follows:

✔ **Exposure meter:** An *exposure meter* is a little linear graphic that indicates whether your current settings will properly expose the image. Figure 5-13 gives you three examples. The minus-sign end of the meter represents underexposure; the plus sign, overexposure. So if the little notches on the meter fall to the right of 0, as in the left example in the figure, the camera is alerting you that the image will be underexposed. If the indicator moves to the left of 0, as in the middle example, the image will be overexposed. The farther the indicator moves toward the plus or minus sign, the greater the potential exposure problem.

As you adjust shutter speed, aperture, or ISO, the exposure meter updates accordingly. When the meter shows a balanced exposure, as in the third example in the figure, you're good to go.

Underexposure Overexposure Good exposure

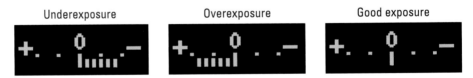

Figure 5-13: The exposure meter indicates whether your exposure settings are on target.

The exposure meter appears only in the S, A, and M exposure modes. And in S and A modes, the meter appears in both the viewfinder and Shooting Info display *only* if the camera anticipates an exposure problem. In M exposure mode, the meter appears regardless. The meter does turn off in all three cases if you don't press the shutter button for a period of time — 8 seconds, by default. (You can adjust that shut-off time through the Auto Off Timers option on the Custom Setting menu if you prefer.)

It's also important to note that your D60 enables you to replace the exposure meter with a *rangefinder display,* which is a focusing-distance scale that may be helpful when you focus manually. When the Range-finder option is turned Off, as it is by default, the display is used for exposure metering and appears as shown in Figure 5-13. Chapter 6 explains more about the rangefinder display, which you enable via an option on the Custom Setting menu.

✓ **Exposure warning messages:** In S and A exposure modes, a warning like the one you see in the left screen in Figure 5-14 appears in the Shooting Info display if the camera anticipates an exposure problem. In S, A, and M modes, a blinking question mark also appears both at the bottom of the Shooting Info display and in the viewfinder. The blinking question mark indicates that if you press the Thumbnail button (located just below the Menu button), you can display a Help screen that provides possible solutions — usually, the camera suggests that you add flash, as in the right screen in Figure 5-14.

In addition, you may also see the letters *Hi* or *Lo* next to the exposure meter to reinforce the message that your exposure will be too bright or dark.

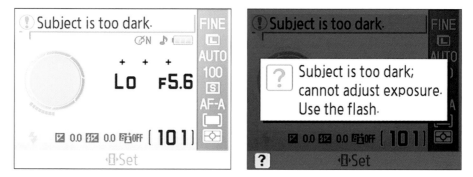

Figure 5-14: The camera warns you if the current exposure settings are off base.

Why no exposure meter in P mode? Well, remember that in P mode — programmed autoexposure — you can select from different combinations of aperture and shutter speed that the camera presents to you. But the combinations are limited to those that will produce a correct exposure, so the meter would always reflect a proper exposure, thereby rendering it a little pointless. You do get the under- or overexposure warnings in the Shooting Info display and viewfinder if the light is such that the camera can't select *any* combination of aperture or shutter speed that will properly expose the image, however.

One more word of advice about the exposure meter: Keep in mind that the meter's take on the issue may not always be the one you want to follow. First, the meter bases its call on the current *exposure metering mode.* As covered next, you can choose three different metering modes, and each one calculates exposure on a different area of the frame. So you need to review those modes and see whether you and the meter agree as to which area of the picture is the most important in making the exposure calculation. Second, you may want to purposely choose exposure settings that leave parts of the image very dark or parts very light for creative reasons. For example, you may want to shoot a backlit subject in silhouette, in which case you *want* that subject to be underexposed. Again, depending on the metering mode, the camera may not understand your creative intent and report an exposure problem in the exposure meter. In other words, the meter is a guide, not a dictator.

Choosing an Exposure Metering Mode

To fully interpret what your exposure meter tells you, you need to first know which *metering mode* is active. (I know, there's lots more to this whole exposure thing than you thought, but hang with me — this particular bit of business needn't stress you out too much.)

Anyway, the metering mode determines which part of the frame the camera analyzes to calculate the proper exposure. The metering mode affects the meter reading you see in the viewfinder and Shooting Info display, as well as the exposure settings that the camera chooses in any fully automatic shooting modes — as well as in the semi-auto modes (P, S, and A).

Your D60 offers three metering modes, described in the following list and represented in the Shooting Info display by the icons you see in the margins:

 ✔ **Matrix metering:** The camera analyzes the entire frame and then selects an exposure that's designed to produce a balanced exposure.

 ✔ **Center-weighted metering:** The camera bases exposure on the entire frame but puts extra emphasis — or *weight* — on the center of the frame.

⌐•⌐ ✔ **Spot metering:** The camera bases exposure only on the light that falls in the currently active autofocus area. (Chapter 2 introduces autofocus areas, which are indicated by the three brackets you see in the viewfinder.) For example, if the left focus bracket is active, exposure is based on that area of the frame. However, if you set the autofocus area mode to Closest Subject, your Nikon always meters exposure on the center focus bracket.

As an example, Figure 5-15 shows the same image captured thee times, with no changes to exposure settings between shots except to the metering mode. In the Matrix example, the bright background caused the camera to select an exposure that left the statue quite dark. Switching to center-weighted metering helped somewhat, but didn't quite bring the statue out of the shadows. Spot metering produced the best result as far as the statue goes, although the resulting increase in exposure left the sky and background monument a little washed out.

Matrix metering Center-weighted metering Spot metering

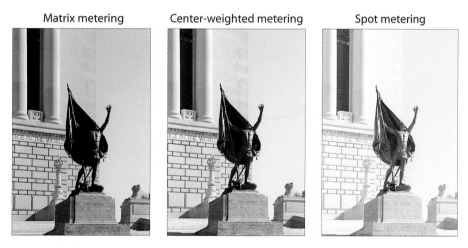

Figure 5-15: The metering mode determines which area of the frame the camera considers when calculating exposure.

You don't have a choice of metering modes in Auto mode or any of the Digital Vari-Program scene modes; the camera automatically uses matrix mode for all shots. But in P, A, S, or M modes, you can specify which metering mode you prefer. You can do so in two ways:

✔ **Via the Quick Settings display:** First, display the Shooting Info screen by pressing the shutter button halfway or pressing the Zoom button. Then press the Zoom button to shift from Shooting Info display mode into Quick Settings display mode. Use the Multi Selector to highlight the Metering Mode option, as shown in the left screen in Figure 5-16. Press OK to display the second screen in the figure, highlight your metering-mode choice, and press OK again.

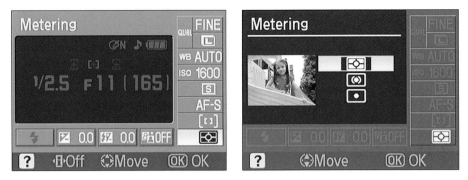

Figure 5-16: Select a metering mode via the Quick Settings display.

✔ **Via the Custom Setting menu:** Highlight the Metering option, as shown in Figure 5-17. Press OK, highlight the mode you want to use, and then press OK again.

In theory, the best practice is to always check the metering mode before you shoot and to choose the one that best matches your exposure goals. But in practice, that's a bit of a pain, not just in terms of having to adjust yet one more capture setting but in terms of having to *remember* to adjust one more capture setting.

Figure 5-17: Or change the metering mode via the Custom Setting menu.

So here's my advice: Until you're really comfortable with all the other controls on your camera, just stick with the default setting, which is matrix metering. That mode produces good results in most situations, and, after all, you can see in the monitor whether you disagree with how the camera metered or exposed the image and simply reshoot after adjusting the exposure settings to your liking. This option, in my mind, makes the whole metering mode issue a lot less critical than it is when you shoot with film.

The one exception to this advice might be when you're shooting a series of images in which a significant contrast in lighting exists between subject and background, as in my examples here. Then, switching to center-weighted metering or spot metering may save you the time of having to adjust the exposure for each image.

Don't forget that the Active D-Lighting feature, explained next, can also be a huge help in properly exposing a high-contrast image. And if that's not enough, you can tweak the exposure even more after the fact using the D-Lighting filter on the Retouch menu; see Chapter 10 for details on that option.

Taking Advantage of Active D-Lighting

A scene like the one in Figure 5-18 presents the classic photographer's challenge: Choosing exposure settings that capture the darkest parts of the subject appropriately causes the brightest areas to be overexposed. And if you instead "expose for the highlights" — that is, set the exposure settings to capture the brightest regions properly — the darker areas are underexposed.

Active D-Lighting Off Active D-Lighting On

Figure 5-18: Active D-Lighting enabled me to capture the shadows without blowing out the highlights.

In the past, you had to choose between favoring the highlights or the shadows. But thanks to a feature than Nikon calls Active D-Lighting, you have a better chance of keeping your highlights intact while better exposing the darkest areas. In my seal scene, turning on Active D-Lighting produced a brighter rendition of the darkest parts of the rocks and the seals, for example, and yet the color in the sky didn't get blown out as it did when I captured the image with Active D-Lighting turned off. The highlights in the seal and in the rocks on the lower-right corner of the image also are toned down a tad in the Active D-Lighting version.

 To try out this feature, press and hold the Active D-Lighting button, located near the shutter button and shown in the margin here. If you're looking through the viewfinder, the display temporarily reports the status of the feature, as shown on the left in Figure 5-19. And in the Shooting Info display, the icon representing Active D-Lighting, labeled in the right image in the figure, also becomes highlighted. While keeping the button pressed, just rotate the Command dial to switch the feature on or off. When you release the Active D-Lighting button, the viewfinder display and Shooting Info display return to their normal state.

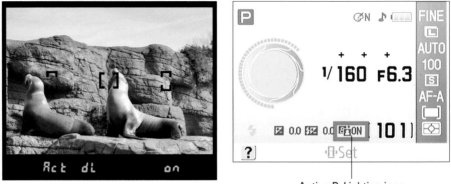

Active D-Lighting icon

Figure 5-19: Press the Active D-Lighting button while rotating the Command dial to turn the feature on and off.

Active D-Lighting actually does its thing in two stages. First, it selects exposure settings that result in a slightly darker exposure than normal. This half of the equation guarantees that you retain details in your highlights. Without that adjustment, the brightest areas of the image might be overexposed, leaving you with a batch of all-white pixels that really should contain a range of tones from light to lighter to white. So a cloud, for example, would appear as a big white blob, with no subtle tonal details to give it form.

After you snap the photo, the second part of the process occurs. During this phase, the camera applies an internal software filter to brighten only the darkest areas of the image. This adjustment rescues shadow detail, so that you wind up with a range of dark tones instead of a big black blob.

 This second stage of the process leads to the one drawback of using Active D-Lighting: The camera needs a few seconds to do its shadow-recovery work. And during that time, you can't take another shot. Unfortunately, that makes Active D-Lighting a hindrance when you're capturing action or otherwise need to fire off shots in rapid succession.

All isn't necessarily lost, however, if the time lag imposed by Active D-Lighting forces you to turn the feature off. After you finish shooting, you can apply the D-Lighting filter from the Retouch menu, which also attempts to restore hidden shadow details. Some photo editing programs, such as Adobe Photoshop Elements and Photoshop, also have good shadow and highlight recovery filters. In either case, you're better off setting the initial exposure settings to record the highlights as you want them. It's very difficult to bring back lost highlight detail after the fact, but you typically can unearth at least a little bit of detail from the darkest areas of the image.

Setting ISO, f-stop, and Shutter Speed

If you want to control ISO, aperture (f-stop), or shutter speed, you must set the camera Mode dial to either programmed autoexposure (P), shutter-priority autoexposure (S), aperture-priority autoexposure (A), or manual exposure (M).

I explain each of these modes at the start of the chapter, but Table 5-1 offers a quick recap, along with a recommendation of when to use each mode. The next sections provide specifics (finally, you say) on how to adjust ISO, aperture, and shutter speed in all four modes.

The table uses the abbreviation *AE* for *autoexposure*. Most photography magazines and other resources use this same abbreviation, so try to find a place in your memory bank to store this little bit of camera lingo.

Table 5-1	Advanced Exposure Modes (P, S, A, M)	
Mode	*How It Works*	*When to Use It*
P (programmed autoexposure)	The camera selects aperture and shutter speed but enables you to choose which combination of the two you prefer.	You want an easy way to experiment with different aperture/shutter speed combos, or you need more control over all aspects of your picture than provided by full auto mode.
A (aperture-priority AE)	You set the aperture; the camera selects the shutter speed to produce a good exposure.	Your main photographic goal is to control depth of field.
S (shutter-priority AE)	You set the shutter speed; the camera selects the appropriate aperture.	Shutter speed is your main concern, as when shooting action or creating motion-blur effects.

(continued)

Table 5-1 (continued)

Mode	How It Works	When to Use It
M (manual exposure)	You set both aperture and shutter speed.	You can't get the results you want from any of the other modes, or you simply want to dial in specific aperture and shutter speed settings as quickly as possible.

Controlling ISO

The ISO setting, introduced at the start of this chapter, adjusts the camera's sensitivity to light. At a higher ISO, you can use a faster shutter speed or a smaller aperture (higher f-stop number) because less light is needed to expose the image. On the D60, the range of possible ISO settings is 100 to 3200.

In addition to the main ISO control, you get two related features, Auto ISO adjustment and a noise-reduction filter. The next three sections spell out the details on all three options.

Selecting an ISO value

First, the simple stuff: You can change the ISO setting either through the Quick Settings display or the Shooting menu, as follows:

> ✔ **Via the Quick Settings display:** Display the Shooting Info screen, press the Zoom button to shift to Quick Settings mode, and then navigate to the ISO setting, highlighted in the left image in Figure 5-20. Press OK to display the second screen in the figure. Select the setting you want to use and press OK.

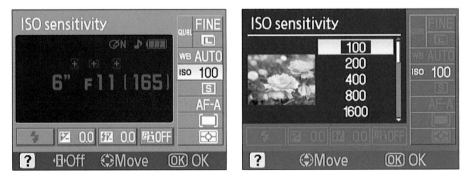

Figure 5-20: You can adjust ISO quickly via the Quick Settings display.

✓ **Via the Shooting menu:** Press the Menu button, navigate to the Shooting menu, and highlight the ISO Sensitivity option, as shown in Figure 5-21. Press OK to display the available ISO settings, highlight your choice, and press OK again.

SHOOTING MENU	
Optimize image	N
Image quality	FINE
Image size	
White balance	AUTO
ISO sensitivity	100
Noise reduction	OFF
Active D-Lighting	OFF

Figure 5-21: You can also access the ISO control from the Shooting menu.

A couple of brief notes on this option:

✓ You can adjust ISO in any of the camera's exposure modes. But you get different ISO options for the Auto and Digital Vari-Program modes than you do in the advanced exposure modes.

✓ In the fully automatic modes, the list of ISO options includes a setting called Auto, which automatically adjusts ISO as needed as lighting conditions change. This setting is the default for all the fully automatic modes, and if you choose to shoot in those modes, Auto ISO isn't a bad idea because it ensures that the camera can select an appropriate shutter speed and aperture for the mode you're using. Say that you set the Mode dial to the Sports setting to capture action, for example. If you're shooting in dim lighting and you set the ISO to 100, the camera may be forced to use a very slow shutter speed, thereby leaving your subject blurry. In Auto mode, the camera will raise the ISO high enough to allow a fast shutter speed. Of course, the downside in that scenario may be that the high ISO will create a noisy image, but a noisy image is probably better than a blurry image.

Note that any time you rotate the Mode dial from the P, S, A, or M setting to one of the fully automatic modes, the camera resets the ISO setting to Auto.

✓ In the advanced exposure modes, the Shooting menu and Quick Settings display don't offer an Auto setting for ISO. But you can enable Auto ISO adjustment through the Custom Setting menu if you want. In this case, you can specify the circumstances in which you want the camera to play with your ISO setting. See the next section for details.

✓ The highest ISO setting, ISO 3200, is called Hi 1 in the camera menus and displays. You must scroll past the initial screenful of settings to get to this option.

Choosing Hi 1 pretty much ensures that you're going to have a noisy image, which is why the camera also applies a noise-reduction filter to your image after you shoot it — a feature that has its pros and cons, as explained in the section after next. Again, if cranking the camera up to ISO 3200 is the only way to capture the image, and you'd rather have a noisy image than no image, Hi 1 is the answer. Otherwise, pass this one

by and adjust shutter speed and aperture to get the exposure you want instead. Even with the noise-removal feature, ISO 3200 images look pretty ugly — just flip back to Figure 5-9 to see what I mean.

Considering Auto ISO adjustment

Although the ISO options available in the Shooting menu and Quick Settings display don't include an Auto setting when you work in the advanced exposure modes, you do have the option of using that feature. It's just buried a bit: Specifically, you have to visit the Custom Setting menu. Highlight ISO Auto, as shown on the left in Figure 5-22, and press OK to display the second screen in the figure. Then just highlight On and press OK again.

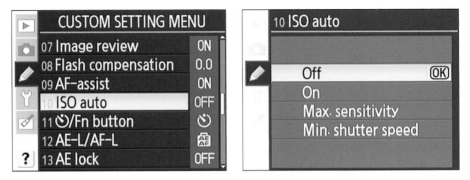

Figure 5-22: Visit the Custom Setting menu to disable automatic ISO adjustment.

After you take this step, the camera uses the ISO setting that you specify via the Shooting menu or Quick Settings display if it determines that the setting is appropriate. If not, it will adjust the ISO setting in the background as needed to produce a good exposure. Depending on the light, the camera may bump the setting as high as ISO 1600. To remind you that Auto ISO adjustment is enabled, the letters ISO-A appear near the top of the Shooting Info display; in the viewfinder, the words ISO Auto appear. If you see either of those reminders blinking at you, the camera's telling you that it plans on adjusting the ISO from your selected setting. After taking a picture, you can tell whether any adjustment was made by setting the playback display mode to Shooting Data. If the ISO value appears red in the shooting data that's displayed over the image, the camera tweaked the ISO setting for you. (See Chapter 4 for details on viewing shooting data during image playback.)

Personally, I don't turn on automatic ISO adjustment, however. Because increasing ISO brings a higher risk of image noise, I don't want the camera making this decision for me. I prefer to be the one deciding whether to

accept the possibility of noise or adjust the shutter speed or f-stop in response to the lighting conditions.

If you do want to enable automatic ISO override for the advanced exposure modes, at least take advantage of the two other controls on the ISO Auto menu (refer to the right screen in Figure 5-22): Max Sensitivity and Min Shutter Speed. With these options, you can specify the highest ISO setting the camera may select when it does its thing; your choices are ISO 400, 800, and 1600. You can also set the minimum shutter speed at which the camera can even adjust the ISO. Note that these settings affect only the P, A, S, and M shooting modes.

Enabling the noise-reduction filter

A high ISO setting is just one cause of image noise. When you use a very slow shutter speed — say, 1 second or more — the long exposure time can also produce noise. Whatever the cause, your camera offers a built-in noise-reduction filter, which is akin to the noise-correction filters found in some photo editing software. This filter is applied after you take the picture, as the camera processes the image data and records it to your memory card.

Noise-reduction filters work primarily by applying a slight blur to the image. Don't expect this process to totally eliminate noise, and do expect some resulting image softness. You may be able to get better results in a photo editor because you can apply the noise-removal blurring just to the areas where the problem is most noticeable — usually in areas of flat color or little detail, such as skies. In addition, the noise filter slows down capture time slightly, which can be problematic when you're trying to shoot at a rapid pace.

If you want to experiment with noise reduction, you enable it via the Shooting menu, as illustrated in Figure 5-23.

Two key points on this feature:

- ✔ Even if you turn it on, the camera applies noise reduction only when you shoot at ISO 400 or higher *or* set the shutter speed to 8 seconds or slower, or both.

- ✔ Even if you turn the feature off, some noise reduction occurs when you select ISO settings above 800.

SHOOTING MENU	
Optimize image	N
Image quality	FINE
Image size	▭
White balance	AUTO
ISO sensitivity	100
Noise reduction	OFF
Active D-Lighting	OFF

Figure 5-23: The Noise Reduction filter attempts to alleviate noise created by very slow shutter speeds or high ISO settings.

Adjusting aperture and shutter speed

To select aperture and shutter speed, start by pressing the shutter button halfway. In P mode, the camera's autoexposure mechanism does its thing and presents its recommended aperture and shutter speed combination, which you can see in the viewfinder display. In S mode, you see the f-stop that the camera selects to go with the currently selected shutter speed; in A mode, the opposite occurs. In manual (M) exposure mode, the meter simply reports its take on the currently selected aperture and shutter speed. (See the earlier section, "Monitoring Exposure Settings" for details.) Assuming that you're using autofocus, focus is established with your half-press of the shutter button as well.

To adjust the aperture and shutter speed, you use the Command dial. Figure 5-24 labels the Command dial and also reminds you of where to find the current aperture and shutter speed settings in the viewfinder.

Exposure Compensation button

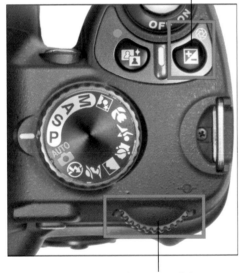

Shutter speed and f-stop

Command dial

Figure 5-24: As you use the Command dial to adjust settings (left), monitor them in the viewfinder display (right).

The specific techniques for adjusting the settings vary depending on the exposure mode (P, S, A, or M), as follows:

✔ **P (programmed auto):** Rotate the Command dial to select a different combination of aperture and shutter speed.

- To select a higher f-stop number (smaller aperture) and slower shutter speed, rotate the dial to the left.

- To select a lower f-stop number (larger aperture) and faster shutter speed, rotate the dial to the right.

The P* symbol that appears in the viewfinder and Shooting Info display after you rotate the Command dial indicates that you adjusted the aperture/shutter speed settings from those the camera initially suggested. To get back to the initial combo, rotate the Command dial until the symbol disappears.

✔ **S (shutter-priority autoexposure):** Rotate the Command dial to the right for a faster shutter speed; nudge it to the left for a slower speed.

As you change the shutter speed, the camera automatically adjusts the aperture as needed to maintain what it considers the proper exposure. Remember that as the aperture shifts, so does depth of field — so even though you're working in shutter-priority mode, keep an eye on the f-stop, too, if depth of field is important to your photo. Also note that in extreme lighting conditions, the camera may not be able to adjust the aperture enough to produce a good exposure at your current shutter speed — again, possible aperture settings depend on your lens. So you may need to compromise on shutter speed (or, in dim lighting, raise the ISO).

✔ **A (aperture-priority autoexposure):** Rotate the Command dial to the right to stop down the aperture to a higher f-stop number. Rotate the dial to the left to open the aperture to a lower f-stop number. As you do, the camera automatically adjusts the shutter speed to maintain the exposure.

When you stop down the aperture, be careful that the shutter speed doesn't drop so low that you run the risk of camera shake if you hand-hold the camera — unless you have a tripod handy, of course. And if your scene contains moving objects, make sure that when you dial in your preferred f-stop, the shutter speed that the camera selects is fast enough to stop action (or slow enough to blur it, if that's your creative goal).

✔ **M (manual exposure):** In this mode, you select both aperture and shutter speed, like so:

- *To adjust shutter speed:* Rotate the Command dial left for a slower shutter speed; rotate right for faster shutter.

- *To adjust aperture:* Press and hold the Exposure Compensation button on top of the camera, shown in Figure 5-24, as you rotate the Command dial. (See the little aperture symbol above the button? That's your cue as to the aperture-related function of the button.) Rotate the dial to the right for a higher f-stop (smaller aperture); rotate left to select a lower f-stop. Don't let up on the button as you rotate the Command dial; if you do, you instead adjust shutter speed.

Keep in mind that when you use P, S, or A modes, the settings that the camera selects are based on what it thinks is the proper exposure. If you don't agree with the camera, you have two options: You can switch to manual exposure mode and simply dial in the aperture and shutter speed that deliver the exposure you want; or if you want to stay in P, S, or A mode, you can tweak the exposure using the feature explained in the very next section.

Overriding Autoexposure Results with Exposure Compensation

When you set your camera to the P, S, or A modes, you can enjoy the benefits of autoexposure support but still retain some control over the final, overall exposure. If you think that the image the camera produced is too dark or too light, you can use a feature known as *Exposure Compensation.*

This feature enables you to tell the camera to produce a darker or lighter exposure than what its autoexposure mechanism thinks is appropriate. Best of all, this feature is probably one of the easiest on the whole camera to understand. Here's all there is to it:

- Exposure Compensation settings are stated in terms of EV values, as in +2.0 EV. On your D60, possible values range from +5.0 EV to –5.0 EV. (The *EV* stands for *exposure value.*)

- A setting of EV 0.0 results in no exposure adjustment.

- For a brighter image, you raise the EV value. The higher you go, the brighter the image becomes.

- For a darker image, you lower the EV value. The picture becomes progressively darker with each step down the EV scale.

As an example, take a look at the first image in Figure 5-25. The initial exposure selected by the camera left the balloon a tad too dark for my taste. So I just amped the Exposure Compensation setting to EV +1.0, which produced the brighter exposure on the right.

In Figure 5-26, I had the opposite problem. The exposure selected by the camera left parts of the dog's fur overexposed — notice the front legs and the haunches. This time, an Exposure Compensation value of EV –0.7 provided a better image.

EV 0.0 EV +1.0

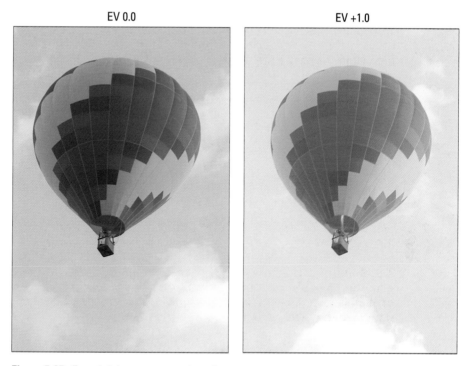

Figure 5-25: For a brighter exposure than the autoexposure mechanism chooses, dial in a positive EV value.

EV 0.0 EV −0.7

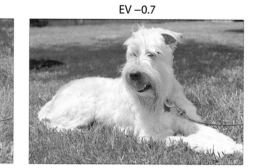

Figure 5-26: Lower the EV value to produce a darker image.

Whatever your reason for adjusting the Exposure Compensation setting, you can get the job done in two ways. Here's the method that I find easiest:

1. **Hold down the Exposure Compensation button on top of the camera.**

 As soon as you press the button, the Shooting Info display appears, with the Exposure Compensation setting active, as shown on the left in Figure 5-27. Additionally, the current EV value appears in the viewfinder, as shown on the right.

2. **While keeping the button pressed, rotate the Command dial to change the EV value.**

 • Rotate the dial to the right to lower the value and produce a darker exposure.

 • Rotate the dial to the left to raise the value and produce a brighter exposure.

 As you adjust the EV value, the exposure meter reflects the effect on the exposure. Of course, if you agreed with the meter (which itself reflects the camera's autoexposure decision), you wouldn't be fooling with EV compensation, so don't be alarmed that the meter indicates an under- or overexposed photo. (See "Monitoring Exposure Settings," earlier in this chapter, for more about meter-reading.)

 If you select a positive EV value, the little EV +/– symbol in the viewfinder shows a plus sign; if you select a negative value, you see a minus sign instead.

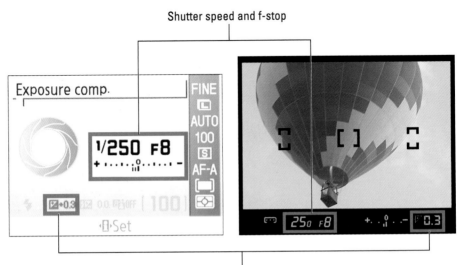

Shutter speed and f-stop

Exposure Compensation value

Figure 5-27: These symbols show the current Exposure Compensation and exposure status.

3. **Release the EV Compensation button after you select the value you want to use.**

 Your Exposure Compensation setting remains in force until you change it, even if you power off the camera. So you may want to make a habit of checking the setting before each shoot.

Here are a few other tips about Exposure Compensation:

✒ How the camera arrives at the brighter or darker image you request through your Exposure Compensation setting depends on the exposure mode:

 • In A (aperture-priority autoexposure) mode, the camera adjusts the shutter speed but leaves your selected f-stop in force. Be sure to check the resulting shutter speed to make sure that it isn't so slow that camera shake or blur from moving objects is problematic.

 • In S (shutter-priority autoexposure) mode, the opposite occurs: The camera opens or stops down the aperture, leaving your selected shutter speed alone.

 • In P (programmed autoexposure) mode, the camera decides whether to adjust aperture, shutter speed, or both.

 However, the camera can adjust the aperture only so much, according to the aperture range of your lens. And the range of shutter speeds, too, is limited by the camera itself. So if you reach the ends of those ranges, you either have to compromise on shutter speed or aperture or adjust ISO.

✒ Exposure compensation isn't the only tool available to you if you're not happy with the results produced by the camera's autoexposure meter. You also can change the exposure metering mode, which tells the camera which part of the frame to consider when calculating exposure. I shot the example images of the balloon and the dog using matrix mode, for example; switching to center-weighted or spot metering probably would have produced a better exposure of the subjects. I usually find it easier to simply change the Exposure Compensation setting than to fiddle with the metering mode, however.

✒ Some photographers use a slightly lower Exposure Compensation value — say, EV –0.3 — for all their shots. The thinking is that while this setting may underexpose some images, resulting in a little necessary retouching work later, it helps protect against blown highlights, which are usually not easy to repair.

 As an alternative, you can enable Active D-Lighting, which also produces a slightly darker exposure and offers the additional benefit of applying a post-capture process that brightens the darkest areas of a scene. The downside of that choice is that the camera needs a longer time to capture each image. See the earlier section "Taking Advantage of Active D-Lighting" for details.

✔ Finally, you can always simply switch to Manual exposure mode — M, on the Mode dial — and select whatever aperture and shutter speed settings produce the exposure you're after. When you do shoot in Manual mode, the current Exposure Compensation setting has no effect; again, that exposure adjustment is made only in the three advanced autoexposure modes (P, S, and A).

Using Autoexposure Lock

To help ensure a proper exposure, your camera continually meters the light in a scene until the moment you depress the shutter button fully and capture the image. In autoexposure modes — that is, any mode but M — it also keeps adjusting exposure settings as needed to maintain a good exposure.

For example, say that you set your camera to shutter-priority autoexposure (S) mode and set the shutter speed to 1/125 second. The camera immediately reports the f-stop that it considers appropriate to expose the scene at that shutter speed. But if the light in the scene changes or you reframe your shot before snapping the picture, the camera may shift the f-stop automatically to compensate.

For most situations, this approach works great, resulting in the right settings for the light that's striking your subject at the moment you capture the image. But on occasion, you may want to lock in a certain combination of exposure settings. Here's one such scenario: Suppose that you're shooting several images of a large landscape that you want to join together into a panorama in your photo editor. Unless the lighting is even across the entire landscape, the camera's autoexposure brain will select different exposure settings for each shot, depending on which part of the scene is currently in the frame. That can lead to weird breaks in the brightness and contrast of the image when you seam the image together. And if it's the f-stop that's adjusted, which is what could happen in P or S exposure modes, you may notice shifts in depth of field as well.

The easiest way to lock in exposure settings is to switch to M (manual) exposure mode and use the same f-stop, shutter speed, and ISO settings for each shot. In manual mode, the camera never overrides your exposure decisions; they're locked until you change them.

But if you prefer to stay in P, S, or A mode, you can lock in the current autoexposure settings by pressing the AE-L/AF-L button, highlighted in Figure 5-28. By default, this step locks both exposure and focus for as long as you press the button, even if you release the shutter button. (AE-L stands for autoexposure lock; AF-L, for autofocus lock.) You see the letters *EL* in the viewfinder when autoexposure lock is in effect.

By combining autoexposure lock with spot metering, you can ensure a good exposure for photographs in which you want your subject to be off-center, and that subject is significantly darker or lighter than the background. Imagine, for example, a dark statue set against a light blue sky. First, select spot metering, so that the camera only considers the object located in the selected autofocus point. Frame the scene initially so that your statue is located within that autofocus point. Press and hold the shutter button halfway to establish focus and then lock exposure and focus on the statue by pressing and holding the AE-L/AF-L button. Now reframe the shot to your desired composition and take the picture. (See Chapter 6 for details on selecting an autofocus point.)

Autoexposure/Autofocus Lock

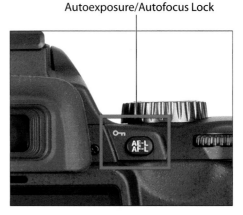

Figure 5-28: This button enables you to lock exposure settings when you shoot in P, S, or A autoexposure modes.

Again, holding down the AE-L/AF-L button locks both exposure and focus by default. But if you dig into the Custom Setting menu, you can change the button's function. You can set the button to lock only exposure, for example, or only focus, instead of locking both as it does by default. Chapter 11 offers details.

Using Flash in Advanced Exposure Modes

Sometimes, no amount of fiddling with aperture, shutter speed, and ISO produces a bright enough exposure — in which case, you simply have to add more light. The built-in flash on your D60 offers the most convenient solution.

When you shoot in the advanced exposure modes, you have much more control over your flash than when you use the fully automatic modes covered in Chapter 2. First, you gain access to flash modes not available in the full-auto modes. Even better, you can adjust the strength of the flash by using a feature called *Flash Compensation*.

The rest of this chapter explains how to use these flash functions and also offers some tips on getting better results in your flash pictures. Be sure to also visit Chapter 7, where you can find additional flash and lighting tips related to specific types of photographs.

Choosing a flash mode

When you shoot in the P, S, A, or M exposure modes, the list of available flash modes doesn't include Auto, in which the camera makes the decisions about when to fire the flash. Instead, if you don't want the flash to fire, you simply keep the flash unit closed. No need to select the Off flash mode, as when you shoot in the fully automatic exposure modes.

If you do want to add flash, press and release the Flash button on the left side of the camera. Then, press the button a second time, but this time, hold it down as you rotate the Command dial to select a flash mode. I labeled both controls in Figure 5-29.

Note that in the viewfinder, you see only a little lightning bolt graphic to indicate that flash is enabled. To see the specific flash mode, you must check the Shooting Info display; look for the flash icon in the lower-left corner of the screen, as shown on the left in Figure 5-30. As soon as you press and hold the Flash button, the Flash Mode setting automatically becomes active, as shown on the right in Figure 5-30. Again, just rotate the Command dial to cycle through the available flash modes, keeping the Flash button pressed as you do so.

Flash button Command dial

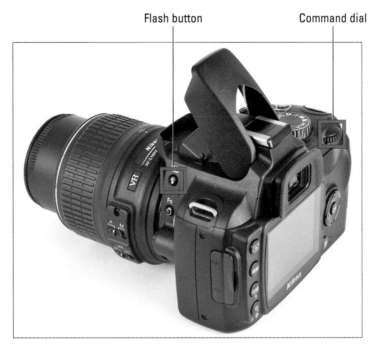

Figure 5-29: Hold down the Flash button and rotate the Command dial to adjust the flash mode.

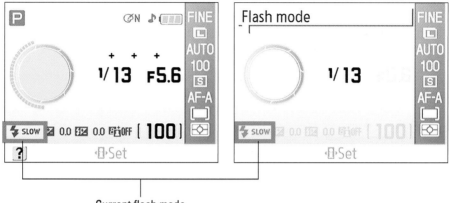

Current flash mode

Figure 5-30: The current flash mode is indicated in the Shooting Info display.

Your flash mode choices break down into three basic categories, described in the next sections: fill flash; red-eye reduction flash; and the "sync" modes, slow-sync and rear-sync, which are special-purpose flash options.

Fill flash: The outdoor photographer's best friend

The fill flash setting on your D60 is represented by plain-old lighting bolt symbol you see in the margin here. You can think of this setting as "normal flash" — at least in the way that most of us think of using a flash.

You may also hear this mode called *force* flash because the flash fires no matter what the available light, unlike in the Auto flash mode (provided for the fully automatic exposure modes), in which the camera decides when flash is needed. In Fill flash mode, the flash fires even in the brightest daylight — which, by the way, is often an excellent idea.

Yep, you read me correctly: Adding a flash can really improve outdoor photos, even when the sun is at its sunniest. Just as an example, Figure 5-31 shows a floral image taken both with and without a flash. The small pop of light provided by the built-in flash is also extremely beneficial when shooting nature or larger subjects that happen to be slightly shaded, such as the carousel horses featured in the next section. For outdoor portraits, a flash is even more important; Chapter 7 discusses that subject.

Using a flash in bright sunlight also produces a slight warming effect, as illustrated in Figure 5-31. This color shift occurs because when you enable the flash, the camera's white balancing mechanism warms color slightly to compensate for the bluish light of a flash. But because your scene is actually lit primarily by sunlight, which is *not* as cool as flash light, the white balance

adjustment takes the image colors a step warmer than neutral. If you don't want this warming effect, see Chapter 6 to find out how to make a manual white balance adjustment.

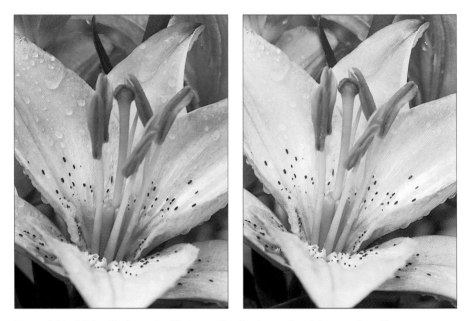

Figure 5-31: Adding flash resulted in better illumination and a slight warming effect.

Do note, however, that when you use flash, you're restricted to a top shutter speed of 1/200 second. That means that in very bright sun, you may need to stop down the aperture significantly to avoid overexposing the image. See the sidebar "In Sync: Flash timing and shutter speed," later in this chapter, for details on shutter-speed ranges available for flash photography.

Red-eye reduction flash

Red-eye is caused when flash light bounces off a subject's retinas and is reflected back to the camera lens. Red-eye is a human phenomena, though; with animals, the reflected light usually glows yellow, white, or green.

Man or beast, this issue isn't nearly the problem with the type of pop-up flash found on your D60 as it is on non-SLR cameras. The D60's flash is positioned in such a way that the flash light usually doesn't hit a subject's eyes straight on, which lessens the chances of red eye. However, red-eye may still be an issue when you use a lens with a long focal length (a telephoto lens) or you shoot subjects from a distance.

 If you do notice red eye, you can try the red-eye reduction mode represented by the icon shown in the margin here. In this mode, the camera fires a small preflash light before the actual flash. The subject's pupils constrict in response to that preflash, allowing less flash light to enter the eye and cause that glowy red reflection. Be sure to warn your subjects to wait for the real flash, or they may step out of the frame or stop posing after the preflash.

For an even better solution, try the flash-free portrait tips covered in Chapter 7. If you do a lot of portrait work that requires flash, you may also want to consider an external flash unit, which enables you to aim the flash light in ways that virtually eliminate red-eye.

If all else fails, check out Chapter 10, which shows you how to use the built-in red-eye removal tool on your camera's Retouch menu. Sadly, though, this feature removes only red-eye, not the yellow/green/white eye that you get with animal portraits.

Slow-sync and rear-sync flash

In fill flash and red-eye reduction flash modes, the flash and shutter are synchronized so that the flash fires at the exact moment the shutter opens.

Technical types refer to this flash arrangement as *front-curtain sync*.

Your Nikon also offers four special-sync modes, which work as follows:

- **Slow-sync flash:** This mode, available only in the P and A exposure modes, also uses front-curtain sync but allows a shutter speed slower than the 1/60 second minimum that is in force when you use fill flash and red-eye reduction flash.

 The benefit of this longer exposure is that the camera has time to absorb more ambient light, which in turn has two effects: Background areas that are beyond the reach of the flash appear brighter; and less flash power is needed, resulting in softer lighting.

 The downside of the slow shutter speed is, well, the slow shutter speed. As discussed earlier in this chapter, the longer the exposure time, the more you have to worry about blur caused by movement of your subject or your camera. A tripod is essential to a good outcome, as are subjects that can hold very, very still. I find that the best practical use for this mode is shooting nighttime still-life subjects such as the one you see in Figure 5-32.

 Some photographers, though, turn the downside of slow-sync flash to an upside, using it to purposely blur their subjects, thereby emphasizing motion.

Normal flash Slow-sync flash

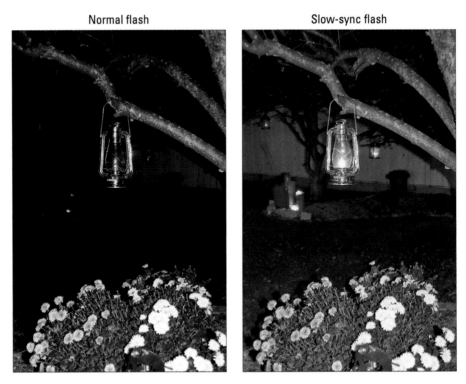

Figure 5-32: Slow-sync flash produces softer, more even lighting than normal flash in nighttime pictures.

- **Rear-curtain sync:** In this mode, available only in shutter-priority (S) and manual (M) exposure modes, the flash fires at the very end of the exposure, just before the shutter closes. The classic use of this mode is to combine the flash with a slow shutter speed to create trailing-light effects like the one you see in Figure 5-33. With rear-curtain sync, the light trails extend behind the moving object (my hand, and the match, in this case), which makes visual sense. If instead you use slow-sync flash, the light trails appear in front of the moving object.

- **Slow-sync with rear-curtain sync:** Hey, not confusing enough for you yet? This mode enables you to produce the same motion trail effects as with rear-curtain sync, but in the P and A exposure modes.

- **Slow-sync with red-eye reduction:** In P and A exposure modes, you can also combine a slow-sync flash with the red-eye reduction feature. Given the potential for blur that comes with a slow shutter, plus the potential for subjects to mistake the red-eye preflash for the real flash and walk out of the frame before the image is actually recorded, I vote this flash mode as the most difficult to pull off successfully.

Note that all of these modes are somewhat tricky to use successfully, however. So have fun playing around, but at the same time, don't feel too badly if you don't have time right now to master these modes plus all the other exposure options presented to you in this chapter. In the meantime, do a Web search for slow-sync and rear-sync image examples if you want to get a better idea of the effects that other photographers create with these flash modes.

Adjusting flash output

TIP

When you shoot with your built-in flash, the camera attempts to adjust the flash output as needed to produce a good exposure in the current lighting conditions. On some occasions, you may find that you want a little more or less light than the camera thinks is appropriate.

Figure 5-33: I used rear-curtain flash to create this candle-lighting image.

You can adjust the flash output by using a feature called *Flash Compensation*. This feature works just like Exposure Compensation, discussed earlier in the chapter, except that it enables you to override the camera's flash-power decision instead of its autoexposure decision. As with Exposure Compensation, the Flash Compensation settings are stated in terms of EV *(exposure value)* numbers. A setting of 0.0 indicates no flash adjustment; you can increase the flash power to EV +1.0 or decrease it to EV –3.0.

As an example of the benefit of this feature — again, available only when you shoot in the P, S, A, or M exposure modes — take a look at the carousel horse images in Figure 5-34. The first image shows you a flash-free shot. Clearly, I needed a flash to compensate for the fact that the horses were shadowed by the roof of the carousel. But at normal flash power, as shown in the same image, the flash was too strong, creating glare in some spots and blowing out the highlights in the white mane, as shown in the middle image. By dialing the flash power down to EV –0.7, I got a softer flash that straddled the line perfectly between no flash and too much flash.

As for boosting the flash output, well, you may find it necessary on some occasions, but don't expect the built-in flash to work miracles even at a Flash Compensation of +1.0. Any built-in flash has a limited range, and you simply can't expect the flash light to reach faraway objects. In other words, don't even try taking flash pictures of a darkened recital hall from your seat in the balcony — all you'll wind up doing is annoying everyone.

No flash

Flash EV 0.0

Flash EV −0.7

Figure 5-34: When normal flash output is too strong, dial in a lower Flash Compensation setting.

With that preface in mind, you can view the current Flash Compensation setting in the Shooting Info screen, shown in Figure 5-35. It's located just to the right of the Exposure Compensation setting. The little flash symbol in the Flash Compensation setting reminds you which is which.

REMEMBER

In sync: Flash timing and shutter speed

In order to properly expose flash pictures, the camera has to synchronize the timing of the flash output with the opening and closing of the shutter. For this reason, the range of shutter speeds available to you is more limited when you use flash than when you go flash-free.

When you use the built-in flash, the maximum shutter speed is 1/200 second. That means that you may not be able to capture blur-free images of fast-moving subjects when a flash is required. In addition, using flash in very bright light (as in outdoor daytime shots) may require a very high f-stop setting to avoid overexposure.

The minimum shutter speed varies depending on your exposure mode, as follows:

- P, A, Auto, Portrait, Child modes: 1/60 second
- Close Up mode: 1/125 second
- Nighttime Portrait mode: 1 second
- S, M modes: 30 seconds

Note that in P and A exposure modes, setting your flash to slow-sync mode does enable you to go even slower than the 1/60 second minimum shown here. In addition, manual exposure mode also enables you to combine flash with bulb exposure, in which the shutter stays open indefinitely as long as you keep the shutter button depressed.

To adjust the flash power, you have three options, as follows:

- **Via the Quick Settings display:** Display the Shooting Info screen, press the Zoom button to shift into Quick Settings mode, and then highlight the Flash Compensation setting, as shown on the left in Figure 5-36. Press OK to display the screen shown on the right in the figure, where you can select the flash power you want to use. Press OK again to return to the Shooting Info display. (Chapter 1 offers help with using the Shooting Info and Quick Settings displays if you need it.)

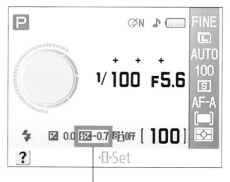

Flash Compensation setting

Figure 5-35: Look here to check the current Flash Compensation setting.

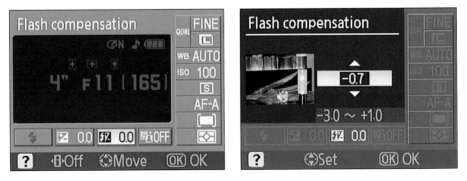

Figure 5-36: You can adjust the setting through the Quick Settings display.

✔ **Via the Shooting Info display:** If you press and hold the Flash button together with the Exposure Compensation button, the Flash Compensation setting in the Shooting Info display becomes active, and a little flag bearing the message "Flash Compensation" appears at the top of the screen. Keeping the buttons pressed, rotate the Command dial to change the setting. I find any technique that involves coordinating this many fingers a little complex, but you may find it easier than I do.

✔ **Via the Custom Setting menu:** If you don't see the Flash Compensation setting on the menu, toggle over to the Setup menu and change the CSM/Setup Menu option to Full, as explained in Chapter 1.

As with Exposure Compensation, any flash-power adjustment you make remains in force, even if you turn off the camera, until you reset the control. So be sure to check the setting before you next use your flash.

Using an external flash unit

In addition to its built-in flash, your camera has a *hot shoe,* which is photo-geek terminology for a connection that enables you to add an external flash head like the one shown in Figure 5-37. The figure features the Nikon Speedlight SB-600, which currently retails for about $200. (The hot shoe is covered by a little cap when you first get the camera; you have to remove it to add your flash.)

Although certainly not the cheapest of camera accessories, an external flash may be a worthwhile investment if you do a lot of flash photography, especially portraits. For one thing, an external flash offers greater power, enabling you to illuminate a larger area than you can with a built-in flash. And with flash units like the one in Figure 5-37, you can rotate the flash head so that the flash light bounces off a wall or ceiling instead of hitting your subject directly. This results in softer lighting and can eliminate the harsh shadows

often caused by the strong, narrowly focused light of a built-in flash. (Chapter 7 offers an example of the difference this lighting technique can make in portraits.)

Whether the investment in an external flash will be worthwhile depends on the kind of photography you want to do. However, if you simply want a softer, more diffused light than your built-in flash produces, you have another option: You can buy a flash diffuser attachment like the one shown in Figure 5-38. This diffuser, made by LumiQuest (www.lumiquest.com), sells for just $13 and is a heck of a lot lighter and smaller to tuck into your camera bag than a flash head. This is just one of many diffuser designs, so visit your camera store to compare all your options.

If you do decide to purchase an external flash, I highly recommend that you visit a good camera store, where the personnel can help you select the right flash model for the kind of flash work you want to do. You don't necessarily need to stick with a Nikon-brand flash, but be aware that third-party flash units may not be fully compatible with your D60. In addition, some Nikon flash units support some advanced features that are part of the so-called *Nikon Creative Lighting System.* These advanced flash features are beyond the scope of this book — in fact, entire books have been written about the system — but you can learn more about them on the Nikon Web site. You may also want to dig into some of the many books that concentrate solely on flash photography. There's a lot more to that game than you may imagine, and you'll no doubt discover some great

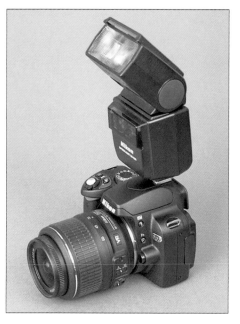

Figure 5-37: An external flash like this Nikon Speedlight offers a rotating flash head for greater lighting flexibility.

Figure 5-38: If you don't own an external flash head, try using a diffuser to soften the light from your built-in flash.

ideas about lighting your pictures with flash. You can start with Chapter 7, which provides some specific examples of how to get better flash results when you shoot portraits, whether you go with the built-in flash, an external flash, or, my favorite, no flash.

6

Manipulating Focus and Color

*T*o many people, the word *focus* has just one interpretation when applied to a photograph: Either the subject is in focus or it's blurry. And it's true, this characteristic of your photographs is an important one. There's not much to appreciate about an image that's so blurry that you can't make out whether you're looking at Peru or Peoria.

But an artful photographer knows that there's more to focus than simply getting a sharp image of a subject. You also need to consider *depth of field,* or the distance over which objects remain sharply focused. This chapter explains all the ways to control depth of field, discusses how to use your D60's advanced autofocus options, and offers some tips on manual focusing.

This chapter also dives into the topic of color, explaining your camera's white balance control, which compensates for the varying color casts created by different light sources. Finally, a section near the end of the chapter introduces you to the Optimize Image feature, which enables you to take even greater control over image sharpness and color.

Reviewing Focus Basics

I touch on various focus issues in Chapters 1, 2, and 5. But just in case you're not reading this book from front to back, here's a recap of the basic process of focusing with your D60:

1. **If you haven't already done so, adjust the viewfinder diopter to your eyesight.**

 Look through the viewfinder and pay attention only to the three focus brackets, labeled in Figure 6-1. Then nudge the diopter slider until the brackets themselves appear sharp — don't worry about the scene in front of the lens. The diopter slider is located just to the right of the viewfinder, tucked behind the little rubber eyepiece; Chapter 1 details this step if you need more help.

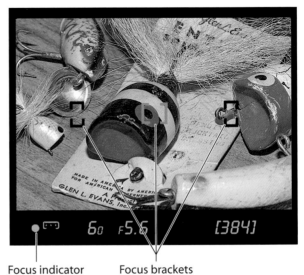

Focus indicator Focus brackets

Figure 6-1: The viewfinder offers these focusing aids.

2. **Set the focusing switch on the lens to manual or automatic focusing.**

 If you want to focus manually, set the switch to the M position, as shown in Figure 6-2. For autofocusing, set the switch to the A position.

 These directions are specific to the kit lens sold with the D60, shown in the figure. On other lenses, the switch may look or operate differently, so check the product manual. And note that not all lenses provide autofocusing when paired with the D60; if your lens offers only manual focusing, be sure to set the Focus mode to MF (manual focus), as explained in the upcoming section "Changing the Focus mode."

3. **To set focus in autofocus mode, press and hold the shutter button halfway down.**

Focusing ring Auto/Manual focus switch

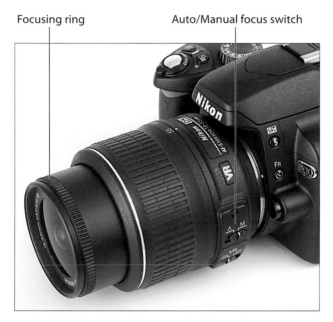

Figure 6-2: Select A for autofocus or M for manual focus.

When focus is established, the focus indicator in the viewfinder lights, and one of the focusing brackets turns red, as shown in Figure 6-1. Focus is maintained as long as you continue to hold the shutter button down halfway. (Press the button the rest of the way when you're ready to snap the picture.)

The red bracket indicates the *active autofocus area,* which is the portion of the frame the camera uses to establish focus. The autofocus area varies depending on the current autofocus area mode, or *AF-area mode,* in the lingo of your camera manual. To find out more about this issue, including how to select the autofocus area you want to use, check out the next section.

4. **To set focus manually, twist the focusing ring on the lens.**

 I labeled the focusing ring in Figure 6-2.

Even in manual mode, you can confirm focus by pressing the shutter button halfway. If the object in the active autofocus area is in focus, the viewfinder's focus indicator lights up. In addition, you can enable the D60's rangefinder display, which provides additional focus feedback. Check out the section "Taking advantage of manual-focusing aids," later in this chapter, for tips.

Shutter speed and blurry photos

A poorly focused photo isn't always related to the issues discussed in this chapter. Any movement of the camera or subject can also cause blur. Both of these problems are related to shutter speed, an exposure control that I cover in Chapter 5. Be sure to also visit Chapter 7, which provides some additional tips for capturing moving objects without blur.

Adjusting Autofocus Performance

You can adjust two aspects of your camera's autofocusing system: the AF-area mode and the Focus mode. The next two sections explain these features.

Changing the AF-area mode

Chapter 2 introduces the three AF-area mode options, which determine what area of the frame the camera uses when establishing autofocus. Here's a quick reminder about how each mode works:

 ✔ **Closest Subject:** The camera bases focus on the pair of brackets that contain the object closest to the camera. This is the default setting for all exposure modes (Auto, P, A, and so on) except the Sports and Close Up Digital Vari-Program modes.

 ✔ **Dynamic Area:** In this mode, you select one of the focus brackets by using the Multi Selector, and the camera sets focus based on that area of the frame. If the object within the focus brackets moves before you press the shutter button the rest of the way down to take the picture, the camera looks at the other brackets to try to find an object on which to focus. This setting is the default for Sports mode.

✔ **Single Point:** You use the Multi Selector to choose one of the three focusing brackets, and the camera bases focus only on that area. This mode is the default setting for Close Up mode.

If you want to change the mode from the default setting, the easiest way is to use the Quick Settings display. First, display the Shooting Info screen by pressing the Zoom button or by pressing the shutter button halfway. (You can release the shutter button after the screen appears.) Next, press the Zoom button to shift to the Quick Settings display and then use the Multi Selector to highlight the AF-area mode option, highlighted in yellow in Figure 6-3. Press OK to display the second screen in the figure, highlight your choice, and press OK again. The three modes are represented in the display by the icons you see in the margins here.

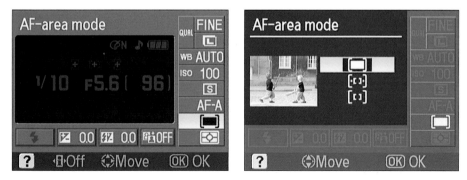

Figure 6-3: You can change the AF-area mode via the Quick Settings display.

If you prefer, you can also adjust the AF-area mode via the Custom Setting menu, shown in Figure 6-4.

A few other things to know about the AF-area mode setting:

Figure 6-4: The AF-area mode control is also found on the Custom Setting menu.

~ **Monitoring the AF-area mode setting.** You can check the AF-area mode setting in the viewfinder as well as in the Shooting Info display. In the viewfinder, a little icon at the far left end of the display, just to the right of the focusing confirmation dot, indicates the AF-area mode. However, note that in the viewfinder, the icon representing Closest Subject mode and Dynamic Area mode look a little different than they do in the Shooting Info display and menus. Figure 6-5 shows you how the icons for all three AF-area modes appear in the viewfinder; Figure 6-6 points out the position of the AF-area mode icon in the Shooting Info display. In that figure, the mode is set to Dynamic Area.

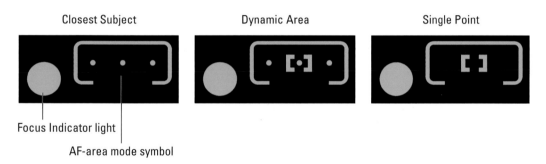

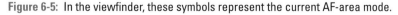

Figure 6-5: In the viewfinder, these symbols represent the current AF-area mode.

✓ **Confirming the active autofocus area.** See those little plus signs that I labeled "Selected autofocus area" in Figure 6-6? They represent the three autofocus areas, just like the brackets that appear in the viewfinder. If you set the AF-area mode to Dynamic Area or Single Point, the plus sign that's surrounded by brackets indicates which of the three focus areas is selected. For example, the display in Figure 6-6 indicates that the leftmost autofocus area is selected. The same brackets appear in the viewfinder, although they're a little hard to see, at least for my middle-age eyes.

Selected autofocus area

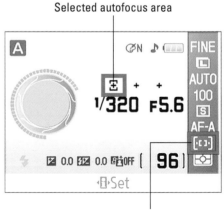

Dynamic Area icon

Figure 6-6: You can verify which focus point is selected as well.

And guess what: There's even more to this bracket/plus sign coding: In Dynamic Area mode, all three plus signs in the Shooting Info display are black, telling you that the autofocus area may shift if your subject moves out of the selected area, as explained earlier. In Single Point mode, only the selected area's plus sign is black; the others are gray, indicating that they won't come into play for your next shot. In Closest Subject mode, the brackets go away entirely. All three plus signs appear bold, and the viewfinder icon shows you all three dots, as in the first example in Figure 6-5. That's your reminder that the camera may focus on any of the three areas, depending on where the object closest to the camera is positioned in the frame.

I share this nugget of detail with you because I feel certain that some hard-working group at Nikon spent time coming up with this elaborate symbol system. But if you can't remember all these intricacies — or you can't see the little brackets in the viewfinder either — just look through the viewfinder and press the shutter button halfway; again, the brackets that appear red show you the selected autofocus area. You do need to know which AF-area mode is enabled, though, to predict whether the camera will stick with that selected point or not.

✓ **Reverting to the default AF-area mode.** When you use the advanced exposure modes (P, S, A, and M), your selected AF-area mode stays in force until you change it. But in the other modes, the AF-area setting reverts to the default when you switch to a different exposure mode. So you may find it more convenient to simply use manual focusing instead of adjusting the AF-area mode when you shoot in those exposure modes.

✔ **Simplifying things with center-point autofocusing.** If you want to simplify your autofocus routine, try this option: Just leave the AF-area mode set to Single Point, with the center focus bracket selected. Now the camera will always set focus based on whatever is at the center of the frame — a setup that may be familiar to you if you've worked with some point-and-shoot cameras. If you want your subject to appear off-center, you still can: Frame the picture initially so that the subject is centered, depress the shutter button halfway to establish focus, and then reframe the image before pressing the shutter button the rest of the way.

Do be careful about autoexposure if you use this technique, however. If the exposure metering mode is set to either spot- or center-weighted metering, and you reframe the image so that your subject isn't at the center of the frame, exposure may be off. The best solution is to lock autoexposure before you reframe, using the AE-L/AF-L lock button. In matrix metering, which bases exposure on the entire frame, this issue shouldn't be a big problem unless your subject is significantly brighter or darker than the rest of the scene — in which case, I suggest changing to spot- or center-weighted metering and locking autoexposure as just described. Chapter 5 provides details about metering modes, autoexposure lock, and other exposure issues.

Changing the Focus mode setting

Throughout this book, I use the term *focusing mode* generically to refer to the lens switch that shifts your camera from autofocusing to manual focusing — at least, on the kit lens sold with the D60. But there also is an official Focus mode setting, which controls another aspect of your Nikon's focusing behavior.

There are four Focus mode options, which work as follows:

✔ **AF-S (single-servo autofocus):** In this autofocus mode, which is geared to shooting stationary subjects, the camera locks focus when you depress the shutter button halfway.

✔ **AF-C (continuous-servo autofocus):** In this autofocus mode, which is designed for moving subjects, the camera focuses continuously for the entire time you hold the shutter button halfway down. So if your subject moves before you take the shot, but you adjust framing to keep that subject within the active autofocus area, focus should be correct. If the subject moves out of the active autofocus area, the camera looks for something else on which to establish focus. If you want to lock focus at a certain distance, you must press the AE-L/AF-L button, as described in the section, "Using autofocus lock," later in this chapter.

✔ **AF-A (auto-servo autofocus):** In this autofocus mode, the camera analyzes the scene and, if it detects motion, automatically selects continuous-servo mode (AF-C). If the camera instead believes you're shooting a stationary object, it selects single-servo mode (AF-S).

✔ **MF (manual focus):** If you use a lens that does not offer an external switch to shift from auto to manual focus, you need to select this setting to focus manually. You also need to choose this setting if your lens doesn't offer an autofocus motor at all. (You can still use the lens, but you get autofocusing capabilities only with lenses like the D60 kit lens, which has its own autofocus motor. Unlike some SLRs, the D60 does not have an autofocus mechanism in the camera body; instead, it relies on the lens to provide that feature.)

On the D60 kit lens featured in this book, simply setting the switch on the lens to M automatically sets the Focus mode to MF. However, choosing this Focus mode setting *does not* free the focusing ring so that you can actually set focus manually; you still must set the switch to the M position.

As for the autofocus options, single-servo mode (AF-S) works best for shooting still subjects, and continuous-servo (AF-C) is the right choice for moving subjects. But frankly, auto-servo (AF-A), which is the default setting, does a good job in most cases of making that shift for you. So, in my mind, there's no real reason to fiddle with the setting unless you're shooting moving objects (in which case the camera shifts to continuous-servo mode) and want to be able to lock focus at a specific position without using the AE-L/AF-L button. Another potential hangup might be if your subject is stationary but background objects are moving, causing the camera to sense motion and shift to continuous-servo mode and try to focus on those moving objects. In either case, you would need to shift to single-servo mode (AF-S) so that you can lock focus by depressing the shutter button halfway — although I think it's simpler to focus manually in that situation.

In fact, the camera restricts you to using either auto-servo (AF-A) or manual mode (MF) if you shoot in any of the fully automatic exposure modes. You can choose from all four Focus modes only when you shoot in P, S, A, or M exposure modes.

At any rate, the quickest way to adjust the Focus mode is via the Quick Settings display. Follow the usual path: Fire up the Shooting Info display, press the Zoom button to shift to the Quick Settings display, and then use the Multi Selector to highlight the Focus mode icon, as shown in Figure 6-7. Press OK to display the second screen in the figure, highlight your choice, and press OK again.

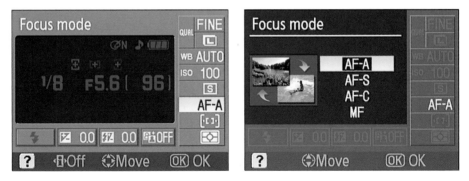

Figure 6-7: Auto-servo mode (AF-A) works fine in most cases.

You can also access the focus mode setting from the Custom Setting menu, as shown in Figure 6-8.

Using autofocus lock

When you set your camera's Focus mode to AF-C (continuous-servo auto-focus), pressing and holding the shutter button halfway initiates autofocus. But focusing is continually adjusted while you hold the shutter button halfway, so the focusing distance may change if the subject moves out of the active autofocus area before you press

Figure 6-8: You can also change the Focus mode from the Custom Setting menu.

the shutter button the rest of the way to take the picture. The same is true if you set the Focus mode to AF-A (auto-servo autofocus) and the camera senses movement in front of the lens, in which case it shifts to AF-C mode and operates as I just described. Either way, the upshot is that you can't control the exact focusing distance the camera ultimately uses.

Should you want to lock focus at a specific distance, you have a couple of options:

- Focus manually.
- Change the Focus mode to AF-S (single-servo autofocus). In this mode, focus is locked when you press and hold the shutter button halfway. Unfortunately, you can't select this mode unless you shoot in the advanced exposure modes (P, S, A, and M). Also, the press-and-hold method doesn't work if you set the Release mode to Continuous. (Remember, the Release mode determines whether you capture a single image or a series of images each time you press the shutter button; Chapter 2 has details.)

✓ Use *autofocus lock*. First set focus by pressing the shutter button halfway. When the focus is established at the distance you want, press and hold the AE-L/AF-L button, located near the viewfinder and labeled in Figure 6-9. Focus remains set as long as you hold the button down, even if you release the shutter button.

Keep in mind, though, that by default, pressing the AE-L/AF-L button also locks in exposure if you're shooting in the P, S, or A autoexposure modes. (Chapter 5 explains.) You can change this behavior, however, setting the button to lock just one or the other. Chapter 11 explains this option as well as a couple other ways to customize the button's function.

Autoexposure/autofocus lock

Figure 6-9: Press the AE-L/AF-L button to lock focus when using autofocusing.

For my money, manual focusing is by far the easiest solution. Yes, it may take you a little while to get comfortable with manual focusing, but in the long run, you really save yourself a lot of time fiddling with the various autofocus settings, remembering which button initiates the focus lock, and so on. Just be sure that you have adjusted the viewfinder diopter to your eyesight, as explained in Chapter 1, so that there's not a disconnect between what you see in the viewfinder and where the camera is actually focusing. After a little practice, focusing manually will become second nature to you. And, as the next section explains, you still get some focusing assistance from the camera.

Taking Advantage of Manual-Focusing Aids

Today's autofocusing systems are pretty remarkable. As long as you follow the suggested techniques for autofocusing and use the right settings for the situation, you can expect a nice, sharply focused subject.

However, some subjects baffle even the most capable autofocus system: objects behind fences, highly reflective objects, dimly-lit subjects, and scenes in which very little contrast exists between the subject and background. For those times when your camera can't seem to lock focus on a subject, don't waste time trying to adjust autofocus settings or otherwise maneuvering the camera to make autofocusing work. Just switch to manual focus and do the job yourself.

Of course, if the lens you use on your D60 doesn't offer an autofocus motor, you must focus manually. But many SLR photographers (including me) prefer to focus manually most of the time even if they do own an autofocus lens. With manual focus, you don't have to worry that you've forgotten to select the appropriate autofocus modes, and, after you become familiar with manual focusing, you often can achieve focus faster than the camera's autofocus brain can do the job, especially with a moving subject.

Manual focus doesn't mean that you don't get some focusing assistance from the camera, however. The camera offers two indicators to let you know whether it thinks you've achieved focus, as explored in the next two sections.

Verifying focus with the focus indicator lamp

When you press the shutter button halfway, one of the three pairs of focus brackets in the viewfinder turns red. In autofocus mode, this signals you as to the AF-area that the camera will use when establishing focus. When focus is set, the green focus indicator lamp in the viewfinder lights.

You can take advantage of this same focusing cue when you switch to manual focusing. First, press the shutter button halfway to see which pair of focus brackets turns red and is thus currently active. If you want to select a different set of focus brackets, you can do so by pressing the Multi Selector right or left. Now just position your selected brackets over your subject, as illustrated in Figure 6-10, twist the lens focusing ring to set focus, and then press the shutter button halfway. If the camera agrees that you focused correctly on the object in the active brackets, the green focus indicator lights.

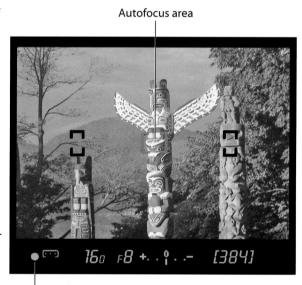

Autofocus area

Focus indicator lamp

Figure 6-10: Even when you focus manually, the focus indicator lights when focus is achieved.

Using the rangefinder to verify manual focus

Normally, the area to the right of the shutter speed and f-stop readout in the viewfinder display is reserved for the exposure meter, introduced in Chapter 5 and shown in Figure 6-10. (It's the little bar graph to the right of the f-stop value.) But if you prefer, you can replace the exposure meter with a focus-distance meter, called the *rangefinder*.

Here's how it works: You take the same manual focusing approach as mentioned in the preceding section, first selecting a pair of focus brackets, positioning the brackets over your subject, and then dialing in focus by twisting the focusing ring on the lens. When you press the shutter button halfway, the rangefinder display indicates whether focus is set on the object in the selected focus brackets. (Remember, those are the ones that appear red when you press the shutter button halfway.)

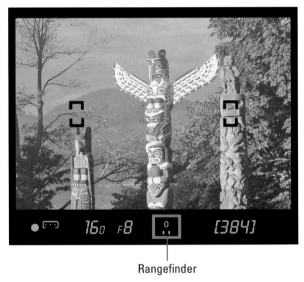

Rangefinder

Figure 6-11: When the rangefinder looks like this, focus is set on the object in the active focus brackets.

If you see just the 0 and a single bar on either side, as in Figure 6-11, the rangefinder is telling you that you're locked on your target. If bars appear to the left of the 0, as shown in the left example in Figure 6-12, focus is set in front of the subject; if the bars are to the right, as in the middle example, focus is slightly behind the subject. The more bars you see, the greater the focusing error. As you twist the focusing ring, the rangefinder updates to help you get focus on track.

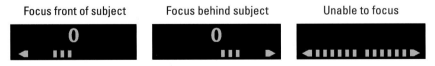

Focus front of subject Focus behind subject Unable to focus

Figure 6-12: These rangefinder readouts indicate a focus problem.

Before I tell you how to activate this feature, I want to point out a couple of issues:

- ✔ You can't use the rangefinder in Manual exposure mode. In that mode, the viewfinder always displays the exposure meter. (You can still confirm focus by checking the focus-indicator lamp, as outlined in the preceding section.)

- ✔ Your lens must offer a maximum aperture (f-stop number) of f/5.6 or lower. To understand f-stops, head back to Chapter 5. The kit lens sold with the D60 meets this qualification.

- ✔ With subjects that confuse the camera's autofocus system, the rangefinder may not work well either; it's based on the same system. If the rangefinder readout looks like the final example in Figure 6-11, the camera can't track focus, so you should just rely on your eyes to make the focus judgment. (Again, adjusting the viewfinder diopter to your eyesight is critical; see Chapter 1 for how-to's.)

If none of those caveats concern you, you can enable the rangefinder display via the Custom Setting menu. Scroll down the menu to highlight the Rangefinder option, as shown in Figure 6-13. Press OK to move to the next screen, highlight On, and press OK again. (If you don't see the Rangefinder option, switch to the Setup menu and set the CSM/Setup Menu option to Full. Only then can you access all the available menu items.)

	CUSTOM SETTING MENU	
13	AE lock	OFF
14	Built-in flash	TTL⚡
15	Auto off timers	LONG
16	Self-timer	⏱10s
17	Remote on duration	⏱1M
18	Date imprint	OFF
19	**Rangefinder**	**ON**

Figure 6-13: You enable the rangefinder via the Custom Setting menu.

After you turn the Rangefinder option to On, the rangefinder automatically replaces the exposure meter in the viewfinder when you switch to manual focusing, assuming that you set the Mode dial to any exposure setting but M (for Manual exposure). Again, you don't have the option to replace the exposure meter with the rangefinder in M exposure mode.

Do you need to worry about not having the exposure meter in the other modes? Well, remember that in the P mode, you don't get an exposure meter anyway, for reasons explained in Chapter 5. The same holds true for the Auto and Digital Vari-Program modes; you don't see an exposure meter for those modes, either. And in A and S modes, the meter still appears in the Shooting Info display if the camera anticipates an exposure problem. So you can always check exposure in the Shooting Info display and then monitor focus through the rangefinder.

That said, I typically leave the Rangefinder off and just rely on the focus indicator lamp to verify focus. I shoot in the S and A exposure modes frequently, and I just find it a pain to have to monitor exposure in the Shooting Info display rather than in the viewfinder. That's not a recommendation to you either way — it's just how I prefer to work.

Manipulating Depth of Field

Getting familiar with the concept of *depth of field* is one of the biggest steps you can take to becoming a more artful photographer. I introduce you to depth of field in Chapters 2 and 5, but here's a quick recap just to hammer home the lesson:

Aperture, f/5.6; Focal length, 300mm

- ✔ *Depth of field* refers to the distance over which objects in a photograph appear sharply focused.

- ✔ With a shallow, or small, depth of field, distant objects appear more softly focused than the main subject (assuming that you set focus on the main subject, of course).

- ✔ With a large depth of field, the zone of sharp focus extends to include objects at a distance from your subject.

Which arrangement works best depends entirely on your creative vision and your subject. In portraits, for example, a classic technique is to use a short depth of field, as I did for the photo in Figure 6-14. This approach increases emphasis on the subject while diminishing the impact of the background. But for the photo shown in Figure 6-15, I wanted to emphasize that the foreground figures were in St. Peter's Square, at the Vatican in Rome, so I used a large depth of field, which kept the background buildings sharply focused and gave them equal weight in the scene.

Figure 6-14: A shallow depth of field blurs the background and draws added attention to the subject.

So exactly how do you adjust depth of field? You have three points of control: aperture, focal length, and camera-to-subject distance, as spelled out in the following list:

✔ **Aperture setting (f-stop):** The aperture is one of three exposure settings, all explained fully in Chapter 5. Depth of field increases as you stop down the aperture (by choosing a higher f-stop number). For shallow depth of field, open the aperture (by choosing a lower f-stop number). Figure 6-16 offers an example; in the f/22 version, focus is sharp all the way through the frame; in the f/13 version, focus softens as the distance from the center lure increases. I snapped both images using the same focal length and camera-to-subject distance, setting focus on the center lure.

Aperture, f/14; Focal length, 42mm

Figure 6-15: A large depth of field keeps both foreground and background subjects in focus.

Aperture, f/22; Focal length, 92mm

Aperture, f/13; Focal length, 92mm

Figure 6-16: A lower f-stop number (wider aperture) decreases depth of field.

✔ **Lens focal length:** In lay terms, *focal length* determines what the lens "sees." As you increase focal length, measured in millimeters, the angle of view narrows, objects appear larger in the frame, and — the important point for this discussion — depth of field decreases. Additionally, the spatial relationship of objects changes as you adjust focal length. As an example, Figure 6-17 compares the same scene shot at a focal length of 127mm and 183mm. I used the same aperture, f/5.6, for both examples.

Aperture, f/5.6; Focal length, 127mm

Aperture, f/5.6; Focal length, 183mm

Figure 6-17: Zooming to a longer focal length also reduces depth of field.

Whether you have any focal length flexibility depends on your lens: If you have a zoom lens, you can adjust the focal length — just zoom in or out. (The D60 kit lens, for example, offers a focal range of 18–55mm.) If you don't have a zoom lens, the focal length is fixed, so scratch this means of manipulating depth of field.

For more technical details about focal length and your D60, see the sidebar "Fun facts about focal length."

✔ **Camera-to-subject distance:** As you move the lens closer to your subject, depth of field decreases. This assumes that you don't zoom in or out to reframe the picture, thereby changing the focal length. If you do, depth of field is affected by both the camera position and focal length.

Together, these three factors determine the maximum and minimum depth of field that you can achieve, as illustrated by my clever artwork in Figure 6-18 and summed up in the following list:

- **To produce the shallowest depth of field:** Open the aperture as wide as possible (the lowest f-stop number), zoom in to the maximum focal length of your lens, and get as close as possible to your subject.

- **To produce maximum depth of field:** Stop down the aperture to the highest possible f-stop number, zoom out to the shortest focal length your lens offers, and move farther from your subject.

Greater depth of field:
Select higher f-stop
Decrease focal length (zoom out)
Move farther from subject

Shorter depth of field:
Select lower f-stop
Increase focal length (zoom in)
Move closer to subject

Figure 6-18: f-stop, focal length, and your shooting distance determine depth of field.

Just to avoid a possible point of confusion that has arisen in some of the classes I teach: When I say *zoom in,* some students think that I mean to twist the zoom barrel *in* toward the camera body. But in fact, the phrase *zoom in* means to zoom to a longer focal length, which produces the visual effect of bringing your subject closer. This requires twisting the zoom barrel of the lens so that it extends further *out* from the camera. And the phrase *zoom out* refers to the opposite maneuver: I'm talking about widening your view of the subject by zooming to a shorter focal length, which requires moving the lens barrel *in* toward the camera body.

Here are a few additional tips and tricks related to depth of field:

✏ When depth of field is a primary concern, try using aperture-priority exposure mode (A). In this mode, detailed fully in Chapter 5, you set the f-stop, and the camera selects the appropriate shutter speed to produce a good exposure. The range of aperture settings you can access depends on your lens.

✏ Some of the Digital Vari-Program modes are also designed with depth of field in mind. Portrait, Child, and Close Up modes produce shortened depth of field; Landscape mode produces a greater depth of field. You can't adjust aperture in these modes, however, so you're limited to the setting the camera chooses.

✏ The extent to which background focus shifts as you adjust depth of field also is affected by the distance between the subject and the background. For increased background blurring, move the subject farther in front of the background.

✏ If you adjust aperture to affect depth of field, be sure to always keep an eye on shutter speed as well. To maintain the same exposure, shutter speed must change in tandem with aperture, and you may encounter a situation where the shutter speed is too slow to permit hand-holding of the camera. Lenses that offer optical image stabilization, or vibration reduction (VR lenses, in the Nikon world), do enable most people to use a slower shutter speed than normal, but double-check your results just to be sure. Or use a tripod for extra security.

Controlling Color

Compared with understanding some aspects of digital photography — resolution, aperture and shutter speed, depth of field, and so on — making sense of your camera's color options is easy-breezy. First, color problems aren't all that common, and when they are, they're usually simple to fix with a quick shift of your D60's white balance control. And getting a grip on color requires learning only a couple of new terms, an unusual state of affairs for an endeavor that often seems more like high-tech science than art.

The rest of this chapter explains the aforementioned white balance control, plus a couple of menu options that enable you to fine-tune the way your camera renders colors. For information on how to use the Retouch menu's color options to alter colors of existing pictures, see Chapters 10 and 11.

Correcting colors with white balance

Every light source emits a particular color cast. The old-fashioned fluorescent lights found in most public restrooms, for example, put out a bluish-greenish light, which is why our reflections in the mirrors in those restrooms always look so sickly. And if you think that your beloved looks especially attractive by candlelight, you aren't imagining things: Candlelight casts a warm, yellow-red glow that is flattering to the skin.

Fun facts about focal length

Every lens can be characterized by its *focal length,* or in the case of a zoom lens, the range of focal lengths it offers. Measured in millimeters, focal length determines the camera's angle of view, the apparent size and distance of objects in the scene, and depth of field. According to photography tradition, a focal length of 50mm is described as a "normal" lens. Most point-and-shoot cameras feature this focal length, which is a medium-range lens that works well for the type of snapshots that users of those kinds of cameras are likely to shoot.

A lens with a focal length under 35mm is characterized as a *wide-angle* lens because at that focal length, the camera has a wide angle of view and produces a long depth of field, making it good for landscape photography. A short focal length also has the effect of making objects seem smaller and farther away. At the other end of the spectrum, a lens with a focal length longer than 80mm is considered a *telephoto* lens and often referred to as a *long lens.* With a long lens, angle of view narrows, depth of field decreases, and faraway subjects appear closer

and larger, which is ideal for wildlife and sports photographers.

Note, however, that the focal lengths stated here and elsewhere in the book are so-called *35mm equivalent* focal lengths. Here's the deal: For reasons that aren't really important, when you put a standard lens on most digital cameras, including your D60, the available frame area is reduced, as if you took a picture on a camera that uses 35mm film negatives (the kind you've probably been using for years) and then cropped it.

This so-called *crop factor,* sometimes also called the *magnification factor,* varies depending on the digital camera, which is why the photo industry adopted the 35mm-equivalent measuring stick as a standard. With the D60, the cropping factor is roughly 1.5. So the 18–55mm kit lens, for example, actually captures the approximate area you would get from a 27–82mm lens on a 35mm film camera. In the figure here, for example, the red outline indicates the image area that results from the 1.5 crop factor.

Photo courtesy Chuck Pace

Note that although the area the lens can capture changes when you move a lens from a 35mm film camera to a digital body, depth of field isn't affected, nor are the spatial relationships between objects in the frame. So when lens shopping, you gauge those two characteristics of the lens by looking at the stated focal length — no digital-to-film conversion math is required.

Science-y types measure the color of light, officially known as *color temperature,* on the Kelvin scale, which is named after its creator. You can see the Kelvin scale in Figure 6-19.

When photographers talk about "warm light" and "cool light," though, they aren't referring to the position on the Kelvin scale — or at least not in the way we usually think of temperatures, with a higher number meaning hotter. Instead, the terms describe the visual appearance of the light. Warm light, produced by candles and incandescent lights, falls in the red-yellow spectrum you see at the bottom of the Kelvin scale in Figure 6-19; cool light, in the blue-green spectrum, appears at the top of the Kelvin scale.

At any rate, most of us don't notice these fluctuating colors of light because our eyes automatically compensate for them. Except in very extreme lighting conditions, a white tablecloth appears white to us no matter whether we view it by candlelight, fluorescent light, or regular houselights.

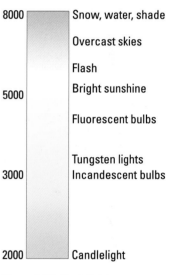

Figure 6-19: Each light source emits a specific color.

Similarly, a digital camera compensates for different colors of light through a feature known as *white balancing.* Simply put, white balancing neutralizes light so that whites are always white, which in turn ensures that other colors are rendered accurately. If the camera senses warm light, it shifts colors slightly to the cool side of the color spectrum; in cool light, the camera shifts colors the opposite direction.

The good news is that, as with your eyes, your camera's Auto white balance setting tackles this process remarkably well in most situations, which means that you can usually ignore it and concentrate on other aspects of your picture. But if your scene is lit by two or more light sources that cast different colors, the white balance sensor can get confused, producing an unwanted color cast like the one you see in the left image in Figure 6-20.

Figure 6-20: Multiple light sources resulted in a yellow color cast in Auto white balance mode (left); switching to the Incandescent setting solved the problem (right).

I shot this product image in my home studio, which I light primarily with a couple of high-powered photo lights that use tungsten bulbs, which produce light with a color temperature similar to regular household incandescent bulbs. The problem is that the windows in that room also permit some pretty strong daylight to filter through. In Auto white balance mode, the camera reacted to that daylight — which has a cool color cast — and applied too much warming, giving my original image a yellow tint. No problem: I just switched the white balance mode from Auto to the Incandescent setting. The right image in Figure 6-20 shows the corrected colors.

There's one little problem with white balancing as it's implemented on your D60, though. You can't make this kind of manual white balance selection if you shoot in the Auto mode or the Digital Vari-Program scene modes. So if you spy color problems in your camera monitor, you need to switch to either P, S, A, or M exposure mode. (Chapter 5 details all four modes.)

The next section explains precisely how to make a simple white balance correction; following that, you can explore some advanced white balance options.

Changing the white balance setting

To switch from automatic to manual white balancing, follow these steps:

1. **Set the camera Mode dial to the P, S, A, or M exposure mode.**

 Again, you can tweak white balance only in these advanced exposure modes.

2. **Display the Shooting Info screen.**

 You can either press the Zoom button or press the shutter button halfway and then release it. (Chapter 1 offers more explanation about using the Shooting Info screen.)

3. **Press the Zoom button to switch from the Shooting Info display to the Quick Settings display.**

 You see the screen shown on the left in Figure 6-21.

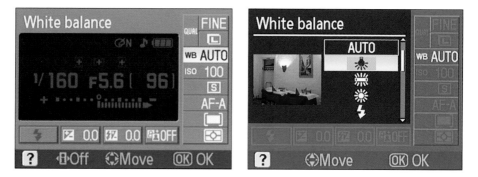

Figure 6-21: WB stands for white balancing.

4. **Use the Multi Selector to highlight the white balance option.**

 The control is the one highlighted in yellow in the left screen in Figure 6-21.

 WB is the standard abbreviation for white balancing, in case you were wondering. The abbreviation AWB is often used for auto white balancing (but not on your D60).

5. **Press OK to display the second screen shown in Figure 6-21.**

Use the Multi Selector to scroll through the list of manual white balance settings. You have seven choices, including a Preset option, which is an advanced setting I discuss in the next section. (You can see only part of the list of choices in Figure 6-21.)

6. **Select the option that most closely matches your primary light source.**

Table 6-1 deciphers the icons used to represent the different light sources; the little example image in the monitor also can help you select the right option.

7. **Press OK.**

You're returned to the Quick Settings display and are now set to take your picture at the selected white balance setting.

I need to share a few more bits of information about this setting:

✏ You also can change the white balance setting from the Shooting menu. Highlight White Balance and then press OK to display the left screen you see in Figure 6-22. Highlight your choice and press OK again.

✏ If you select Fluorescent as the White Balance setting, as shown in Figure 6-22, you can go a step further and specify which type of fluorescent bulb is in use. To do so, you must work through the Shooting menu instead of the Quick Settings display. After highlighting Fluorescent, as shown on the left in Figure 6-22, press the Multi Selector right to display the second screen in the figure. Scroll through the list to highlight the option that most closely matches your bulbs and then press OK. Press OK again, and you're taken to a screen where you can fine-tune the setting even more. If you need to do so, the next section explains; if not, just press OK once more to return to the Shooting menu.

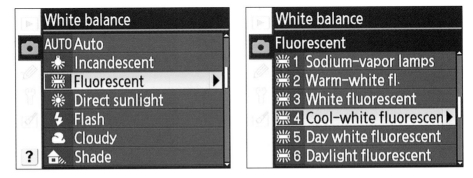

Figure 6-22: You can select a specific type of fluorescent bulb.

✒ Your selected white balance setting remains in force for the P, S, A, and M exposure modes until you change it again. So you may want to get in the habit of resetting the option to the Auto setting after you finish shooting whatever subject it was that caused you to switch to manual white balance mode.

Table 6-1	Manual White Balance Settings
Symbol	*Light Source*
-●-	Incandescent
☰	Fluorescent
☀	Direct sunlight
⚡	Flash
☁	Cloudy
⌂	Shade
PRE	Custom preset

Fine-tuning white balance settings

If you can't get the right amount of color correction from one of the six prefab manual white balance settings, you can do a little fine-tuning via the Shooting menu. Through the White Balance control on that menu, you can adjust the amount of warming or cooling that is applied at the various white balance settings. In fact, you can even specify that you want the camera to apply a little more warming or cooling even in the Auto white balance mode.

Here's how it works:

1. **Display the Shooting menu and highlight the White Balance option, as shown on the left in Figure 6-23.**

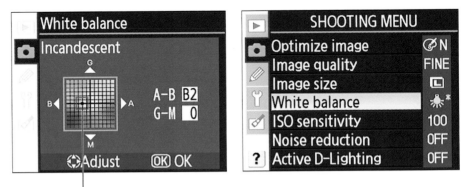

Figure 6-23: You can fine-tune the white balance settings via the Shooting menu.

2. **Press OK to display a list of the available white balance settings, as shown in the right image in Figure 6-23.**

3. **Highlight the setting you want to adjust and press the Multi Selector right.**

 Now you're taken to a screen where you can do your fine-tuning, as shown in the left image in Figure 6-24.

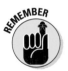

 If you select Fluorescent, you first go to the screen shown in Figure 6-22, where you start the fine-tuning process by selecting a specific type of bulb, as covered in the preceding section. After you highlight your choice, press OK to get to the fine-tuning screen shown in Figure 6-24.

White balance adjustment marker

Figure 6-24: The asterisk next to the icon in the Shooting menu indicates that you fine-tuned the setting.

4. Fine-tune the color adjustment that's applied by the white balance option you chose in Step 3.

You do this by moving the little black square, labeled "White Balance adjustment marker" in Figure 6-24, in the color grid. The grid is set up around two color pairs: Green and Magenta, represented by G and M; and Blue and Amber, represented by B and A. By pressing the Multi Selector, you can move the adjustment marker around the grid.

As you move the marker, the A–B and G–M boxes on the right side of the screen show you the current amount of color shift. A value of 0 indicates the default amount of color compensation applied by the selected white balance setting. In Figure 6-24, for example, I moved the marker two levels toward blue to specify that I wanted colors to be a tad cooler.

If you're familiar with traditional colored lens filters, you may know that the density of a filter, which determines the degree of color correction it provides, is measured in *mireds* (pronounced *my-redds*). The white balance grid is designed around this system: Moving the marker one level is the equivalent of adding a filter with a density of 5 mireds.

5. Press OK to return to the Shooting menu.

Notice the asterisk that appears next to the white balance symbol in the menu, as shown in the right screen in Figure 6-24. That's your reminder that you tweaked the white balance setting. The asterisk also appears with the white balance icon in the Shooting Info display.

Creating a white balance preset

If you can't get the results you want from any of the standard white balance options, even after adjusting them as described in the preceding section, you can go one step further and take advantage of the Preset option on the White Balance menu.

This feature enables you to do two things:

✔ You can base white balance on a direct measurement of the actual lighting conditions, which you accomplish by taking a picture of a white or neutral gray card. This method is usually a faster way to get accurate white balancing than fine-tuning one of the standard settings.

✔ You can match white balance to an existing photo.

The next two sections provide you with the step-by-step instructions for using both of these Preset options.

Setting white balance with direct measurement

To use this technique, you need a small piece of card stock that's either neutral gray or absolute white — not eggshell white, sand white, or any other close-but-not-perfect white. (You can buy reference cards made just for this purpose in many camera stores for under $20.)

Position the reference card so that it receives the same lighting you'll use for your photo. Then take these steps:

1. **Set the camera to the P, S, A, or M exposure mode.**

 If the Shooting Info display or viewfinder reports that your image will be under- or overexposed at the current settings, make the necessary adjustments now. (Chapter 5 tells you how.)

2. **Display the Shooting menu, highlight White Balance, and press OK.**

3. **Highlight PRE (Preset Manual) and then press the Multi Selector right.**

 You need to scroll through the first screen of White Balance settings to get to this option. After you press the Multi Selector right, you see the screen shown on the left in Figure 6-25.

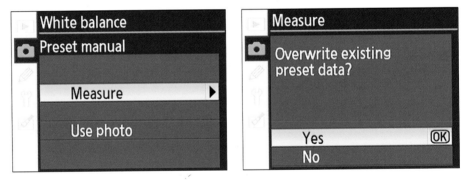

Figure 6-25: You can create a Preset white balance based on a direct measurement of the current light.

4. **Highlight Measure and press the Multi Selector right.**

 Now the screen shown on the right in Figure 6-25 appears.

5. **Highlight Yes and press OK.**

 The camera instructs you to take a picture of your reference card, as shown in the left screen of Figure 6-26. After a second or so, the message disappears, and the screen and the viewfinder display begin to flash. That's your cue to move forward to Step 6.

6. **Aim your lens at your reference card and frame the card so that it completely fills the viewfinder.**

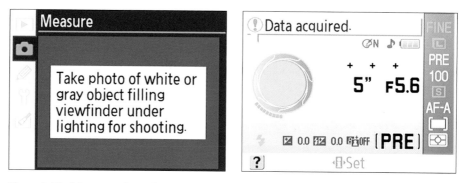

Figure 6-26: After you take a picture of a white or gray reference card, the camera creates your new white balance Preset.

7. **Press the shutter button all the way down.**

 You don't have to worry about focusing for this project.

 If all went well, the message "Data Acquired" appears in the top left corner of the Shooting Info display, as shown in the right screen in Figure 6-26. (No picture is actually recorded.) If you see a message saying that the camera couldn't establish white balance, go back to Step 1 and try again.

Your custom white balance setting remains stored until the next time you work your way through these steps. So anytime you're shooting in the same lighting conditions and want to apply the same white-balance correction, just select PRE from the list of white balance settings.

Matching white balance to an existing photo

Suppose that you're the marketing manager for a small business, and one of your jobs is to shoot portraits of the company big-wigs for the annual report. You build a small studio just for that purpose, complete with a couple of photography lights and a nice, conservative beige backdrop.

Of course, the big-wigs can't all come to get their pictures taken in the same month, let alone on the same day. But you have to make sure that the colors in that beige backdrop remain consistent for each shot, no matter how much time passes between photo sessions. This scenario is one possible use for an advanced white balance feature that enables you to base white balance on an existing photo.

Basing white balance on an existing photo works well only in strictly controlled lighting situations, where the color temperature of your lights is consistent from day to day. Otherwise, the white balance setting that produces color accuracy when you shoot Big Boss Number One may add an ugly color cast to the one you snap of Big Boss Number Two.

To give this option a try, follow these steps:

1. **Copy the picture that you want to use as the reference photo to your camera memory card, if it isn't already stored there.**

 You can copy the picture to the card using a card reader and whatever method you usually use to transfer files from one drive to another. Copy the file to the folder named DCIM, inside the main folder, named 100NCD60 by default. (See Chapter 8 for help with working with files and folders.)

2. **Open the Shooting menu, highlight White Balance, and press OK.**

3. **Select PRE (Preset Manual) and press the Multi Selector right.**

 Again, you must scroll to the second page of White Balance settings to uncover the PRE setting. After you press the Multi Selector right, the screen shown on the left in Figure 6-27 appears.

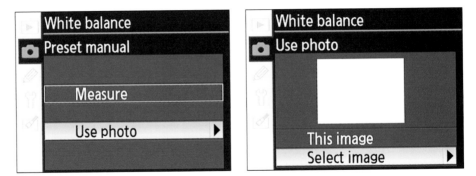

Figure 6-27: You can base white balance on an existing photo.

4. **Highlight Use Photo and press the Multi Selector right.**

 Now you see the second screen shown in Figure 6-27.

5. **Highlight Select Image and press the Multi Selector right.**

 You then see a list of the folders on your memory card, as shown on the left in Figure 6-28. (The folder name appears just as NCD60 on this screen.)

6. **Highlight the folder named NCD60 and press the Multi Selector right.**

 You then see thumbnails of all images in the selected folder. (My folder name reference here assumes that you stick with the default naming system used by your camera. If you create custom folders, a trick you can discover in Chapter 11, select the folder into which you stored your reference image.)

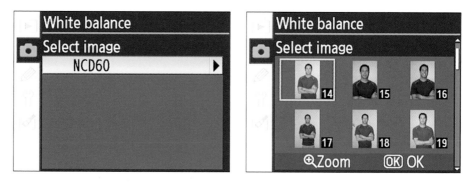

Figure 6-28: Select the folder containing your reference photo (left) and then scroll through your images until your reference photo is highlighted (right).

7. **Highlight your reference photo.**

Just press the Multi Selector right and left as needed to scroll through the thumbnails until the yellow highlight box surrounds the photo.

8. **Press OK.**

White balance is established, and you're returned to the Shooting Info display.

A couple of notes about this feature:

✏ If you later do a direct white balance measurement by shooting a white or gray card, that white balance setting becomes your new preset — the one the camera applies when you select PRE as your white balance setting.

✏ After you go through these steps, the white box shown in the second screen in Figure 6-27 is replaced by the photo you selected as your reference photo. To reload that photo as your white balance preset, just select This Image from that same screen and press OK.

✏ Only photos that you shoot with your D60 can serve as reference photos.

✏ Like the other white balance adjustments, this feature is available only in the P, S, A, or M exposure modes.

Optimizing Image Sharpening and Color

Perched at the top of the Shooting menu, an option called Optimize Image offers you one more way to tweak image sharpening, color, and contrast.

Sharpening, in case you're new to the digital meaning of the term, refers to a software process that adjusts contrast in a way that creates the illusion of slightly sharper focus. I explain sharpening fully in Chapter 10, but the important thing to note for now is that sharpening produces a subtle *tweak* and is not a fix for poor focus.

In fact, many of the adjustments that you can make through the Optimize Image menu are pretty subtle, at least to my eye. The impact of any of these settings varies depending on your subject, but on the whole, if you want to make large-scale changes to color, contrast, or sharpening, you're probably going to need to use your computer and photo editing software.

Again, though, your mileage may vary, as they say, as may your opinion of what constitutes the optimum color and sharpening characteristics. I happen to think that the Nikon default settings are just ducky, but I leave it to you to do your own testing and decide for yourself. (Inspect your test shots on your computer monitor, where the differences produced by the various optimization settings are easier to spot than on the camera monitor or on these pages.)

To explore your options, set your camera Mode dial to one of the advanced exposure modes (P, S, A, or M). Then open the Shooting menu and highlight Optimize Image, as shown in the left screen in Figure 6-29. Press OK to display the menu items you see in the right screen in the figure.

Figure 6-29: You can get even more control over color and sharpness via the Optimize Image menu.

The menu offers you seven options, which produce the following results:

- **Normal:** The default setting, this option captures the image normally — that is, using the characteristics that Nikon offers up as suitable for the majority of subjects.

- **Softer:** This setting reduces image sharpening and contrast a little.

✔ **Vivid:** In this mode, the camera amps up color saturation, contrast, and sharpening. It's designed for users who like bold, big colors and images with sharp edges.

✔ **More Vivid:** This mode does about the same thing as Vivid, but to a higher degree.

✔ **Portrait:** This mode reduces sharpening slightly less than the Softer mode. Nikon recommends this mode for portraits, but either this mode or Softer should work for that purpose. Contrast isn't adjusted in this mode, but colors are tweaked slightly to produce pleasing skin tones.

✔ **Black-and-White:** This setting produces, er, black-and-white photos. Only in the digital world, they're called *grayscale images* because a true black-and-white image contains only black and white, with no shades of gray.

✔ **Custom:** In this mode, you can get even more detailed about how you want your image rendered, tweaking five different characteristics individually. Explaining these options requires drilling down to a whole 'nother level of detail, so I cover them in their very own bulleted list, coming up shortly.

Again, the extent to the settings affect your image depends on the subject as well as the exposure settings you choose and the lighting conditions. But just to give you a general idea of what to expect, Figure 6-30 shows a scene captured at the Normal setting, and Figures 6-31 and 6-32 show how the other settings rendered the same subject.

Normal

As for the Black-and-White setting, I'm not altogether keen on creating grayscale images this way. I prefer to shoot in full color and then do my own grayscale conversion in my photo editor instead of handing the job over to the camera. Assuming that you work with a decent photo editor, you can control what original tones are emphasized in your grayscale version.

Figure 6-30: I took this picture with Optimize Image set to Normal mode.

Just as one example, Figure 6-33 shows you the camera-produced grayscale version of my example photo compared with one that I created in Adobe Photoshop Elements.

Softer

Portrait

Figure 6-31: The Softer and Portrait modes produce slightly softer images.

Vivid

More Vivid

Figure 6-32: Vivid and More Vivid modes increase contrast, saturation, and sharpness.

Also, you can always convert a color image to grayscale, but you can't go the other direction. So if you shoot in the black-and-white mode and then decide you want a color image later, you're out of luck. You do also have the option to create a black-and-white copy of your color image right in the camera, too; Chapter 11 shows you how. Again, though, you don't have control over the conversion as you do in a photo editor.

Camera black-and-white mode Conversion done in photo software

Figure 6-33: I prefer the grayscale conversion I created in my photo editor to the one produced by the camera.

And now the promised details about the Custom optimization mode: If you highlight this option, as shown on the left in Figure 6-34, and press the Multi Selector right, you display a whole new menu, as shown on the right side of the figure. Here's a look at what each menu option enables you to do:

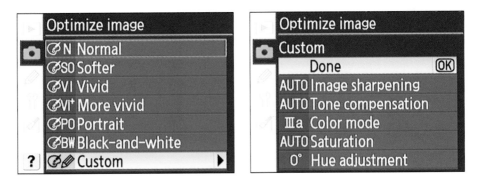

Figure 6-34: You can even create your own custom set of optimization settings.

- ✔ **Image Sharpening:** You can increase or decrease sharpening slightly via this option. The Auto setting results in normal sharpening.

 I really, really advise against cranking up sharpening. An oversharpened image looks grainy and can even exhibit noticeable *sharpening halos* (little strips of light and dark pixels along the edges of high-contrast areas). You can't get rid of these defects easily in a photo editor (if at

all), so it's best to stick with a low level of sharpening and then boost it a little in your photo editor if needed. You can also control exactly where and how the sharpening is applied in your photo editor, which you can't do with in-camera sharpening. See Chapter 10 for the full scoop on sharpening.

That said, even images taken at the High sharpening setting, which applies the maximum amount, don't look drastically different from those shot in the Normal setting. Only if you compare the None setting, which applies no sharpening, and the High setting, do the levels of sharpening appear distinct — and even then, the variations are subtle. For my purposes, the Normal setting seems to work out just fine, but I do regularly sharpen my photos slightly in my photo editor.

✔ **Tone Compensation:** This option adjusts allover contrast. Choose the –1 setting to reduce contrast slightly; select –2 for even more contrast reduction. To go the other direction, choose +1 or +2. Select the 0 setting, Auto, to let the camera handle the decision.

You also can select a Custom setting, but this option is designed to work only with Nikon's Camera Control Pro software. That program enables you to control your camera by using your computer. (See Chapter 8 for details.) If you do buy the software, you can use it to create and store a custom tone compensation setting, or tone *curve,* that you can then apply to your image.

✔ **Color Mode:** Normally, your camera captures images using the sRGB color mode, which simply refers to an industry-standard spectrum of colors. (The *s* is for *standard,* and the RGB is for red-green-blue, which are the primary colors in the digital imaging color world.) This color mode was created to help ensure color consistency as an image moves from camera (or scanner) to monitor and printer; the idea was to create a spectrum of colors that all these devices can reproduce.

However, the sRGB color spectrum leaves out some colors that *can* be reproduced in print and onscreen, at least by some devices. So as an alternative, your camera also enables you to shoot in the Adobe RGB color mode, which includes a larger spectrum (or *gamut)* of colors. Figure 6-35 offers an illustration of the two spectrums.

Note that in the camera menu, you actually get three options. Ia and IIIa both give you sRGB, but the first is customized just a tad to better render portraits. And the second, which is the default, is customized to capture landscapes and nature shots. Choose II for Adobe RGB.

✔ **Saturation:** You get three options here: Normal, Moderate, and Enhanced. Choose Moderate for less saturated colors; go with Enhanced for greater saturation; select Normal for no saturation adjustment. At the default setting, Auto, the camera determines the appropriate saturation level based on the subject.

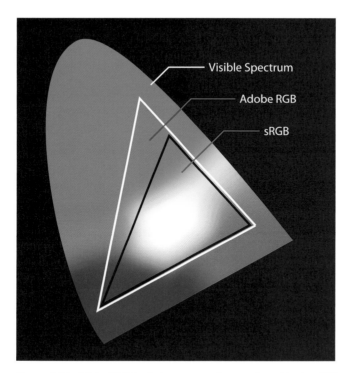

Figure 6-35: Adobe RGB includes some colors not found in the sRGB spectrum.

Here again, I recommend that you don't crank up saturation. Doing so can actually rob your image of subtle details. Where you should have an expanse of pixels that range from medium-high to full saturation, for example, you instead get a big blob of fully saturated pixels. And as with sharpening, you can control saturation adjustments, if needed, with greater precision in a photo editing program.

✔ **Hue Adjustment:** This option is based on the *RGB color wheel,* which plots out hues on a 360-degree circle. The Hue Adjustment option enables you to shift colors around the wheel from –9 degrees to +9 degrees.

In plain English, that means that if you choose a positive value, reds shift toward orange, greens become a little bluer, and blues take on a touch of purple. If you go the other direction, reds become more purple, blues get a little greener, and greens become more yellow. At the default setting, 0, no adjustment is made. Just for fun, Figure 6-36 shows you the result of shooting my example image at –9 and +9, respectively.

Hue +9 Hue −9

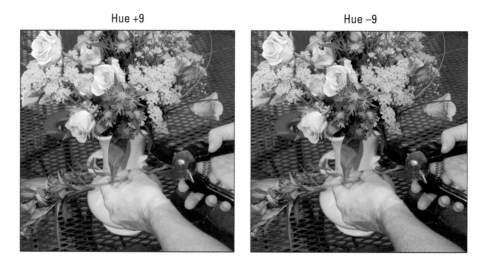

Figure 6-36: The Hue control enables you to shift all colors around the RGB color wheel.

After you select your choice for each of these settings, press OK to return to the main Custom menu. Then scroll up the menu to highlight Done (as shown in Figure 6-34) and then press OK. Don't skip the Done step, or your settings aren't saved, by the way.

Remember that all of these settings apply only to pictures that you take in the P, S, A, and M exposure modes, too; you give up control of these and other picture characteristics when you shoot in full auto or the Digital Vari-Program modes.

Putting It All Together

*E*arlier chapters of this book break down each and every picture-taking feature on your D60, describing in detail how the various controls affect exposure, picture quality, focus, color, and the like. This chapter pulls all that information together to help you set up your camera for specific types of photography.

The first few pages offer a quick summary of 11 critical picture-taking settings that should serve you well no matter what your subject. Following that, I offer my advice on which settings to use for portraits, action shots, landscapes, and close-ups. To wrap things up, the end of the chapter includes some miscellaneous tips for dealing with special shooting situations and subjects.

Keep in mind that although I present specific recommendations here, there are no hard and fast rules as to the "right way" to shoot a portrait, a landscape, or whatever. So don't be afraid to wander off on your own, tweaking this exposure setting or adjusting that focus control, to discover your own creative vision. Experimentation is part of the fun of photography, after all — and thanks to your camera monitor and the Delete button, it's an easy, completely free proposition.

Recapping Basic Picture Settings

Your subject, creative goals, and lighting conditions determine which settings you should use for some picture-taking options, such as aperture and shutter speed. I offer my take on those options throughout this chapter. But for the basic options shown in Table 7-1, I recommend the same settings for almost every shooting scenario, with the few caveats mentioned in the following descriptions:

Table 7-1	All-Purpose Picture-Taking Settings	
Option	*Recommended Setting*	*Menu*
Optimize Image*	Normal	Shooting
Image Quality	JPEG Fine or NEF (Raw)	Shooting
Image Size	Large or medium	Shooting
White Balance*	Auto	Shooting
ISO Sensitivity	100	Shooting
ISO Auto*	Off	Custom Setting
Noise Reduction	Off	Shooting
Focus Mode	AF-A (Auto-servo)	Custom Setting
Release Mode	Action photos: Continuous; all others: Single	Custom Setting
Metering*	Matrix	Custom Setting
Active D-Lighting	Off	Shooting

Adjustable only in P, S, A, and M exposure modes.

- ✔ **Optimize Image:** Through this option, you can adjust image sharpness, color, and contrast. I suggest that you stick with the default setting, Normal, and make such adjustments in your photo software, where you have more control over the outcome. Chapter 6 details the settings if you want to try them out for yourself, however.

- ✔ **Image Quality:** This setting, introduced in Chapter 3, determines the file format, or type, of picture file the camera creates. For best quality, choose JPEG Fine or NEF (Raw). Keep in mind that you must process NEF files in a raw converter; Chapter 8 explains that issue.

✔ **Image Size:** Also covered in Chapter 3, this setting determines resolution (pixel count). The Medium setting (5.6 MP) is fine for everyday photos; select Large (10.2 MP) if you may want to crop the photo, print it very large, or both.

✔ **White Balance:** White balance compensates for the color casts produced by different light sources. Auto mode usually does the trick unless you're dealing with multiple light sources; in that case, you may need to switch to manual white balance control. Chapter 6 tells you how.

✔ **ISO Sensitivity and ISO Auto:** These two settings relate to the light sensitivity of the camera's image sensor. Increasing the ISO Sensitivity value can create noise defects, so stick with the lowest setting possible given the available light. I also recommend that you turn off Auto ISO so that you, and not the camera, control this critical setting. Chapter 5 details both issues.

✔ **Noise Reduction:** This in-camera software filter attempts to remove noise, a defect that can occur when you use a high ISO Sensitivity setting or a very slow shutter speed. I keep this option turned off because it can result in slight loss of image sharpness and adds to the time the camera needs to record the picture to the memory card. For more information, see Chapter 5.

✔ **Focus mode:** Chapter 6 details this option, which affects the autofocus system. In the AF-A (auto-servo) mode, the camera chooses the best autofocus mode based on whether it thinks you're shooting a still or moving subject. In most cases, this setting works well.

✔ **Release mode:** This setting enables you to shift from single-shot shooting — in which you record a single image each time you press the shutter button — to continuous, self-timer, or remote-control shooting. Single mode is the best choice in most cases, but continuous can come in handy for action shots, as covered later in this chapter. And self-timer mode enables you to get into the shot. Chapter 2 explains all the Release mode settings.

✔ **Metering:** This option determines what part of the frame the camera analyzes when calculating exposure. Matrix metering takes the whole frame into account, which produces good results for most scenes. See Chapter 5 for the scoop on the other two options, Center-Weighted and Spot metering.

✔ **Active D-Lighting:** This feature, covered in Chapter 5, is designed to help you capture high-contrast scenes in a way that brightens the darkest areas without simultaneously making the highlights too hot. It can work wonders in the right lighting conditions, but because it also increases the time that the camera needs to process and store the picture file, preventing you from shooting at a quick pace, I recommend that you keep it turned off until you need its help.

A few final reminders:

✏ As indicated in Table 7-1, you can't adjust the Optimize Image, White Balance, ISO Auto, or Metering settings if you shoot in Auto or the Digital Vari-Program scene modes. If you want to tweak these settings, you must set the camera Mode dial to one of the advanced exposure modes (P, S, A, or M).

✏ You can check the status of all settings except Noise Reduction by looking at the Shooting Info display. Figure 7-1 offers a reminder of where to find the various options. Note that the ISO Auto icon doesn't appear if you disable the feature, which is why the icon isn't included in Figure 7-1. If you do turn on the option, you see the letters ISO-A just to the left of the Optimize Image indicator.

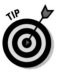

✏ After activating the Shooting Info display, you can press the Zoom button to shift to Quick Settings mode and then adjust most settings through that display instead of digging through the menus. See Chapter 1 for details on adjusting settings this way. The exceptions are the ISO Auto and Optimize Image options, which can be changed only through the menus.

✏ You can quickly enable and disable Active D-Lighting by rotating the Command dial while pressing the button shown in the margin here. The button's on top of the camera, near the shutter button. As long as you hold down the Active D-Lighting button, the viewfinder reports the on/off status of the feature. See Chapter 5 for details.

Figure 7-1: You can monitor critical options in the Shooting Info display.

Setting Up for Specific Scenes

For the most part, the settings detailed in the preceding section fall into the "set 'em and forget 'em" category. That leaves you free to concentrate on a handful of other camera options, such as aperture and shutter speed, that you can manipulate to achieve a specific photographic goal.

The next four sections explain which of these additional options typically produce the best results when you're shooting portraits, action shots, landscapes, and close-ups. I offer a few compositional and creative tips along the way — but again, remember that beauty is in the eye of the beholder, and for every so-called rule, there are plenty of great images that prove the exception.

Shooting still portraits

By "still portrait," I mean that your subject isn't moving. For subjects who aren't keen on sitting still long enough to have their picture taken — children, pets, and even some teenagers I know — skip ahead to the next section and use the techniques given for action photography instead.

Assuming that you do have a subject willing to pose, the classic portraiture approach is to keep the subject sharply focused while throwing the background into soft focus. This artistic choice emphasizes the subject and helps diminish the impact of any distracting background objects in cases where you can't control the setting. The following steps show you how to achieve this look:

1. **Set the Mode dial to A (aperture-priority autoexposure) and select the lowest f-stop value possible.**

 As Chapter 5 explains, a low f-stop setting opens the aperture, which not only allows more light to enter the camera but also shortens depth of field, or the range of sharp focus. So dialing in a low f-stop value is the first step in softening your portrait background. (The f-stop range available to you depends on your lens.) Also keep in mind that the farther your subject is from the background, the more blurring you can achieve.

 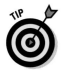

 I recommend aperture-priority mode when depth of field is a primary concern because you can control the f-stop while relying on the camera to select the shutter speed that will properly expose the image. Just rotate the Command dial to select your desired f-stop. (You do need to pay attention to shutter speed also, however, to make sure that it's not so slow that any movement of the subject or camera will blur the image.)

 If you aren't comfortable with this advanced exposure mode, Child and Portrait modes also result in a more open aperture, although the exact f-stop setting is out of your control. Chapter 2 details these two modes.

Whichever mode you choose, you can monitor the current aperture and shutter speed both in the Shooting Info display, as shown on the left in Figure 7-2, and in the viewfinder display, as shown on the right.

Shutter speed and aperture (f-stop)

Figure 7-2: You can view exposure settings in the Shooting Info display or viewfinder.

2. **To further soften the background, zoom in, get closer, or both.**

As covered in Chapter 6, zooming in to a longer focal length also reduces depth of field, as does moving physically closer to your subject.

Avoid using a lens with a short focal length (a wide-angle lens) for portraits. They can cause features to appear distorted — sort of like how people look when you view them through a security peephole in a door.

3. **For indoor portraits, shoot flash-free if possible.**

Shooting by available light rather than flash produces softer illumination and avoids the problem of red-eye. To get enough light to go flash-free, turn on room lights or, during daylight, pose your subject next to a sunny window, as I did for the image in Figure 7-3.

Figure 7-3: For more pleasing indoor portraits, shoot by available light instead of using flash.

In the A exposure mode, simply keeping the built-in flash unit closed disables the flash. In Child or Portrait mode, hold the Flash button on the side of the camera and rotate the Command dial until you see the flash-off symbol (the lightning bolt with a slash) in the Shooting Info display.

If flash is unavoidable, see my list of flash tips at the end of the steps to get better results.

4. For outdoor portraits, use a flash.

Even in bright daylight, a flash adds a beneficial pop of light to subjects' faces, as discussed in Chapter 5 and illustrated here in Figure 7-4.

In the A exposure mode, just press the Flash button on the side of the camera to enable the flash. For daytime portraits, use the fill flash setting. (That's the regular, basic flash mode.) For nighttime images, try red-eye reduction or slow-sync mode; again, see the flash tips at the end of these steps to use either mode most effectively.

Unfortunately, Child and Portrait modes both employ Auto flash, and if the ambient light is very bright, the flash may not fire. Switch to an advanced exposure mode (A, S, P, or M) to regain flash control.

No flash Fill flash

Figure 7-4: To properly illuminate the face in outdoor portraits, use fill flash.

5. **Press and hold the shutter button halfway to establish and lock focus.**

 Make sure that the active autofocus area falls over your subject. In the viewfinder, the active focus area is indicated by the pair of brackets that turns red when you depress the shutter button halfway. Chapter 6 explains more about using autofocus, but if you have trouble, simply set your lens to manual focus mode and then twist the focusing ring to set focus.

6. **Press the shutter button the rest of the way to capture the image.**

Again, these steps just give you a starting point for taking better portraits. A few other tips can also improve your people pics:

- ✓ **Pay attention to the background.** Scan the entire frame looking for intrusive objects that may distract the eye from the subject. If necessary, reposition the subject against a more flattering backdrop. Inside, a softly textured wall works well; outdoors, trees and shrubs can provide nice backdrops as long as they aren't so ornate or colorful that they diminish the subject (for example, a magnolia tree laden with blooms).

- ✓ **Pay attention to white balance if your subject is lit by both flash and ambient light.** If you set the white balance setting to Auto, as I recommend in Table 7-1, enabling flash tells the camera to warm colors to compensate for the cool light of a flash. If your subject is also lit by room lights or sunlight, the result may be colors that are slightly warmer than neutral. This warming effect typically looks nice in portraits, giving the skin a subtle glow. But if you aren't happy with the result or want even more warming, see Chapter 6 to find out how to fine-tune white balance. Again, you can make this adjustment only in P, S, A, or M exposure modes.

- ✓ **When flash is unavoidable, try these tricks to produce better results.** The following techniques can help solve flash-related issues:

 - *Indoors, turn on as many room lights as possible.* With more ambient light, you reduce the flash power that's needed to expose the picture. This step also causes the pupils to constrict, further reducing the chances of red-eye. (Pay heed to my white balance warning, however.)

 - *Try setting the flash to red-eye reduction or slow-sync mode.* If you choose the first option, warn your subject to expect both a pre-flash, which constricts pupils, and the actual flash. And remember that slow-sync flash uses a slower-than-normal shutter speed, which produces softer lighting and brighter backgrounds than normal flash. (Chapter 5 has an example.) This mode is available in P and A exposure modes and is also the default setting in Night Portrait mode.

Remember that the slow shutter speed of slow-sync mode means that you should use a tripod and ask your subject to stay very still to avoid blurring.

- *Soften the flash light by attaching a diffuser to the flash head.* This inexpensive tool both softens and spreads the light. You can see a picture of one type of diffuser in Chapter 5. You may need to bump up exposure slightly to compensate for the light filtering that occurs; the camera doesn't know that you attached the diffuser and therefore doesn't adjust the exposure on its own. In the P, S, and A autoexposure modes, you can use exposure compensation to adjust the image brightness. As an alternative, you can increase the flash power slightly. Chapter 5 details these exposure features.

- *For professional results, use an external flash with a rotating flash head.* Then aim the flash head upward so that the flash light bounces off the ceiling and falls softly down onto the subject. An external flash isn't cheap, but the results make the purchase worthwhile if you shoot lots of portraits. Compare the two portraits in Figure 7-5 for an illustration. In the first example, the built-in flash resulted in strong shadowing behind the subject and harsh, concentrated light. To produce the better result on the right, I used the Nikon Speedlight SB-600 and bounced the light off the ceiling.

Figure 7-5: To eliminate harsh lighting and strong shadows (left), I used bounce flash and moved the subject farther from the background (right).

• *To reduce shadowing from the flash, move your subject farther from the background.* I took this extra step for the right image in Figure 7-5. The increased distance not only reduced shadowing but also softened the focus of the wall a bit (because of the short depth of field resulting from my f-stop and focal length).

A good general rule is to position your subjects far enough from the background that they can't touch it. If that isn't possible, though, try going the other direction: If the person's head is smack up against the background, any shadow will be smaller and less noticeable. For example, you get less shadowing when a subject's head is resting against a sofa cushion than if that person is sitting upright, with the head a foot or so away from the cushion.

✓ **Frame the subject loosely to allow for later cropping to a variety of frame sizes.** Your D60 produces images that have an aspect ratio of 3:2. That means that your portrait perfectly fits a 4-x-6-inch print size but will require cropping to print at any other proportions, such as 5 x 7 or 8 x 10. Chapter 9 talks more about this issue.

Capturing action

A fast shutter speed is the key to capturing a blur-free shot of any moving subject, whether it's your tennis-playing teen, a spinning Ferris wheel, or, as in the case of Figure 7-6, a butterfly dancing from flower to flower. In the left image, a shutter speed of 1/125 second was too slow, resulting in some slight blurring of the butterfly. For the right image, I bumped the shutter speed up to 1/320 second, which "froze" the butterfly.

1/125 second 1/320 second

Figure 7-6: Raising the shutter speed produced the blur-free image on the right.

Along with the basic capture settings outlined in Table 7-1, try the techniques in the following steps to photograph a subject in motion:

1. **Set the Mode dial to S (shutter-priority autoexposure).**

 In this mode, you control the shutter speed, and the camera takes care of choosing an aperture setting that will produce a good exposure.

 If you aren't ready to step up to this advanced exposure mode, explained in Chapter 5, try using Sports mode, detailed in Chapter 2. But be aware that you have no control over any other aspects of your picture (such as white balance, flash, and so on) in that mode.

2. **Rotate the Command dial to select the shutter speed.**

 Refer to Figure 7-7 to locate shutter speed in the Shooting Info display. After you select the shutter speed, the camera selects an aperture (f-stop) to match.

 What shutter speed do you need exactly? Well, it depends on the speed at which your subject is moving, so some experimentation is needed. But generally speaking, 1/500 second should be plenty for all but the fastest subjects (race cars, boats, and so on). For very slow subjects, you can even go as low as 1/250 or 1/125 second.

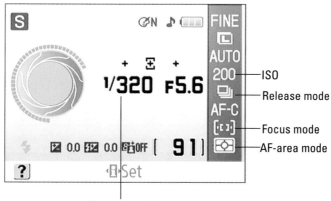

Shutter speed

Figure 7-7: Changing the Release mode to Continuous allows rapid-fire shooting.

3. **Raise the ISO setting or add flash to produce a brighter exposure if needed.**

 In dim lighting, you may not be able to get a good exposure at your chosen shutter speed without taking this step. Raising the ISO does increase the possibility of noise, but a noisy shot is better than a blurry shot. Figure 7-7 reminds you of where to find the current ISO setting in the Shooting Info display. (Note that in Sports mode, the camera automatically overrides your ISO setting if it deems it necessary. For more on this automatic ISO adjustment, see Chapter 5.)

Adding flash is a bit tricky for action shots, unfortunately. First, the flash needs time to recycle between shots, so try to go without if you want to capture images at a fast pace. Second, the built-in flash has limited range — so don't waste your time if your subject isn't close by. And third, remember that the fastest shutter speed you can use with flash is 1/200 second, which may not be high enough to capture a quickly moving subject without blur.

If you do decide to use flash, you must bail out of Sports mode, though; it doesn't permit you to use flash.

4. For rapid-fire shooting, set the Release mode to Continuous.

In this mode, you can capture multiple images with a single press of the shutter button. As long as you hold down the button, the camera continues to record images, at a pace of up to three frames per second.

To achieve the maximum frames-per-second rate, you need to focus manually and select a shutter speed of 1/250 second or higher. Also, you can't take advantage of flash; as soon as you enable the flash, you're limited to taking one shot at a time even if you select Continuous as your Release mode.

To adjust the Release mode, display the Shooting Info screen, and press the Zoom button to switch to the Quick Settings display. Highlight the Release mode option (look for it in the position labeled in Figure 7-7), press OK, select a mode, and press OK again.

5. For fastest shooting, switch to manual focusing.

Again, manual focusing helps you get the fastest frames-per-second rate because you then eliminate the time the camera needs to lock focus in autofocus mode. Chapter 1 shows you how to focus manually, if you need help.

If you do use autofocus, try these two autofocus settings for best performance:

- Set the AF-area mode to Dynamic Area.
- Set the Focus mode to AF-C (continuous-servo autofocus).

Chapter 6 details these autofocus options, which you can select via the Quick Settings display. The options appear set to my recommended settings in Figure 7-7. You may not actually need to change the Focus mode,

though; in the auto-servo mode, AF-A, which is the default setting, the camera automatically shifts to continuous-servo autofocus if it senses movement from the subject.

6. **Turn off Image Review and Active D-Lighting to speed up the camera even more.**

 You turn off Image Review via the Custom Setting menu. Turning the option off can help speed up the time your camera needs to recover between shots. Active D-Lighting also increases the time the camera needs to record the image; you can turn off this feature via the Shooting menu or by simply pressing the Active D-Lighting button on top of the camera as you rotate the Command dial.

7. **Compose the subject to allow for movement across the frame.**

 In my example images, for instance, I zoomed out to a wide view so that my subject wouldn't fly out of the frame.

8. **Lock in autofocus (if used) in advance.**

 Press the shutter button halfway to do so. Now when the action occurs, just press the shutter button the rest of the way. Your image-capture time is faster because the camera has already done the work of establishing focus.

Using these techniques should give you a better chance of capturing any fast-moving subject. But action-shooting strategies also are helpful for shooting candid portraits of kids and pets. Even if they aren't currently running, leaping, or otherwise cavorting, snapping a shot before they do move or change positions is often tough. So if an interaction or scene catches your eye, set your camera into action mode and then just fire off a series of shots as fast as you can.

For example, one recent afternoon, I spotted my furball and his equally fluffy new neighbor introducing themselves to each other through the fence that separates their yards. I ran and grabbed my camera, flipped it into shutter-priority mode, and just started shooting. Most of the images were throwaways; you can see some of them in Figure 7-8. But somewhere around the tenth frame, I captured the moment you see in Figure 7-9, which puts a whole new twist on the phrase "gossiping over the backyard fence." Two seconds later, the dogs got bored with each other and scampered away into their respective yards, but thanks to a fast shutter, I got the shot that I wanted.

Figure 7-8: I used speed-shooting techniques to capture this interaction between a pair of pups.

Figure 7-9: Although most of the shots were deletable, this one was a keeper.

Capturing scenic vistas

Providing specific capture settings for landscape photography is tricky because there's no single best approach to capturing a beautiful stretch of countryside, a city skyline, or other vast subject. Take depth of field, for example: One person's idea of a super cityscape might be to keep all buildings in the scene sharply focused. But another photographer might prefer to shoot the same scene so that a foreground building is sharply focused while the others are less so, thus drawing the eye to that first building.

That said, I can offer a few tips to help you photograph a landscape the way *you* see it:

✓ **Shoot in aperture-priority auto-exposure mode (A) so that you can control depth of field.** If you want extreme depth of field, so that both near and distant objects are sharply focused, as in Figure 7-10, select a high f-stop value. For short depth of field, use a low value.

You can also use the Landscape Digital Vari-Program scene mode to achieve the first objective. In this mode, the camera automatically selects a high f-stop number, but you have no control over the exact value (or any other picture-taking settings).

✓ **If the exposure requires a slow shutter, use a tripod to avoid blurring.** The downside to a high f-stop is that you need a slower shutter speed to produce a good exposure. If the shutter speed drops below what you can comfortably hand-hold — for me, that's

Figure 7-10: Use a high f-stop value (or Landscape mode) to keep foreground and background sharply focused.

about 1/50 second — use a tripod to avoid picture-blurring camera shake. No tripod handy? Look for any solid surface on which you can steady the camera. Of course, you can always increase the ISO Sensitivity setting to allow a faster shutter, too, but that option brings with it the chances of increased image noise. See Chapter 5 for details.

✔ **For dramatic waterfall shots, consider using a slow shutter to create that "misty" look.** The slow shutter blurs the water, giving it a soft, romantic appearance. Figure 7-11 shows you a close-up of this effect. Again, use a tripod to ensure that the rest of the scene doesn't also blur due to camera shake.

✔ **At sunrise or sunset, base exposure on the sky.** The foreground will be dark, but you can usually brighten it in a photo editor if needed. If you base exposure on the foreground, on the other hand, the sky will become so bright that all the color will be washed out — a problem you usually can't fix after the fact.

As an alternative, turn on Active D-Lighting. With this feature enabled, the camera brightens dark areas but doesn't alter the highlights, leaving your sky colors intact. Chapter 5 explains more about this feature. (Remember, you can turn Active D-Lighting on and off by pressing the button you see in the margin here as you rotate the Command dial.)

Figure 7-11: For misty waterfalls, use a slow shutter speed (and tripod).

✔ **For cool nighttime city pics, experiment with slow shutter.** Assuming that cars or other vehicles are moving through the scene, the result is neon trails of light like those you see in the foreground of the image in Figure 7-12, taken by my friend Jonathan Conrad. Shutter speed for this image was 5 seconds.

Instead of changing the shutter speed manually between each shot, try *bulb* mode. Available only in M (manual) exposure mode, this option records an image for as long as you hold down the shutter button. So just take a series of images, holding the button down for different lengths of time for each shot. In bulb mode, you also can exceed the standard maximum shutter speed of 30 seconds.

✔ **For the best lighting, shoot during the "magic hours."** That's the term photographers use for early morning and late afternoon, when the light cast by the sun is soft and warm, giving everything that beautiful, gently warmed look.

Can't wait for the perfect light? Tweak your camera's white balance setting, using the instructions laid out in Chapter 6, to simulate magic-hour light.

✓ **In tricky light, bracket exposures.** *Bracketing* simply means to take the same picture at several different exposures to increase the odds that at least one of them will capture the scene the way you envision. Bracketing is especially a good idea in difficult lighting situations such as sunrise and sunset.

In manual exposure mode, simply adjust the aperture or shutter speed between each shot to do this. In P, S, or A autoexposure modes, you instead must use the Exposure Compensation control to achieve a brighter or darker exposure than what the camera considers appropriate. Chapter 5 details this control. Unfortunately, you can't take advantage of Exposure Compensation in any of the fully automatic exposure modes, but you can choose to enable or disable Active D-Lighting.

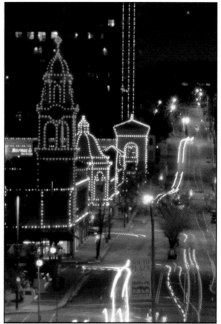

Jonathan Conrad

Figure 7-12: A slow shutter also creates neon light trails in city-street scenes.

✓ **Worry about wide-angle distortion later.** Shooting with a wide-angle lens can cause vertical structures to appear to tilt either inward or outward, as in Figure 7-13. You can't do anything to avoid this problem, known as *convergence,* unless you buy a very expensive lens designed especially to avoid it.

Figure 7-13: Converging verticals are a fact of life with most wide-angle lenses.

Fortunately, many photo editing programs enable you to adjust the perspective of your images to straighten things out again. I used the Correct Camera Distortion filter found in Adobe Photoshop Elements to produce the corrected image in Figure 7-14.

Figure 7-14: I used a correction filter in Photoshop Elements to straighten things out.

Capturing dynamic close-ups

For great close-up shots with your Nikon, start with the basic capture settings outlined in Table 7-1. Then try the following additional settings and techniques:

- **Check your owner's manual to find out the minimum close-focusing distance of your lens.** How "up close and personal" you can get to your subject depends on your lens, not the camera body itself.

- **Take control over depth of field by setting the camera mode to A (aperture-priority autoexposure) mode.** Whether you want a shallow, medium, or extreme depth of field depends on the point of your photo. In classic nature photography, for example, the artistic tradition is a very shallow depth of field, as shown in Figure 7-15, and requires an open aperture (low f-stop value). For this image, the f-stop was f/5.6. But if you want the viewer to be able to

Figure 7-15: Shallow depth of field is a classic technique for close-up floral images.

clearly see all details throughout the frame — for example, if you're shooting a product shot for your company's sales catalog — you need to go the other direction, stopping down the aperture as far as possible.

Not ready for the advanced exposure modes yet? Try the Close Up scene mode instead. (It's the one marked with the little flower on your Mode dial.) In this mode, the camera automatically opens the aperture to achieve a short depth of field and bases focus on the center of the frame.

✓ **Remember that zooming in and getting close to your subject both decrease depth of field.** So back to that product shot: If you need depth of field beyond what you can achieve with the aperture setting, you may need to back away, zoom out, or both. (You can always crop your image to show just the parts of the subject that you want to feature.)

✓ **When shooting flowers and other nature scenes outdoors, pay attention to shutter speed, too.** Even a slight breeze may cause your subject to move, causing blurring at slow shutter speeds.

✓ **Use flash for better outdoor lighting.** Just as with portraits, a tiny bit of flash typically improves close-ups when the sun is your primary light source. However, keep in mind that the maximum shutter speed possible when you use flash is 1/200 second. So in very bright light, you may need to use a high f-stop setting to avoid overexposing the picture. If you shoot in an advanced exposure mode (M, P, S, or A), you can also adjust the flash output via the camera's Flash Compensation control. Chapter 5 offers details about flash and flash compensation.

✓ **When shooting indoors, try not to use flash as your primary light source.** Because you'll be shooting at close range, the light from your flash may be too harsh even at a low Flash Compensation setting. If flash is inevitable, turn on as many room lights as possible to reduce the flash power that's needed — even a hardware-store shop light can do in a pinch as a lighting source. (Remember that if you have multiple light sources, though, you may need to tweak the white balance setting.)

✓ **To really get close to your subject, invest in a macro lens or a set of diopters.** A true macro lens, which enables you to get really, really close to your subjects, is an expensive proposition; expect to pay around $200 or more. But if you enjoy capturing the tiny details in life, it's worth the investment.

For a less expensive way to go, you can spend about $40 for a set of *diopters,* which are sort of like reading glasses that you screw onto your existing lens. Diopters come in several strengths — +1, +2, +4, and so on — with a higher number indicating a greater magnifying power. I took this approach to capture the extreme close-up in Figure 7-16, attaching a +2 diopter to my lens. The downfall of diopters, sadly, is that they typically produce images that are very soft around the edges, as in Figure 7-16 — a problem that doesn't occur with a good macro lens.

Coping with Special Situations

A few subjects and shooting situations pose some additional challenges not already covered in earlier sections. So to wrap up this chapter, here's a quick list of ideas for tackling a variety of common "tough-shot" photos:

- ✔ **Shooting through glass:** To capture subjects that are behind glass, try putting your lens right flat against the glass. Then switch to manual focusing; the glass barrier can give the autofocus mechanism fits. Disable your flash to avoid creating any unwanted reflections, too. I used this technique at the zoo to capture the snake image you see in Figure 7-17.

- ✔ **Shooting out a car window:** Set the camera to shutter-priority autoexposure or manual mode and dial in a fast shutter speed to compensate for the movement of the car. Oh, and keep a tight grip on your camera.

- ✔ **Shooting in strong backlighting:** When the light behind your subject is very strong, the result is often an underexposed subject. You have a couple of options: You can turn on your flash, assuming that the subject isn't beyond its reach. Or you can turn on Active D-Lighting, which captures the image in a way that retains better detail in the shadows without blowing out highlights. (Chapter 5 offers an example.)

But for another creative choice, you can purposely underexpose the subject to create a silhouette effect, as

Figure 7-16: To extend your lens' close-focus ability, you can add magnifying diopters.

Figure 7-17: He's watching you . . .

shown in Figure 7-18. Just base your exposure on the sky and turn off Active D-Lighting so that the darker areas of the frame remain dark. (For indoor silhouettes, you must disable your flash.)

✔ **Shooting fireworks:** First off, use a tripod; fireworks require a long exposure, and trying to handhold your camera simply isn't going to work. If using a zoom lens, zoom out to the shortest focal length. Switch to manual focusing and set focus at infinity (the farthest focus point possible on your lens). Set the exposure mode to manual, choose a relatively high f-stop setting — say, f/16 or so — and start a shutter speed of 1 to 3 seconds. From there, it's simply a matter of experimenting with different shutter speeds.

Be especially gentle when you press the shutter button — with a very slow shutter, you can easily create enough camera movement to blur the image. If you purchased the accessory remote control for your camera, this is a good situation in which to use it.

Figure 7-18: Experiment with shooting backlit subjects in silhouette.

You also may want to enable your camera's noise-reduction feature because a long exposure also increases the chances of noise defects. See Chapter 5 for details. (Keep the ISO Sensitivity setting low to further dampen noise.)

✔ **Shooting reflective surfaces:** In outdoor shots taken in bright sun, you can reduce glare from reflective surfaces such as glass and metal by using a *circular polarizing filter,* which you can buy for about $40. A polarizing filter can also help out when you're shooting through glass, as I did for my snake image.

But know that in order for the filter to work, the sun, your subject, and your camera lens must be precisely positioned. Your lens must be at a 90-degree angle from the sun, for example, and the light source must also be reflecting off the surface at a certain angle and direction. In addition, a polarizing filter also intensifies blue skies in some scenarios, which may or may not be to your liking. In other words, a polarizing filter isn't a surefire cure-all.

A more reliable option for shooting small reflective objects is to invest in a light cube or light tent such as the ones shown in Figure 7-19, from Cloud Dome (www.clouddome.com) and Lastolite (www.lastolite.com), respectively. You place the reflective object inside the tent or cube and then position your lights around the outside. The cube or tent acts as a light diffuser, reducing reflections. Prices range from about $50 to $200, depending on size and features.

Cloud Dome, Inc. Lastolite Limited

Figure 7-19: Investing in a light cube or tent makes photographing reflective objects much easier.

Part III
Working with Picture Files

In this part . . .

You've got a memory card full of pictures. Now what? Now you turn to the first chapter in this part, which explains how to get those pictures out of your camera and onto your computer and, just as important, how to safeguard them from future digital destruction. After downloading your files, head for Chapter 9, which offers step-by-step guidance on printing your pictures, sharing them online, and even viewing them on your television.

Downloading, Organizing, and Archiving Your Photos

*F*or many novice digital photographers (and even some experienced ones), the task of moving pictures to the computer and then keeping track of all of those image files is one of the more confusing aspects of the art form. In fact, students in my classes have more questions about this subject than just about anything else.

Frankly, writing about the download and organizing process isn't all that easy, either. (I know, poor me!) The problem is that providing you with detailed instructions is pretty much impossible because the steps you need to take vary widely depending on what software you have installed on your computer and whether you use the Windows or Macintosh operating system.

To give you as much help as possible, however, this chapter shows you how to transfer and organize pictures using the free Nikon software that came in your camera box. After exploring these discussions, you should be able to adapt the steps to any other photo program you may prefer.

This chapter also covers a few other aspects of handling your picture files, including converting pictures taken in the NEF (Raw) format to a standard image format. Finally — and perhaps most important — this chapter explains how to ensure that your digital images stay safe after they leave the camera.

One note before you dig in: Most figures in this chapter and elsewhere feature the Windows Vista operating system. If you use some other version of Windows or own a Mac, what you see on your screen may look slightly different but should contain the same basic options unless I specify otherwise.

Sending Pictures to the Computer

You can take two approaches to moving pictures from your camera memory card to your computer:

- **Connect the camera directly to the computer.** For this option, you need to dig out the USB cable that came in your camera box. Your computer must also have a free USB slot, or *port,* in techie talk. If you're not sure what these gadgets look like, Figure 8-1 gives you a look.

The little three-pronged icon, labeled in Figure 8-1, is the universal symbol for USB. Be sure to check for this symbol because a different type of slot, called a FireWire slot, looks very similar to a USB slot, and your USB cable can even seem to fit (sort of) into a FireWire slot.

USB icon

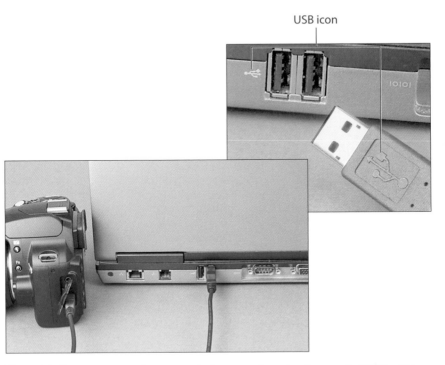

Figure 8-1: You can connect the camera to the computer using the supplied USB cable.

↙ **Transfer images using a memory card reader.** Many computers now also have slots that accept common types of memory cards. If so, you can simply pop the card out of your camera and into the card slot instead of hooking the camera up to the computer.

As another option, you can buy stand-alone card readers such as the SanDisk model shown in Figure 8-2. This particular model accepts a variety of memory cards, including the SD Card used by your D60. Check your printer, too; many printers now have card slots that serve the purpose of a card reader.

Courtesy SanDisk Corporation

 I prefer to use a card reader, for two reasons: First, when you transfer via the camera, the camera must be turned on during the process, wasting battery power. Second, with a card reader, I don't have to keep track of that elusive camera cable. And third, when I copy photos to my desktop system, transferring via the camera requires that I get down on all fours to plug the cable into the computer's USB slot, which is of

Figure 8-2: A card reader offers a more convenient method of image transfer.

course located in the least convenient spot possible. The card reader, by contrast, stays perched on my desk, connected to my computer at all times, so there's very little physical activity involved in transferring pictures, which is how I prefer to live my life.

If you want to transfer directly from the camera, however, the next section explains some important steps you need to take to make that option work. If you choose to use a card reader, skip ahead to the section "Starting the transfer process" to get an overview of what happens after you insert the card into the reader.

Connecting the camera and computer

You need to follow a specific set of steps when connecting the camera to your computer. Otherwise, you can damage the camera or the memory card.

Also note that in order for your camera to communicate with the computer, the computer must be running one of the following operating systems:

✔ Windows Vista 32-bit Home Basic, Home Premium, Business, Enterprise, or Ultimate edition

✔ Windows XP with Service Pack 2, Home or Professional edition

✔ Mac OS X 10.3.9 or 10.4 and higher

If you use another OS (operating system, for the non-geeks in the crowd), check the support pages on the Nikon Web site (www.nikon.com) for the latest news about any updates to system compatibility. You can always simply transfer images with a card reader, too.

With that preamble out of the way, here are the steps to link your computer and camera:

1. **Assess the level of the camera battery.**

 Just look at the little battery-status indicator in the top-right corner of the Shooting Info display. If the battery is low, charge it before continuing. Running out of battery power during the transfer process can cause problems, including lost picture data. Alternatively, if you purchased the optional AC adapter, use that to power the camera during picture transfers.

2. **Turn the computer on and give it time to finish its normal startup routine.**

3. **Turn the camera off.**

4. **Insert the smaller of the two plugs on the USB cable into the USB port on the side of the camera.**

 The slot is hidden under a little rubber door just around the corner from the four buttons that flank the left side of the monitor, as shown in Figure 8-3. Gently pry open the little door and insert the cable end into the slot.

5. **Plug the other end of the cable into the computer's USB port.**

 Be sure to plug the cable into a port that is actually built into the computer, as opposed to one that's on your keyboard or part of an external USB hub. Those accessory-type connections can sometimes foul up the transfer process.

USB port

Figure 8-3: The USB slot is hidden under the little rubber door on the left rear side of the camera.

6. **Turn the camera on.**

 What happens now depends on whether you connected the camera to a Windows-based or Mac computer and what photo software you have installed on that system. The next section explains the possibilities and how to proceed with the image transfer process.

7. **When the download is complete, turn off the camera and then disconnect it from the computer.**

 I repeat: Turn off the camera before severing its ties with the computer. Otherwise, you can damage the camera.

Starting the transfer process

After you connect the camera to the computer (be sure to carefully follow the steps in the preceding section) or insert a memory card into your card reader, your next step depends, again, on the software installed on your computer and the computer operating system.

Here are the most common possibilities and how to move forward:

✔ **On a Windows-based computer, a Windows message box similar to the one in Figure 8-4 appears.** Again, the figure shows the dialog box as it appears on a computer running Windows Vista. Whatever its design, the dialog box suggests different programs that you can use to download your picture files. Which programs appear depend on what you have installed on your system; if you installed Nikon Transfer, for example, it should appear in the program list, as in the figure. In Windows Vista, just click the transfer program that you want to use. In other versions of Windows, the dialog box may sport an OK button; if so, click that button to proceed.

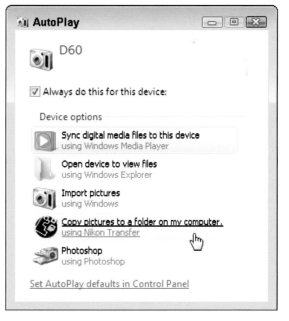

Figure 8-4: Windows may display this initial boxful of transfer options.

If you want to use the same program for all of your transfers, select the Always Do This for This Device check box, as shown in the figure. The next time you connect your camera or insert a memory card, Windows will automatically launch your program of choice instead of displaying the message box.

✔ **An installed photo program automatically displays a photo-download wizard.** For example, the Nikon Transfer downloader or a downloader associated with Adobe Photoshop Elements, Picasa, or some other photo software may leap to the forefront. On a Mac, the built-in iPhoto software may display its auto downloader. (Apple's Web site, www.apple.com, offers excellent video tutorials on using iPhoto, by the way.)

Usually, the downloader that appears is associated with the software that you most recently installed. Each new program that you add to your system tries to wrestle control over your image downloads away from the previous program.

If you don't want a program's auto downloader to launch whenever you insert a memory card or connect your camera, you should be able to turn that feature off. Check the software manual to find out how to disable the auto launch.

✔ **Nothing happens.** Don't panic; assuming that your card reader or camera is properly connected, all is probably well. Someone — maybe even you — simply may have disabled all the automatic downloaders on your system. Just launch your photo software and then transfer your pictures using whatever command starts that process. (I show you how to do it with Nikon Transfer later in the chapter; for other programs, consult the software manual.)

As another option, you can use Windows Explorer or the Mac Finder to simply drag and drop files from your memory card to your computer's hard drive. Whether you connect the card through a card reader or attach the camera directly, the computer sees the card or camera as just another drive on the system. So the process of transferring files is exactly the same as when you move any other file from a CD, DVD, or other storage device onto your hard drive.

In the next sections, I provide details on using Nikon Transfer to download your files and Nikon ViewNX to view and organize your pictures. Remember, if you use some other software, the concepts are the same, but check your program manual to get the small details. In most programs, you also can find lots of information by simply clicking open the Help menu.

Downloading and Organizing Photos with the Nikon Software

Remember unpacking your camera box when you first brought home your D60? Did you notice a CD-ROM called Nikon Software Suite? If you haven't already done so, dig out that CD and pop it into your computer's CD drive. Then install the following two programs:

- ✔ **Nikon Transfer:** This program assists you with the process of transferring pictures from your camera or memory card to the computer.

- ✔ **Nikon ViewNX:** After downloading your files, you can view and organize your picture files using this program. You also can print and e-mail your photos from ViewNX.

Safeguarding your digital photo files

To make sure that your digital photos enjoy a long, healthy life, follow these storage guidelines:

- ✔ Don't rely on your computer's hard drive for long-term, archival storage. Hard drives occasionally fail, wiping out all files in the process. This warning applies to both internal and external hard drives.

- ✔ Camera memory cards, flash memory keys, and other portable storage devices are similarly risky. All are easily damaged if dropped or otherwise mishandled. And being of diminutive stature, these portable storage options also are easily lost.

- ✔ The best way to store important files is to copy them to nonrewritable CDs. (The label should say CD-R, not CD-RW.) Look for quality, brand-name CDs that have a gold coating, which offer a higher level of security than other coatings.

- ✔ Recordable DVDs offer the advantage of holding lots more data than a CD. However, as of today, no DVDs offer the longer-life, archival gold coating that you can get with some CDs. In addition, the DVDs you create on one computer may not be playable on another because multiple recording formats and disc types exist: DVD minus, DVD plus, dual-layer DVD, and so on. So I use DVDs only for noncritical images; precious family photos go on CDs.

- ✔ Online photo-sharing sites such as Shutterfly, Kodak Gallery, and the like aren't designed to be long-term storage tanks for your images. Consider them only a backup to your backup, and read the site terms carefully so that you understand how long the site will hold onto your files if you stop buying prints and other products. Also investigate whether the terms of membership give the site permission to use and distribute your photos without your say-so. In other words, the fine print is important.

The CD also contains a copy of Apple QuickTime, which you can use to play any stop-motion movies that you create using the process that I cover in Chapter 9, and Microsoft DirectX, which is a Windows tool. Your system may already have these latter two programs; if so, check to see whether the version on the CD is more current than what you already have. (Ask your local computer nerd to help if you're not sure how to make the call.)

Note that this book features Nikon Transfer version 1.0.2 and Nikon ViewNX version 1.0.4, which were the most current at the time of publication. If you own an earlier version of these programs, visit the Nikon Web site to install them. (To find out what versions you have installed open the program in question. Then, in Windows, choose Help⇨About. On a Mac, choose the About command from the Nikon Transfer or Nikon ViewNX menu.)

The next five sections give you the most basic of introductions to using Nikon Transfer and ViewNX. If you want more details, just look in the Help system built into the programs. (Click the Help menu to access the system.)

Before you move on, though, I want to clear up one common point of confusion: You can use the Nikon software to download and organize your photos and still use any photo-editing software you prefer. And to do your editing, you don't need to re-download photos — after you transfer photos to your computer, you can access them from any program, just as you can any file that you put on your system. In fact, you can set things up so that you can select a photo in ViewNX and then open that picture in your chosen photo editor with a click or two. (I explain how to do this in aforementioned "Linking ViewNX to a photo editor.")

Downloading with Nikon Transfer

The following steps explain how to download new pictures to your computer using Nikon Transfer:

1. **Attach your camera or insert a memory card into your card reader, as outlined in the first part of this chapter.**

 Depending on what software you have installed on your system, you may see the initial Nikon Transfer window, as shown in Figure 8-5. Or, in Windows, you may see a dialog box similar to the one shown in Figure 8-4. In that case, click the item that has the Nikon Transfer logo, as shown in Figure 8-4.

 If nothing happens, start Nikon Transfer by using the same process you use to launch any program on your computer. (If some other photo software pops up, close it first.)

2. **On the Source tab, click the icon for the camera or memory card drive that holds your pictures.**

Figure 8-5: Nikon Transfer makes transferring images to your computer a painless process.

If you're transferring directly from the camera, you see a D60 icon, as in Figure 8-5. If you're transferring images from a memory-card reader, the icon title should either bear the name of your card reader or have a generic label such as Removable Disk plus a drive letter — E, F, or the like — instead of carrying the D60 moniker.

3. **Click the Thumbnails arrow to expand the dialog box, as shown in Figure 8-6.**

 I labeled the arrow in Figure 8-6. After you click it, you can see thumbnail previews of all the images on your memory card. (You may want to maximize or enlarge the program window so that you can see more previews at a time.)

4. **Select the images that you want to download.**

 A check mark in the little box under a thumbnail tells the program that you want to download the image. Just click the box to toggle the check mark on and off.

 You also can select images quickly by using these tricks:

 • *Select all images.* Click the little icon labeled Select All in Figure 8-6.

 • *Select protected images.* If you used the in-camera functions to protect pictures (see Chapter 4), you can select just those images by clicking the Protected icon, also labeled in Figure 8-6.

 • *Deselect all images.* Click the Deselect icon, labeled in Figure 8-6.

Deselect All

Select Protected

Hide/Display Thumbnails Select box Select All

Figure 8-6: Select the check boxes of the images that you want to download.

5. **Click the Primary Destination tab at the top of the window.**

 When you click the tab, the top of the transfer window offers options that enable you to specify where and how you want the images to be stored on your computer. Figure 8-7 offers a close-up look at these controls.

6. **Choose the folder where you want to store the images from the Primary Destination Folder drop-down list.**

 If the folder you want to use isn't in the list, choose Browse from the bottom of the list and then track down the folder and select it.

 By default, the program puts images in a folder titled Nikon Transfer, which is housed inside a folder named My Pictures in Windows XP and Pictures in Windows Vista and on a Mac. That My Pictures or Pictures folder is itself housed inside a folder that your system creates automatically for each registered user of the computer.

Figure 8-7: Specify the folder where you want to put the downloaded images.

You don't have to stick with this default location — you can put your pictures anywhere you please. But because most photo programs automatically look for pictures in these standard folders, putting your pictures there just simplifies things a little down the road. Note that you can always move your pictures into other folders after you download them if needed, too. The upcoming section "Organizing pictures" explains how to do so in Nikon ViewNX.

7. **Specify whether you want the pictures to be placed inside a new subfolder.**

If you select the Create Subfolder for Each Transfer option, the program creates a new folder inside the storage folder you selected in Step 6. Then it puts all the pictures from the current download session into that new subfolder. You can either use the numerical subfolder name the program suggests (001, in Figure 8-7) or click the Edit button to set up your own naming system. If you created custom folders on the camera memory card, an option you can explore in Chapter 11, select the Copy Folder Names from Camera check box to use those folder names instead.

8. **Tell the program whether you want to rename the picture files during the download process.**

 If you do, select the Rename Photos During Transfer check box. Then click the Edit button to display a dialog box where you can set up your new filenaming scheme. Click OK after you do so to close the dialog box.

9. **Click the Preferences tab to set the rest of the transfer options.**

 Now the tab shown in Figure 8-8 takes over the top of the program window. Here you find a number of options that enable you to control how the program operates. Most of the options are self-explanatory, but a couple warrant a few words of advice:

 - *Launch automatically when device is attached.* Deselect this check box if you *don't* want Nikon Transfer to start every time you connect your camera to your computer or insert a memory card into your card reader.

 - *Transfer new photos only.* This option, when selected, ensures that you don't waste time downloading images that you've already transferred but are still on the memory card.

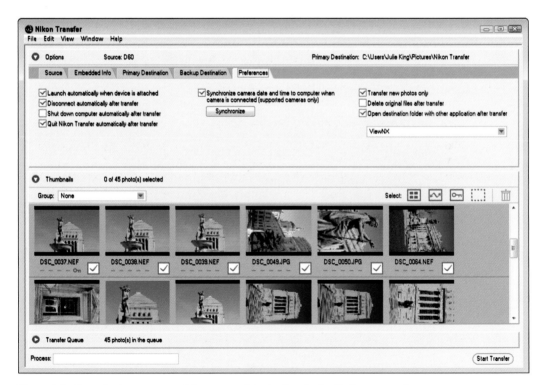

Figure 8-8: Control other aspects of the program's behavior via the Preferences tab.

• *Delete original files after transfer.* Turn this option off, as shown in Figure 8-8. Otherwise, your pictures are automatically erased from your memory card when the transfer is complete. You should always check to make sure the pictures really made it to the computer before you delete them from your memory card. (See Chapter 4 to find out how to use the Delete function on your camera.)

• *Open destination folder with other application after transfer.* By default, Nikon Transfer shuts itself down when the file download is complete, and Nikon ViewNX then starts automatically so that you can view and organize your images. If you want to use a program other than ViewNX for that task, open the drop-down list, click Browse, and select the program from the dialog box that appears. Click OK after doing so.

Your choices remain in force for any subsequent download sessions, so you don't have to revisit this tab unless you want the program to behave differently.

10. **When you're ready to start the download, click the Start Transfer button.**

It's located in the lower-right corner of the program window. After you click the button, the Process bar in the lower-left corner indicates how the transfer is progressing. Again, what happens when the transfer is complete depends on the choices you made in Step 9; by default, Nikon Transfer closes, and ViewNX opens, automatically displaying the folder that contains your just-downloaded images.

Browsing images in Nikon ViewNX

Nikon ViewNX is designed to do exactly what its name suggests: enable you to view and organize the pictures that you shoot with your D60. Of course, you can also view images that weren't captured by your D60 — photos that you scanned, received from friends via e-mail, or took with a different model of digital camera, for example. The only requirement is that the file format is one that ViewNX can read; for still photos, that means JPEG, TIFF, or NEF, which is the Nikon flavor of Camera Raw. (Chapter 3 explains file formats.) The program also can play the stop-motion movie files that you create with your D60. For a complete rundown of supported file formats, check the Appendix section of the built-in program Help system.

Figure 8-9 offers a look at the ViewNX window as it appears by default in Windows Vista. The Mac version is nearly identical, although it features the usual Mac "look and feel" instead of the Microsoft Windows design.

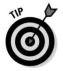

On either type of system, you can customize a variety of aspects of the window layout by using the options on the View and Window menus.

File Directory tab

Zoom slider

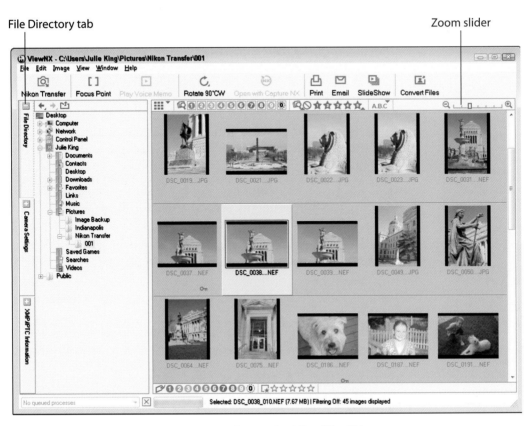

Figure 8-9: You can browse and organize your photos using Nikon ViewNX.

To start viewing your pictures, first display the File Directory panel along the left side of the program window, as shown in Figure 8-9. You can display the panel by choosing Window⇨File Directory or simply clicking the File Directory tab, labeled in the figure. Now open the folder that holds the photos you want to view. (If you came to ViewNX directly after downloading pictures via Nikon Transfer, the folder that holds the new images should already be selected for you.) Thumbnails of those images should then appear on the right side of the program window, as in the figure.

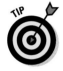

By opening the View menu, you can choose from three different viewing options, which work as follows:

- ✔ **Thumbnail Grid:** This is the default layout, shown in Figure 8-9. You can adjust the size of the thumbnails by dragging the Zoom slider, labeled in the figure.

- ✔ **Image Viewer:** This option displays your images as shown in Figure 8-10. Small thumbnails appear along the top of the pane; the selected thumbnail appears in the larger preview area underneath. Use these maneuvers to inspect your images:

- To select an image, just click its thumbnail.

- Magnify or reduce the size of the thumbnails and the preview by using the Zoom sliders labeled in Figure 8-10.

- Drag in the large preview to scroll the display as needed to view hidden parts of the photo.

- To scroll through your images, click the little arrows atop the large preview, labeled Previous Image and Next Image in the figure.

- You can display a histogram for the current image by choosing Window⇨Histogram⇨RGB. To hide the histogram, choose Off from the same menu. This histogram is a little more complicated than the one you can display on the camera monitor, which I explain in Chapter 4, however, because it breaks down the image brightness values into the core red, green, and blue components that comprise a digital photo. If you want to learn about this type of histogram, the ViewNX Help system offers a good background lesson.

Previous Image Next Image Zoom sliders

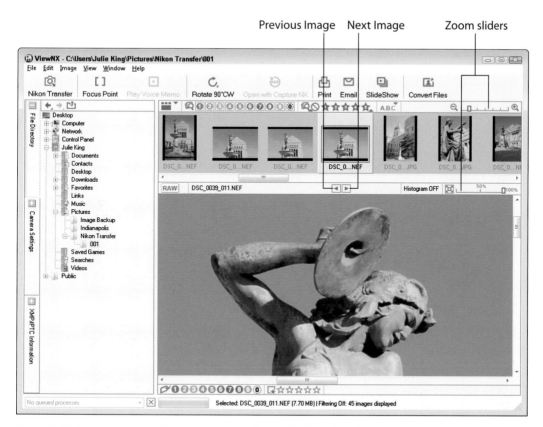

Figure 8-10: Change to Image View display to see images in filmstrip style.

✏ **Full Screen:** Want to see a photo at full-screen size, as shown in Figure 8-11? If you're working in Thumbnail Grid view, just double-click the picture thumbnail. In Image Viewer view, first click the thumbnail to display it in the large preview. Then double-click the large preview. Or, in either view, click the thumbnail and then press the letter F.

In Full Screen view, as in the other views, you can magnify the image by dragging the Zoom slider. To view additional photos at full-screen size, click the Previous Image and Next Image arrows at the top of the window. (See Figure 8-11.) To return to the main browser window, just click the window's close button or press Esc on your keyboard.

Figure 8-11: Use the arrows to scroll images in full-screen view.

 In addition to seeing the images themselves, you also can inspect the picture *metadata,* which refers to extra data that the camera stores in the picture file. This metadata shows you all the settings that you used to capture the image, along with the capture date and time. For details, see the next section.

Viewing picture metadata

When you snap a picture with your D60, the camera includes in the picture file some extra data that records all the critical camera settings that were in force. This data, known by nerds as *metadata*, also includes the capture date and time. And, if you take advantage of the Image Comment feature that I cover in Chapter 11, you can even store a brief bit of custom text, such as the shooting location.

Reviewing this data is a great way to better understand what settings work best for different types of pictures, especially when you're just getting up to speed with aperture, shutter speed, white balance, and all the other digital photography basics. To get the full story on how each setting affects your pictures, see Chapters 5 and 6.

To view the metadata in ViewNX, first select an image by clicking its thumbnail in the ViewNX browser window. Then click the Camera Settings tab on the left side of the window or choose Window⇨Camera Settings. The metadata information then replaces the File Directory information, as shown in Figure 8-12.

Within the Camera Settings panel, the metadata is divided into several sections of related capture settings: File Info 1, File Info 2, Camera Info, Exposure, Flash, and so on. To hide or display a section, click the triangle next to its name — I labeled one of the little guys in Figure 8-12. You may need to use the scroll bar along the right side of the panel to view all the available information. (Note that Nikon supplies ViewNX with cameras other than the D60, and some categories of data apply only to those other models.)

In addition to the information on the Camera Settings panel, you can glean one other bit of shooting information by clicking the Focus Point button on the toolbar. When you do, a red bracket appears on the image thumbnails and previews. That bracket serves the same purpose as the one that appears in the camera viewfinder when you lock focus: It indicates which part of the frame the camera used to establish focus. To turn off the focus indicator, click the Focus Point button again. Check out Chapter 2 for an introduction to how the camera decides which bracket to use when you use autofocusing; Chapter 6 offers more focus tips.

Organizing pictures

When you download pictures from your camera using Nikon Transfer, you can specify where on your computer's hard drive you want to store those images. After you get the images on the system, you can further organize them in ViewNX. You can create new folders and subfolders, move images from one folder to another, rename and delete images, and more.

Camera Settings tab

Hide/Display panel

Figure 8-12: Inspecting metadata is a great way to see what settings work best for different subjects and lighting conditions.

To begin organizing your images, first display the File Directory panel by clicking its tab on the left side of the program window. In this panel, you can see and manage the contents of all the drives and folders on your computer. From here, you can set up and rearrange your image storage closet as follows:

✓ **Hide/display the contents of a drive or folder.** See a little plus sign (Windows) or right-pointing triangle (Mac) next to a drive or folder? Click it to display the contents of that storage bin. A minus sign (Windows) or a down-pointing triangle (Mac) means that the drive or folder is open; click that minus sign or triangle to close the drive or folder.

✓ **Create a new folder.** First, click the drive or folder where you want to house the new folder. For example, if you want to create it inside your Pictures or My Pictures folder, click it. Icons representing all the folders and files currently found within that folder then appear in the image thumbnail area.

Next, choose File➪New Folder. An icon representing the new folder should then appear, with the name box activated, as shown in Figure 8-13. Type the folder name and press Enter.

You can create as many new folders and subfolders as you like. I prefer to organize my images according to subject matter — for example, in Figure 8-13, I created a folder called Indianapolis and then created two folders inside, one to hold pictures from our local zoo and one to hold pictures of downtown landmarks. But you can set up any system that makes sense to you.

New Folder icon

Figure 8-13: I prefer to sort my images into folders based on subject.

- **Move a photo from one folder to another.** First, display that photo's thumbnail in the browser. Then just drag the thumbnail to the destination folder in the File Directory pane.

- **Delete a photo.** In Windows, click the image thumbnail and then choose Edit⇨Delete or press the Delete key. On a Mac, choose Edit⇨Move to Trash or press ⌘+Delete. You then see a message asking you to confirm that you really want to trash the photo. Click Yes if you want to move forward.

- **Protect or unlock photos.** If you used the Protect feature on your camera's Playback menu to "lock" a photo, a process you can explore in Chapter 4, you need to remove the protection if you want to edit the image in your photo software. To do so, choose File⇨Protect Files⇨Unprotect.

 You also can protect images in ViewNX; just choose Protect from the File⇨Protect Files submenu. A little key icon then appears on the image thumbnail to remind you that the image is now protected from editing or erasing. If you later want to delete the file, you must first unprotect it.

- **Select multiple files for moving, deleting, or other actions.** Click the thumbnail of the first image and then Ctrl+click (Windows) or ⌘+click (Mac) the rest. To select all images in the current folder, press Ctrl+A (Windows) or ⌘+A (Mac.)

As your image collection grows, also investigate the ViewNX keywords, tags, and rating functions. You access these options via the XMP/IPTC tab on the left side of the program window. These functions, along with the program's search feature, provide you with various tools that make locating specific pictures easier, including the option to search for pictures based on the shooting date.

In case you're curious about the name of that third tab, IPTC refers to text data that press photographers are often required to tag onto their picture files, such as captions and copyright information. XMP refers to a data format developed by Adobe to enable that kind of data to be added to the file. IPTC stands for International Press Telecommunication Council; XMP stands for Extensible Metadata Platform.

Linking ViewNX to a photo editor

Nikon ViewNX offers no photo editing or retouching tools. So if you want to crop your photos, correct exposure or color, or make any other changes, you need a different program. The next section offers some advice on picking the right program for the type of photo editing you want to do.

After you choose a photo editing program, you can open your pictures in that program through ViewNX. Here's how: Select a thumbnail in ViewNX and then choose File⇨Open With Another Application. A submenu pops up, listing any

programs on your system that have already been set up as the default pro-
grams for handling the type of file you selected. (Some programs establish
this setting upon installation.) If your photo editor appears on the submenu,
just select that program. Your photo editor starts up, and your file is opened
in that program, ready for editing.

If your photo editor doesn't appear on the submenu, follow these steps to
put it there:

1. **Choose File⇨Open with Another Application⇨Register.**

 You see the Options dialog box, where you can establish all sorts of pro-
 gram preferences. The Open with Application part of the dialog box is
 displayed automatically, as shown in Figure 8-14.

2. **Click the Add button.**

 What happens next — and what you need to do in response — varies
 depending on whether you use a Windows-based PC or a Mac:

Figure 8-14: Click the Add button to link your photo editor to ViewNX.

- *Windows:* After you click the Add button, you see the Choose Application dialog box, shown in Figure 8-15. The box presents a list of potential programs that are installed on your system. If the program you want to use is listed, click it and then click OK and skip to Step 6. Otherwise, click the Other button and move on to Step 3.

- *Mac:* Clicking the Add button displays a Finder window, with the Applications folder automatically opened for you.

3. **Select the file that launches the program that you want to use and click Open (Windows) or Select (Mac).**

In Windows, files that launch programs have the three-letter file extension *exe* tagged onto the end of the filename. On a Mac, dig into the main program folders and look for the program's graphical icon.

After you choose a program, you're returned to the Options dialog box.

4. **Verify that the program is now listed in the box on the right side of the Options dialog box.**

5. **To add additional programs, repeat Steps 2–4.**

You can add as many programs as you like to the list of potential photo editors.

6. **Click OK to close the Options dialog box.**

To open pictures in your photo editor, just click its thumbnail in ViewNX, choose File➪Open with Another Application, and select the program from the submenu.

Choose Application

- Adobe Photoshop Elements 6.0 (Editor)
- Adobe Reader 8.1
- Internet Explorer
- Media Center
- Notepad
- Paint
- Windows Calendar
- Windows Media Player
- Windows Wordpad Application

 OK

 Cancel

 Other...

Figure 8-15: In Windows, click Other if you don't see the program you want to use listed in this box.

Exploring Other Software Options

If all you want to do with your digital photos is organize, print, and share them online, Nikon ViewNX may suit your needs just fine. But if you want to retouch your photos or use them in creative projects such as digital scrapbook pages or greeting cards, you need to invest in another program.

Here are just some of the products to consider:

✔ **Beginning/consumer programs:** Unless you're retouching photos for professional purposes or want to get into photo editing at a serious level for other reasons, a program such as Adobe Photoshop Elements ($100, www.adobe.com) is a good fit. Elements has been the best-selling consumer photo editor for some time, and for good reason. With a full complement of retouching tools, onscreen guidance for novices, and an assortment of tools and templates for creating artistic photo projects, Elements offers all the features that most consumers need, including a built-in photo organizing tool.

Figure 8-16 offers a look at Elements 6 for Windows; the Mac version looks similar, although it follows the usual Mac design conventions for window controls and the like.

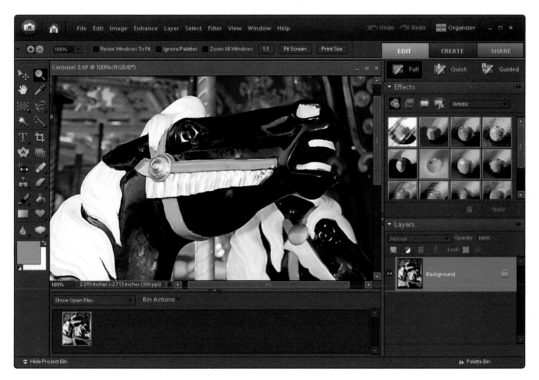

Figure 8-16: Adobe Photoshop Elements offers a good balance of power and ease of use.

For other candidates in this category and price range, visit the Web sites of Corel (www.corel.com) and ArcSoft (www.arcsoft.com). Both companies offer multiple programs aimed at the beginner-to-intermediate user.

✔ **Advanced/professional tools:** The best-known option in this category is Adobe Photoshop (www.adobe.com). Photoshop offers professional-grade photo editing tools and, unfortunately, carries a professional-grade price of $650. If that seems like too big a hit on your budget, Nikon's own Capture NX software, pictured in Figure 8-17 and priced at $150, may be a good alternative. You can check it out further at www.nikon.com.

Both programs offer powerful photo retouching tools plus built-in photo organizers; Photoshop also provides tools needed by people preparing images for commercial printing, Web design, and other high-end uses. Expect to spend lots of time getting up to speed with either program, however, as you don't get the friendly interfaces and guidance offered by the beginner-level programs. Nor do these advanced programs offer the automated photo-creation features, such as greeting card templates and clip art, that you find in consumer programs.

Other programs aimed at the professional market include Apple Aperture ($300, www.apple.com) and Adobe Lightroom (also $300, www.adobe.com). These two programs are geared toward users who routinely need to process lots of images but who typically do only light retouching work. Figure 8-18 offers a look at Aperture.

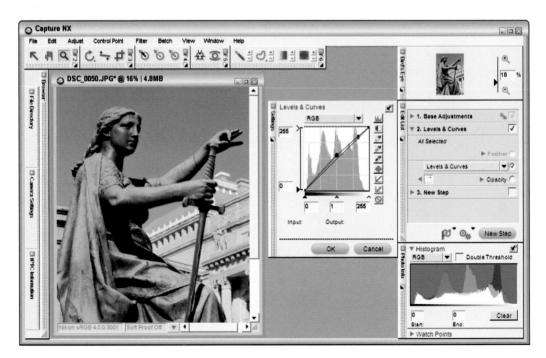

Figure 8-17: Nikon Capture NX offers powerful tools but can be intimidating to novices.

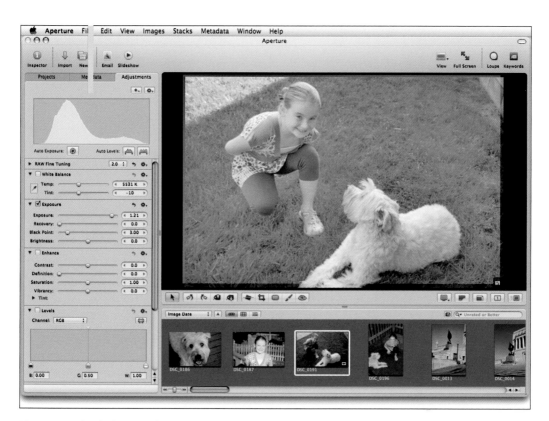

Figure 8-18: Apple Aperture is geared to users who need to quickly process lots of images.

A few important tips before you buy:

✏ Check the software's system requirements to make sure that your computer can run the program. Some of the products I mention here aren't available for Macintosh computers; Apple Aperture, on the other hand, isn't available for Windows-based systems. Also make sure that your computer offers the system memory (RAM), processor speed, and other components that the software requires.

✏ If you shoot in the Raw format (NEF, on your Nikon), be sure that the software you choose includes a good Raw converter tool. You need this tool to process your Raw images and then save them in a standard image format (JPEG or TIFF). See the next section for details on this process.

✏ You also can buy stand-alone photo organizing programs if you aren't interested in serious photo editing but want a more powerful image-management tool than ViewNX. Check out the offerings in this category from ACDSee (www.acdsee.com), ThumbsPlus (www.thumbsplus.com), and Extensis (www.extensis.com).

You may be amused, as I am, to know that the photo industry uses the term *DAM* software — for digital asset management — to refer to the function provided by image-organizing programs. (I dare you to walk into your local computer store and ask where you can find the DAM software. Wait; I double-dare you.)

✔ Many software companies enable you to download free trials from their Web sites so that you can actually use the software for a short period to make sure that it fits your needs.

Processing Raw (NEF) Files

Chapter 3 introduces you to the Camera Raw file format, which enables you to capture images as raw data. The advantage of capturing Raw files, which are called NEF files on Nikon cameras, is that you make the decisions about how to translate the raw data into an actual photograph. You can specify attributes such as color intensity, image sharpening, contrast, and so on — all of which are handled automatically by the camera if you use its other file format, JPEG.

The bad news: You have to specify attributes such as color intensity, image sharpening, contrast, and so on before you can do much with your pictures. You can't share them online, print them from most programs other than Nikon ViewNX, or edit them in your photo software until you process them using a tool known as a Raw converter. At the end of the conversion process, you save the finished file in a standard file format, such as JPEG or TIFF.

With the D60, you have a couple of Raw processing options:

✔ **Use the in-camera processing feature.** Through the Retouch menu, you can process your Raw images right in the camera. You can specify only limited image attributes (color, sharpness, and so on), and you can save the processed files only in the JPEG format, but still, having this option is a nice feature. See the next section for details.

✔ **Process and convert in ViewNX.** ViewNX also offers a Raw processing feature. Again, the controls for setting picture characteristics are a little limited, but you can save the adjusted files in either the JPEG or TIFF format. The last section of this chapter walks you through this option.

✔ **Use Nikon Capture NX or a third-party Raw conversion tool.** For the most control over your Raw images, you need to open up your wallet

and invest in a program that offers a truly capable converter. Several of the programs described in the preceding section, including Capture NX, offer good Raw converters.

As mentioned earlier, though, Capture NX is a little pricey and can be overwhelming in terms of learning curve for beginners. Figure 8-19 shows an alternative that's less expensive and, in my experience, easier for novices to understand: the converter found in Adobe Photoshop Elements 6. The Adobe Camera Raw converter, known in the industry as ACR, is widely considered one of the best available, and buying Elements is a low-priced way to access that tool. (Note that the converter in Elements doesn't offer all the bells and whistles of the version of ACR provided with Photoshop, however.)

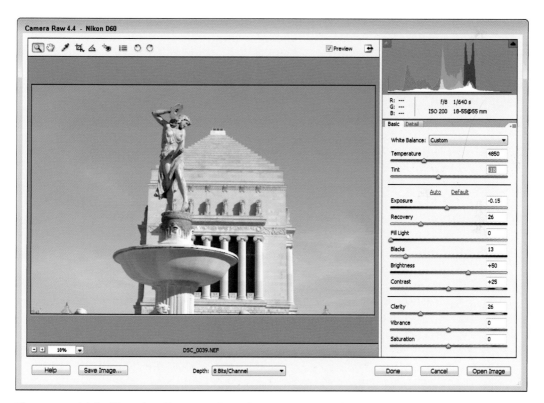

Figure 8-19: Adobe Photoshop Elements offers a very good Raw converter.

If you do opt for a third-party conversion tool, check the program's Help system for details on how to use the various controls, which vary from program to program. The following general tips apply no matter what converter you use, however:

- Whenever possible, save your processed files in a nondestructive format, such as TIFF, or in Adobe Photoshop or Photoshop Elements, save them in the PSD format. For top quality, don't save originals in the JPEG format, which applies *lossy compression.* You can read about the potential damage to image quality that lossy compression creates in Chapter 3. If you need a JPEG image to share online, Chapter 9 shows you how to create a duplicate of your original, converted image in that format.

- Some Raw converters give you the option of creating a 16-bit image file. (A *bit* is a unit of computer data; the more bits you have, the more colors your image can contain.) Many photo editing programs either can't open 16-bit files or limit you to a few editing tools, so I suggest you stick with the standard, 8-bit image option. Your image will contain more than enough colors, and you'll avoid potential conflicts caused by so-called *high-bit* images.

- Resist the temptation to crank up color saturation too much. Doing so can actually destroy image detail. Likewise, be careful about overdoing sharpening, or you can create noticeable image defects. Chapter 10 offers some additional information about sharpening and saturation to help you find the right amounts of each.

Using your mouse as a shutter button

Along with ViewNX and Capture NX, Nikon offers a piece of specialty software known as Nikon Camera Control Pro, which sells for about $70. Whereas ViewNX and Capture NX are designed for working with pictures after you shoot them, Camera Control Pro enables you to use your computer to operate your camera.

While your camera is connected to your computer, the software displays a window that contains clickable controls for adjusting all the standard camera settings, from aperture to white balance. When you get those options established, you click another button to record whatever scene is in front of your camera lens.

What's the point? Well, Camera Control Pro is great in scenarios that make having a live photographer close to the subject either difficult or dangerous — for example, trying to get a shot of a chemical reaction in a science lab or to capture an image of an animal that's shy around humans. Additionally, the software enables easy time-lapse photography, enabling you to set the camera to take pictures automatically at specified intervals over a period of minutes, hours, or even days.

Processing Raw images in the camera

Scroll past the initial screen of options on the Retouch menu, and you come to a menu item called NEF (Raw) Processing, as shown in Figure 8-20. With this feature, you can process Raw files right in the camera — no computer or other software required.

I do want to share two reservations about this option:

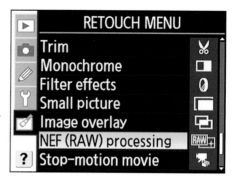

✔ First, you can save your processed files only in the JPEG format. As discussed in Chapter 3, that format results in some quality loss because of the file compression that JPEG applies. You can choose the level of JPEG compression you want to apply during Raw processing; you can create a JPEG Fine, Normal, or Basic file. Each of those settings produces the same quality as you get when you shoot new photos in the JPEG format and select Fine, Normal, or Basic from the Image Quality menu.

Figure 8-20: You can process NEF images and save them as JPEGs right in the camera.

Chapter 3 details the JPEG options, but, long story short, choose Fine for the best JPEG quality. And if you want to produce the absolute best quality from your Raw images, use a software solution and save your processed file in the TIFF format instead.

✔ You can make adjustments to exposure, color, and image sharpness as part of the in-camera Raw conversion process. Evaluating the effects of your adjustments on the camera monitor can be difficult because of the size of the display, so for really tricky images, you may want to forgo in-camera conversion and do the job on your computer, where you can get a better view of things. If you do go the in-camera route, make sure that the monitor brightness is set to its default position so that you aren't misled by the display. (Chapter 1 shows you how to adjust monitor brightness via the Setup menu.)

That said, in-camera Raw processing offers a quick and convenient solution when you need JPEG copies of your NEF images for immediate online sharing. (JPEG is the standard format for online use.) Follow these steps to get the job done:

1. **Display the Retouch menu and highlight NEF (RAW) Processing, as shown in Figure 8-20.**

 Again, you need to scroll past the first screen of menu items to get to this option.

2. Press the OK button.

Now you see a screen similar to the one in Figure 8-21, with thumbnails of Raw images that are stored on your memory card. JPEG images are hidden from view.

3. Navigate to the image that you want to process.

Just use the Multi Selector to move the yellow highlight box over the image.

Figure 8-21: Highlight an image and press OK to start the conversion process.

4. Press OK.

Up pops the screen shown in Figure 8-22, only with a thumbnail showing your image instead of mine. This screen is command central for specifying what settings you want the camera to use when creating the JPEG version of your Raw image.

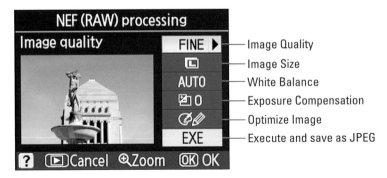

Figure 8-22: After setting the conversion options, highlight EXE and press OK.

5. Set the conversion options.

Along the right side of the screen, you see a vertical column offering five conversion options, which I labeled in Figure 8-22. To establish the setting for an option, use the Multi Selector to highlight it and then press OK. You then see the available settings for the option. For example, if you highlight the first option, Image Quality, and press OK, you see the screen shown in Figure 8-23. Use the Multi Selector to highlight the setting you want to use and press OK to return to the main Raw conversion screen.

Rather than detailing all the options here, the following list points you to the chapter where you can explore the settings available for each:

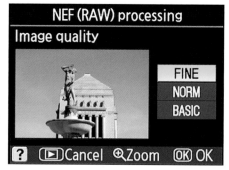

Figure 8-23: Select the setting you want to use and press OK.

- *Image Quality:* See the Chapter 3 section related to the JPEG quality settings for details on this option.

- *Image Size:* The first part of Chapter 3 explains this one.

- *White Balance:* Check out Chapter 6 for details about White Balance options.

- *Exposure Compensation:* With this option, you can adjust image brightness by applying exposure compensation, a feature that I cover in Chapter 5.

- *Optimize Image:* This option enables you to adjust color, contrast, and image sharpness. For an in-depth discussion of the available settings, see the last part of Chapter 6.

6. **When you finish setting all the conversion options, highlight EXE and press OK.**

The camera records a JPEG copy of your Raw file and displays the copy in the monitor, as shown in Figure 8-24. To remind you that the image was created with the help of the Retouch menu, the top-left corner of the display sports the little Retouch icon, and the filename of the image begins with CSC rather than the usual DSC. (See Chapter 4 for details about filenaming conventions used by the D60.)

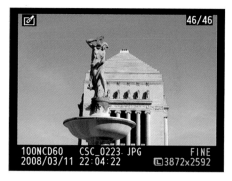

Figure 8-24: Filenames of processed JPEG images start with CSC.

Processing Raw files in ViewNX

In ViewNX, you can convert your Raw files to either the JPEG format or, for top picture quality, to the TIFF format. (See Chapter 3 if you're unsure about the whole concept of file format and how it relates to picture quality.)

Although the ViewNX converter isn't as full-featured as the ones in Nikon Capture NX, Adobe Photoshop Elements, and some other photo-editing programs, it does enable you to make the same sort of adjustments to your Raw images as you can apply using the in-camera processing option.

The ViewNX Converter gives you three basic adjustment controls:

- ✔ **Exposure Compensation,** which enables you to adjust image brightness.

- ✔ **White Balance,** which you can use to remove any unwanted color cast.

- ✔ **Picture Control,** which enables you to apply some prefab settings that each affect the color, sharpness, and contrast of the image in specific ways. For even more control, you can dig into the Picture Control Utility, which you can use to create your own groups of settings so that you can quickly apply the same adjustments to a batch of images.

For now, I suggest that you skip the Picture Control options and instead concentrate on the first two options. Because the exact changes made by the Picture Control settings aren't really obvious, it's hard to predict how they will affect your image. Creating your own Picture Control setting via the Picture Control Utility requires some knowledge of photo editing tools, such as a Curves filter, and you can just as easily mess things up as improve them. If you do want to experiment, the Help system offers some assistance to get you started. Note, though, that one feature described in the Help system — the option to copy your custom settings to your camera memory card and apply them in-camera — doesn't apply to the D60. (Again, ViewNX is designed for use with other cameras, so some of its features aren't relevant to D60 users.)

With that recommendation in mind, the following steps show you how to process your Raw images, sans the aforementioned Picture Control options:

1. **Click the thumbnail of the NEF (Raw) image to select it.**

 You may want to set the program to Image Viewer mode, as shown in Figure 8-25, so that you can see a larger preview of your image. Just choose View➪Image Viewer to switch to this display mode.

2. **Display the Camera Settings panel by clicking its tab on the left side of the program window.**

 I labeled the tab in Figure 8-25.

3. **Display the Quick Adjustment area of the panel, as shown in Figure 8-25.**

 Look at the very bottom of the Camera Settings panel. Click the little Quick Adjustment triangle to open up that part of the panel, as shown in the figure.

Camera Settings tab

Hide/Display Quick Adjustment panel

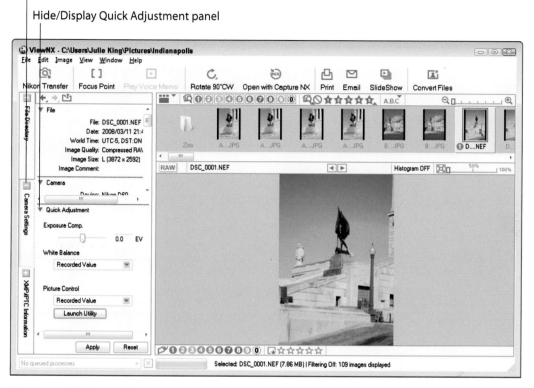

Figure 8-25: Display the Quick Adjustment panel to tweak Raw images before conversion.

4. **Adjust image brightness by dragging the Exposure Compensation slider.**

 Drag to the right to make the picture brighter; drag to the left to make it darker. This control is designed to mimic the effects of the Exposure Compensation option on your camera. You can explore that feature in Chapter 5.

5. **To adjust color, choose a setting from the White Balance drop-down list.**

 In addition to six preset values geared to specific light sources, you have three other options:

 • *Recorded Value:* This one reapplies the White Balance value that the camera initially used when you took the picture. In other words, choose this option to return to the original colors if you choose some other setting in ViewNX and then don't like the results.

- *Calculate Automatically*: If you select this option, the program analyzes the image and adjusts colors as it deems fit, with the intent of removing any perceived color cast.

- *Use Gray Point*: This option enables you to click an area in your image that you think should be neutral gray. After you do, the program makes whatever color adjustment is needed to make that area neutral gray, which also should remove any color cast from the rest of the photo as well.

 To use this option, click the Start button that appears under the drop-down list when you select Use Gray Point. Then click in the image preview on the object that should be neutral gray. If you don't like the results, just click on another spot in the preview. When you're happy with the image colors, click the Finish button that appears under the drop-down list. (It replaces the Start button as soon as you click in the preview.)

 For more information about white balance and how light sources affect your picture colors, see Chapter 6.

6. **Click the Apply button at the bottom of the Quick Adjustment area.**

7. **To save the processed file, choose File⇨Convert Files.**

 Or just click the Convert Files button on the toolbar at the top of the program window. You see the Convert Files dialog box, shown in Figure 8-26.

8. **Select TIFF (8 Bit) from the File Format drop-down list.**

 You also can opt for TIFF (16 Bit) and JPEG, but I don't recommend it. TIFF (16 Bit) can cause problems when you try to open the file in certain photo editing and organizing programs. And saving in the JPEG format applies *lossy compression,* thereby sacrificing some image quality. If you need a JPEG copy of your processed Raw image for online sharing, you can easily create one from your TIFF version by following the steps laid out in Chapter 9.

9. **Deselect the Use LZW Compression option, as shown in the figure.**

 Although LZW Compression reduces the file size somewhat and does not cause any quality loss, some programs can't open files that were saved with this option enabled. So turn it off.

10. **Deselect the Change the Image Size check box.**

 This step ensures that you retain all the original pixels in your image, which gives you the most flexibility in terms of generating quality prints at large sizes. For details on this issue, check out Chapter 3.

 One note here for Mac users: Your dialog box contains a Compression Ratio slider beneath the Change Image Size options. But this slider becomes active only when you select JPEG as your file format; for TIFF images, it has no use. See the bullet point related to converting directly to JPEG, following these steps, for details.

Current drive and folder

Convert Files

File Format: TIFF(8 Bit)

☐ Use LZW Compression

Original Image Size: 2592 x 3872 pixels

☐ Change the image size

Short Edge: 2592 pixels

Long Edge: 3872 pixels

☐ Remove camera setting information

☐ Remove XMP/IPTC information

☐ Remove ICC color profile

C:\Users\Julie King\Pictures Browse...

☐ Create a new subfolder for each file conversion Naming Options...

☐ Change file names Naming Options...

Total Number of Files: 1 Convert... Cancel

Figure 8-26: To retain the best image quality, save processed Raw files in the TIFF format.

11. Deselect the three Remove check boxes.

If you select the check boxes, you strip image metadata — the extra text data that's stored by the camera — from the file. Unless you have some specific reason to do so, clear all three check boxes so that you can continue to access the metadata when you view your processed image in programs that know how to display metadata.

The first two check boxes relate to data that you can view on the Camera Settings tab and XMP/IPTC tab in ViewNX; earlier sections of this chapter give you the lowdown. The ICC profile item refers to the image *color space,* which is either sRGB or Adobe RGB on your D60. Chapter 6 explains the difference.

12. **Select a storage location for the processed TIFF file.**

 In Windows, the current drive and folder location appear in the area labeled in Figure 8-26. On a Mac, the location is displayed inside a white box in the same general area of the dialog box. On either type of system, you can change the storage destination by clicking the Browse button and then selecting the drive and folder where you want to put the file.

 By selecting the Create a New Subfolder for Each File Conversion check box, you can put your TIFF file into a separate folder within the destination folder. If you select the box, click the Naming Options button and then specify how you want to name the subfolder.

13. **Specify whether you want to give the processed TIFF a different filename from the original Raw image.**

 To do so, select the Change File Names check box and then click the Naming Options button and enter the name you want to use.

 If you don't change the file name, ViewNX gives the file the same name as the original Raw file. But you don't overwrite that Raw file because you are storing the copy in a different file format (TIFF). In Windows, the filename of the processed TIFF image has the three-letter extension .TIF.

14. **Click the Convert button.**

 A window appears to show you the progress of the conversion process. When the window disappears, your TIFF image appears in the storage location you selected in Step 10.

A few final notes on the issue of processing Raw files in ViewNX:

✔ **Saving time with batch processing:** *Batch processing* is the nerdy way of saying "converting a bunch of Raw images together," which can be a time and energy saver. To go this route, first apply any exposure and color adjustments you want to make to each image. (You don't have to use the same settings for every picture.) Then select the thumbnails of all the Raw images you want to convert: In Windows, click the first thumbnail and then Ctrl+click the others; on a Mac, click the first thumbnail and then ⌘+click the others. Finally, choose File➪Convert Files and set up the conversion options as outlined in Steps 7 through 13.

✔ **Converting from NEF (Raw) directly to JPEG:** Although saving your converted files in the TIFF format retains the images at their highest quality, you can't share TIFF files online because Web browsers and e-mail programs can't display them. Again, you can always use the steps provided in Chapter 9 to convert your TIFF files to JPEGs. But if you want to skip that step and go directly from Raw to JPEG, just select JPEG as the file format in Step 7.

When you do, the Convert Files dialog box changes slightly, offering a Compression Ratio slider, as shown in Figure 8-27. (Again, on a Mac, the slider is always present but becomes active only when you select JPEG

as your file format.) Drag the slider all the way to the right to apply the least amount of JPEG compression and therefore retain the best possible image quality.

Of course, as you reduce the compression amount, the file size increases. If you're concerned about file size, you may want to compromise on quality a bit. Unfortunately, the Convert Files box doesn't indicate the estimated file size of your soon-to-be JPEG file; the only way to find out the file size is to go through with the conversion and then look at the size of the resulting JPEG file. Remember, too, that for onscreen viewing, you don't need lots of pixels, so you may also want to reduce the image size, using the Change the Image Size option, when you save directly to JPEG. Refer to Chapters 3 and 9 for more about JPEG and onscreen image viewing.

JPEG Compression slider

Convert Files

File Format: JPEG ▼

☐ Use LZW Compression

Original Image Size: 2592 x 3872 pixels

☐ Change the image size

Short Edge: 2592 pixels

Long Edge: 3872 pixels

Compression Ratio: Good Quality

☐ Remove camera setting information

☐ Remove XMP/IPTC information

☐ Remove ICC color profile

C:\Users\Julie King\Pictures Browse...

☐ Create a new subfolder for each file conversion Naming Options...

☐ Change file names Naming Options...

Total Number of Files: 1 Convert... Cancel

Figure 8-27: If you instead use JPEG as the format, you can set the level of file compression.

✔ **Creating a black-and-white version of your Raw photo:** Here's one exception to my earlier recommendation to bypass the Picture Control option until you're an advanced user: By selecting the Monochrome setting from the Picture Control drop-down list (in the Quick Adjustments area of the Camera Settings panel), you can easily turn your full-color image into a black-and-white photo. You can then use the other Quick Adjustments options to tweak the look of your black-and-white image. Or click the Launch Utility button, found under the Picture Control drop-down list. Clicking the button opens the Picture Control Utility dialog box, shown in Figure 8-28, where you find more controls for adjusting how colors are translated to black and white.

You can create a tinted monochrome image by selecting an option other than B&W from the Toning drop-down list on the right side of the Picture Control Utility dialog box. Again, check out the program's Help system for details. And be sure to also check out Chapter 11, which shows you how to produce monochrome images using your camera's Retouch menu.

Figure 8-28: The Picture Control Utility dialog box offers advanced Raw conversion adjustments.

9

Printing and Sharing Your Photos

*W*hen my first digital photography book was published, way back in the 1990s, consumer digital cameras didn't offer the resolution needed to produce good prints at anything more than postage-stamp size — and even then, the operative word was "good," not "great." And if you did want a print, it was a pretty much a do-it-yourself proposition unless you paid sky-high prices at a professional imaging lab. In those days, retail photo labs didn't offer digital printing, and online printing services hadn't arrived yet, either.

Well, time and technology march on, and, at least in the case of digital photo printing, to a very good outcome. Your D60 can produce dynamic prints even at large sizes, and getting those prints made is easy and economical, thanks to an abundance of digital printing services now in stores and online. And for home printing, today's printers are better and cheaper than ever, too.

That said, getting the best output from your camera still requires a little bit of knowledge and prep work on your part. To that end, this chapter tells you exactly how to ensure that your picture files will look as good on paper as they do in your camera monitor.

In addition, this chapter explores ways to share your pictures electronically. First, I show you how to prepare your picture for e-mail — an important step

if you don't want to annoy friends and family by cluttering their inboxes with ginormous, too-large-to-view photos. Following that, you can find out how to create digital slide shows and stop-motion movies, view your pictures on a television, and join online photo-sharing communities.

Preventing Potential Printing Problems

Boy, I love a good alliteration, don't you? Oh, just me, then. Anyway, as I say in the introduction to this chapter, a few issues can cause hiccups in the printing process. So before you print your photos, whether you want to do it on your own printer or send them to a lab, read through the next three sections, which show you how to avoid the most common trouble spots.

Match resolution to print size

Resolution, or the number of pixels in your digital image, plays a huge role in how large you can print your photos and still maintain good picture quality. You can get the complete story on resolution in Chapter 3, but here's a quick recap as it relates to printing:

- On your D60, you set picture resolution via the Image Size option, which you can access either via the Shooting menu or the Quick Settings display. You must select this option *before* you capture an image, which means that you need some idea of your ultimate print size before you shoot. And remember that if you crop your image, you eliminate some pixels, so take that factor into account when you do the resolution math.

- For good print quality, the *minimum* pixel count (in my experience, anyway) is 200 pixels per linear inch, or 200 ppi. That means that if you want a 4-x-6-inch print, you need at least 800 x 1200 pixels.

- Depending on your printer, you may get even better results at 200+ ppi. Some printers do their best work when fed 300 ppi, and a few (notably, some from Epson) request 360 ppi as the optimum resolution. However, going higher than that typically doesn't produce any better prints.

 Unfortunately, because most printer manuals don't bother to tell you what image resolution produces the best results, finding the right resolution is a matter of experimentation. (Don't confuse the manual's statements related to the printer's *dpi* with *ppi*. DPI refers to how many dots of color the printer can lay down per inch; many printers use multiple dots to reproduce one image pixel.)

- If you're printing your photos at a retail kiosk or at an online site, the printing software that you use to order your prints should determine the resolution of your file and then guide you as to the suggested print size. But if you're printing on a home printer, you need to be the resolution cop. (Some programs, however, do alert you in the Print dialog box if the resolution is dangerously low.)

So what do you do if you find that you don't have enough pixels for the print size you have in mind? You just have to decide what's more important, print size or print quality.

If your print size does exceed your pixel supply, one of two things must happen:

- ✔ The pixel count remains constant, and pixels simply grow in size to fill the requested print size. And if pixels get too large, you get a defect known as *pixelation.* The picture starts to appear jagged, or stairstepped, along curved or digital lines. Or at worst, your eye can actually make out the individual pixels, and your photo begins to look more like a mosaic than, well, a photograph.

- ✔ The pixel size remains constant, and the printer software adds pixels to fill in the gaps. You can also add pixels, or *resample the image,* in your photo software. Wherever it's done, resampling doesn't solve the low resolution problem. You're asking the software to make up photo information out of thin air, and the result is usually an image that looks worse than it did before resampling. You don't get pixelation, but details turn muddy, giving the image a blurry, poorly rendered appearance.

Just to hammer home the point and remind you one more time of the impact of resolution picture quality, Figures 9-1 through 9-3 show you the same image as it appears at 300 ppi (the resolution required by the publisher of this book), at 50 ppi, and resampled from 50 ppi to 300 ppi. As you can see, there's just no way around the rule: If you want the best quality prints, you need the right pixel count.

300 ppi

Figure 9-1: A high-quality print depends on a high-resolution original.

50 ppi

Figure 9-2: At 50 ppi, the image has a jagged, pixelated look.

50 ppi resampled to 300 ppi

Figure 9-3: Adding pixels in a photo editor doesn't rescue a low-resolution original.

Allow for different print proportions

Unlike many digital cameras, your D60 produces images that have an aspect ratio of 3:2. That is, images are 3 units wide by 2 units tall — just like a 35mm film negative — which means that they translate perfectly to the standard 4-x-6-inch print size. (Most digital cameras produce 4:3 images, which means the pictures must be cropped to fit a 4-x-6-inch piece of paper.)

If you want to print your digital original at other standard sizes — 5 x 7, 8 x 10, 11 x 14, and so on — you need to crop the photo to match those proportions. Alternatively, you can reduce the photo size slightly and leave an empty margin along the edges of the print as needed.

As a point of reference, Figure 9-4 shows you a 3:2 original image. The red outlines indicate how much of the original can fit within a 5-x-7-inch frame and an 8-x-10-inch frame.

See Chapter 10 for information on two cropping methods: using your photo software and doing the job in-camera, using the Trim function on the Retouch menu.

5 x 7 frame area 8 x 10 frame area

Figure 9-4: Composing your shots with a little head room enables you to crop to different frame sizes.

You also can usually crop your photo using the software provided at online printing sites and at retail print kiosks. But if you plan to simply drop off your memory card for printing at a lab, be sure to find out whether the printer automatically crops the image without your input. If so, use your photo software to crop the photo, save the cropped image to your memory card, and deliver that version of the file to the printer.

To allow yourself printing flexibility, leave at least a little margin of background around your subject when you shoot, as I did for the example in Figure 9-4. Then you don't clip off the edges of the subject no matter what print size you choose. (Some people refer to this margin padding as *head room,* especially when describing portrait composition.)

Get print and monitor colors in synch

Your photo colors look perfect on your computer monitor. But when you print the picture, the image is too red, or too green, or has some other nasty color tint. This problem, which is probably the most prevalent printing issue, can occur because of any or all of the following factors:

- **Your monitor needs to be calibrated.** When print colors don't match what you see on your computer monitor, the most likely culprit is actually the monitor, not the printer. If the monitor isn't accurately calibrated, the colors it displays aren't a true reflection of your image colors.

 To ensure that your monitor is displaying photos on a neutral canvas, you can start with a software-based calibration utility, which is just a small program that guides you through the process of adjusting your monitor. The program displays various color swatches and other graphics and then asks you to provide feedback about what you see on the screen.

 If you use a Mac, the operating system offers a built-in calibration utility, called the Display Calibrator Assistant; Figure 9-5 shows the welcome screen that appears when you run the program. (Access it by opening the System Preferences dialog box, clicking the Displays icon, clicking the Color button, and then clicking the Calibrate button.) You also can find free calibration software for both Mac and Windows systems online; just enter the term *free monitor calibration software* into your favorite search engine.

 Software-based calibration isn't ideal, however, because our eyes aren't that reliable in judging color accuracy. For a more accurate calibration, you may want to invest in a hardware solution, such as the Pantone Huey ($90, www.pantone.com) or the ColorVision Spyder2express ($80, www.datacolor.com). These products use a device known as a *colorimeter,* which you attach to or hang on your monitor, to accurately measure your display colors.

Figure 9-5: Mac users can take advantage of the operating system's built-in calibration tool.

Whichever route you go, the calibration process produces a monitor *profile,* which is simply a data file that tells your computer how to adjust the display to compensate for any monitor color casts. Your Windows or Mac operating system loads this file automatically when you start your computer. Your only responsibility is to perform the calibration every month or so, because monitor colors drift over time.

✔ **One of your printer cartridges is empty or clogged.** If your prints look great one day but are way off the next, the number-one suspect is an empty ink cartridge or a clogged print nozzle or head. Check your manual to find out how to perform the necessary maintenance to keep the nozzles or print heads in good shape.

If black-and-white prints have a color tint, a logical assumption is that your black ink cartridge is to blame, if your printer has one. But the problem is usually a color cartridge instead. Most printers use both color and black inks even for black-and-white prints, and if one color is missing, a tint results.

When you buy replacement ink, by the way, keep in mind that third-party brands, while they may save you money, may not deliver the performance you get from the cartridges made by your printer manufacturer. A lot of science goes into getting ink formulas to mesh with the printer's ink-delivery system, and the printer manufacturer obviously knows most about that delivery system.

✓ **You chose the wrong paper setting in your printer software.** When you set up your print job, be sure to select the right setting from the paper-type option — glossy, matte, and so on. This setting affects how the printer lays down ink on the paper.

✓ **Your photo paper is low quality.** Sad but true: The cheap, store-brand photo papers usually don't render colors as well as the higher-priced, name-brand papers. For best results, try papers from your printer manufacturer; again, those papers are engineered to provide top performance with the printer's specific inks and ink-delivery system.

✓ **Your printer and photo software are fighting over color management duties.** Some photo programs offer *color management* tools, which are features that enable the user to control how colors are handled as an image passes from camera to monitor to printer. Most printer software also offers color-management features. The problem is, if you enable color-management controls both in your photo software and your printer software, you can create conflicts that lead to wacky colors. So check your photo software and printer manuals to find out what color-management options are available to you and how to turn them on and off.

Even if all the aforementioned issues are resolved, however, don't expect perfect color matching between printer and monitor. Printers simply can't reproduce the entire spectrum of colors that a monitor can display. In addition, monitor colors always appear brighter because they are, after all, generated with light.

Finally, be sure to evaluate your print colors and monitor colors in the same ambient light — daylight, office light, whatever — because that light source has its own influence on the colors you see.

Printing Online or In-Store

Normally, I'm a do-it-yourself type of gal. I mow my own lawn, check my own tire pressure, hang my own screen doors. I am woman; hear me roar. Unless, that is, I discover that I can have someone *else* do the job in less time and for less money than I can — which just happens to be the case for digital photo printing. Although I occasionally make my own prints for fine-art images that I plan to sell or exhibit, I have everyday snapshots made at my local retail photo lab.

Unless you're already very comfortable with computers and photo printing, I suggest that you do the same. Compare the cost of retail digital printing with the cost of using a home or office photo printer — remember to factor in the required ink, paper, and your precious time — and you'll no doubt come out ahead if you delegate the job.

You can choose from a variety of retail printing options, as follows:

✔ **Drop-off printing services:** Just as you used to leave a roll of film at the photo lab in your corner drug store or camera store, you can drop off your memory card, order prints, and then pick up your prints in as little as an hour.

✔ **Self-serve print kiosks:** Many photo labs, big-box stores, and other retail outlets also offer self-serve print kiosks. You insert your memory card into the appropriate slot, follow the onscreen directions, and wait for your prints to slide out of the print chute.

✔ **Online with mail-order delivery:** You can upload your photo files to online printing sites and have prints mailed directly to your house. Photo-sharing sites such as Shutterfly, Kodak Gallery, and Snapfish are well-known players in this market. But many national retail chains, such as Ritz Cameras, Wal-Mart, and others also offer this service.

✔ **Online with local pickup:** Here's my favorite option. Many national chains enable you to upload your picture files for easy ordering but pick up your prints at a local store.

This service is a great way to share prints with friends and family who don't live nearby. I can upload and order prints from my desk in Indianapolis, for example, and have them printed at a store located a few miles from my parents' home in Texas.

Printing from Nikon ViewNX

If you prefer to print your own pictures on a home or office printer, the process is much the same as printing anything from your computer: You open the picture file in your photo software of choice, choose File⇨Print, and specify the print size, paper size, paper type, and so on, as usual.

The next sections explain how to print from Nikon ViewNX, the free photo-organizer software provided with your camera. (You must download your pictures from your camera to your computer first, a process you can read about in Chapter 8.) If you use some other software, the basic concepts are the same, but you should check your program's manual for details about specific printing options.

Printing a single image

To print a single image from ViewNX, first click the thumbnail of the image that you want to print. (Chapter 8 explains all about viewing and selecting images, if you need help.) Then take these steps:

1. **Click the thumbnail for the image that you want to print.**

2. **Click the Print icon on the toolbar or choose File⇨Print.**

 Either way, you see the Print dialog box, shown in Figure 9-6.

Current printer setup

Figure 9-6: Click the Page Setup button to select a different paper size or orientation.

3. **Check the printer information in the lower-left corner of the dialog box.**

 Look in the area labeled "Current printer setup" in Figure 9-6. This information tells you the currently selected printer, paper size, and print orientation (vertical or horizontal). If needed, you can change the setup as follows:

 - *Change the paper size or orientation.* Click the Page Setup button. You're then taken to the standard Windows or Mac Page Setup dialog box, which works just the same as when you set up any print job.

 - *Select a different printer on a Mac or in Windows XP.* Click the Printer button at the bottom of the Page Setup dialog box. After making your selections, click OK to return to the Print dialog box.

 - *Select a different printer in Windows Vista.* You must exit the Page Setup dialog box, close ViewNX, and then use the Windows Control Panel's Printers utility to make the printer the default printer. Then restart ViewNX and choose File⇨Print again; the printer should then appear selected in the ViewNX Print dialog box. (Sorry, I just report the rules, I don't make 'em.)

4. Select an option from the Print As drop-down list.

You get three choices:

- *Full Page:* Choose this option if you want to devote the entire sheet of paper to your photograph.

- *Index Print:* You can use this option to print tiny thumbnails of a batch of photos; see the next section for details.

- *Standard Photo Sizes:* Choose this option to print your image at common print sizes: 4 x 6 inches, 5 x 7 inches, and the like.

5. Select an option from the Format list.

Your choices depend on whether you selected Full Page or Standard Photo Sizes in Step 4:

- *Full Page options:* Choose Fit to Page to automatically reduce or enlarge the image as needed to fit the selected paper size. Or, if you want the photo to spread across the entire sheet of paper, select Fill Page. Choosing this option may mean that your photo has to be cropped to fit the proportions of the paper. (See the earlier section "Allow for different print proportions" to better understand this issue.)

 By using the Resize Photo slider, you can reduce the image size if you select Fit to Page from the Format list. If you select Fill Page from the list, you can enlarge the image; any areas that expand beyond the page boundaries are cropped away. Either way, the preview updates to show you the results of the slider setting.

 Select the Rotate to Fit box to automatically adjust the orientation of the image to best fit the page.

- *Standard Photo Sizes options:* Select a photo size from the Format list. When you do, the dialog box preview updates to show you the size and positioning of the image with respect to the selected paper size.

 If the selected paper size is large enough to accommodate multiple copies of your photo at the chosen print size, the preview displays dotted rectangles to indicate the orientation you must use to achieve that print size. For example: When you set the paper size to 8 x 10 inches and select 4 x 6 as your print size, you must orient the photo with the long side running horizontally and the short side running vertically, as shown in Figure 9-7. Select the Rotate to Fit check box to tell the program to automatically adjust the orientation of your image if needed to maintain the print size.

 Select the Crop Photos to Fit check box if you want the program to automatically enlarge and crop your image as necessary to match the proportions of the chosen print size. The preview updates show you the results of the adjustment.

```
┌─────────────────────────────────────────────────────────────────────────┐
│ Print                                                            [✕]      │
│                                                                           │
│                              Print As: │Standard Photo Sizes        ▼│    │
│         1 photos selected                                                 │
│                              Format  ┌──────────────────────────────┐▲   │
│       ┌────────────────────┐         │ 1x1.5 in (25.4x38.1mm)       │     │
│       │                    │         │ 1.5x2 in (38.1x50.8mm)       │▤    │
│       │                    │         │ Wallet (2x3 in / 50.8x76.2 mm)│    │
│       │                    │         │ 4x6 in (101.6x152.4 mm)      │     │
│       │                    │         │ 5x7 in (127x177.8 mm)        │     │
│       │                    │         │ Greeting Card                │▼    │
│       └────────────────────┘         └──────────────────────────────┘     │
│       ┌· · · · · · · · · · ·┐                                             │
│       ·                    ·         ☐ Crop photos to fit                 │
│       ·                    ·         ☑ Rotate to fit                      │
│       ·                    ·    Print │1   ▼│ copy(s) of each photo       │
│       ·                    ·                                              │
│       ·                    ·         ☐ Print Photo Information  │Settings...│ │
│       └· · · · · · · · · · ·┘                                             │
│                                                                           │
│        ◄      1 of 1      ►                                               │
│                                      Printer Type: │Inkjet printer   ▼│   │
│                                      Print Priority:  ◉ Quality  ○ Speed  │
│   │Page Setup...│  Paper:(203.20 x 254.00 mm) Portrait.                   │
│                   Printer: EPSON Stylus Photo RX595  │Print...│ │Cancel│  │
└─────────────────────────────────────────────────────────────────────────┘
```

Figure 9-7: The dotted outline represents the appropriate image orientation for the selected layout.

6. **Specify the number of copies per page via the Print drop-down list.**

 You can print as many as five copies per page. If your print size is too large for all copies to fit on a single page, the program creates additional pages to hold the overflow.

 This setting determines only how many duplicates of the image appear on a single piece of paper. You set up the number of copies of your print job via the Printer dialog box, in Step 11.

7. **To print camera metadata and other text with the image, select the Print Photo Information check box.**

 Metadata, introduced in Chapter 8, is simply extra data that is stored with your image file when you snap a picture. The metadata records camera settings such as aperture, shutter speed, date, and more.

8. **Click the Settings button to specify what data to include with the print.**

 When you click the button, you see the Advanced Print Information Settings dialog box shown in Figure 9-8. On the Photo Information tab, select the boxes for the metadata you want to print with the image. Click the Header/Footer tab to add custom text to the top of every page

(header text) or to the bottom of every page (the footer text). Click OK when you're done to close the dialog box.

Advanced Print Information Settings

Photo Information | Header/Footer

Display Under Photo:

☑ File Name ☑ Simple Camera Settings

Camera name, Shutter speed, F number, Size, Exposure mode, White balance

☑ Shoot Date

☐ Time

☐ Description ☐ Additional Camera Details

Metering mode, Exposure comp., Focal length, AF mode, Sensitivity

Font Settings:

Arial ▼ | Regular ▼ | Auto ▼

Ok Cancel

Figure 9-8: You can print picture metadata along with the image.

9. **From the Printer Type drop-down list, select the print technology that matches your printer.**

 You get only two choices: Inkjet and All Others. (This option should automatically be selected for you, but double-check just in case.)

10. **When printing NEF (Raw) images, select a Print Priority option.**

 This setting determines whether the program outputs the image using the actual Raw data or a temporary preview that is created to enable you to view your images before converting them to a standard format. (Chapter 8 explains this process.) For best results, select Quality.

 Although you can print Raw images directly from ViewNX, you may not be able to do so from other photo software. If the program you want to use for printing can't deal with Nikon Raw images (NEF files), follow the instructions in Chapter 8 to convert the images to a standard format before printing.

11. **Click the Print button.**

 The standard Windows or Mac Print dialog box opens. Set up the remaining print options as you see fit — the options vary depending on your printer. Do be sure to choose the right paper type (glossy, matte, and so on). Check your printer manual for other settings recommended for outputting photo prints.

The printing features of ViewNX are designed to give you a quick and convenient way to print original images from your D60. But if you use your photo software to crop an image to some nonstandard dimensions — maybe 4 inches by 4 inches to fit a square photo frame, for example — you're better off printing from your photo software because ViewNX doesn't offer a custom print-size option. You can either fill an entire sheet of paper or print at the established, common print dimensions. Most photo editors, on the other hand, enable you to precisely control print output size and resolution as well as position images on the page.

Printing multiple images and index prints

You also can use ViewNX to print several different images at the same time. The steps are just as outlined in the preceding section, except that you select all the thumbnails for the images you want to print in Step 1. You can choose to put each picture on its own piece of paper or put multiple images on the same page.

To select multiple thumbnails, click the first one and then Ctrl+click (Windows) or ⌘+click (Mac) the others. To select all photos in a folder, press Ctrl+A (Windows) ⌘+A (Mac).

ViewNX offers one other handy option: You can create an *index print* that contains thumbnails of a batch of photos, as shown in Figure 9-9. Again, follow the steps in the preceding section, but select in Step 1 all the image thumbnails you want to include in the index print. Then, in Step 4, choose Index Print. You then can specify the layout and design of the index print by using the other options in the dialog box.

DPOF, PictBridge, and computerless printing

Your Nikon offers two technologies, called DPOF *(dee-poff)* and PictBridge, that enable you to print images directly from your camera or memory card, without using the computer as middle-machine. In order to take advantage of direct printing, your printer must also support one of the two technologies, and you must capture the images in the JPEG file format, which I explain in Chapter 3. (You can also capture the photo in the Raw format and then use your D60's in-camera conversion tool to make a JPEG copy suitable for direct printing.)

DPOF stands for Digital Print Order Format. With this option, accessed via your camera's Playback menu, you select the pictures on your memory card that you want to print, and you specify how many copies you want of each image. Then, if your photo printer has an SD Card slot and supports DPOF, you just pop the memory card into that slot. The printer reads your "print order" and outputs just the requested copies of your selected images. (You use the printer's own controls to set paper size, print orientation, and other print settings.)

PictBridge works a little differently. If you have a PictBridge-enabled photo printer, you can connect the camera to the printer using the USB cable supplied with your camera. A PictBridge interface appears on the camera monitor, and you use the camera controls to select the pictures you want to print. With PictBridge, you specify additional print options, such as page size and whether you want to print a border around the photo, from the camera as well.

Both DPOF and PictBridge are especially useful in scenarios where you need fast printing. For example, if you shoot pictures at a party and want to deliver prints to guests before they go home, DPOF offers a quicker option than firing up your computer, downloading pictures, and so on. And if you invest in one of the tiny portable photo printers on the market today, you can easily make prints away from your home or office — you can take both your portable printer and camera along to your regional sales meeting, for example.

For the record, I prefer DPOF to PictBridge because with PictBridge, you have to deal with cabling the printer and camera together. Also, the camera must be turned on for the whole printing process, wasting battery power. But if you're interested in exploring either printing feature, your camera manual provides complete details.

Figure 9-9: For a handy record of all photos in a folder, create an index print.

Preparing Pictures for E-Mail

How many times have you received an e-mail message that looks like the one in Figure 9-10? Some well-meaning friend or relative has sent you a digital photo that is so large that it's impossible to view the whole thing on your monitor.

The problem is that computer monitors can display only a limited number of pixels. The exact number depends on the monitor's resolution setting and the capabilities of the computer's video card, but suffice it to say that the average photo from one of today's digital cameras has a pixel count in excess of what the monitor can handle. Figure 9-10, for example, shows you how much of a 6-megapixel image is viewable when displayed in a typical e-mail program window. And the image you see in Figure 9-10 contains far fewer pixels than the 10 megapixels produced by your D60's top Image Size setting!

In general, a good rule is to limit a photo to no more than 640 pixels at its longest dimension. That ensures that people can view your entire picture without scrolling, as in Figure 9-11. This image measures 640 x 428 pixels. As you can see, it's plenty large enough to provide a decent photo-viewing experience. On a small monitor, it may even be *too* large.

Figure 9-10: The attached image has too many pixels to be viewed without scrolling.

This size recommendation means that even if you shoot at your D60's lowest Image Size setting (1936 x 1296 pixels), you need to dump pixels from your images before sending them to the cyber post office. You have a couple of options for creating an e-mail-sized image:

- ✒ Use the Small Picture feature on your camera's Retouch menu. This feature enables you to create your e-mail copy right in the camera.

- ✒ Downsample the image in your photo editor. *Downsampling* is geekspeak for dumping pixels. Most photo editors offer a feature that handles this process for you. Use this option if you want to crop or otherwise edit the photo before sharing it.

The next two sections walk you through the steps for both ways of creating your e-mail images. You can use the same steps, by the way, for sizing images for any onscreen use, whether it's for a Web page or multimedia presentation. You may want your copies to be larger or smaller than the recommended e-mail size for those uses, however.

Figure 9-11: Keep e-mail pictures to no larger than 640 pixels wide or tall.

One last point about onscreen images: Remember that pixel count has *absolutely no effect* on the quality of pictures displayed onscreen. Pixel count determines only the size at which your images are displayed.

Creating small copies using the camera

To create small, e-mailable copies of your images without using a computer, use your camera's Small Picture feature. Here's how:

1. **Display the Retouch menu and highlight Small Picture, as shown on the left in Figure 9-12.**
2. **Press OK to display the screen shown on the right in Figure 9-12.**
3. **Highlight Choose Size and press the Multi Selector right.**

 Now you see a list of three picture-size options, as shown in Figure 9-13.

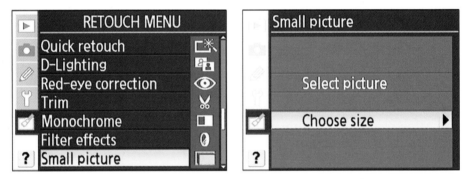

Figure 9-12: You can create a low-resolution copy of your image via the Retouch menu.

4. **Highlight the size you want to use for your copy.**

 For pictures that you plan to send via e-mail, choose either 640 x 480 or 320 x 240 pixels unless the recipient is connected to the Internet via a very slow, dial-up modem connection. In that case, you may want to go one step down, to 160 x 120 pixels. (The display size of the picture may be quite small at that setting however, depending on the resolution of the monitor on which the picture is viewed.)

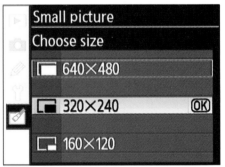

Figure 9-13: The medium size option is good for e-mail images.

The largest option, 640 x 480 pixels, is more suitable to creating pictures for multimedia presentations or for viewing on a television screen, an option you can explore at the end of this chapter.

5. **Press OK to return to the main Small Picture screen (shown on the right in Figure 9-12).**

6. **Highlight Select Picture and press the Multi Selector right.**

Now you see thumbnails of all the images on your memory card, as shown in Figure 9-14.

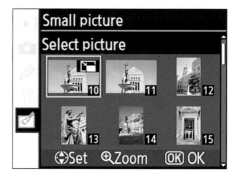

Figure 9-14: Press the Multi Selector up to tag the picture you want to copy and resize.

7. **Use the Multi Selector to select an image (or images) for copying, as follows:**

 • Press right or left to scroll the display until the yellow highlight box surrounds the image you want to copy and resize.

 • Press up to tag the image for copying. A little Small Picture icon like the one you see on the top left thumbnail in Figure 9-14 appears on the image.

 • Press down to deselect the image. The Small Picture icon disappears.

8. **After selecting all the photos you want to copy, press OK.**

The camera displays a screen like the one in Figure 9-15, asking you to confirm that you want small copies created.

9. **Highlight Yes and press OK.**

The camera duplicates the selected images and downsamples them to achieve the size you specified in Step 4.

Figure 9-15: Confirm that you want to create a small copy.

When you view your small-size copies on the camera monitor, they appear surrounded by a gray border, as shown in Figure 9-16. A tiny Retouch icon appears on the display as well, as labeled in the figure. Note that you can't zoom in to magnify the view of small-size copies as you can your original images.

Retouch icon

Figure 9-16: The gray border indicates a small-size copy.

The camera automatically names the small copies using the file number of the original image but with the letters SSC at the start of the name. So, for example, if the original filename is DSC_0143.jpg, the small copy is named SSC_0143.jpg.

If you're a math lover, you may have noticed that the Small Copy function creates pictures that have an aspect ratio of 4:3, while your original images have an aspect ratio of 3:2. The camera trims the small-copy image as needed to fit the 4:3 proportions.

Downsizing images in Nikon ViewNX

You can also create a low-resolution copy of your image in ViewNX. However, be aware that the program restricts you to a minimum size of 640 pixels along the photo's longest side.

If you need a smaller version, use the in-camera Small Picture option to create the copy instead. Or, if you own a photo editing program, investigate its image-resizing capabilities; you likely can create the small copy at any dimensions you like.

That said, if the 640-pixel restriction isn't a problem, follow these steps to create your small-size copy in ViewNX:

1. **Select the image thumbnail in the main ViewNX window.**

 Chapter 8 explains how to view your image thumbnails, if you need help. Just click a thumbnail to select it.

2. **Choose File⇨Convert Files.**

 You see the dialog box shown in Figure 9-17. (As with other figures, this one shows the box as it appears in Windows Vista; it may appear slightly different on a Mac or in other versions of Windows, but the essentials are the same.)

Convert Files

File Format: JPEG ▾

☐ Use LZW Compression

Original Image Size: 2592 x 3872 pixels

☑ Change the image size

Short Edge: 428 pixels

Long Edge: 640 pixels

Compression Ratio: Excellent Quality

☑ Remove camera setting information

☑ Remove XMP/IPTC information

☑ Remove ICC color profile

C:\Users\Julie King\Pictures\Indianapolis Browse...

☐ Create a new subfolder for each file conversion Naming Options...

☐ Change file names Naming Options...

Total Number of Files: 1 Convert... Cancel

Figure 9-17: You also can reduce photos to e-mail size in Nikon ViewNX.

3. **Select JPEG from the File Format drop-down list, as shown in the figure.**

 The other format option, TIFF, is a print format. Web browsers and e-mail programs can't display TIFF images, so be sure to use JPEG.

4. **Select the Change the Image Size check box.**

 Now the Short Edge and Long Edge text boxes become available.

5. **Type the desired pixel count of the longest side of your picture into the Long Edge box.**

 The program automatically adjusts the Short Edge value to keep the resized image proportional.

 Again, to ensure that the picture is viewable without scrolling when opened in the recipient's e-mail program, I suggest that you keep the Long Edge value at 640 pixels or less, which is the minimum size permitted by the Convert Files feature.

6. **Adjust the Compression Ratio slider to set the amount of JPEG file compression.**

 As Chapter 3 explains, a greater degree of compression results in a smaller file, which takes less time to download over the Web, but reduces image quality. Notice that as you move the slider to the right,

the resulting quality level appears above the slider. For example, in Figure 9-17, the level is Excellent Quality.

Because the resolution of your image already results in a very small file, you can probably use the highest quality setting without worrying too much about download times. The exception is if you plan to attach multiple pictures to the same e-mail message, in which case you may want to set the slider a notch or two down from the highest quality setting.

7. **Select the next three check boxes (Remove Camera Setting Information, Remove XMP/IPTC Information, and Remove ICC Color Profile) in the dialog box, as shown in Figure 9-17.**

 When selected, the three options save the resized picture without the original image metadata, the extra text data that your camera stores with the image or you enter when organizing your files. (Chapter 8 explains.) Including this metadata adds to the file size, so for normal e-mail sharing, strip it out. The exception, of course, is when you want the recipient to be able to view the metadata in a photo program that can do so.

8. **Set the file destination.**

 In layman's terms, that just means to tell the program the location of the folder or drive where you want to store your downsized image file. The current destination appears just to the left of the Browse button. To choose a different folder, click that Browse button.

 By selecting the Create a New Subfolder for Each File Conversion check box, you can create a new subfolder within your selected storage folder. If you do, the resized file goes into that subfolder, which you can name by clicking the Naming Options button.

9. **Specify a filename for the resized copy (optional).**

 By default, ViewNX names the small copy using the original filename plus a two-number sequential tag: If the original filename is DSC_186.jpg, for example, the small-copy filename is DSC_186_01.jpg. You can change a couple of aspects of this filenaming routine by selecting the Change File Names check box and then clicking the Naming Options button and adjusting the settings in the resulting dialog box. After making your wishes known, click OK to return to the Convert Files dialog box.

10. **Click the Convert button to finish the process.**

ViewNX also offers an e-mail wizard that enables you to resize and send photos by e-mail in one step. If you use this feature, however, you don't create an actual small-size copy of your file; the program simply reduces the size of the file temporarily for e-mail transmission. Also, the wizard works only with certain e-mail programs. On the plus side, the wizard permits you to send a photo at a much smaller size than you can create with the Convert Files feature. For more details, check out the ViewNX Help system.

Creating a Digital Slide Show

Many photo-editing and cataloging programs offer a tool for creating digital slide shows that can be viewed on a computer or, if copied to a DVD, on a DVD player. You can even add music, special transition effects, and the like to jazz up your presentations.

But if you just want a simple slide show — that is, one that simply displays all the photos on the camera memory card one by one — you don't need a computer or any photo software. You can create and run the slide show right on your camera. And by connecting your camera to a television, as outlined in the last section of this chapter, you can present your show to a whole roomful of people.

Follow these steps:

1. **Display the Playback menu and highlight Slide Show, as shown on the left in Figure 9-18.**

2. **Press OK to display the Slide Show screen shown on the right in Figure 9-18.**

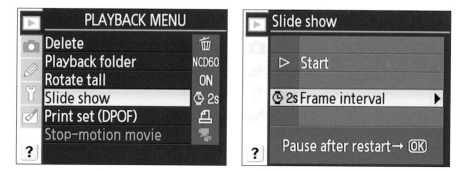

Figure 9-18: Choose Slide Show to set up automatic playback of all pictures on your memory card.

3. **Highlight Frame Interval and press the Multi Selector right.**

 You see the screen shown on the left in Figure 9-19. Here, you can specify how long you want each image to be displayed. You can set the interval to 2, 3, 5, or 10 seconds.

4. **Highlight the frame interval you want to use and press OK.**

 Now you see the right screen in Figure 9-19.

5. **To start the show, highlight Start and press OK.**

 The camera begins displaying your pictures on the camera monitor (and, if the camera is connected to your TV, on the TV set as well).

Online photo sharing: Read the fine print

If you want to share more than a couple of photos, consider posting your images at an online photo-album site instead of attaching them to e-mail messages. Photo-sharing sites such as Shutterfly, Kodak Gallery, and Picasa all enable you to create digital photo albums and then invite friends and family to view your pictures and order prints of their favorites.

At most sites, picture-sharing is free, but your albums and images are deleted if you don't

order prints or make some other purchase from the site within a specified amount of time. Additionally, many free sites enable you to upload high-resolution files for printing but then don't let you retrieve those files from the site. (In other words, don't think of album sites as archival storage solutions.) And here's another little bit of fine print to investigate: The membership agreement at some sites states that you agree to let the site use your photos, for free, for any purpose that it sees fit.

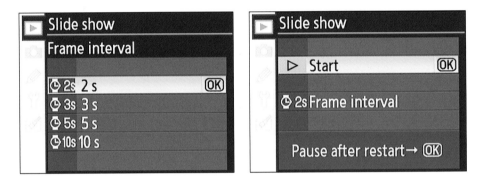

Figure 9-19: You can adjust the display time for each image.

When the show ends, you see a screen similar to the one in Figure 9-20. You can choose to restart the show, adjust the frame interval, or exit to the Playback menu. Highlight your choice and press OK.

During the show, you can control playback as follows:

- **Pause show:** Press OK. Select Restart and press OK to begin displaying pictures again.

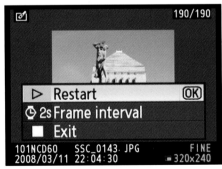

Figure 9-20: This message appears after the last image in the show.

✓ **Exit show:** You've got three options:

- To return to full-frame, regular playback, press the Playback button.
- To return to the Playback menu, press the Menu button.
- To return to picture-taking mode, press the shutter button halfway.

✓ **Display next/previous image:** Press the Multi Selector left to display the previous image; press right to advance to the next image.

✓ **Change the information displayed with the image:** Press the Multi Selector up or down to cycle through the info-display modes. (See Chapter 4 for details on what information is provided in each mode.)

Turning Still Photos into a Stop-Motion Movie

By using the Stop-Motion Movie feature on the Retouch menu, you can combine a series of still images into your very own movie. More precisely, you can create brief, animation-style digital videos that can be played on the computer. You also can connect your camera to a TV for playback; see the next section for details.

One popular use of this feature is to animate still objects, similar to what Hollywood types do when producing so-called "claymation" movies. Here's an example: You take 50 shots of a riderless tricycle on your driveway. Before each shot, you rotate the pedals slightly to move the bike forward so that each image captures the bike at a different spot on the driveway. In your finished movie, the individual images are displayed sequentially, at a pace rapid enough to create the illusion that the bike is moving across the driveway by itself, as if it had a ghost rider.

You can also use the Stop-Motion Movie feature to reanimate a subject that was actually moving of its own volition during your shoot. For example, on a recent trip to a local garden, I spotted a butterfly posing on a leaf. As he opened and closed his wings, I clicked off a rapid-fire series of images so that I could capture his wings at different positions. Turned into a stop-motion movie, the images blended together to reproduce the fluttering of the butterfly's wings.

Lest you get the wrong idea here, I should stress that the Stop-Motion Movie feature isn't designed to replace a real video or movie camera. First, the movies you can produce on your D60 can be recorded and played at a maximum of 15 frames per second, whereas the standard for motion-picture films is 24 frames per second; video, at 30 frames per second. The difference means

that your stop-motion movies appear a little jerky — more like what you see when you fast-forward through a movie on DVD — and not like the smooth, seamless scenes you watch on your TV or at the local cineplex.

Second, the D60 limits the number of images in a movie to 100. So if you have 100 frames, played back at 15 frames per second, the maximum length of your stop-motion movie is just shy of 7 seconds. If you want a longer movie, you need to create separate movie files and then join them together in a video-editing program. (If you have such a program, you may find it easier to just import your images into it and join them together there instead of doing the job in the camera.)

Despite its limitations, though, the Stop-Motion Movie feature provides an interesting creative option for a slow day. And if all this frames-per-second and other movie talk has you a little confused, don't worry. After you create your first movie, which I show you how to do in the upcoming steps, everything should become clear. It's one of those things that's much easier to do than to describe in text, especially since I can't provide a little sample movie player and movie on this page.

To get started, first record a series of images of a moving subject. You can either stage the movement, as in my tricycle illustration, or capture a real moving object like my butterfly.

Try setting your camera's Release mode to Continuous if you're shooting a moving subject. In this mode, explained at the end of Chapter 2, you can record multiple images with one press of the shutter button. See Chapter 7 for more tips on capturing action.

After you have your images recorded, take these steps to turn them into a movie:

1. **Open the Retouch menu and highlight Stop-Motion Movie, as shown in Figure 9-21.**

 You see the three options shown on the left in Figure 9-22.

2. **Press OK.**

3. **Highlight Frame Size and press the Multi Selector right.**

 Now you see the screen shown on the right in Figure 9-22. Here, you set the pixel dimensions — that is, the size of the movie frames, in pixels. The larger the size, the larger you can view the finished

Figure 9-21: The Stop-Motion Movie feature enables you to animate a series of still photos.

movie. But a larger frame size also means a larger data file needed to store the movie. So for online sharing, consider using one of the two smaller sizes to reduce the time people must spend downloading the file.

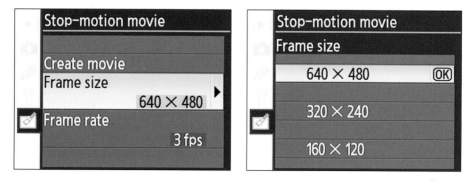

Figure 9-22: The frame dimensions affect the size of the data file needed to store the movie on your memory card.

To understand how pixels display onscreen, whether it's a TV or computer monitor, see "Preparing Pictures for E-Mail," earlier in this chapter. Chapter 3 offers some additional tips about pixels.

4. **Select a frame size and press OK.**

5. **Highlight Frame Rate, as shown on the left in Figure 9-23, and press the Multi Selector right.**

 You're presented with the screen shown on the right in the figure. Here, you specify the number of frames per second in your movie. The higher the frame rate, the smoother the playback, but the shorter the movie duration.

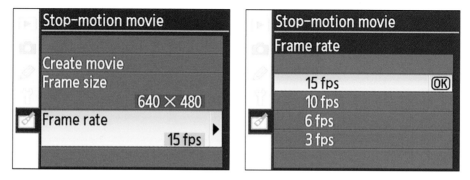

Figure 9-23: For the smoothest playback, choose 15 frames per second (fps).

6. **Select a frame rate and press OK.**

 You're returned to the main Stop-motion movie screen.

7. **Highlight Create Movie, as shown on the left in Figure 9-24, and press OK.**

 You see a screen similar to the one on the right in Figure 9-24, with thumbnails of the images on your memory card.

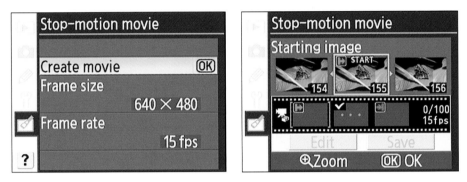

Figure 9-24: Select the image that you want to use as the starting frame of the movie.

8. **Highlight the image that you want to use as the starting shot in the movie.**

 Notice that one thumbnail is surrounded by a yellow box and is marked with the word Start — in Figure 9-24, it's image 155. Press the Multi Selector right or left until that Start icon lands on the image that you want to use to kick off your movie.

9. **Press OK to select the highlighted image.**

 The highlight is then replaced with a version that says End instead of Start, as shown in Figure 9-25.

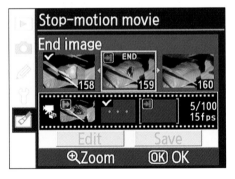

Figure 9-25: Then select the ending frame of the movie.

10. **Highlight the image that will be the last one in the movie and press OK.**

Again, just press the Multi Selector right or left to move the highlight over the ending image. Don't worry if there are frames between the Start and End images that you don't want to include in the movie; you can exclude them in the next step.

The little "filmstrip" at the bottom of the screen displays thumbnails of the images you selected as the Start and End pictures, as shown on the left in Figure 9-26.

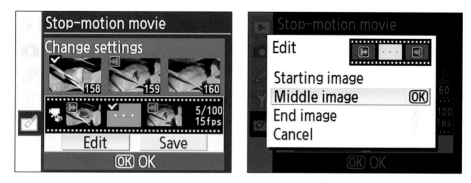

Figure 9-26: Select Edit to exclude frames or change the start or end frame.

11. Edit out any unwanted intermediate frames (optional).

If you don't want to include one or more of the frames that fall between your start and end frame, highlight Edit, as shown on the left in Figure 9-26, and press OK. You then see the screen shown on the right in the figure. Highlight Middle Image and press OK to return to a thumbnail view that displays all the frames between your start and end images, as shown in Figure 9-27.

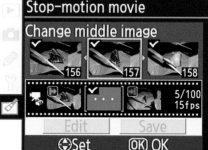

Figure 9-27: Frames with a check mark are included in the movie.

Images marked with a check mark are tagged to be included in the movie. Press the Multi Selector left or right to highlight a frame and then press up or down to toggle the check mark on or off.

Should you decide to change the start or end frame, select Starting Image or End Image instead of Middle Image when you see the screen shown on the right in Figure 9-26. Then simply re-choose your start or end frame and press OK.

12. Highlight Save, as shown on the left in Figure 9-28, and press OK.

Now you see the screen shown on the right in the figure.

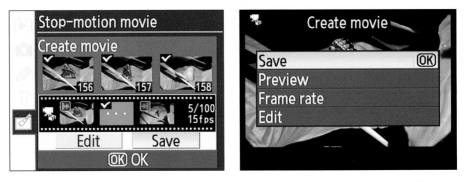

Figure 9-28: Choose Preview to take a look at your movie before you actually save the file.

13. Highlight Preview and press OK.

The camera plays a preview of your movie. If you're not happy with the results, you can take two routes:

- *Adjust the Frame Rate.* Highlight Frame Rate and press OK to adjust the frame rate that you selected in Step 5. You must do this *before* you save the movie file, or the camera saves the file at the original frame rate.

- *Select different images for the movie.* Highlight Edit and press OK to return to the Edit screen (see the right figure in Figure 9-26) to change the start, end, or intermediate images in the movie. After you do so, press OK to return to the Create Movie screen you see on the right in Figure 9-28.

14. Highlight Save and press OK.

The camera takes a few seconds to process and store the movie file, which is recorded in a standard digital movie format known as AVI. Then the first image in the movie appears in full frame on the monitor, as shown in Figure 9-29.

To play the movie, press OK when you see the screen shown in Figure 9-29. Or display the Playback menu and highlight Stop-Motion Movie, as shown on the left in Figure 9-30, and press OK.

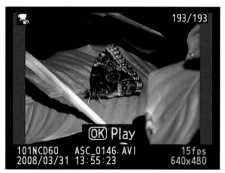

You then see a screen that displays thumbnails representing the starting image of all stop-motion movies on the memory card. In the right image in Figure 9-30, for example, you see the starting image of the butterfly movie that I created. (This movie was the only one on the card, so just one

Figure 9-29: Movie files are stored in the AVI digital video format.

thumbnail is displayed.) Use the Multi Selector to highlight the thumbnail that represents the movie you want to play (again, only if you created multiple movies on the card) and press OK.

Figure 9-30: You can play movies on the memory card by choosing Stop-Motion Movie from the Playback menu.

During playback, a little control bar appears at the bottom of the screen, looking something like the pause, forward, reverse and stop buttons found on most video and DVD players. To use those playback buttons, press the Multi Selector right or left to highlight the control you want to use and then press OK.

After you transfer your image files to the computer, you also can view your movie in any program that can handle AVI files.

Viewing Your Photos on a Television

Your Nikon is equipped with a *video-out port,* which is tucked under the little rubber cover on the left-rear side of the camera, as shown on the left in Figure 9-31. That feature means that you can output your pictures for display on a television screen.

To take advantage of this option, you need to purchase a special video cable; the one that fits your D60 goes by the Nikon part name Video Cable EG-D100. Unfortunately, the cable isn't provided in the camera box, but at a price of around $10, it's worth adding to your equipment bag.

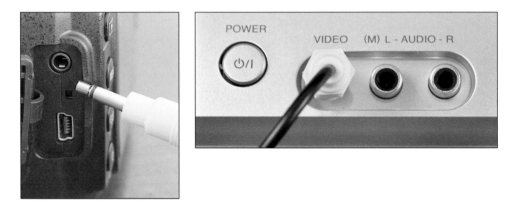

Figure 9-31: You can connect your camera to a television for big-screen playback.

The cable has little yellow plug ends like those you see in Figure 9-31. Turn the camera off and then plug the end of the cable that's shown in the left image in the figure into the camera's video-out port. Next, plug the other end of the cable into the video-in port on your television, as shown in the right half of the figure. (You can also insert the plug into the video-in port on a VCR or DVD player that's connected to your TV.)

When the two devices are connected, turn the camera and TV (or VCR or DVD) on. At this point, you need to consult your TV/VCR/DVD manual to find out what channel to select for playback of signals from auxiliary input devices like your camera. After you sort that issue out, you can control playback using the same camera controls as you normally do to view pictures on your camera monitor. You can also run a slide show by following the steps outlined earlier in this chapter, in the section "Creating a Digital Slide Show."

And if you create a stop-motion movie, following the process laid out in the section just before this one, you can view that creative work on the TV as well.

Note that you may need to adjust one camera setting, Video Mode, which is found on the Setup menu, as shown in Figure 9-32. You get just two options here: NTSC and PAL. Select the video mode that is used by your part of the world. (In the United States, Canada, and Mexico, NTSC is the standard.)

SETUP MENU

Video mode	NTSC
Language	En
Image comment	OFF
Folders	NCD60
File no. sequence	ON
Clean image sensor	--
Mirror lock-up	--

Figure 9-32: Adjust the Video Mode setting on the Setup menu.

Part IV
The Part of Tens

The 5th Wave By Rich Tennant

"I think you've made a mistake. We do photo retouching, not family portrai....Oooh, wait a minute — I think I get it!"

In this part . . .

In time-honored *For Dummies* tradition, this part of the book contains additional tidbits of information presented in the always popular "Top Ten" list format. Chapter 10 shows you how to do some minor picture touchups, such as cropping and adjusting exposure, by using a combination of tools on your camera's Retouch menu and those in most photo-editing programs. Following that, Chapter 11 introduces you to ten camera functions that I consider specialty tools — bonus options that, while not at the top of the list of the features I suggest you study, are nonetheless interesting to explore when you have a free moment or two.

Ten Fast Photo-Retouching Tricks

*E*very photographer produces a clunker image now and then. When it happens to you, don't be too quick to reach for the Delete button on your camera. Many common problems are surprisingly easy to fix, either by using the Retouch menu on your camera or the tools in your photo editing software.

This chapter shows you both options for rescuing a less-than-perfect photo. Look here for the step-by-step instructions for using the quick-and-easy in-camera tools for removing red-eye, trimming away excess background, adjusting exposure, and tweaking color. For times when the in-camera retouching features aren't enough, this chapter also introduces you to some of the retouching tools found in most photo editing programs.

For computer-based repairs, the steps in this chapter feature Adobe Photoshop Elements, a popular program that's available for both Windows and Mac systems. The figures feature version 6 for Windows, so if you use another version of the program, what you see on your computer screen may look different than what you see here. The basics of using the tools that I cover, however, are the same from version to version unless I state otherwise. In fact, even if you use some program other than Elements, you should be able to translate the steps easily to your software, as these retouching tools work in a fairly standard fashion no matter where you find them.

Two Ways to Repair Red-Eye

From my experience, red-eye is not a major problem with the D60. Typically, the problem occurs only in very dark lighting, which makes sense: When little ambient light is available, the pupils of the subjects' eyes widen, creating more potential for the flash light to cause red-eye reflection.

If you spot a red-eye problem before you transfer photos to your computer, you can try removing it with the built-in red-eye remover on your camera's Retouch menu. On occasion, that tool may not recognize that you have a red-eye issue, however, or may not repair the eye in a way you approve. Sometimes, the camera's red-eye filter can mistake ordinary red pixels for red-eye pixels. In that case, or if you don't realize a problem until you view your image close-up on your computer monitor, most photo editing programs have red-eye removal tools that enable you to specify exactly which areas of the photo need correction.

The next two sections show you each method for fixing the problem. For tips on avoiding red-eye in the first place, visit the portrait-shooting section of Chapter 7.

Unfortunately, no red-eye remover works on animal eyes. Red-eye removal tools know how to detect and replace only red-eye pixels, and animal eyes typically turn yellow, white, or green in response to a flash. The only solution is to use the paintbrush tool found in most photo editors to paint in the proper eye colors. Be careful not to paint over the white specular highlight that naturally occurs in the eye. (Or if you do, replace it with a small dab of white paint.)

Using the in-camera red-eye remover

Follow these steps to use the red-eye repair tool found on the camera's Retouch menu:

1. **Display the Retouch menu and highlight Red-Eye Correction, as shown on the left in Figure 10-1.**

2. **Press OK to display thumbnails of the images on your memory card, as shown on the right in Figure 10-1.**

 An X appears over any photos that weren't taken with a flash — meaning that red-eye shouldn't be a problem for those images.

3. **Scroll the display until the thumbnail for the picture you want to fix is surrounded by the yellow highlight box.**

 Press the Multi Selector left and right to scroll the thumbnail display.

Figure 10-1: An automated red-eye remover is built right into your camera.

4. **Press OK.**

 If the camera can detect red-eye, it applies the removal filter and displays the results in the monitor, as shown in Figure 10-2. Move on to Step 5 to evaluate and approve the change.

 If the camera can't find any red-eye, it displays a message telling you so. Skip to the next section, where you can find out how to repair red-eye in your photo editing software.

Figure 10-2: Zoom in to inspect the repair.

5. **Carefully inspect the repair.**

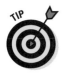

 Press the Zoom button to magnify the display so that you can check the camera's work. To scroll the display, press the Multi Selector up, down, right, or left. The yellow box in the tiny navigation window in the lower-right corner of the screen indicates the area of the picture that you're currently viewing.

 If your image contains red objects or areas other than the eyes, pan around the frame to check those parts of the image, too. The automated red-eye remover can sometimes get confused and try to repair red areas that it shouldn't.

6. **If you're satisfied with the repair, press OK.**

The camera creates a retouched copy of your original image and saves the copy in the JPEG format. The filename of the repaired image begins with the letters CSC instead of the usual DSC to differentiate it from an original. During image playback, the top-left corner of the screen also displays the Retouch icon (the tiny paintbrush, visible in the icon column of the screens in Figure 10-1).

One more tip regarding this and the other Retouch menu options: You can also access them from full-frame Playback mode. When the image you want to retouch is displayed, just press the OK button to display a miniaturized version of the Retouch menu over the image. Then select the menu option as usual. If you choose to go this route, you don't see the image-selection thumbnails that I discuss in Step 3 and show in Figure 10-1 and in other figures in the chapter.

Removing red-eye in a photo editor

Most photo editing programs offer a red-eye removal tool. Typically, you either click a single button, after which the software attempts to automatically detect and repair red-eye, or you click in the red-eye area to tell the program exactly what pixels to fix. The Photoshop Elements version of this tool offers both approaches. I prefer to bypass the first option, though; it's just not as reliable (or fast) as the other method. As with the in-camera red-eye filter, fully automated red-eye correctors — in Elements and in other programs — sometimes "correct" the wrong red pixels.

Here are the steps that I find work the best:

1. **Select the Zoom tool, labeled in Figure 10-3.**

Now drag around the first set of eyes you want to fix so that you can get a close-up view, as shown in the figure.

2. **Select the Red-Eye Removal tool, also labeled in Figure 10-3.**

3. **Click on the red pixels in the first eye.**

(The tool cursor looks like a little white plus sign, as shown in the left eye in Figure 10-3.) After you click, the program attempts to replace the red pixels with the proper eye colors. If you're happy with the results, rinse and repeat to fix the remaining red eyes.

If you aren't happy with the repair, choose Edit⇨Undo and try again. Before you reclick in the eye, try adjusting the values for the Pupil Size and Darken Amount options, found on the options bar (that horizontal bar just above the image window). The first option adjusts the area that is affected by the repair; the second, the brightness of the replacement pixels.

Red-Eye Removal tool

Zoom tool

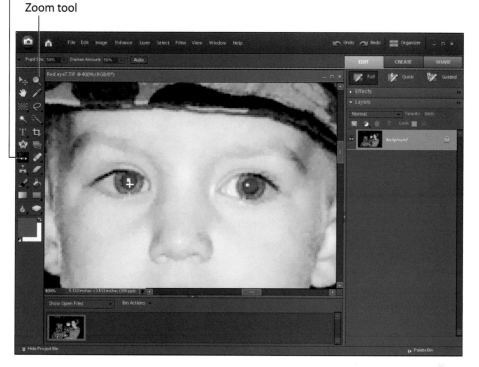

Figure 10-3: To repair red-eye in Elements, just click on the red pixels.

Most red-eye removal tools, including the one in Elements, are pretty capable. But if the eyes are very bright, the tool simply may not be able to make the repair. As with animal eyes, the best solution is to just paint in the correct eye colors by using your software's paintbrush tool.

A Pair of Cropping Options

To *crop* a photo simply means to trim away some of its perimeter. Cropping away excess background can often improve an image, as illustrated by my original butterfly scene, shown in Figure 10-4, and its cropped cousin, shown in Figure 10-5. When shooting this photo, I couldn't get close enough to the butterfly to fill the frame with it, and as a result, the original composition suffers. Not only is there too much extraneous background, you can see the foot of another photographer in the upper right corner. So I simply cropped the image to the composition you see in Figure 10-5.

Figure 10-4: The original contains too much extraneous background.

Figure 10-5: Cropping creates a better composition and eliminates background clutter.

You may also want to crop an image so that it fits a specific frame size. As Chapter 9 explains, the original images from your D60 fit perfectly in 4-x-6-inch frames, but if you want a 5 x 7, 8 x 10, or other standard print size, you need to crop your image to those new proportions. (If you don't, the photo printer software or retail print lab will crop for you, and the result may not be the composition that you'd choose.)

As with red-eye removal, you can crop your image using a command on the camera's Retouch menu or do the job in your photo editor. The next two sections explain both methods.

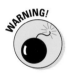

Whether you crop in your camera or on your computer, remember that cropping eliminates pixels. If you crop too tightly, you may not wind up with enough remaining pixels to produce a good print of the cropped photo. So keep the original image resolution in mind as you make your cropping decisions. For details on resolution and print size, see Chapters 3 and 9.

Applying in-camera cropping

With the Trim function on the Retouch menu, you can trim away excess background right in the camera. However, do note a few things about this feature:

✔ You can crop to only five specific sizes: 2560 x 1920 pixels, 1920 x 1440 pixels, 1280 x 960 pixels, 960 x 720 pixels, and 640 x 480 pixels. All these sizes produce an image with proportions of 4:3. So if your purpose for cropping is to prepare your image for a frame size that has different proportions, crop in your photo software instead.

✔ After you apply the Trim function, you can't apply any other fixes from the Retouch menu. So be sure to make trimming the last of your retouching steps.

Keeping those caveats in mind, trim your image as follows:

1. **Display the Retouch menu and highlight Trim, as shown on the left in Figure 10-6.**

2. **Press OK to display a screen showing thumbnails of your images, as shown on the right in Figure 10-6.**

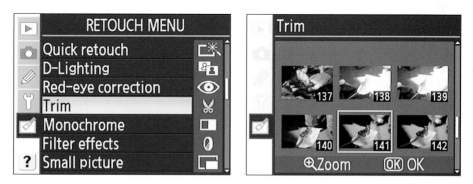

Figure 10-6: You can perform limited cropping using the Trim function.

3. **Scroll the display until the image you want to crop is surrounded by the yellow highlight box.**

 Press the Multi Selector right or left to scroll the display.

4. **Press OK.**

 Now you see a screen similar to the one in Figure 10-7. In the lower-right corner, the tiny window shows you the entire image. The yellow highlight box indicates the current crop boundary. Anything outside that boundary is set to be trimmed away.

 The larger preview shows you the image as it will appear when trimmed. In the upper-left corner of the preview, you see

Pixels in cropped image Crop boundary

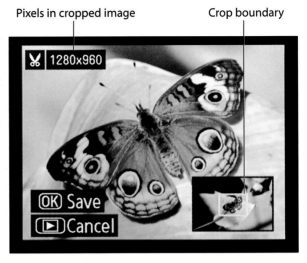

Figure 10-7: Zoom in or out to crop the image tighter or more loosely, respectively.

the image dimensions (in pixels) that will result if you crop at the current setting.

5. **Adjust the crop boundary by using the Zoom button, Thumbnail button, and Multi Selector.**

 Use these techniques:

 - Press the Zoom button to zoom in on your image, which results in a tighter crop.

 - Press the Thumbnail button to zoom out, which expands the size of the crop boundary, leaving more of your original image intact.

 - Press the Multi Selector up, down, right, and left to shift the crop boundary so that it falls over a different portion of the image.

 As you zoom in or out, the image dimension values in the top-left corner of the screen change to reflect how many pixels remain within the crop boundary.

6. **When you're happy with the crop boundary, press OK to trim the image.**

 The camera saves the cropped image as a new file, leaving your original untouched. As with all retouched copies, the file is stored in the JPEG file format, with a filename that begins with the letters CSC.

Cropping in a photo editor

Doing your picture cropping in a photo editor gives you much more say-so over the result than using the Trim function in your camera. Whereas the Trim function limits you to a few crop sizes and final proportions of only 4:3, the Crop tool in most photo editors enables you to crop to any size or shape.

The following steps show you how to crop in Photoshop Elements. If you use another program, the tool likely operates much the same way, but check your software manual if you encounter tool options that are unfamiliar to you.

1. **Select the Crop tool, labeled in Figure 10-8.**

2. **Select the desired crop proportions via the Aspect Ratio drop-down list at the left end of the options bar, as shown in the figure.**

 Again, the options bar is the horizontal strip of controls across the top of the image window. (Each time you select a tool, the options bar changes to show you controls available for that tool.)

Crop tool

Figure 10-8: Choose the desired crop proportions from the Aspect Ratio drop-down list.

You can select several standard print sizes from the drop-down list or, if you don't want to limit the tool to any particular size or shape, select No Restriction.

Don't choose the Use Photo Ratio option from the list. This option adds pixels to, or *resamples,* your image after cropping so that you wind up with the same number of pixels in your trimmed image as you had in your original. Resampling almost always degrades picture quality, so avoid doing so. (Chapter 9 offers an example.)

3. Check the Width and Height values.

If you chose a standard print size in Step 2, Elements automatically enters the crop dimensions in the Width and Height boxes. If you want to reverse those values, click the little pair of arrows between the two boxes.

4. Make sure that the Resolution box is empty.

If the box contains a value, the program will resample your image after cropping — again, Not a Good Thing.

5. Drag across the image to create a dotted crop box, as shown in Figure 10-9.

Anything outside the crop box appears dimmed to indicate the image area that will be cropped away.

6. Adjust the crop box if needed.

Use these techniques:

- *To change the size of the crop box:* Drag the tiny squares, or *handles,* that appear around its perimeter. (See Figure 10-9.) If you chose a specific crop size in Step 2, you can drag the box to any size, but you can't change the original proportions. If you chose No Restriction in Step 2, you can adjust width and height independently.

- *To move the crop box:* Place your cursor inside the dotted crop boundary and drag to reposition it. Or after putting your cursor inside the box, press the arrow keys on your keyboard to nudge the box one pixel in the direction of the arrow key.

Handle Crop boundary

Cancel

Accept

Figure 10-9: After dragging an initial crop box, drag the handles to adjust its size.

If you position your cursor outside a corner handle, the cursor changes to a curved, double-headed arrow. Dragging while this cursor is active tells the program that you want to rotate and crop the image at the same time. In Elements, you get more control over image rotation if you use the Image⇨Transform⇨Free Transform command, and you can preview the rotation, which isn't possible if you rotate while cropping. For those reasons, I suggest that you don't rotate as you crop. (If you do use Free Transform, you see a bounding box that looks much like the crop box, complete with handles. Just place your cursor outside a corner handle and drag to rotate the photo.)

7. **When you're happy with the crop box, click the green Accept check box (labeled in Figure 10-9).**

 The neighboring button, labeled Cancel in the figure, gets rid of the crop box and cancels out of the operation without changing your image. (The exact position of these two buttons varies slightly depending on the position of the crop box with respect to the image margins.)

8. **Choose File⇨Save As to save your cropped image under a new filename.**

If you choose the plain-old Save command, you overwrite your original image, and you may want those original pixels back some day. Choose TIFF or PSD as the file format; both formats produce the highest image quality. (PSD is the Photoshop format.) If you need a JPEG copy of your cropped image to share online, Chapter 9 shows you how to create one.

Focus Sharpening (Sort Of)

Have you ever seen one of those spy-movie thrillers where the good guys capture a photo of the villain's face — only the picture is so blurry that it could just as easily be a picture of pudding? The heroes ask the photo-lab experts to "enhance" the picture, and within seconds, it's transformed into an image so clear you can make out individual hairs in the villain's mustache.

It is with heavy heart that I tell you that this kind of image rescue is pure Hollywood fantasy. You simply can't take a blurry image and turn it into a sharply focused photo, even with the most sophisticated photo software on the market.

There is, however, a digital process called *sharpening* that can *slightly* enhance the apparent focus of pictures that are *slightly* blurry, as illustrated by the before and after images in Figure 10-10. Notice that I say "apparent" focus: Sharpening doesn't really adjust focus but instead creates the *illusion* of sharper focus by increasing contrast in a special way.

Figure 10-10: A slightly blurry image (left) can benefit from a sharpening filter (right).

Here's how it works: Wherever pixels of different colors come together, the sharpening process boosts contrast along the border between them. The light side of the border gets lighter; the dark side gets darker. Photography experts refer to those light and dark strips as *sharpening halos.* You can get a close-up look at the halos in the right, sharpened example in Figure 10-11, which shows a tiny portion of the face and background from the images in Figure 10-10. Notice that in the sharpened example, the skin side of the boundary between face and background received a light halo, while the background received a dark halo.

A little sharpening can go a long way toward improving a slightly soft image, as shown in Figure 10-10. But too much sharpening does more damage than good. The halos become so strong that they're clearly visible and the image takes on a sandpaper-like texture. And again, no amount of sharpening can repair a truly out-of-focus image, so all you do when you crank up sharpening is make matters worse.

To apply sharpening in your photo editor, your best bet is to use a filter called the Unsharp Mask filter, which is found in advanced photo editing programs and some beginner-level programs, including Photoshop Elements. Figure 10-12 shows you the filter dialog box from Photoshop Elements 6. To open the dialog box, choose Enhance⇨Unsharp Mask. (In Elements Version 4 and earlier, instead choose Filter⇨Sharpen⇨Unsharp Mask.)

Original Sharpened

Figure 10-11: Sharpening adds light and dark halos along color boundaries.

The Elements dialog box contains the three controls common to most Unsharp Mask filters. You adjust the sharpening effect with these controls, as follows:

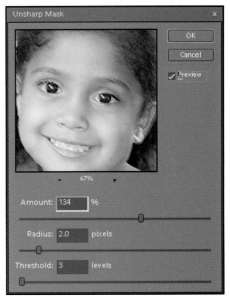

- ✓ **Amount:** This slider adjusts the intensity of the sharpening halos.

- ✓ **Radius:** This slider adjusts the width of the halos. Generally speaking, you should keep the value under 2 for print pictures and even lower for pictures that will be viewed onscreen. Otherwise, you can create pretty noticeable sharpening halos.

- ✓ **Threshold:** With this slider, you can limit the sharpening effect just to high-contrast color boundaries. Try raising the value a few notches up from 0 when sharpening portraits to sharpen the image without adding unwanted texture to the skin.

Figure 10-12: The Unsharp Mask filter provides three levels of sharpening control.

If your photo software doesn't have an Unsharp Mask filter, it may instead offer a single Sharpening control. This type of sharpening filter isn't as sophisticated as Unsharp Mask because you can only increase or decrease

the sharpening amount — you can't fine-tune the effect as you can with the Amount, Radius, and Threshold options of Unsharp Mask. So keep a close watch on your image to make sure that you aren't oversharpening.

Shadow Recovery with D-Lighting

In Chapter 5, I introduce you to a feature called Active D-Lighting. If you turn on this option when you shoot a picture, the camera captures the image in a way that brightens the darkest parts of the image, bringing shadow detail into the light, while preserving highlight detail as well. It's a great trick for dealing with high-contrast scenes or subjects that are backlit.

You can also apply this kind of adjustment after you take a picture by choosing the D-Lighting option on the Retouch menu. I took this approach for the photo in Figure 10-13, where strong backlighting left the balloon underexposed in the original image.

Original image D-Lighting, High

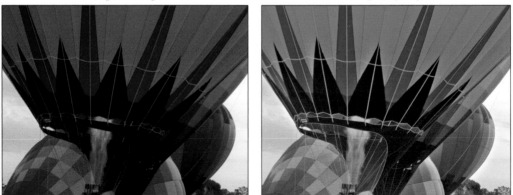

Figure 10-13: An underexposed subject (left) gets help from the in-camera D-Lighting filter (right).

Here's how to apply the filter:

1. **Display the Retouch menu and highlight D-Lighting, as shown on the left in Figure 10-14.**

2. **Press OK to display thumbnails of your images, as shown on the right in Figure 10-14.**

3. **Highlight the image that you want to adjust.**

 Just press the Multi Selector right or left to scroll the display until your image is surrounded by the yellow highlight box.

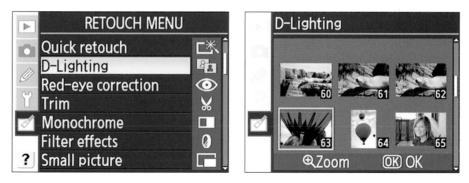

Figure 10-14: Apply the D-Lighting filter via the Retouch menu.

4. **Press OK to display the D-Lighting screen shown in Figure 10-15.**

 You see a thumbnail of your original image on the left side of the screen; the "after" thumbnail appears on the right.

5. **Select the level of adjustment by pressing the Multi Selector up or down.**

 You get three levels: Low, Normal, and High. I used High for the repair to my balloon image.

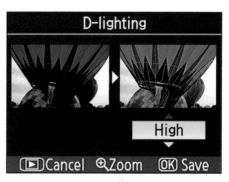

Figure 10-15: Press the Multi Selector up and down to adjust the intensity of the effect.

6. **To go forward with the correction, press OK.**

 The camera makes a copy of your photo, applies the D-Lighting correction to the copy, and then saves the copy in the JPEG file format, leaving your original file intact. The filename of the copy begins with the letters CSC so that you can easily tell that it has been retouched. You also see the Retouch paintbrush icon on the image display when you view the picture on the camera monitor.

Note that you can't apply D-Lighting to an image if you capture the photo with the Optimize Image feature set to Black-and-White. (See Chapter 6 for details on Optimize Image.) Nor does D-Lighting work on any pictures to which you've applied the Monochrome filters. (I cover these filters, also on the Retouch menu, in Chapter 11.) And, as mentioned earlier in this chapter, you can't apply any retouching tools to pictures that you've cropped using the Trim command.

Boosting Shadows, Contrast, and Saturation Together

Located at the top of the Retouch menu, the Quick Retouch filter increases picture contrast and saturation. If your subject is backlit, the filter also applies a D-Lighting adjustment to the image to restore some shadow detail that otherwise might be lost. In other words, Quick Retouch is like D-Lighting Plus. Well, sort of, anyway.

Figure 10-16 illustrates the difference between the two filters. The first example shows my original, a close-up shot of a tree bud about to emerge. I applied the D-Lighting filter to the second example, which brightened the darkest areas of the image. In the final example, I applied the Quick Retouch filter. Again, shadows got a slight bump up the brightness scale. But the filter also increased color saturation and adjusted the overall image to expand the tonal range across the entire brightness spectrum, from very dark to very bright. In this photo, the saturation change is most noticeable in the yellows and reds of the tree bud. (The sky color may initially appear to be less saturated, but in fact, it's just a brighter hue than the original, thanks to the contrast adjustment.)

To try the filter out for yourself, highlight Quick Retouch, as shown on the left in Figure 10-17, and press OK. Select the image that you want to tweak and press OK again to display the second screen in the figure. As with the D-Lighting filter, you can select the level of adjustment you want to apply by selecting Low, Normal, or High. Just press the Multi Selector up or down to change the setting. (For my example photos, I

Original

D-Lighting

Quick Retouch

Figure 10-16: Quick Retouch boosts contrast, saturation, and, if needed, also applies a shadow-recovery step similar to the D-Lighting filter.

applied both the D-Lighting and Quick Retouch filters at the Normal level.) Then press OK to finalize the job. As with other filters, the camera creates a copy of your original, applies the filter to the copy, and then saves the copy in the JPEG file format.

Figure 10-17: Quick Retouch lightens shadows and also bumps up contrast and saturation.

If you want to tweak colors without also adjusting shadows, check out the Filter options on the Retouch menu, explained near the end of this chapter. Also check out Chapter 5, which discusses using flash to provide additional lighting for outdoor subjects such as the tree bud. In many cases, a little pop of flash can also enhance a backlit subject.

Note that the same issues related to D-Lighting, spelled out in the preceding section apply here as well: You can't apply the Quick Retouch filter to black-and-white, monochrome, or trimmed images. Additionally, you can't apply the Quick Retouch filter to a retouched copy that you created by applying the D-Lighting filter, and vice versa. However, you can create two retouched copies of your original image, applying D-Lighting to one and Quick Retouch to the other, and then use the Before and After feature to compare the retouched versions to see which one you prefer. The last section of this chapter details the Before and After feature.

Exposure Adjustment with a Levels Filter

Cool as it is, the D-Lighting filter can't solve all exposure problems. For times when you need more powerful exposure correction, search your photo software for a tool called a *Levels filter.*

With this filter, found in many photo programs, you can adjust your picture's shadows, midtones (areas of medium brightness), and highlights individually. This setup offers much better results than the basic Brightness/Contrast filters offered by some entry-level photo editors, which force you to adjust all

pixels in your image to the same degree — meaning that if you brighten shadows, your highlights and midtones get the same change, which isn't always (or even very often) a good solution. For example, the original image in Figure 10-18 needs its midtones and highlights brightened but its shadows deepened.

Original image Adjusted with the Levels filter

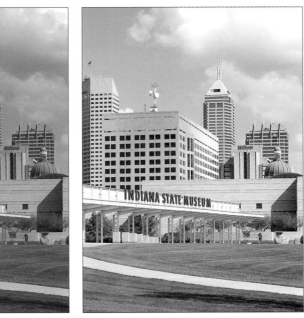

Figure 10-18: To create the improved image, I darkened shadows and brightened midtones and highlights using a Levels filter.

Figure 10-19 shows you the Levels filter dialog box as it appears in Photoshop Elements. To open the dialog box, choose Enhance⇨Adjust Lighting⇨Levels.

Now, I know what you're thinking: "Wow, that looks *way* too complicated for me." Trust me, though, that this filter is actually pretty easy to use. First, ignore everything but the graph in the middle of the box, labeled *Histogram* in the figure, and the three sliders underneath, labeled *Shadows, Midtones,* and *Highlights*. See? Easier already.

The histogram works just like the one that appears on your camera monitor if you view your images in Histogram display mode, which I discuss in Chapter 4. To recap, the horizontal axis of the graph represents the possible brightness values in an image, ranging from black on the left side to white on the right. The vertical axis shows you how many pixels fall at a particular brightness value. So if you have a tall spike, you have lots of pixels at that brightness value.

Histogram

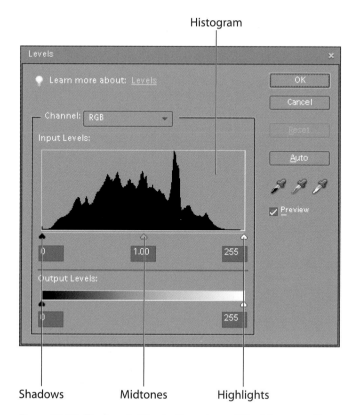

Shadows Midtones Highlights

Figure 10-19: The Levels filter isn't nearly as difficult to use as it appears.

To adjust exposure, you simply drag the three sliders underneath the histogram, as follows:

- **Darken shadows:** Drag the Shadows slider to the right.
- **Adjust midtones:** Drag the middle slider to the right to darken midtones; drag it to the left to brighten them.
- **Brighten highlights:** Drag the Highlights slider to the left.

Note that as you drag the Shadows or Highlights slider, the Midtones slider also moves in tandem. So you may need to readjust that slider after you set the other two.

What if your photo needs the opposite correction from the one you can get from Levels? That is, instead of darkening shadows and brightening highlights, you need to brighten shadows and tamp down your highlights? Well, the D-Lighting filter, explained in the preceding section, brightens shadows. If that doesn't do the job or highlights are the issue, both Photoshop Elements and Photoshop offer a Shadows/Highlights filter that is designed expressly to

correct too-dark shadows and too-bright highlights. (In Elements, the filter is located on the same menu as the Levels filter.) If you use some other photo editor, it may offer a similar tool — although the name may be different, so check the program's Help system.

Playing with Color

Chapter 7 explains how to use your camera's White Balance control to ensure accurate image colors. But even if you play with that setting all day, you may wind up with image colors that you'd like to tweak just a tad. You can do some color adjustments via the Filter Effects features on your camera's Retouch menu. Highlight Filter Effects, as shown on the left in Figure 10-20 and press OK to display the list of filters, as shown on the right.

Figure 10-20: The Filter Effects menu offers six color-tweaking controls.

You get a total of six color-retouching filters (the seventh filter on the menu, Cross Screen, is a special-effects filter that you can explore in Chapter 11). These color-shifting filters work like so:

- **Skylight filter:** This option is designed to replicate the effects of a traditional lens filter that reduces the amount of blue in an image. The end result is a very subtle warming effect.

- **Warm filter:** This one produces a warming effect that's a little stronger than the Skylight filter, but still pretty subtle.

- **Three color intensifiers:** You can boost reds, greens, or blues individually by applying these filters.

- **Color Balance:** This filter is more complex than the others, enabling you to adjust colors with more finesse. You can shift colors toward any part of the color spectrum. For example, you can make colors a little greener or a lot greener, a lot more yellow or less yellow, and so on.

As an example of the impact of the filters, Figure 10-21 shows you an original image and three filtered versions. Again, the Skylight and Warm filters are both very, very subtle; in this image, the effects are most noticeable in the sky. For the Color Balance image, I shifted colors the opposite direction that those two filters move the image, opting to increase the amount of blue.

Original image Skylight filter

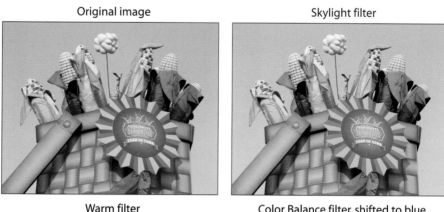

Warm filter Color Balance filter, shifted to blue

Figure 10-21: Here you see the results of applying the three Filter Effects color adjustments.

In case you're wondering, the subject of the image was a huge piece of art created for the Indiana State Fair the year that corn was the celebrated farm product. The same year, the fair-food people also introduced Deep Fried Pepsi — I kid you not — but apparently no one felt the need to create any kind of giant homage to that foodstuff.

Follow these steps to apply the color filters:

1. **Display the Retouch menu, highlight Filter Effects, and press OK.**

2. **Select a filter effect and then press OK to display thumbnails of your images.**

3. **Select the photo that you want to retouch.**

 As always, just press the Multi Selector left and right to scroll the display until the yellow selection box surrounds the image that you want to repair.

4. **Press OK.**

 What happens next depends on the filter you selected. For all filters except the Color Balance filter, you see a full-frame preview of the effect. For the Color Balance filter, you instead see a screen similar to the one in Figure 10-22.

5. **To apply the Skylight or Warm filter, press OK.**

 Or press the Playback button if you want to cancel the filter application. You can't adjust the intensity of these two filters.

6. **To apply one of the color-intensifier filters, use the Multi Selector to specify the amount of color shift and then press OK.**

Figure 10-22: Press the Multi Selector to shift the tiny black box within the color grid.

 Just press the Multi Selector up or down to adjust the filter intensity.

7. **To apply the Color Balance filter, use the Multi Selector to shift colors as needed and then press OK.**

 As you press the Multi Selector, the little black box in the color grid moves, indicating the direction that you're shifting your image across the color spectrum. Press up to make the image more green, press right to make it more red, and so on.

 The three histograms on the right side of the display show you the resulting impact on the red, green, and blue brightness values in the image, a bit of information that's helpful if you're an experienced student in the science of digital imaging. If not, just check the image preview to monitor your results.

Whichever filter you apply, the camera makes a copy of your corrected image and saves it in the JPEG file format, giving it a filename that begins with the letters CSC. When you view the retouched copy on the camera monitor, a little Retouch icon appears in the top-left corner of the screen.

Comparing Before and After Images

After you apply a change to an image through the Retouch menu, you can compare the original and retouched photos side by side on the camera monitor. Here's how:

1. Display either the original or edited picture in full-frame view, as shown on the left in Figure 10-23.

Figure 10-23: Display your image and press OK to display this version of the Retouch menu.

See Chapter 4 if you need help with picture playback.

2. Press OK.

A variation of the Retouch menu appears superimposed on the image, as shown on the right in Figure 10-23.

3. Highlight Before and After and press OK.

Now you see the original image in the left half of the frame, with the retouched version on the right, as shown in Figure 10-24. The Retouch options you applied appear at the top of the screen.

If you created multiple retouched versions of the same original, you can compare all the versions with the original. First, press the Multi Selector right or left to surround the After image with the yellow highlight box, as shown in Figure 10-24. Now press the Multi Selector up and down to scroll through all the retouched versions.

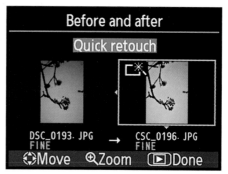

Figure 10-24: The original appears on the left; the retouched version, on the right.

4. **To temporarily view the original or retouched image at full-frame view, highlight its thumbnail and then press and hold the Zoom button.**

When you release the button, you're returned to Before and After view.

5. **To exit Before and After view and return to full-frame playback, press OK.**

Note that this view option doesn't appear on the Retouch menu if you display the menu by pressing the Menu button. You can only take advantage of Before and After view by using the method described in the steps.

Ten Special-Purpose Features to Explore on a Rainy Day

In This Chapter

▶ Adding text comments to images

▶ Creating custom menus and folders

▶ Setting the operation of the Function and AE-L/AF-L buttons

▶ Changing the look of the Shooting Info display

▶ Experimenting with manual flash-power control

▶ Layering and tinting images

*C*onsider this chapter the literary equivalent of the end of one of those late-night infomercial offers — the part where the host exclaims, "But wait! There's more!"

The ten features covered in these pages fit the category of "interesting bonus." They aren't the sort of features that drive people to choose one camera over another, and they may come in handy only for certain users, on certain occasions. Still, they're included at no extra charge with your D60 purchase, so check 'em out when you have a few spare moments. Who knows; you may discover that one of these bonus features is actually a hidden gem that provides just the solution you need for one of your photography problems.

Annotate Your Images

Through the Image Comment feature, found on the Setup menu, you can add text comments to your picture files. Suppose, for example, that you're traveling on vacation and visiting a different destination every day. You can annotate all the pictures you take on a particular outing with the name of the location or attraction. You can then view the comments either in Nikon ViewNX, which

ships free with your camera, or Capture NX, which you must buy separately. The comments also appear in some other photo programs that enable you to view metadata. (You may need to specify via the program preferences that you want to see all metadata, and not just the basic categories of information.)

Here's how the Image Comment feature works:

1. **Display the Setup menu and highlight Image Comment, as shown on the left in Figure 11-1.**

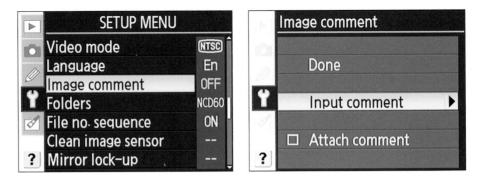

Figure 11-1: You can tag pictures with text comments that you can view in Nikon ViewNX.

2. **Press OK to display the right screen in the figure.**

3. **Highlight Input Comment and press the Multi Selector right.**

Now you see a keyboard-type screen like the one shown in Figure 11-2.

4. **Use the Multi Selector to highlight the first letter of the text you want to add.**

5. **Press OK to enter that letter into the display box at the bottom of the screen.**

6. **Keep highlighting letters and pressing OK to continue entering your comment.**

Your comment can be up to 36 characters long.

Figure 11-2: Highlight a letter and press OK to enter it into the comment box.

To move the text cursor, rotate the Command dial. To delete a letter, rotate the Command dial to move the cursor under the offending letter. Then press the Delete button on the camera back.

7. **To save the comment, press the Zoom button.**

 Don't press OK instead — for this function, OK adds another letter to the text.

 After you press the Zoom button, you're returned to the Image Comment menu, shown on the left in Figure 11-3.

8. **Highlight Attach Comment and press the Multi Selector right to put a check mark in the box, as shown on the left in Figure 11-3.**

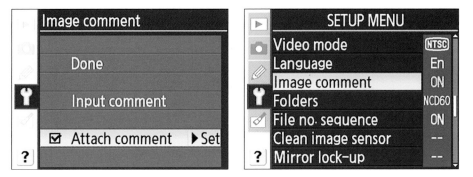

Figure 11-3: Press the Multi Selector right to toggle the Attach Comment check box on and off.

The check mark turns the Image Comment feature on.

9. **Highlight Done and press OK to wrap things up.**

 You're returned to the Setup menu. If all went well, the Image Comment item should now be set to On, as shown on the right in Figure 11-3.

The camera applies your comment to all pictures you take after turning on Image Comment. To disable the feature, revisit the Image Comment menu, highlight Attach Comment, and press the Multi Selector right to toggle the check mark off.

To view comments in Nikon ViewNX, display the Camera Settings tab. (Click the tab on the left side of the program window.) Select an image by clicking its thumbnail. The Image Comment text appears in the File section of the Camera Settings panel, as shown in Figure 11-4. See Chapter 8 for more details about using ViewNX.

Image Comment

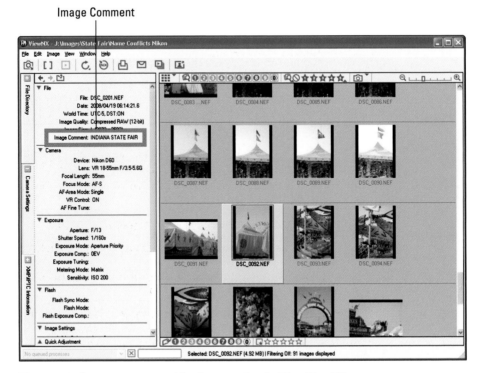

Figure 11-4: Comments appear with other metadata in Nikon ViewNX.

Customizing Camera Menus

On the Setup menu, the first item is called CSM/Setup menu. The CSM part stands for Custom Setup Menu. Through this option, you can customize the camera menus.

In Chapter 1, I advise you to set this option to Full so that you can access the entire assortment of menu items while reading this book; at the default setting, Simple, some items are hidden from view. After getting to know your camera, though, you may find that you have no use for some menu items. For example, the Playback menu contains an option that enables you to establish a print order for a direct printing option called DPOF, which I cover in Chapter 9. If your printer doesn't support DPOF printing, that command does you no good.

To customize your menus, follow these steps:

1. **Display the Setup menu and highlight CSM/Setup Menu, as shown on the left in Figure 11-5.**

2. **Press OK to display the three options shown on the right in Figure 11-5.**

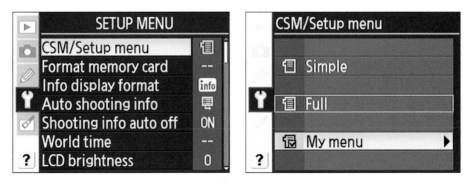

Figure 11-5: The CSM/Setup option enables you to hide or display selected menu items.

3. **Highlight My Menu and press the Multi Selector right.**

 Now you see a list of all camera menus, as shown on the left in Figure 11-6.

4. **Highlight the menu that you want to customize and press the Multi Selector right.**

 Now you see a list of all options on that menu, with a box next to each item, as shown on the right in Figure 11-6. A check mark in a box indicates that the item is currently displayed on the menu.

5. **Highlight a menu item and then press the Multi Selector right to toggle its display check mark on and off.**

6. **When you finish marking or unmarking check boxes, highlight Done and press OK.**

 You're returned to the list of menus (as shown on the left in Figure 11-6). To edit another menu, just repeat Steps 4-6.

7. **When you finish customizing all menus, highlight Done in the main menu list.**

 (Again, that's the one on the left in Figure 11-6.)

Figure 11-6: Press the Multi Selector right to toggle the display of a menu item on and off.

8. **Press OK.**

Now your menus show you only the items you deemed important.

To return to the default menu setup, choose Simple in Step 3. Or to return to the complete menu listings, choose Full. Then press OK to apply the change.

Creating Custom Image Folders

By default, your camera initially stores all your images in one folder, which it names 100NCD60. Folders have a storage limit of 999 images; when you exceed that number, the camera creates a new folder, assigning a name that indicates the folder number — 101NCD60, 102NCD60, and so on.

If you choose, however, you can create your own, custom-named folders. For example, perhaps you sometimes use your camera for business and sometimes for personal use. To keep your images separate, you can set up one folder named DULL and one named FUN — or perhaps something less incriminating, such as WORK and HOME.

Whatever your folder-naming idea, you create custom folders like so:

1. **Display the Setup menu and highlight Folders, as shown on the left in Figure 11-7.**

 This option appears on the menu only if you first set the CSM/Setup option at the top of the Setup menu (not shown in the figure) to Full.

2. **Press OK to display the screen shown on the right in Figure 11-7.**

3. **Highlight New and press the Multi Selector right.**

 You see a keyboard-style screen similar to the one used to create image comments, as described at the start of the chapter. The folder-naming version appears in Figure 11-8.

▶	SETUP MENU	
🅾	Video mode	NTSC
✎	Language	En
	Image comment	OFF
🔧	Folders	NCD60
☑	File no. sequence	ON
	Clean image sensor	--
?	Mirror lock-up	--

	Folders
	Select folder
🔧	New ▶
	Rename
?	Delete

Figure 11-7: You can create custom folders to organize your images right on the camera.

4. **Enter a folder name up to 5 characters long.**

 Use these techniques:

 - To enter a letter, highlight it by using the Multi Selector. Then press OK.

 - To move the text cursor, rotate the Command dial.

 - To delete a letter, rotate the Command dial to move the cursor under that letter. Then press the Delete button on the camera back.

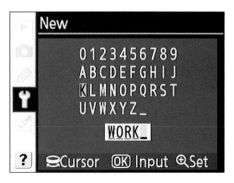

Figure 11-8: Folder names can contain up to five characters.

5. **After creating your folder name, press the Zoom button to complete the process and return to the Setup menu.**

If you take advantage of this option, you must remember to specify where you want your pictures stored each time you shoot. To do so, display the Setup menu, highlight Folders, and press OK to display the screen shown on the left in Figure 11-9. Highlight Select Folder and press the Multi Selector right to display a list of all your folders, as shown on the right in Figure 11-9. Highlight the folder that you want to use and then press OK.

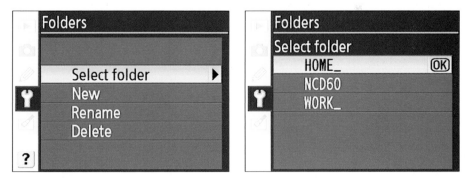

Figure 11-9: Remember to specify where you want to store new images.

Your choice also affects which images you can view in Playback mode. By default, the camera displays only the images in the currently selected folder, which is shown in the Playback Folder area of the Playback menu, as shown on the left in Figure 11-10. To view images in all folders instead, highlight Playback Folder and press OK to display the screen shown on the right in the figure. Select All and press OK again. (This step isn't necessary unless you create custom folders; the camera automatically displays all images if you stick with the default folder-naming scheme, even if the card contains multiple folders.)

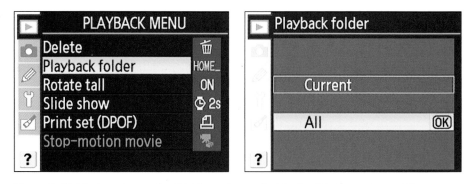

Figure 11-10: To view pictures in all folders, change the Playback Folder option to All.

If necessary, you can rename a custom folder by returning to the Setup menu. Select the Folders option and then select Rename. (See the left image in Figure 11-9.) The Delete option on the same screen enables you to get rid of all empty folders on the memory card.

Changing the Function Button's Function

When your camera ships from the Nikon factory, the Function button on the side of the camera, highlighted in Figure 11-11, is set up to provide you with a shortcut to the self-timer feature. Just press the button, and the camera shifts into self-timer mode. (I discuss self-timer shooting in Chapter 2.)

However, you can change this behavior so that the Function button instead provides quick access to one of these other settings:

Figure 11-11: You can change the feature that's activated by the Function button.

 ✔ **Release mode:** The Release mode setting controls whether the camera is set to single-frame shooting, continuous capture, self-timer mode, or remote-control mode. Again, Chapter 2 covers these options.

 ✔ **Image Quality and Image Size:** These settings affect the file format (JPEG or NEF), the JPEG quality, and the image pixel count, or resolution. Chapter 3 contains details on these issues.

✓ **ISO Sensitivity:** This setting adjusts the sensitivity of the camera's image sensor, making it more or less responsive to light. Chapter 5 fully explains the impact of ISO.

✓ **White Balance:** This control, covered in Chapter 6, is designed to ensure accurate colors in any light source.

If you set the Function button to any of these four options, you change the selected setting by rotating the Command dial as you press the button. You monitor the setting adjustment in the Shooting Info display, introduced in Chapter 1.

To select the setting that you want the Function button to control, take these steps:

1. **Display the Setup menu and make sure that the CSM/Setup option is set to Full.**

 Otherwise, you can't access the Function button adjustment.

2. **Now display the Custom Setting menu and highlight the Fn Button option, as shown on the left in Figure 11-12.**

3. **Press OK to display the options shown on the right in Figure 11-12.**

 You see the four options described in the preceding list, plus the default Self-Timer option.

4. **Highlight your choice and press OK.**

 If you choose any option but Self-Timer, the letters Fn appear next to the control in the Quick Settings display to remind you which option can be adjusted by rotating the Command dial while pressing the Function button. To find out how to use the Quick Settings display, head for Chapter 1. (Note that the Fn marker doesn't appear in the Shooting Info screen, only in the Quick Settings display.)

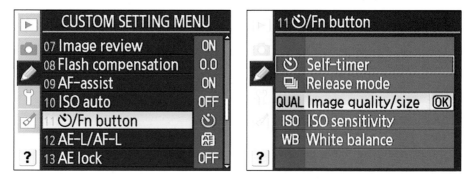

Figure 11-12: Set the button's function via the Custom Setting menu.

Limiting the AE-L/AF-L Button's Impact

Set just to the right of the viewfinder, as shown in Figure 11-13, the AE-L/AF-L button enables you to lock focus and exposure settings when you shoot in autoexposure and autofocus modes, as explored in Chapters 5 and 6.

Normally, focus and exposure are locked when you press the button and remain locked as long as you keep your finger on the button. But you can change the button's behavior. To access the available options, take these steps:

Autoexposure/autofocus lock

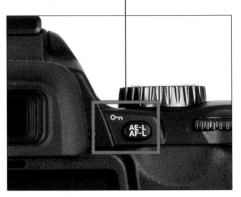

Figure 11-13: You can adjust the function of the AE-L/AF-L button, too.

1. **Open the Setup menu and ensure that the CSM/Setup option is set to Full.**

 As with the Function button control, the AE-L/AF-L button control is available only if you set the CSM/Setup option to Full.

2. **Display the Custom Setting menu and highlight AE-L/AF-L, as shown on the left in Figure 11-14.**

3. **Press OK to display the options screen shown on the right in Figure 11-14.**

 The options produce these results:

 - *AE/AF Lock:* This is the default setting. Focus and exposure remain locked as long as you press the button.

 - *AE Lock Only:* Exposure is locked as long as you press the button; autofocus isn't affected. (You can still lock focus by pressing the shutter button halfway.)

 - *AF Lock Only:* Focus remains locked as long as you press the button. Exposure isn't affected.

 - *AE Lock Hold:* This one locks exposure only with a single press of the button. The exposure lock remains in force until you press the button again or the exposure meters turn off.

 - *AF-ON:* Pressing the button activates the camera's autofocus mechanism. If you choose this option, you can't lock autofocus by pressing the shutter button halfway.

4. **Highlight your choice and press OK.**

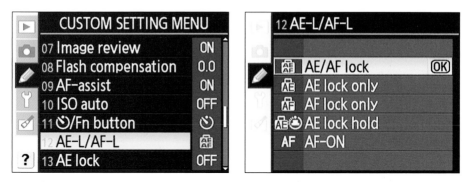

Figure 11-14: You get four button options in addition to the default setting.

The information that I give in this book with regard to using autofocus and autoexposure assumes that you stick with the default setting. So if you change the button's function, remember to amend my instructions accordingly.

On a related note, all my instructions also assume that the AE Lock function, found on the Custom Setting menu, is set to its default, which is Off. At that setting, pressing the shutter button halfway locks focus but not exposure. If you turn the feature on, your half-press of the shutter button locks both focus and exposure.

Changing the Shooting Info Display Style

When you're first learning about photography, using the Shooting Info design that you see throughout this book and in the top-right example in Figure 11-15 can be helpful: The large gold circle on the left side of the screen is a graphical representation of the aperture and is designed to help you remember the relationship between the f-stop setting and the size of the aperture opening. As you choose a higher f-stop number, the circle shrinks to indicate that you're reducing the size of the aperture opening. (If the word *aperture* is new to you, Chapter 5 explains it.)

After you have that concept down cold, however, you may want to see whether one of the other two display styles suits you better. You can change to the Classic style or Wallpaper style, both also shown in Figure 11-15. With Wallpaper style, you can display the shooting data against a default sky image already stored in the camera or against one of your own images. My personal favorite is Classic, though, because the size of some of the display data is larger, making it easier to read.

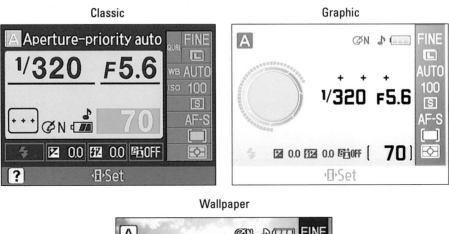

Figure 11-15: You can choose from three designs for the Shooting Info display.

Whatever your choice, follow this path to change the display style:

1. **Display the Setup menu and highlight Info Display Format, as shown on the left in Figure 11-16.**

2. **Press OK to reveal the options shown on the right in the figure.**

 The first two options enable you to choose the shooting modes that you want to affect with your change. You can specify a different display for the Digital Vari-Program exposure modes (and Auto mode) than for P, S, A, or M exposure modes.

3. **Highlight one of the exposure mode options and press the Multi Selector right.**

 Now you see a screen listing the three display styles: Classic, Graphic, and Wallpaper.

4. **Highlight your preferred display style and press the Multi Selector right.**

 Now you're taken to a screen where you can choose from a few other options.

5. **If you selected Graphic or Classic, choose one of the three available background colors and press OK.**

 You're returned to the screen shown on the right in Figure 11-16.

6. **If you selected Wallpaper, choose a type scheme and then select your wallpaper image.**

 First, specify whether you want light type with a dark outline or vice versa. Press OK to return to the main Info Display Format screen, shown on the right in Figure 11-16.

 Next, highlight Select Wallpaper and press the Multi Selector right. You see thumbnails of your images. Scroll the display (press the Multi Selector right and left) until the image you want to use is surrounded by the yellow box. Then press OK to select that image.

 The camera saves a copy of your wallpaper image and stores it internally so that the wallpaper isn't stripped when you remove your memory card. If you later choose a new wallpaper image, the old one is deleted from the camera's internal memory.

7. **Repeat Steps 3 through 6 to set the display style for the other exposure mode.**

Figure 11-16: And you can choose a different style for different shooting modes.

Controlling Flash Output Manually

By default, your camera automatically adjusts the output of its built-in flash based on the ambient light so that you wind up with a proper exposure. But if you're experienced in the way of the flash, you do have the option of manually setting the flash output.

To take advantage of this option, you must use one of the advanced exposure modes (P, S, A, or M). After setting the camera to one of those modes, open the Custom Setting menu, highlight the Built-In Flash option, and then press OK. (The control is available only if you first set the CSM/Setup option on the Setup menu to Full.) You see the screen shown on the left in Figure 11-17. Then

change the setting from TTL (which stands for *through the lens*) to Manual. Press OK to display the available flash-power settings, as shown on the right in Figure 11-17. Highlight the power you want and press OK.

Adjusting flash power this way is a little cumbersome and, again, requires some lighting expertise to use properly. So remember that you can also keep the flash in auto mode (TTL mode) and then use the Flash Compensation control to bump the flash power up or down a few notches from what the camera's metering system thinks is appropriate. See Chapter 5 for details.

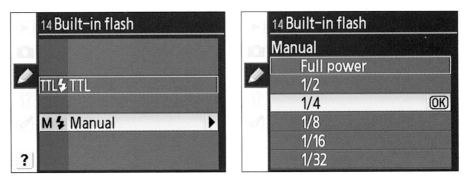

Figure 11-17: For experienced flash photographers, the camera offers manual control over flash output.

Combining Two Photos with Image Overlay

Found on the Retouch menu, the Image Overlay feature enables you to merge two photographs into one, creating the digital equivalent of a multiple exposure. I used the feature to combine a photo of a werewolf friend, shown on the top left in Figure 11-18, with a nighttime garden scene, shown on the top right. The result is the ghostly image shown beneath the two originals. Oooh, scary!

On a more serious note, some photographers use this feature when trying to capture a scene that has both very dark and very bright areas, such as a sunset scene. They take two shots of the same scene, exposing one for the highlights and one for the shadows. Then they combine the two images to produce a composite that contains more shadow and highlight detail than would be possible with a single exposure. For this technique to work, however, you must use a tripod and manual focusing so that the only difference between the two images is exposure. Otherwise, the photos won't blend seamlessly.

Additionally, the Image Overlay feature works only with pictures that you shoot in the Camera Raw (NEF) format. For details on Raw, see Chapter 3. The resulting image is also created in the Raw format, which means that you have to use a Raw processor to convert it into an actual image file before you can print or share it. Chapter 8 has details on that issue.

Figure 11-18: Image Overlay merges two Raw (NEF) photos into one.

To be honest, I don't use Image Overlay for the purpose of serious photo compositing, however. I prefer to do this kind of work in my photo editing software, where I have more control over the blend. In addition, previewing the results of the overlay settings you use is difficult given the size of the camera monitor.

That said, it's a fun project to try, so give it a go when you have a spare minute. Take these steps:

1. Display the Retouch menu, highlight Image Overlay, and press OK.

You see the screen shown on the left in Figure 11-19, with the preview area for Image 1 highlighted. (The yellow border indicates the active preview area.)

2. Press OK to display thumbnails of your images.

3. Select the first of the two images that you want to combine.

A yellow border surrounds the currently selected thumbnail. Press the Multi Selector right and left to scroll the display until the border appears around your chosen image. Then press OK.

The Image Overlay screen now displays your first image as Image 1.

Figure 11-19: Preview the overlay image by pressing the Zoom button.

4. **Repeat Steps 2 and 3 to select the second image.**

Now you see both images in the Image Overlay screen, with the combined result appearing in the Preview area, as shown on the right in Figure 11-19.

5. **Press the Multi Selector right to move the yellow selection box over the Preview thumbnail.**

6. **In the Preview thumbnail area, highlight Overlay and press OK to get a full-frame view of the merged image.**

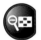

If you aren't happy with the result, press the Thumbnail button to exit the preview. Then adjust the gain setting underneath the image thumbnails to manipulate the combined image. Press the Multi Selector right or left to highlight Image 1 or Image 2 and then press up or down to adjust the gain for that image. To see the results of your adjustment in full-frame view, just highlight Overlay and press OK again. Press the Thumbnail button to exit the full-frame preview.

7. **To save the merged image, highlight Save (in the Preview thumbnail area) and press OK.**

Again, the combined image is created in the Camera Raw (NEF) format.

Creating Monochrome Images

The D60 enables you to either shoot black-and-white images, by using the Optimize Image feature, or turn an existing color image to black-and-white by applying the Monochrome option on the Retouch menu. You can also create sepia and *cyanotype* (blue and white) images via the Monochrome option. Figure 11-20 shows you examples of all three effects.

Original image

Black and white

Sepia

Cyanotype

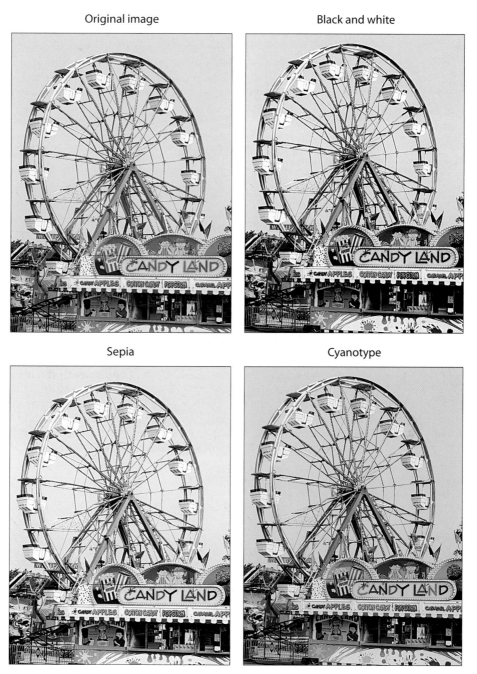

Figure 11-20: You can create three monochrome effects through the Retouch menu.

I prefer to always shoot in color and then create black-and-white copies or apply other color effects in my photo editor. Going that route simply gives you more control, not to mention the fact that it's easier to preview your results on a large computer monitor than on the camera monitor. Still, I know that not everyone's as much of a photo editing geek as I am, so I present to you here the steps involved in applying the Monochrome effects to a color original in your camera:

1. **Display the Retouch menu and highlight Monochrome, as shown on the left in Figure 11-21.**

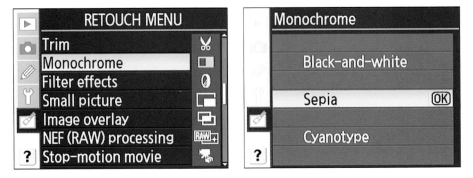

Figure 11-21: Select a filter and press OK to start the process.

2. **Press OK to display the three effect options, as shown on the right in the figure.**

3. **Highlight the effect that you want to apply and press OK.**

 The monitor now displays thumbnails of your images.

4. **Select your photo.**

 Take the usual tack here: Press the Multi Selector right or left to scroll through your thumbnails until the yellow border surrounds the image that you want to select. Then press OK.

 You then see a full-frame preview of the image with your selected photo filter applied, as shown in Figure 11-22.

5. **To adjust the intensity of the sepia or cyanotype effect, press the Multi Selector up or down.**

 No adjustment is available for the black-and-white filter.

6. **To save a copy of the image with the filter applied, press OK.**

 The camera creates your copy, stores it in the JPEG file format, and assigns a filename that begins with the letters CSC. When you view the image on the camera monitor, the little Retouch icon — a tiny paintbrush symbol — appears at the top of the screen.

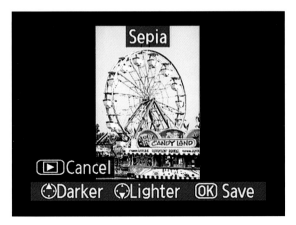

Figure 11-22: Press the Multi Selector up or down to adjust the intensity of the color filters.

Adding a Starburst Effect

Want to give your photo a little extra sparkle? Experiment with your D60's Cross Screen filter. This filter adds a starburst-like effect to the brightest areas of your image, as illustrated in Figure 11-23.

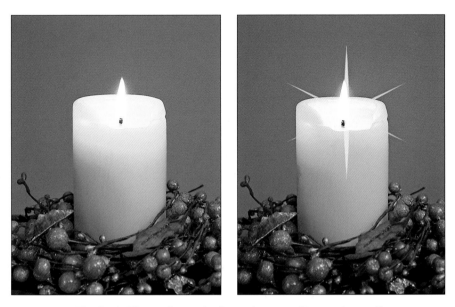

Figure 11-23: The Cross Filter option on the Retouch menu adds a starburst effect.

Traditional photographers create this effect by placing a special filter over the camera lens; the filter is sometimes known as a Star filter instead of a Cross Screen filter. With your D60, you apply it to an existing image, via the Retouch menu, as follows:

1. **Display the Retouch menu, highlight Filter Effects, as shown on the left in Figure 11-24, and press OK.**

 You see the list of available filters. (For details about the color filters, see Chapter 10.)

2. **Highlight Cross Filter, as shown on the right in Figure 11-24, and press OK.**

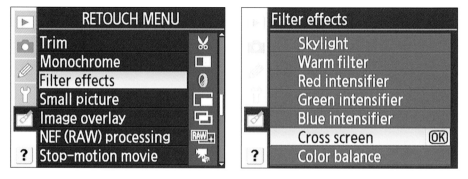

Figure 11-24: The Cross Filter effect is grouped with the color filters.

You're presented with thumbnails of the images on your camera memory card.

3. **Select the image to which you want to add the star effect and press OK.**

 Just press the Multi Selector to move the yellow highlight box around the image. After you press OK, you see the screen shown in Figure 11-25. The preview shows you the results of the Cross Screen filter at the current filter settings.

4. **Adjust the filter settings as needed.**

 You can adjust the number of points on the star, the strength of the effect, the length of the star's rays, and the angle of the effect. Just use the Multi Selector to highlight an option and then press the Multi Selector right to display the available settings. Highlight your choice and press OK. I labeled the four options in Figure 11-25.

Filter intensity

Number of points

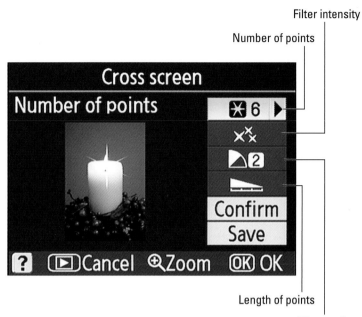

Filter angle

Length of points

Figure 11-25: You can play with four filter settings to tweak the effect.

To update the preview, highlight Confirm and press OK.

 You can also press and hold the Zoom button to temporarily view your image in full-screen view. Release the button to return to the normal preview display.

5. **Highlight Save and press OK to create your star-crossed image.**

The camera makes a copy of your original image, applies the Cross Screen filter to the copy, and then saves the retouched copy in the JPEG format. The filename begins with the letters CSC to indicate a retouched photo.

Keep in mind that the number of starbursts the filter applies depends on your image. You can't change that number; the camera automatically adds the twinkle effect wherever it finds very bright objects. If you want to control the exact placement of the starbursts, you may want to forgo the in-camera filter and find out whether your photo software offers a more flexible star-filter effect. (You can also create the effect "manually" by painting the cross strokes onto the image in your photo editor.)

Appendix

Firmware Notes and Menu Map

*F*irmware is the internal software that runs your camera. On occasion, the camera manufacturer updates this software, either to fix recently discovered problems or to enable minor new features. You can find out which firmware version your camera is running via the Setup menu, as explained in the next section.

Speaking of menus, the second part of this appendix provides a handy summary of all the commands on the Setup menu, as well as the other four camera menus. For each menu option, I provide a quick description and, where relevant, a cross-reference to the chapter where you can find any additional details.

Firmware Facts

Keeping your camera's firmware current can help you avoid problems down the road, so periodically visit the Nikon Web site to find out whether any updates have been posted. Start from the Nikon home page (www.nikon.com) and just follow the product support links to the firmware updates. (The actual link names vary depending on which of Nikon's international sites you use.)

To check your firmware version, follow these steps:

1. **Display the Setup menu.**

2. **Highlight Firmware Version, as shown on the left in Figure A-1, and press OK.**

 If you don't see the Firmware Version item, scroll to the top of the menu and set the CSM/Setup menu option to Full. Some menu items are hidden until you take that step.

3. **Press OK.**

 You see a screen similar to the one on the right in Figure A-1, with both an A and B firmware file number shown.

At the time I write this, the current firmware version number for both A and B is 1.00, as shown in the figure. If a check of the Nikon site uncovers an even more recent version than 1.00, follow the instructions on the firmware download site to update your camera. These instructions vary depending on your computer operating system and the firmware release itself, and because the instructions on the Nikon site are very detailed, I won't waste space repeating them to you here.

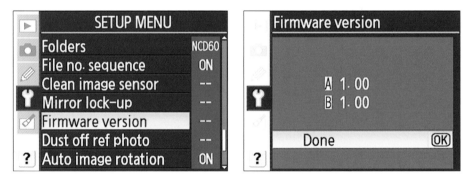

Figure A-1: Check your firmware version via the Setup menu.

Menu Quick Reference

To help you locate all the features on your D60, the following sections list the options found on each of the camera's five menus. Chapter 1 details the process of using menus, if you need help.

The settings shown for the menu items here may or may not be the best choice, depending on your subject and other photographic conditions. So visit the chapters referenced in the table for details that will help you lock in the right settings.

The Playback menu

Shown in Figure A-2 and detailed in Table A-1, this menu contains options related to picture playback but also contains controls for deleting, protecting, and printing images.

Figure A-2: Playback menu options affect more than image viewing.

Table A-1	The Playback Menu
Menu Option	*Choose This Option To . . .*
Delete	Erase all photos or selected photos from the memory card. Doesn't delete pictures that you tag with the Protect feature. See Chapter 4 for details.
Playback Folder	Select the image folder that you want to view, which is required only if you create custom folders; see Chapters 4 and 11.
Rotate Tall	Display vertically oriented photos in their upright position during playback mode. See Chapter 4.
Slide Show	Display all pictures on the memory card automatically, one by one, with a brief interval between each image, as explained in Chapter 9.
Print Set (DPOF)	Print directly from a memory card, using a card slot on a photo printer that supports DPOF (Digital Print Order Format). Chapter 9 has details.
Stop-Motion Movie	View stop-motion movies that you create through the Retouch menu. See Chapter 9 for more information.

The Shooting menu

Visit this menu, shown in Figure A-3, to set the picture-taking options listed in Table A-2.

SHOOTING MENU

Optimize image	⊘N
Image quality	NORM
Image size	▣
White balance	AUTO
ISO sensitivity	100
Noise reduction	OFF
Active D-Lighting	OFF

Figure A-3: Find important quality and color options here.

Table A-2	The Shooting Menu
Menu Option	**Choose This Option To . . .**
Optimize Image[1]	Apply preset adjustments to image sharpness, contrast, and color or create a custom setting that applies your own adjustments to sharpness, contrast, color mode (Adobe RGB or sRGB), saturation, and hue. See Chapter 6.
Image Quality	Choose the image file format. Select from three JPEG settings (Fine, Normal, and Basic); NEF (Raw); or NEF (Raw) + JPEG Basic. For the best image quality, choose JPEG Fine or NEF (Raw). See Chapter 3 for details.
Image Size	Set the image resolution (number of pixels). See Chapter 3 for help deciding what resolution you need.
White Balance[1]	Eliminate unwanted color cast caused by a particular light source. Chapter 6 explains.
ISO Sensitivity	Adjust the light sensitivity of the camera's image sensor so that you can capture an image with less light. Choosing a higher ISO setting increases sensitivity but can produce noise. Chapter 5 tells all.
Noise Reduction	Apply a filter to reduce the appearance of noise in images shot at a high ISO or with a slow shutter speed. Some softening of image sharpness may result. See Chapter 5.
Active D-Lighting	Enable or disable Active D-Lighting, a feature that can help produce better exposure results when you shoot high-contrast subjects. Chapter 5 covers this feature.

[1]*Available only in P, S, A, and M exposure modes.*

The Custom Setting menu

This lengthy menu, the first page of which is shown in Figure A-4, contains options that enable you to customize various aspects of your camera's basic operation as well as adjust some advanced picture-taking options. Table A-3 describes the function of each option.

Figure A-4: Some options on this menu are hidden by default.

By default, many of this menu's options are hidden, as indicated in the table. To display them, you must change the CSM/Setup menu option on the Setup menu (explained in the next section) to Full.

Table A-3	The Custom Setting Menu
Menu Option	*Choose This Option To . . .*
Reset	Reset all options on this menu to their default settings. See Chapter 1 for other ways to restore default settings.
Beep	Enable or disable the beep that the camera emits during some autofocus operations and when you use self-timer mode and some remote-control modes.
Focus mode	Select from three autofocus modes — AF-A (auto-servo) AF-S (single-servo), or AF-C (continuous-servo) — or select manual focusing (MF). Chapter 6 provides details.
AF-Area mode	Choose from three autofocus options that determine which part of the frame the camera uses when setting focus: Closest Subject, Dynamic Area, and Single Point. Chapter 6 covers each option.
Release mode	Choose from Single Frame shooting, to take one picture at a time; Continuous, to record multiple images with one press of the shutter button; or Self-Timer, to record the image a few moments after the shutter button is pressed. Two options are also provided for adjusting the shutter response if you use the optional Remote Control unit. See Chapter 2 for details on using the Release mode option.
Metering[1]	Choose one of three settings that control what part of the frame the camera analyzes when determining exposure: Matrix (entire frame), Center-Weighted (entire frame, but with emphasis to the middle), or Spot (one of three specific areas selected by the user). Chapter 5 details these options.
No Memory Card?	Specify whether you want the camera to disable the shutter release when no memory card is inserted. See Chapter 1 for memory card information.
Image Review[2]	Control whether images appear automatically on the monitor for a few seconds after they're captured. Chapter 1 has details.
Flash Compensation[1,2]	Adjust the intensity of the built-in flash. See Chapter 5 for more information.
AF-Assist[2,3]	Enable or disable the auto-focus assist illuminator, the tiny light that shoots out from the front of the camera to help the autofocus mechanism find its target in dim lighting. See Chapter 6 for other autofocus information.

(continued)

Table A-3 *(continued)*

Menu Option	Choose This Option To . . .
ISO Auto[1,2]	Turn automatic ISO adjustment on or off for advanced exposure modes (P, S, A, and M). If you turn the feature on, you also can specify the maximum allowable ISO and the minimum shutter speed at which the camera raises ISO. See Chapter 5 for help.
Fn Button[2]	Choose which of five features the self-timer/Fn button controls. See Chapter 11 for your options.
AE-L/AF-L[2]	Choose which of five autoexposure and autofocus lock functions the button performs. Again, Chapter 11 has details.
AE Lock[2]	Specify whether you want the camera to lock exposure when you press the shutter button halfway. See Chapter 5 for more exposure-locking information.
Built-In Flash[1,2]	Switch from automatic flash mode (TTL, or *through the lens* mode), in which the camera adjusts the flash output to match ambient light, and manual flash mode, in which you set the flash output. Chapter 11 explains this option.
Auto-Off Timers[2]	Specify the time at which the monitor and exposure meters automatically turn off (to save battery life) if the camera is on but not currently performing any operations. Chapter 5 explains exposure metering; see Chapter 4 for monitor-playback issues.
Self-Timer[2]	Change the length of the delay between the time you press the shutter button and the image is captured when you shoot in Self-Timer mode. Chapter 2 covers this issue.
Remote On Duration[2]	Tell the camera how soon to cancel out of either of the two remote shooting modes if no signal is received from a remote control unit. See Chapter 2 for details.
Date Imprint[2]	Add the shooting date, date and time, or date counter to the lower-right corner of the photo. See Chapter 1 for details.
Rangefinder[2]	Enable the Rangefinder display, a manual-focusing aid you can explore in Chapter 6.

[1]Available only in P, S, A, and M exposure modes.
[2]Hidden by default; change the CSM/Setup menu option on the Setup menu to Full to access.
[3]Available in all modes except the Landscape and Sports Digital Vari-Program scene modes.

The Setup menu

Another lengthy menu, this one offers additional ways to customize basic operations plus options related to camera maintenance, file handling, and computer/printer connections. Figure A-5 shows just the first page of the menu; Table A-4 describes all the options.

As with the Custom Setting menu, some options on the Setup menu are hidden, by default. Set the first menu option, CSM/Setup menu, to Full to display hidden menu items.

	SETUP MENU	
▶		
📷	CSM/Setup menu	📇
✏	Format memory card	--
	Info display format	info
🔧	Auto shooting info	🖥
☑	Shooting info auto off	ON
	World time	--
?	LCD brightness	0

Figure A-5: More customization options appear on this menu.

Table A-4	The Setup Menu
Menu Option	*Choose This Option To . . .*
CSM/Setup menu	Choose one of three menu display options: Full, to display all menu items; Simple, to display only basic menu items; or Custom, to specify exactly which menu items appear. (Choose Full while working with this book.) See Chapter 11 for help creating custom menus.
Format Memory Card	Erase all memory card data and prepare the card for use by the camera. (Deletes even protected image files and any non-image files on the card.) Chapter 4 discusses the difference between formatting the card and simply deleting images.
Info Display Format	Select one of three styles for the Shooting Info display. See Chapter 11 for a look at your options.
Auto Shooting Info	Specify whether the Shooting Info screen automatically appears when you depress the shutter button halfway and then release it without taking a picture. (The On setting also displays the screen immediately after you take a picture if you disable automatic image review on the Custom Setting menu.) Chapter 1 explains the Shooting Info screen.
Shooting Info Auto Off	Choose whether the camera automatically shuts off the Shooting Info display and turns on the viewfinder display when you put your eye to the viewfinder. Chapter 1 has the details.

(continued)

Table A-4 *(continued)*

Menu Option	*Choose This Option To . . .*
World Time	Set the camera's internal date and time clock, which affects the date and time that's recorded in the picture *metadata* (camera data that you can view in many photo programs). See Chapter 8 for information about viewing metadata.
LCD Brightness	Adjust the brightness of the camera monitor. Chapter 1 has details.
Video mode	Choose the video format (NTSC or PAL) used when you connect the camera to a television or other video device. See Chapter 9 for help.
Language	Select the language used in menus and other text displays.
Image Comment	Add a text comment to the image metadata (which you can view in Nikon ViewNX, Capture NX, and some other photo programs). Chapter 11 explains this feature.
Folders[1]	Create custom folders for storing your images on the camera memory card. See Chapter 11 for information.
File No. Sequence[1]	Specify whether the camera resets file numbering to 0001 each time you insert a new memory card, format the card, or create a new folder. See Chapter 1 for details.
Clean Image Sensor[1]	Control whether sensor cleaning happens automatically when you turn the camera on and off; perform an immediate sensor cleaning. Chapter 1 spells out your options.
Mirror Lock-Up[1]	Lock the camera's mirror (part of the optical assembly) into the up position to permit cleaning of the filter that protects the image sensor. *Note:* This process is best left to professional camera repair and maintenance experts.
Firmware Version[1]	Display the version number of the current camera firmware. (See the start of this appendix for details.)
Dust-Off Reference Photo[1]	Create a reference photo that you can use in conjunction with an automated dust-removal filter provided in Nikon Capture NX software.
Auto Image Rotation[1]	Specify whether the image file should contain data that indicates the camera orientation at the time the picture was shot. When this data is included, ViewNX and some other photo programs automatically rotate images to their proper orientation, as does the camera monitor. See Chapter 4.

[1]*Not displayed on menu by default; change the CSM/Setup menu option on the Setup menu to Full to access.*

The Retouch menu

This menu, the first screen of which you can see in Figure A-6, accesses the camera's built-in photo-retouching tools, which you apply to images that you've already taken. In all cases, the camera creates a copy of the original image and applies the retouching effect to the copy only. Table A-5 describes each retouching process.

Figure A-6: You can create retouched copies of your originals via this menu.

Table A-5	The Retouch Menu
Menu Option	**Choose If You Want To . . .**
Quick Retouch	Boost saturation and contrast as well as apply a D-Lighting exposure correction. Chapter 10 explains.
D-Lighting	Brighten dark areas of a photo. See Chapter 10 for details.
Red-Eye Correction	Automatically remove red-eye from a picture taken with flash. Chapter 10 covers this one, too.
Trim	Crop a photo to one of several preset image sizes; see Chapter 10.
Monochrome	Create a black-and-white, sepia, or cyanotype (blue and white) copy of an image. Chapter 11 has details.
Filter Effects	Tweak photo colors (see Chapter 10) or apply a starburst special effect. (See Chapter 11.)
Small Picture	Create a Web-sized copy of a large image. Chapter 9 explains this option.
Image Overlay	Blend two NEF (Raw) images to create a composite photo (also created in the NEF format). See Chapter 11 for a look at this feature.
NEF (Raw) Processing	Create a copy of a NEF (Raw) image in the JPEG file format. Chapter 8 explores this issue.
Stop-Motion Movie	Turn a series of still images into a stop-motion movie. Chapter 9 guides you through the process.
Before and After	Compare an original image with one that you altered through a Retouch menu option. Note that this feature appears only if you access the Retouch menu by displaying a photo in full-frame view and then pressing the OK button. See Chapter 10 for more information.

Index